ISBN 88-492-0876-6

500 Years of Papal Portraiture

Pope John Paul II Cultural Center
Washington DC

Gangemi Editore

PAPI IN POSA – 500 years of Papal Portraiture
Washington DC, Pope John Paul II Cultural Center
16 Ottobre 2005 – 30 Marzo 2006

Centro Europeo per il Turismo
ROMA

Pope John Paul II Cultural Center
WASHINGTON

President
Giuseppe Lepore

Executive Director
Reverend Monsignor William A. Kerr

General Director
Stefano Zelli

Director of the Museums
Penelope C. Fletcher

Press Office Director
Franco Cavallaro

Director of Exhibitions and Publications
Daniel G. Callahan

Public Relations
Letterio Allegra
Salvatore Alaimo

Publications Manager
Scott G. Rall

Secretary
Simona Padelletti
Edoardo Porta
Isidoro Lenato

Curator
Jaime E. Fletcher

Registrar
Kelly E. Rushing

Insurance Companies
Lloyd's of London
Progress Insurance Broker S.r.l.
RAS

Consultant
Suzy Ford
Ph D Candidate and Lecturer,
Department of Art History
Rutgers University

Transport
Montenovi S.r.l.

In cooperation with

Vatican Museums, Vatican

Palazzo Chigi in Ariccia (Rome)

Catalogue and exhibition edited by

Francesco Petrucci

<table>
<tr><td>

Scientific Committee

Card. Francesco Marchisano
(Archpriest Patriarcale Basilica di San Pietro)
Chairman of Committee

Dr. Maria Elisa Tittoni
(Director Musei d'Arte Medievale e Moderna – Museo di Roma)
Vice-chairman Committee

Dr. Francesco Buranelli
(Director Vatican Museums)
Vice-chairman Committee

Mons. Mauro Piacenza
(President Pontificia Commissione
per i Beni Culturali della Chiesa)

Dr. Francesco La Motta
(Central Director Fondo Edifici di Culto
del Ministero dell'Interno)

Prof. Claudio Massimo Strinati
(Superintendent Polo Museale Romano)

Dr. Antonio Paolucci
(Superintendent Polo Museale Fiorentino)

Dr.ssa Penelope C. Fletcher
(Director of The Pope John Paul II Cultural Center
of Washington DC)

Prof. Baldassarre Conticello
(Archeologist – Consultant Centro Europeo Turismo)

Arch. Francesco Petrucci
(Director Palazzo Chigi in Ariccia)

</td><td>

Honorary Committee

Cardinal Francesco Marchisano
Archpriest Patriarcale Basilica di San Pietro

Adam Cardinal Maida
Archbishop of Detroit
Pope John Paul II Cultural Foundation President

Arch. Agostino Marchetto
Secretary "Pontificio Consiglio Migranti ed Itineranti"

Mons. Mauro Piacenza
President Pontificia Commissione
Per i Beni Culturali della Chiesa

Giuseppe Pisanu
Secretary of the Interior

Rocco Buttiglione
Minister Cultural Affairs of Italy

Piero Marrazzo
President Regional Committee of Latium

Walter Veltroni
Mayor of Rome

Gianni Borgna
Commissioner "Politiche Culturali" City of Rome

Vincenzo Maria Vita
Commissioner "Politiche Culturali" Province of Rome

</td></tr>
</table>

Authors of writings

Paolo Appignanesi
Francesco Buranelli
Pietro Cannata
Isabella Colucci
Rossella Leone
Anna Lo Bianco
Susanna Marra
Maria Antonia Nocco
Daniele Petrucci
Francesco Petrucci
Pier Paolo Quieto
Renata Sansone
Simone Starnotti
Maria Elisa Tittoni
Antonio Vannugli

Text editor

Susanna Marra

Lenders

Ariccia (Rome), Palazzo Chigi
Artena (Rome), don Andrea Scirè Borghese collection
Baltimore, Walters Art Gallery
Bologna, Museo Civico Medievale
Camerino, Palazzo Comunale
Cantalupo in Sabina, Camuccini collection
Cingoli, marchesi Castiglioni collection
Detroit, Monsignor Michael R. Dylag collection
Florence, Galleria degli Uffizi
Frascati (Rome), Villa Sora
Genzano (Rome), Palazzo Jacobini
Milan, Etro collection
Milan, Koelliker collection
Milan, galleria Baratti
Minneapolis, The Minneapolis Institute of Arts
Ro Ferrarese (Ferrara), Cavallini Sgarbi Fondation
Rome, Accademia Nazionale di San Luca
Rome, Galleria Nazionale d'Arte Moderna, Museo Manzù di Ardea
Rome, Ministero dell'Interno – Fondo Edifici di Culto
Rome, Museo di Roma, Palazzo Braschi
Rome, Vatican Museums
Rome, Palazzo Spada
Rome, Reverenda Fabbrica Basilica di San Pietro
Rome, eredi Mario Russo collection
Rome, gallerie antiquarie Benucci
Rome, galleria Bigetti
Rome, Gasparrini Antiquari
Senigallia, Palazzo Mastai Ferretti, Diocesi di Senigallia
Washington DC, Pope John Paul II Cultural Center

Photographic Credits

Ariccia (Rome), Archivio Fotografico Palazzo Chigi
Baltimore, Walters Art Gallery Photographic Services
Bologna, Archivio Fotografico dei Musei Civici d'Arte Antica
Milan, Collezione Koelliker Archive
Minneapolis, The Minneapolis Institute of Arts Photographic Services
Rome, Archivio Fotografico Soprintendenza Speciale Polo Museale Romano
Rome, Archivio Fotografico dei Musei Vaticani
Rome, Archivio Iconografico del Museo di Roma
Rome, Galleria Nazionale d'Arte Moderna di Roma, Collezione Museo Manzù di Ardea
Archivio Fotografico Fondo Edifici di Culto (Sandro Pisello)

Acknowledgments

Maurizio Antonimi
Frabrizio Apolloni
Giorgio Baratti
Mario Bigetti
Principe Paolo Boncompagni Ludovisi
Principe Alessandro Boncompagni Ludovisi Altemps
Principe Andrea Borghese
Valneo Budai
Barone Vincenzo Camuccini
Marchesa Adriana Castiglioni
Patrizia Comand
Marcello Fagiolo
Franco Di Felice
Don Pietro Fausto Frisoli
Alessandra Gregori
Fabiano Forti Bernini
NH Massimo Jacobini
Luigi Koelliker
Monsignor Vittorio Lanzani
Anna Lo Bianco
Marchese Duccio Marignoli
Susanna Marra
Clemente Mastrella
Massimo Medica
Massimiliano Montenovi
Monsignor Giuseppe Orlandoni
Daniele Petrucci
Gabriele Reina
Roberto Scardella

Special acknowledgments to

Ministero per i Beni e le Attività Culturali
Ministero dell'Interno - Fondo Edifici di Culto
Gruppo Tutela Patrimonio Archeologico della Guardia di Finanza

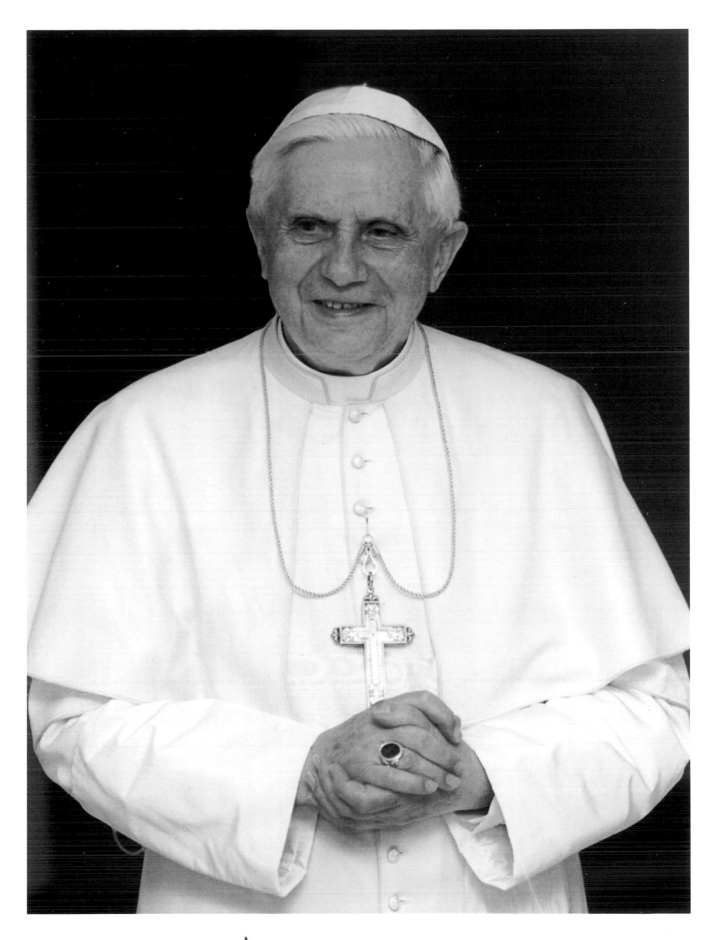

Benedictus PP XVI

Prefaces

Introductory essay

Catalogue

The exhibition entitled "Papi in Posa," i.e., "Papal Portraiture," with the highly refined and historically significant Braschi Palace – home of the Museum of Rome – in 2004, and now in Washington, Pope John Paul II Cultural Center, is not offered only as an excellent exposition of masterpieces from major international museums – such as the Vatican Museums – and prestigious private collections, but stands out in particular because it is one of the most important expositions of portrait painting ever because of both the outstanding quality and the considerable number of paintings and sculptures offered – executed by Europe's leading artists from the last five centuries – and the great spiritual and social significance of the personages portrayed: the greatest Pontiffs who from the 16th century to the present have sat in the Chair of Saint Peter.

It is suggestive to observe, as we scan the unique artistic itinerary offered by the curators of the exhibition, how through the succession of historical periods and particularly by virtue of the esthetic verve and inner sensitivity of the artists, the description of the human person was oriented, with extreme plastic ductility and acuity in their perception of their subjects' physiognomy, to represent not only the body lines of the subject being depicted but, in particular, the most intimate traits of the heart, the lively mobility of their thought, the innermost lines of the subject's character, in an intense dialogue of chiaroscuro observations from which the characterizing notes of complex personages are evinced – persons who appear completely clear and evident only to those who are capable of sublimating their outward appearance into an acute observation.

From this prestigious gallery of portraits it emerges unmistakably how the anthropocentric path of human thought has manifestly reverberated within the bounds of the figurative arts through a progressive contextualization, which sees the subject represented unbound through a metatemporal aura of rarefied abstraction and placed, naturalistically, in a precise and well defined spatiotemporal sphere. At the same time, we witness a gradual definition of the personage portrayed as the bearer of a clear personal connotation – the self and the identity, which seem to be invisible and thus impossible to represent – no longer, hortatively, as an idealized and metaphoric emblem of absolute values in deference to a markedly ethical and pedagogical conception.

The exhibited works, which rightfully range themselves among the most outstanding expressions of portraiture, reveal a deep spiritual harmony evocative of beauty and unleash a lively dialogue with the onlooker based on a real and inherent economy of the

act of viewing, albeit freed from the exercise of a psychologism oriented toward uncontrollable wanderings.

The reception of the meaning of the formal systems – thoughtful poses and attitudes – involves, to be sure, the active presence of the spectator in a sort of visual dialogue with the portrait that is not considered exclusively as a fixed commemorative system but rather as an interactive structure.

In the perspective of the reception, the observer becomes a fundamental element for the construction of the meaning of the image that, from this very private perspective, undergoes obvious momentous transformations.

Observer and image thus become integral parts of a fascinating system of visual exchange not unlike the mechanisms of verbal dialogue: both members of the "pair" take on contemporaneously the dual role of subject/object, restructuring the complex relational web established in a rapport between an "I" and a "you."

Beyond the temporal contingencies, each portrait is recounted and seduces us through the universal language of fame: this incarnates, deeply, the artist's attempt to describe the personality of the subjects portrayed, consigning the multiform essence of their nature to one attitude or to a single expression by resorting to a refined psychological introspection in an attempt to render visually the subject's inner world.

It is owing to the above considerations that, while I applaud the felicitous initiative of giving life to such a culturally transcendent exhibition, I would wish that all those who will have the pleasure of visiting it or at least of perusing the pages of this catalogue will be able to perceive the portraits of the individual popes not as so many freestanding elements, but rather as integrated parts of a related set of men who, albeit struggling with the many and varied anxieties of everyday life, endeavored to serve Christ among their brothers, each one with a clear perception of himself as *servo servorum Dei* – the servant of God's servants!

Through looks, attitudes and symbols committed by the artist in a well-constructed iconographic code to the pictorial or sculptural page, the discerning observer cannot help but grasp a veiled spiritual harmony that reflects the profound mystery of faith and propagates an echo of the ineffable beauty of God, revealing how, through art, man – pulled between the eternal and the transient – strives to draw close to his Creator.

Francesco Cardinal Marchisano
Patriarchal Archpriest of Saint Peter's Basilica

*U*pon this Rock

The cornerstone, containing a part taken from the area of the tomb of St. Peter in the Vatican Basilica, will serve to symbolize the Center's union of purpose with the evangelizing efforts of the Successors of Peter.

Pope John Paul II, May 30, 1996
Vatican City
On the occasion of the blessing of the cornerstone

Visitors entering the Rotunda of the Pope John Paul II Cultural Center immediately notice the Center's cornerstone housed behind glass. It is small but significant, in that it is a stone taken from the area beneath the Vatican Basilica identified as St. Peter's Tomb. The inscription above it states the overall mission of the Pope John Paul II Cultural Center to promote and assist in the evangelizing work of the Holy See. It is a stone that represents the rock – St. Peter the Apostle – upon which Christ established his Church. In this light our cornerstone evokes the great tradition of the papacy.

Papal portraiture can be found throughout Rome and the Vatican. Many of the popes whose portraits are presented in the exhibition are buried in the crypt of St. Peter's Basilica near the area where our cornerstone originated, and their portraits are often incorporated into their funerary monuments. But these representations are unlike the portraits in the exhibition which are portraits painted from life; the works assembled for *Papi in Posa* provide us with insights to the living personality of each pope and his vision for the Church. These are portraits of faith – living faith – from which a foundation was laid for the Church of our modern world. The Pope John Paul II Cultural Center celebrates this faith-filled legacy through this wonderful exhibition of papal portraiture and it is altogether fitting that the exhibition *Papi in Posa, 500 Years of Papal Portraiture* finds a place here.

I wish to thank Francesco Cardinal Marchisano, who first realized the significance of this exhibition and envisioned it coming to the Cultural Center and Adam Cardinal Maïda for his constant and loving guidance of the Pope John Paul II Cultural Center. We

PAPI
IN
POSA 500 Years
of Papal Portraiture

acknowledge and thank Francesco Petrucci, Conservatore del Palazzo Chigi in Ariccia, for his fine work and research on this project; and the Palazzo Chigi in Ariccia for their extraordinary cooperation and kindness in helping us organize this wonderful exhibit. We are grateful to Professore Giuseppe Lepore, President of Centro Europeo per Il Turismo e la Cultura and his fine staff who have put together a magnificent exhibition, and Massimiliano Montenovi for his assistance and friendship.

I extend an additional note of gratitude to Penelope C. Fletcher, Director of Museums; Daniel G. Callahan, Director of Exhibitions; Jaime E. Fletcher; Curator; and the entire staff who made this exhibition a reality.

In the year of this exhibition – and for many years to come – the Cultural Center will celebrate the legacy of our namesake, Pope John Paul II. John Paul's legacy is rooted in the living tradition of the papacy. The faith and vision of the popes represented in *Papi in Posa* have created a living legacy now realized in our Supreme Pontiff Pope Benedict XVI.

Monsignor William A. Kerr
Executive Director
Pope John Paul II Cultural Center

There are so many ways of rereading the history of this city through its works of art by admiring the collections of the statuary from Imperial Rome, or the masterpieces of the Baroque, or even the prints of the 19th century.

This American exhibition – after the similar one that took place in Rome last year- offers us a key to a different and particularly incisive reading: that of the papal iconography.

And there is great reason to reflect on the history of Rome by taking in the depictions of the great popes of the past – from the grave mien of Julius II della Rovere, painted by Raphael, to the frowning glare of Innocent X, by Velázquez, to the suffering features of Pius XII, sculpted by Francesco Messina.

In this solemn gallery of pontiffs we can travel through centuries of history and, at the same time, observe the different approaches employed by the great artists of the different eras, who, in their papal portraiture, sought to concentrate on the man or the politician or the spiritual leader.

This portraiture has also been sensitive to the different historical and artistic phases, and who cannot note the profound differences between Raphael's "psychological" approach, Caravaggio's naturalistic approach or David's formal approach.

The Pope John Paul II Cultural Center in Washington is doubtless the ideal site for this exciting review and the curiosity of Americans will certainly bring them to take advantage of this never-to-be-repeated opportunity to view this unique and illustrious "family album" with portraits from the world's most prestigious museums.

The opening date of the exhibition was chosen by us to coincide with the 26th anniversary of the elevation of John Paul II to the papal throne to whom the exhibition itself has been dedicated.

Gianni Borgna
Member of the Advisory Council for Cultural Policies
of the Municipality of Rome

The European Centre for Tourism has organized with the Pope John Paul II Cultural Center in Washington, the exhibition *PAPI IN POSA ("PAPAL PORTRAITURE")* to honor the 26 years of the Pontificate of His Holiness, John Paul II. The purpose of this tribute is to express our heartfelt thanks and deep admiration for the Pontiff who, from the first day of his election in 1978, with skill, courage and persistence proved himself up to the task of reminding, encouraging and urging the Catholic faithful to open their hearts to Christ, to follow the Gospel with consistency and exhort all men of goodwill to pursue peace and justice through his writings, speeches, meetings and apostolic visits.

At a time of worldwide social, political and economical crises and the sudden collapse of ideologies heretofore considered firmly entrenched, with the resulting confusion and disorientation, John Paul II showed himself to be one of the few, if not the only person in the world, beyond the different creeds and religious orientations, to possess a charisma capable of becoming a guidepost for so many persons left perplexed and in search of true human values.

After having accompanied us into the Third Millennium, untiringly and in every way, in imitation of Christ's invitation to Peter, he kept on striving to "put out into the deep" so that the love of Christ, Mankind's Redeemer, would be known by all and expand in every direction, and to exhort every believer to continue with new impetus the program of transforming history, "making it the force which inspires our journey of faith" (*Novo Millennio Ineunte, 29*).

Giuseppe Lepore
President of the European Centre for Tourism

The Power of Images

The Pope John Paul II Cultural Center is proud to present the exhibition *Papi in Posa: 500 Years of Papal Portraiture*. The exhibit was produced to honor the memory of Pope John Paul II, and it opened at the Cultural Center on October 16, 2005 – the 27th anniversary of the election of the late pontiff. This extraordinary exhibit presents a visual history of the papacy looking back over five centuries. It reveals, in ways that writers of biographies and histories cannot, the struggles and triumphs of the men known as "the popes." The exhibit's dedication to John Paul II is fitting, for he, like all the popes represented in this exhibition, was adept at using his image for the advancement of the Catholic faith and the Church.

Pope John Paul II knew well the "power of images" and took advantage of every opportunity to create new perceptions of the pope as a man of peace, a defender of the poor and the defenseless, an inspiration for youth and a man of faith.

While scholars will pour over the late pontiff's encyclicals, apostolic letters and other writings in an effort to understand him more fully, the world came to know and understand Pope John Paul II through the countless photographic images and endless miles of film available to us. Such is the power of images, that the people of the world felt they understood this pope as well as any scholar. In the same way that Pope John Paul II employed photography to project his image, Pope Julius II employed Raphael. Today's "media opportunity" is the equivalent of the "portrait sitting" in centuries past. Popes understood the power of the portrait to aid them in their promotion of the faith. The artists they commissioned were masters at capturing more than just likeness of face and body; their portraits embodied the accomplishments, challenges and further aspirations of the sitting pope.

The advent of photography in the mid-19th century did not eliminate the need for portrait artists at the Vatican as the exhibit demonstrates with the inclusion of the portraits and sculpture busts from the 20th century, including those of Pope John Paul II. These are the chosen images of each pope, designed to provide an image and message to last through the centuries.

To understand the changing symbolism in the exhibition's portraiture is to understand the 500 years of emerging culture for which the symbols were produced. For this reason the Pope John Paul II Cultural Center is the appropriate venue for the *Papi*

in Posa exhibition. The Center's museums exhibit great works from around the world in order to present the works for their contribution to faith. Above all, the Cultural Center is dedicated to exploring the interaction between faith and culture. The brilliance of the portraits included in the exhibit is that they not only demonstrate each pope's personal perception of himself, but also his understanding of the cultural environment for which the portrait was being produced.

Understanding each portrait in this exhibit provides us insight into the minds and hearts of the pontiffs for whom the portraits were produced. Looking back we can determine the impact each pope had on the lives of those for whom he was a shepherd and father. What can be supposed of future generations' perceptions when they study the portraits of Pope John Paul II? I believe they will know how fortunate we were to have him as our pope.

Penelope C. Fletcher
Director of the Museums
Pope John Paul II Cultural Center

In his treatise *Considerazioni sulla pittura* [Reflections on the Art of Painting], written in the third decade of the seventeenth century, Giulio Mancini distinguished two types of portraits, the first a "simple portrait" "without action and affective expression," in which the primary concern is an exacting likeness of the sitter. The second type is characterized by action and mood and constitutes, according to the Sienese author, the foundation of history painting. Therefore the second type of portrait assumes a distinct status among artistic genres codified in art treatises of the Renaissance and Baroque periods.

For this reason the principal figure of a painting was required meet strict conditions: "accurate likeness, gesture, costume, decorum and grace, each expressed through action, position, station and expression, combining all those things to signify and represent the action of whatever figure you require."

Even today, papal portraiture takes its cue from canonical Renaissance models in the lineage proposed by Mancini, in order to communicate both the physical appearance of the Vicar of Christ and his role as head of the Church and of the Papal States.

Papal portraits, whether painted or sculpted, are intended not only to render to the faithful and to the Pope's subjects a record of the physical and transient image of the reigning Pontiff, but to affirm, through consistent and fundamental analogy of pose, dress, and attributes, the continuity and perpetuity of papal spiritual and temporal power.

The selection of artist to produce a papal portrait was at the discretion of the client. Such a commission could seal the fame of the chosen artist, often the result of his increased visibility as copies of the portrait were produced to satisfy requests from churches, religious orders, family and friends, or members of the papal court.

Ownership of a papal portrait therefore became, to the extent that the image was publically known, an emblem of prestige and power but also of devotion and faithfulness. The social status of the owner was determined by the quality of the work: original, autograph replica, workshop replica, or copy. Comissioning a portrait was not the exclusive prerogative of the pontiff or of his family; members of the court could order portraits to acquire merit or to consolidate their positions. An example is the Sacchetti family commission to Pietro da Cortona for the *Portrait of Urban VIII*. Cortona's original remained with the Sacchetti family until its sale to the Campodoglio in the eighteenth century, while documents reveal that the Barberini family possessed a modest copy.

The coincidence of temporal and spiritual power in the same individual made the Roman situation unique with respect to the typology of royal or aristocratic portraits in

European courts from the sixteenth to the nineteenth centuries. This had an important influence on formulae for papal portraits, necessarily limited to carefully observed patterns in which few variants could be allowed. On the other hand, a portrait of the pontiff was never a private question, exclusively the concern of the family; it dealt with committing to posterity the memory of the head of the Catholic Church.

In the execution of such a work the artist was required to respect established iconographic canons and was unable to rely entirely on invention. Nevertheless this imposed limit frequently produced real masterpieces in which all the skills of the painter or sculptor converged in pictorial richness or in the handling of materials, or in elegant compositional variants introduced at the request of the patron.

The best papal portraits are characterized by a subtle equilibrium between the realism necessary to identify the sitter and a desire to idealize the image of the sovereign Pontiff in order to accentuate his grandeur. The portrait evokes the power of the sitter through the artist's ability to realize a complex mediation between truth and beauty and to avoid the pitfalls of prosaic realism in order to achieve what Bellori called "judicious imitation."

The events related to the commission and execution of papal portraits, thoroughly described in the entires of this catalogue, find their rightful place in the many "histories" that make up the great history of Rome.

Maria Elisa Tittoni
Director Musei d'Arte Medievale e Moderna – Museo di Roma

« *W*

"Where Peter is, there the Church is; where the Church is, death is not, but rather everlasting life." (Ambrose, *Commentary on the Psalms*, XL, 30) With these words, which contain one of his most celebrated expressions ("*ubi Petrus ibi Ecclesia*"), St. Ambrose, Father of the Church, wished to express clearly the unity of all local churches with the Church of Rome and with its bishop, the Pope. This fraternal communion signifies, moreover, the continuity of the community of apostles and its leader, Peter, with the college of bishops and the Pope, successor to that first bishop of Rome upon whom Jesus established the foundation of his Church. (cfr. Matthew 16:18)

Since the dawn of Christianity, the ecclesiastical community of Rome recognized its unique role as a benchmark and guide for the whole Church, by virtue of the succession of its bishop from Peter. In his *Letter to the Romans* St. Ignatius of Antioch described this singular primacy as a "presidency of charity."

The face of the Universal Church, therefore, is reflected in the face of the Roman church and of its Bishop, and "Christ being the 'Light of the World,' his light, reflected in the appearance of the Church, illuminates all mankind through the proclamation of the Gospel to every creature" (in the celebrated opening words of the constitution on the Church, *Lumen Gentium*, of the Second Vatican Council.)

In this exhibition of papal portraiture to which the Vatican Museums have contributed in considerable measure, then, we would wish to read more than artistic and historical information, but also to discern the spiritual quality that has distinguished this unique "dynasty" continually throughout two millennia, concerned always with a reign that is "not of this world" (John 18:36). The tiara and keys, the same pontifical insignia that suggest the temporal concerns included for many centuries in Petrine service, refer simultaneously to its highly spiritual significance. The tiara, of Byzantine origin, assumed its present appearance at the beginning of the fourteenth century when its one tier was increased to three to signify the regal, imperial, and priestly authority of the Roman Pontiff. The keys derive from the well-known Gospel account in which Christ passes to Peter the keys of the kingdom of heaven (cfr. Matthew 16:13-20), and also reflect the temporal and spiritual power of Peter's successor. The exhibition "*Papi in Posa: 500 Years of Papal Portraiture*" presents the faces of the principal Popes from the beginning of the sixteenth century through today, as they take their turns on the throne of Peter. These commissions were frequently entrusted to prestigious artists, and in some cases (as with Popes whose reigns were very brief), the images are unique and constitute crucial evidence in a scant visual record. Comparative

study of these images will expand a critical and historical discourse that has received little investigation to date, although a stimulating foretaste of the present dialogue was provided by Francesco Petrucci's *Papal Portraiture in Paintings of the Sixteenth Century to Today*. Through their unfolding chronology and changing pictorial styles, these images offer a singular approach to the investigation of papal history and succession.

We conclude this brief contribution with a reference that seems fundamental, in that it identifies the institution in which this exhibition was conceived: the Museum of Rome.

The present show in Washington revisits, with a greater number of works and diversity of artistic styles, the exhibition *"Papi in Posa*: From the Renaissance to John Paul II" held in Rome in the autumn of 2004. It has been said that Rome is truly the papal city, and naturally it is tied to the pastoral service of its Bishop. Throughout the centuries, those who rose to the throne of Peter were frequently Rome's own, the most illuminated minds of the city's leading families. But even when the Popes were from distant lands, whether in Italy or elsewhere, they always professed a symbolic Roman citizenship, embracing a heritage in the capital of Christianity founded on the testimony of the apostles and martyrs. This bond between Rome and the papacy remains firm despite the end of the secular temporal power that characterized the papacy for so long. In two memorable visits to the Campidoglio, Popes Paul VI and John Paul II confirmed the new form, free but indissoluble, of the relationship between Rome and its Bishop. It seems fitting to conclude with their words.

"We [the Popes] no longer have temporal sovereignty to maintain here. We preserve the historical record of it, of a secular, legitimate and, in many ways, visionary institution of earlier times, but today we do not mourn it, have nostalgia for it, or entertain some secret foolish ambition to reclaim it. But should some other, minuscule temporal power, more symbolic than real, qualifiy us to regard ourselves free and independent people, we will not forget that we are Roman people!" (address of Paul VI from the Campidoglio, April 16, 1966).

"Civil Rome and Christian Rome do not find themselves in opposition or in competition, but joined together, while respecting their different responsibilities, by their love for this city and by the desire to make its image an example for the whole world: [...] a city called to be a beacon of civilization, 'disciple of truth' (Leo the Great, tract 97), and 'welcoming mother of the people' (Prudenzio, *Peristephanon*, 11, 191)" (Address of John Paul II from the Campidoglio, January 15, 1998).

Francesco Buranelli
Director Vatican Museums

PAPI
IN
POSA

500 Years
of Papal Portraiture

Papal Portraiture since the 16th Century

Francesco Petrucci

No royal family, imperial or princely dynasty can match the long and uninterrupted sequence of masterpieces offered by papal portraiture either in the quality of the works or in their temporal extension and continuity.[1] Renaissance producers of papal portraits were leading artists such as Raphael, Sebastiano del Piombo, Titian, Caravaggio, Bernini, Algardi, Velázquez, Baciccio, Maratta, Batoni, Mengs, Canova, Lawrence and many other great painters and sculptors; even earlier, they were masters such as Giotto or Pisanello. Papal portraiture falls within the context of portrait typologies linked to power and it is intimately related to the supreme spiritual and charismatic burden that the Church and society's collective expectations assigned to the Roman Pontiffs. Until 1870 these portraits were also linked to the political function of the Vicar of Christ as the sovereign of an independent state. The scheme of the portrait is therefore perfectly functional to that role, in a mechanism of recognition of immediate intelligibility: these portraits are emblematic of meanings loaded with symbolic and metaphoric values, and they are not descriptive of individual identities.

According to the iconographic model of Saint Peter in the Vatican Basilica, the immovable *ex cathedra* Pontiff, seated on the papal throne, as king of kings, expresses stability in the preservation of orthodoxy and the supreme ecclesiastical authority . This typology is therefore prevalent, without substantial variations, up to these days. Nevertheless, beginning in the 18th century, new schemes asserted themselves, which underwent variations and developments of poses in the course of last century.

A real deviation from the traditional typologies occurs with the pontificate of Paul VI, who introduced not only revolutionary solutions and compositional innovations in papal portraiture, but also a modernization of the language of religious art, compared with the avant-garde movements and the numerous new ferments that arose in the field of the visual arts in the course of the 20th century. One can understand the symbolic significance of papal portraiture comparing it with portraits of cardinals and aristocrats. Portraits of cardinals in their role of new apostles, charged with the transmission of the message of Christ in the world, such as the portrait of Cardinal Alessandro Farnese by Raphael (Naples, Capodimonte), develops in the 17th century and especially in the 18th century the typology of the sitter's standing pose, with a weighty message in a hand and about to act . The 16th century garb of a "condottiero", instead, expresses preferably the function of the Roman prince as a defender of Catholicism. A secular and more intellectual appearance increasingly asserts itself, beginning in the second half of the following century and especially in the 1700s, thanks to the circulation of the new enlightened ideas . In this concern, Msgr. Giovan Battista Agucchi, in his 1610 *Trattato sulla Pittura* [Treatise on Painting], maintained that the most developed form of portraiture was that which depicted the personages as they should have been, according to their status in the world, going beyond the subject's likeness.[2]

This idealizing tendency in official portraiture was a widespread practice in

ancient times: Leon Battista Alberti, quoting Plutarch, remembers that the painters of antiquity, when they executed portraits of sovereigns, would suppress their imperfections and defects, although they retained the resemblance (1, 2, *Della Pittura*, p. 29). Renaissance portraiture itself is eminently idealizing, shrouding sitters in an otherworldly abstract dimension, particularly in Tuscan and Roman areas, where a neo-Platonic philosophical culture prevailed. This is particularly evident in portraits of illustrious personalities, rendered godlike by the artist's brush or chisel to arouse the admiration of those they were to impress. The 16th and 17th century esthetic theories are a reference point for such attainments. (Vasari, Zuccari, Agucchi, Bellori). The portrait of a pope, cardinal and prince must therefore be understood in this context. Its purpose is not to reflect the psychology, the disposition and inner nature of the subject, as it has been arbitrarily and insistently maintained in the recent examination of the portraiture from the 16th to the 18th centuries, but to express his social status and function in society. Therefore, more attention is paid to what the subject "ought to be" or "wants to be", than to what he actually "is." There is, then, an essentially "political" portraiture, seeking to convince or transmit more general values, and not investigate the inner feelings of each individual.[3] The portrait of a pontiff will express spirituality and steadfastness in his supreme role as a custodian of dogma: it would be difficult to extract from a Renaissance and Baroque papal portrait the true nature of the man under the camauro (skullcap) and the mozzetta (bishop's cape). It is often easier to read the personality of the portraitist than the subject's , i.e., the varying mental conditions assumed by the artist vis-à-vis his model. Art should not be confused with science (psychoanalysis), because psychology and psychoanalytic examination are acquisitions of modern thought. Portraiture is a subjective expression: although the subject with his complex personality remains the same, his portraits executed by different artists can bear no resemblance with each other. Portraiture is a reflection of the culture and the values of the time in which the artist lives: between Renaissance and Neoclassicism, it observed the idealizing principle of picking and choosing from reality in pursuit of a practical and rhetorical end, in which form and appearance assume a preeminent value (the portraits of Leo X by Raphael or Louis XIV by Rigaud, for example, have little to do with the true nature of the subjects, but a lot with contemporary politics).

Raphael's Portrait of Julius II, at the National Gallery in London (fig. 1), is the prototype of modern iconography of popes and cardinals . This archetype codifies a scheme that will enjoy great success in subsequent centuries up until the 20th century, with a three-quarter view of the seated figure, foreshortened on the right, the subject's eyes looking thoughtfully down, his forearms resting on the arms of the papal throne, his right hand clutching the handkerchief. It prevailed over the preceding iconic archetype, which portrayed the pontiff in an abstract code, like a divinity; an example is the portrait of Martin V by Pisanello, with the pope in profile as on a medal. Positioning the subject with his right side turned toward the viewer has a precise communicative meaning because offering one's right is a sign of respect, in this sense, in fact, walking with a person to his right puts him at ease. In addition, as Jesus Christ sits at the right hand of God the Father, in

Fig. 1.
Raphael, Portrait of Julius II.
London, National Gallery

the same way the pope should relate to his own immediate collaborators and the faithful. In a broad sense, turning to the right is full of symbolic meanings, such as faithfulness to tradition and to the authority of the past, with its centuries-old religious institutions and their rituality. Such iconography has an intrinsic eschatological value, based not merely on the ability to evoke a sensorial and esthetic experience, but to put the viewer into a relationship with the metaphysical essence of the pontifical image. At any rate, the enormous significance of symbolism in Catholicism cannot fail to involve papal iconography as well, as an ulterior expression destined to evoke the presence of the supernatural in the real world. On the other hand, the reflected pose with the pope turned to the left side, was introduced more rarely fore the sole purpose of showing his arm raised in blessing, so that it would not cover or overlap the figure. This latter pose was chosen only for esthetical reasons. Indeed, until the 19th century, the majority of papal iconography, following the example of Raphael's Julius II, favors the pope posing to show his right side (Velázquez, Mola, Maratta, Batoni, Camuccini, Mengs, etc.).

Another element of interest, introduced by Raphael in this archetype, is the presence of the handkerchief clutched in the right hand. At first glance, bringing the pope down on earth from the abstract sphere in which until then he was elevated in depictions might seem a merely realistic motif of the representation, too. Nevertheless, it conceals a deeper meaning: the handkerchief to wipe away the sweat of his toil is a reference to the shroud offered by Veronica to Christ in the ascent to Calvary. Like Christ, the Pontiff, visibly tested by his weariness, must face with

steadfastness and determination the adversities that confront him, without yielding.

A curious iconography, emblematic once more of the pontiff's resoluteness and combativeness, represents Julius II in profile dressed as a soldier during the siege of Mirandola. It is known through the canvas at Palazzo Chigi in Ariccia (fig. 2) and the versions by Della Rocca de Candal at Palazzo Bruschi in Corneto and by Duca Giacomo Salviati in Rome: it probably derives from a life sketch executed by an artist such as Bernardino de' Conti or, as Zeri thought, by Ambrogio de Predis in January 1511.[4]

Compared with Raphael's Julius II, Sebastiano del Piombo's Clement VII at the Kunsthistorisches Museum in Vienna replaces the handkerchief with a letter, while the portrait of the same pontiff in the National Museum in Naples (fig. 3) introduces the turned left face variation, as if the sitter had been distracted by someone calling him or by an external event, an archetype for Baroque portraits of prelates.[5]

Titian's Portrait of Paul III Farnese, at

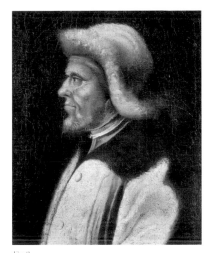

Fig. 2.
Anonymous XVI cent. Portrait of Julius II dressed as a Condottiere.
Ariccia (Rome), Chigi Palace

Fig. 3.
Sebastiano del Piombo,
Portrait of Clement VII.
Naples, National Museum of Capodimonte

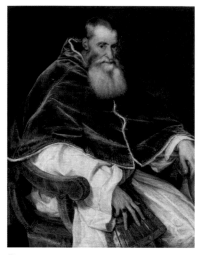

Fig. 4.
Titian, Portrait of Paolo III.
Naples, National Museum of Capodimonte

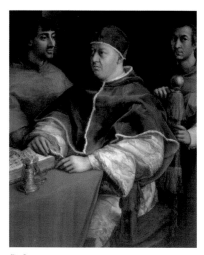

Fig. 5.
Raphael, Portrait of Leo X.
Florence, Uffizi Gallery

Capodimonte (fig. 4), retains the very same pose of Raphael's model and confers the pope a more concrete and confidential dimension: he gazes at us as if he was captured in a moment of private meditation, with his camauro-less bare head, bowed by the weight of his years. The same pontiff is portrayed with the camauro, instead, in the other Capodimonte portrait, where he also has an handkerchief in his right hand, and in the Hermitage version uncertainly attributed to Titian.[6]

Other compositional typologies came out of that hotbed of ideas that was Rome in the Renaissance. The scheme with the seated pope with one or more standing figures nearby is created again by Raphael in his Portrait of Leo X (fig. 5). It has a arduous front-above point of view, showing the table with the bell and breviary on it. The spectacular rendering of the pontiff's garments anticipates Subleyras and Batoni with its effects of sophisticated smoothness and tactility. The care toward the objects belonging to the sitter is an introduction to the 17th century "ritratto ambientato". The portrait had an enormous success and was admired over the centuries as attested tby Anton Raphael Mengs'

unpublished meditation on the pope's face (fig. 6) (Rome, Circolo degli Scacchi).[7]

Titian's Portrait of Pope Paul III with His Nephews Alessandro and Ottavio Farnese (fig. 7) (Naples, Capodimonte) develops from Raphael's Leo X a completely different spatial and compositional situation with figures dialoguing and declaring, almost like in a conversation piece. On the other hand, Jacopino del Conte's Portrait of Paul III and Ottavio Farnese (once in Rome, A. Barsanti collection) standardized the typology of the pope with the "cardinal nephew" in a simple and easily repeatable scheme, later inherited by Domenichino and Masucci. Portraits of Julius III and Paul IV are rare, and even rarer is the iconography of Hadrian VI and Marcellus II, because of the brevity of their pontificates. Nevertheless, the latter is depicted with his bare head, following Raphael's scheme, and a handkerchief clutched in the left hand in a portrait at the Vatican Historical Museum in the Apostolic Lateran Palace, which, according to Vannugli, is a copy of a lost Jacopino del Conte (see cat. 4) (fig. 8).[8]

An important and rare portrait of Pius

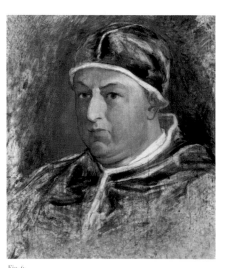

Fig. 6.
Anton Raphael Mengs, Portrait of Leone X.
Rome, Circolo degli Scacchi

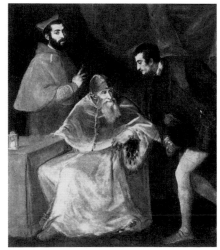

Fig. 7.
Titian, Portrait of Paul III with two nephews.
Naples, National Museum of Capodimonte

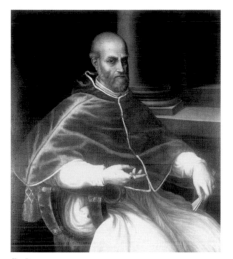

Fig. 8.
*Anonymous XVI c., Portrait of Marcellus II.
Rome, Vatican Museums*

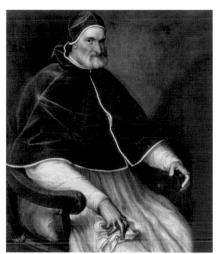

Fig. 9.
*Circle of Titian, Portrait of Pius IV.
Cantalupo in Sabina, Palazzo Camuccini*

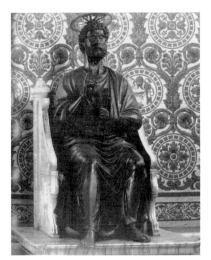

Fig. 10.
*Arnolfo di Cambio (attr.).
Saint Peter in Cathedra.
Rome, Vatican Basilica*

IV, from which derives, as far as the face is concerned, the Lateran portrait on exhibit, is found at Palazzo Camuccini in Cantalupo in Sabina, where it is attributed to the Venetian school of the 16ᵗʰ century and erroneously identified with Pope Pius V (fig. 9). This portrait is obviously compositionally related to Raphael's Julius II, with the hand clutching a handkerchief, but, because of its pictorial technique, it is linked to a strict Titianésque environment (see also the papal throne identical to Titian's Paul III and the elongation of the figure that is also one of his features). Nevertheless, a much-needed restoration would allow a deeper understanding.

The pontiff seated on the papal throne with his hand raised in blessing derives from the iconography of the Savior mostly from the famous Saint Peter seated on a throne, attributed to Arnolfo di Cambio, which is known in two versions: one in marble (obtained by reworking a Roman copy of a statue of an Epicurean philosopher) and one in bronze (fig. 10). This iconography, dominant in sculpture especially with the honorary statues, is also recurrent in painting.[9]

Sebastiano del Piombo himself portrayed Clement VII, at the Pinacotheca in Parma (fig. 11), in the act of blessing with his right hand on the table clutching a handkerchief and with a young man nearby. However, Barolomeo Passerotti 1566 Portrait of Pius V (Baltimore, Walters Art Gallery) codified the scheme of this pose, which depicts the pope facing left , opposite Raphael's Julius II, blessing and holding a breviary in his left hand in allusion to the pontiff's high spirituality (fig. 12).

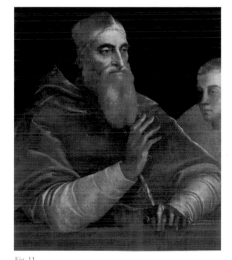

Fig. 11.
*Sebastiano del Piombo, Portrait of Clement VII.
Parma, Pinacoteca*

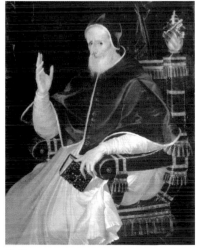

Fig. 12.
*Bartolomeo Passerotti, Portrait of Pius V.
Baltimore, Walters Art Gallery*

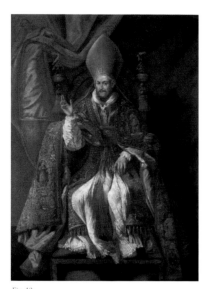

Fig. 13.
Pietro Martire Neri,
Portrait of Innocent X.
Rome, Doria Pamphilj Palace

The pose is repeated in numerous paintings derived from this prototype. Giulio Clovio's Pius V (Milan, Koelliker Collection), displayed in this exhibition, on the other hand, is the best portrait of this pontiff currently known. It confirms Passerotti's typological scheme with the variation of the left hand holding a sheet of paper and the index finger extended, and it is similar to but reversed from Sebastiano's portrait of Clement VII at Capodimonte. The Pope's haloed head suggests a posthumous execution.[10]

This type returns in some 17th century portraits, such as the Portrait of Urban VIII and the similar Portrait of Innocent X by Guidubaldo Abbatini; it also appears in Baciccio's half-bust portraits of Alexander VII and Clement IX . Pier Leone Ghezzi enlivens the composition with a Rococo emphasis: in both versions of his Portrait of Clement XI, at the Museum of Rome and at the Walpole Gallery in London, the position of the face is twisted with regard to the direction of the arms. The

monumental and g Portrait of Innocent X attributed to Pietro Martire Neri is atypical, instead, with the figure framed frontally and the right arm raised in a blessing (fig. 13).[11]

The Portrait of Gregory XIII traditionally and problematically attributed to Scipione Pulzone and recently displayed in the *I Volti del Potere* ["The Faces of Power"] exhibit, was surely an important prototype as well, from which later replicas and copies were derived, such as the oval half-bust version in the Boncompagni Ludovisi collection and another in a private collection (figs. 14 and 15). The portrait, surely traceable to the Roman school, presents an affinity with Federico Zuccari's production, as we can observe in the comparison with the oil on wood Self-portrait in the Biblioteca Hertziana in Rome. Nevertheless, the Pulzonésque features, joined to a certain Nordic influence and Venetian contacts, recall the style of Pulzone's best pupil, Mantuan Pietro Fachetti . On him, Baglione writes: "venne egli a

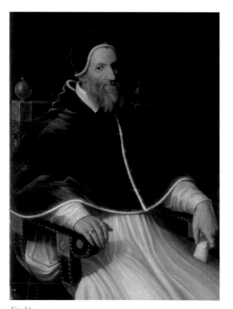

Fig. 14.
Pietro Fachetti (?),
Portrait of Gregory XIII.
Rome, private collection

Fig. 15.
Pietro Fachetti (?),
Portrait of Gregory XIII.
Rome, private collection

Roma giovane nel tempo di GregorioXIII e diedesi a far ritratti si, ch'in quella forte di pittura molto valse, e ne fece di quelli, che potevano stare al paragon di Scipione di Gaeta".[12]

Scipione Pulzone's original panel depicting Gregory XIII in the Boncompagni Ludovisi Collection, on the other hand, was displayed in the 1950 exhibition. The present exhibit, instead, shows a portrait of Pope Boncompagni attributed to Ludovico Carracci.[13]

Sixtus V's portraiture is represented in this exhibition by the portrait from the Lateran Museum attributed to Pietro Facchetti by Antonio Vannugli. The attribution is done on the basis of its rare counterpart engraving in the Biblioteca Casanatense, which flips the Raphaelesque composition on the left side and includes a window opened over Saint Peter's Square. We are also presenting a portrait of Pope Peretti signed by the Roman architect and painter Giovan Battista Cavagna (fig. 16), which asserts itself as the best example of Sistine portraiture because of the high quality of the brushstrokes. The painting comes from Palazzo Camuccini in Cantalupo in Sabina and shows the traditional left-framed pose with the variation of the arm raised in a blessing. The view slightly from above prevents the possible disadvantage of having the hand overlapping the pope's face. This monumental pose is linked to Raphael's two papal portraits, thanks to the inclusion of the curtains in the background and to the extreme attention to detail, including the bell with the Peretti coat-of-arms. The paper on the table bears the signature: "Per Gio. Batta Cavagna."[14]

The portrait of Urban VII of the Koelliker Collection presents Pulzonésque features, especially because of the characteristic curtains, although it doesn't reach the quality standards of the master's portraits. Antonio Vannugli's attribution to Fachetti leaves some problems unsolved. However, I was able to see in a private Roman collection a lovely portrait of Sixtus V, which mirrors perfectly the pose in the Koelliker portrait (fig. 17): it might be Fachetti's prelude to the portrait of Pope Castagna.

The portrait of Urban VII, on display, attributed to Francesco Bassano is of high quality. I am acquainted with a full-figure version in the Wakhevitch Collection in Venice, still in the Venetian style but compositionally similar to the Koelliker portrait, with the variation of the left hand clutching a breviary and the other raised in blessing.[15]

Clement VIII's portraits are rare. One can mention the head in the Villa Aldobrandini in Frascati, assigned to Scalvati by Vannugli, and a portrait with the sitting pontiff turned toward the left and clutching a letter (Spoleto, private collection) (fig. 18):

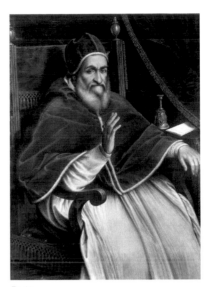

Fig. 16.
Giovan Battista Cavagna,
Portrait of Sixtus V. Cantalupo in Sabina.
Camuccini Palace

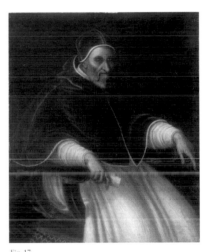

Fig. 17.
Pietro Fachetti (?).
Portrait of Sixtus V.
Rome, private collection

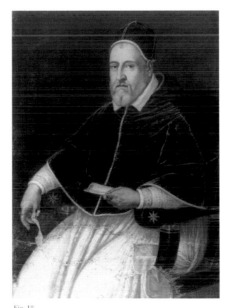

Fig. 18.
Antonio Scalvati (?),
Portrait of Clement VIII.
Spoleto, private collection (before restauration)

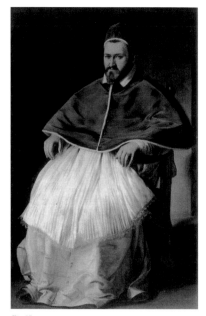

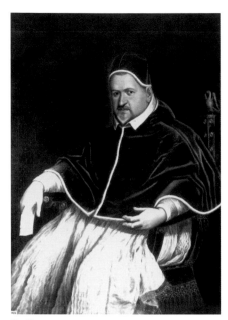

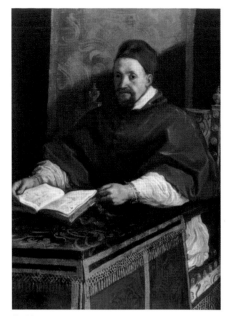

Fig. 19.
Cararaggio, Portrait of Paul V.
Rome, Borghese collection

Fig. 20.
Antonio Scalvati (?), Portrait of Paul V.
Rome, Vatican Museums

Fig. 21.
Guercino, Portrait of Gregory XIII.
Los Angeles, The J. P. Paul Getty Museum

they doubtlessly share the same face pose.[16]

Antonio Scalvati executed a portrait of Leo XI, from which he drew in 1609 an oval oil-on-slate replica. The latter is mentioned by Baglione in the second chapel to the right in the Church of Sant'Agnese fuori le Mura. The original is lost, but the Lateran Museum still keeps a modest copy of it. A later anonymous portrait of Leo XI was found in the Incisa della Rocchetta Collection and displayed in the 1930 *Roma Secentesca* ["Rome in the 1600s"] exhibit and in the 1950 popes exhibit.[17]

Diverse portraits of Paul V survive, including the one from Palazzo Borghese in Artena, on exhibit, which several engravings trace from. Caravaggio portrayed the pope in full figure (fig. 19) almost frontally, slightly foreshortened toward the leftand in a plain setting (Rome, Camillo Borghese Collection). Caravaggio's portrait is mentioned by Manilli (1650), and Bellori relates about its presentation to the Pope by Cardinal Scipione Borghese: "l'introdusse avanti il

Pontefice Paolo V, il quale da lui fu ritratto a sedere"[18] Contemporary copies of this composition are known, including that in Galleria Borghese. The portrait of Paul V preserved in the Secret Vatican Archive (fig. 20) shares a likeness with the Caravaggio painting, at least in the face. Kristina Herrmann Fiore on the basis of a reference furnished by Baglione has attributed it to Scalvati. In fact this portrait resembles the aforementioned Clement VIII portrait in Spoleto, possibly by Scalvati, which shares the same face features of the head in the Villa Aldobrandini in Frascati. The portrait of Pope Paul V by Reni remembered by Malvasia is lost, though, but an earlier pose as a cardinal by the same painter still survives.[19]

The wake of the papal portraiture of Raphaelesque derivation includes the Portrait of Gregory XV by Guido Reni in the Methuen Collection at Corsham Court. On the other hand, absolutely unpublished and without consequences is Guercino's Portrait of Gregorio XV (Los Angeles, the J. P. Paul Getty

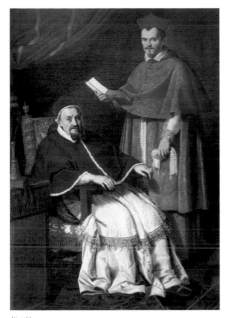

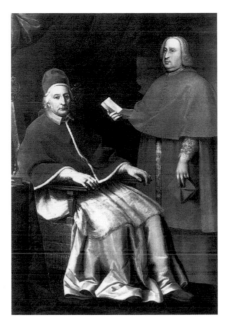

Fig. 22.
*Domenichino, Portrait of Gregory XIII
with the Cardinal Ludovico Ludovisi.
Béziers, Musée des Beaux Arts*

Fig. 23.
*Agostino Masucci, Portrait of Clement XII
with the Cardinal Neri Corsini.
London, private collection*

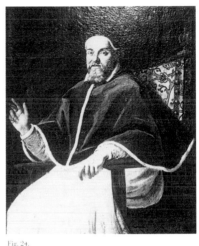

Fig. 24.
*Anonymous XVII c., Portrait of Urban VIII.
Rome, Vatican Museums*

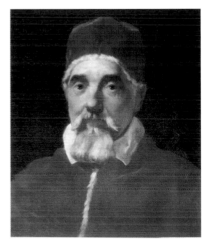

Fig. 25.
*Gian Lorenzo Bernini, Portrait of Urban VIII.
Paris, private collection*

Museum) (fig. 21):the pope is represented in an informal situation, in a private audience, seated facing a table as he leafs through a book. Nevertheless, one might trace a precedent in the Portrait of Cardinal Pompeo Colonna attributed to Lorenzo Lotto in the Galleria Colonna, which depicts the prelate caressing a small dog.[20]

Domenichino's Portrait of Gregory XV with Cardinal Ludovico Ludovisi at the Musée des Beaux Arts in Béziers (fig. 22) (the cardinal with a missive and a handkerchief in his extended left hand), harks back to the typological scheme with pope and cardinal nephew secured by Jacopino del Conte's Portrait of Paul III and Ottavio Farnese. Pietro Martire Neri recycles the same scheme in his Portrait of Innocent X with His Secretary (Madrid, El Escorial), while Agostino Masucci literally takes it up to the limit of plagiarism in his Portrait Clement XI with Cardinal Corsini, later transferred into a mosaic (fig. 23).[21]

Diverse representations of Urban VIII survive, even if important pieces are still missing, such as the portraits executed by Ottavio Leoni, Simon Vouet and Andrea Sacchi; the portrait painted by Giusto Sustermans in 1627 is lost too and it is described by Baldinucci as something out of the ordinary because of its vivacity and resemblance. The dating of the portrait of Urbano VIII by Pietro da Cortona, of Sacchetti provenance, is controversial, ranging between 1624 (Merz) and 1627 (Masini); this latter date may be more plausible because of its connection with a 1630 payment. The painting offers a monumental pose with the pope in a blessing posture, corroborated with variations by Abbatini.

The portrait of the seated pope in a blessing pose at the Lateran Museum (fig. 24) is linked to Peeter de Jode the Younger's 1639 engraving, demonstrating a certain importance of this representation derived, in turn, from the lost Vouet documented by the1624 engraving by Claude Mellan. Particularly significant is the portrait of Urban VIII painted by Gian Lorenzo Bernini(fig. 25), known

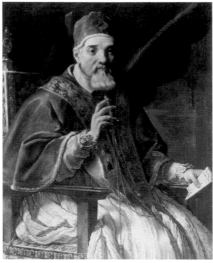

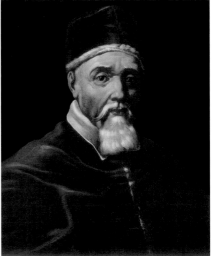

Fig. 26.
*Guidubaldo Abbatini, Portrait of Urban VIII.
Rome, National Gallery of Ancient Art,
Corsini Palace*

Fig. 27.
*Guidubaldo Abbatini, Portrait of Urban VIII.
Private collection*

today through the version in the National Gallery of Ancient Art and other two versions of Barberini provenance. Guidubaldo Abbatini's portrait of Urban VIII (Rome, National Gallery of Ancient Art, Palazzo Corsini)enjoyed a certain iconographic fortune as well : it is connected to the Berninian prototype in regard with the face, a study canvas that survives in private collection (figs. 26 and 27).[22]

One of the leading masterpieces of 17th century portraiture is certainly Velázquez' Portrait of Innocent X (fig. 28), which, although retaining a traditional pose framed on the right side, shows the pontiff's exhaustion in the summer heat and an almost cynical introspective gaze that observes us defiantly. Critics consider original also the canvas version of the head alone at Apsley House in London. Copies are innumerable, including Baciccio's one, executed for the Chigi many years later, and

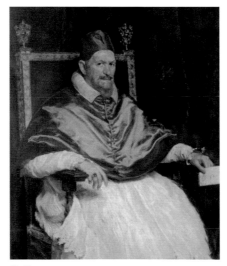

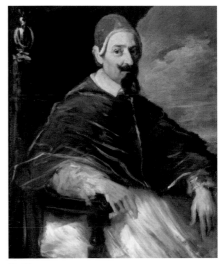

Fig. 28.
*Diego Velázquez, Portrait of Innocent X.
Rome, Doria Pamphilj Palace*

Fig. 29.
*Pier Francesco Mola, Portrait of Alexander VII.
Incisa della Rocchetta collection*

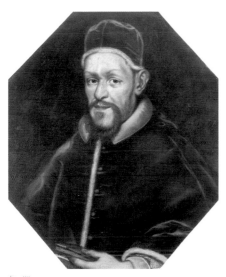

Fig. 30.
Anonymous XVII c.
Private collection

various derivations signed Pietro
Martire Neri. This benchmark
spawned another masterpiece: the
Portrait of Alexander VII by Pier
Francesco Mola (fig. 29),
characterized by very fast
brushstrokes and a modern taste for
the unfinished. Velazquez portrait of
Innocent X constitutes in fact a
reference boundary unavoidable for
many Roman portraitists, as
Palomino recalls, "todos lo copiaron
come estudio y lo consideraron como
una maravilla" [23] One can attribute to
Cortona the portrait of Innocent X in
the Fagiolo collection, displayed in the
exhibit, previously assigned to
Bernini, perhaps identifiable with the
"mezzo figura...sbozzato e non finito"
[24] in Francesco Barberini's 1679
inventory: it is noteworthy that a
portrait by Cortona of the same pope
dressed as an emperor was present in
1713 in the notary Astolfo Galoppi's
inventory and an oval copy is listed
among the effects of the portraitist
Antonio David in 1737 (Provenance
Getty Index Databases). Guidubaldo
Abbatini executed a portrait of
Innocent X as well, replicating his
earlier portrait of Urban VIII and the

storerooms of the Pinacoteca Vaticana
house the faunlike pose attributed to
Juan de Pareja.
The small portrait on copper executed
by the German painter Wolfgang
Heimbach (Copenhagen, Statens
Museum), mentioned by Giovanna
Capitelli, derives from Velázquez'
work as well. The 1650 volume by
Athanasius Kircher *Obeliscus
Pamphilius* shows, instead, an earlier
iconography, which appears in the
Portrait of Innocent X belonging to
the papal series at Palazzo Altieri in
Oriolo Romano. Besides, a Roman
private collector owns a portrait in an
octagonal format (fig. 30), which also
appears to be closely related both to
Kircher's engraving and to the Altieri
canvas. This iconography, in my
opinion, comes from the lost portrait
by Pietro da Cortona, prior to 1650,
the sketched version of which
(Palazzo Chigi in Ariccia, Fagiolo
Collection) is on display. [25]
Alexander VII's iconography is so
complex that one could devote an
entire book to it. Passeri attests that
the Flemish portraitist Louis
Cousin—known as "Luigi Gentile" or
"Luigi Primo"— executed from 1626
to 1656 the first image of the pope
soon after his election : "...et il primo
ritratto, che fosse fatto di questo
nuovo Pontefice in grande a sedere in
una camera ad un tavolino in atto di
dar la benedizione, il fece Luigi
Gentile...". [26] I have recently identified
this important portrait in a Vatican
canvas, which will be the subject of a
special publication (fig. 31). The
portrait bears an apocryphal
inscription with an unlikely
attribution to Domenichino and the
previous identification with Gregory
XV! Alexander VII recalls in his diary,
on the date August 19th 1656, asking
his nephew Cardinal Flavio to
commission his portrait to Cortona:
"Don Flavio passati questi caldi faccia
fare il nostro ritratto a Pietro da

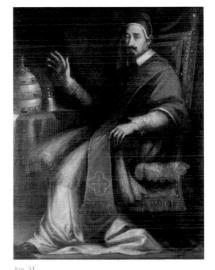

Fig. 31.
Louis Cousin called "Luigi Gentile",
Portrait of Alexander VII.
Rome, Vatican Museums

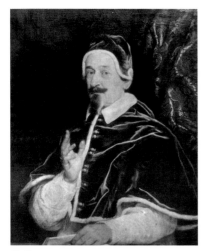

Fig. 32.
Portrait of Alexander VII.
Lost Messinger collection

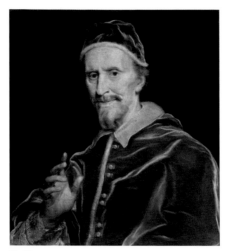

Fig. 33.
Baciccio, Protrait of Clement IX.
Ariccia (Rome), Chigi Palace

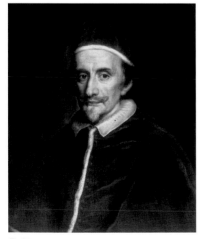

Fig. 34.
Ferdinand Voet, Potrait of Innocent XI.
Rome, Odescalchi Palace

Cortona scoperto"[27] and on October 1st "...circa il nostro ritratto a testa coperta col Piviale per Pietro da Cortona"[28]; it is noteworthy that "il Ritratto della santa memoria di Papa Alessandro Settimo del Cortona"[29], eight palms high, was listed in the 1744 Matteo Sacchetti's inventory (Provenance Getty Index Databases), while a later portrait of the pontiff, also attributed to the Tuscan master, was present in Giacomo Carrara's collection in 1796 . Some portraits of Pope Chigi are known: different versions executed by Giovan Battista Gaulli from the lost prototype in the Messinger Collection (fig. 32), Mola's painting mentioned above, the recently discovered portrait by Giovanni Maria Morandi and the pose, again by Morandi, portraying the pope during the Corpus Domini procession (Nancy, Musée des Beaux Arts). Others, instead, are lost: those executed by Bernini, Pierre Mignard, Bernardino Mei, Guglielmo Cortese "il Borgognone," Denis Duchesne, Alessandro Mattia da Farnese. Nevertheless, they are documented by engravings and inventories. The portrait on exhibit, attributed to Abbatini, develops a new and disconcerting, reclusive and

penitential iconography: the pope by a skull and crucifix, a *memento mori* linked to the iconography of San Carlo Borromeo.[30]

Both the most enjoyable portraits of the second half of the 1600s are devoted to Clement IX's brief pontificate . Maratta ennobles the pontiff's figure in a pictorial monumental pose squared by the drapes like a sculpture. The portrait is again influenced by Velázquez and represented in the Raphaelesque pose, but the pope's gaze is turned toward the viewer and his right arm rest on a missal (Vatican Museums; Saint Petersburg, Hermitage). Maratta's intent is to exalt the moral severity and the authority of Peter's successor. The spiritual Portrait of Clement IX in a blessing pose executed by Baciccio is an absolute masterpiece of introspective strength and pictorial quality.It is known in two versions, at Palazzo Chigi in Ariccia (fig. 33) and at the National Gallery of Ancient Art in Rome, from which replicas and innumerable copies have been taken. Baciccio's sketched version at the Collegio Alberoni in Piacenza, on the other hand, which was reported by Stéphane Loire, shows its own autonomy. Two other portraits of this pope have yet to reappear: Ferdinand Voet's one, documented by an engraving by Testana, and Giovanni Maria Morandi's version, known through engravings and copies.[31] Clement X's pontificate official image is certainly Baciccio's lost portrait, known only through replicas and many copies. The canvas, recently rediscovered by this author in the storerooms of the Uffizi and restored in 1999 on the occasion of the exhibit of the Genovese master, is among the best examples.[32]

Innocent XI, pope of extreme moral severity and intransigent against ostentation, did not allow much room for art, refusing to sit for his portrait.

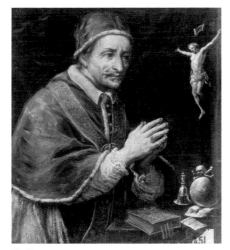

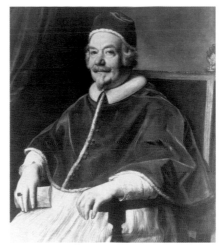

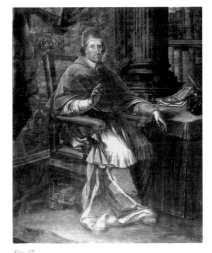

Fig. 35.
Attributed to Giuseppe Passeri,
Portrait of Innocent XI.
Rome, Odescalchi collection

Fig. 36
Giovanni Maria Morandi (?),
Portrait of Alexander VIII
Venice, private collection

Fig. 37.
Biagio Puccini, Portrait of Clement XI.
Rome, Vatican Museums

His official image, still in possession of the Odescalchi heirs, was therefore drawn from his portrait as a cardinal, painted by Ferdinand Voet (Milan, Poldi Pezzoli Museum) (fig. 34). A canvas attributed to Passeri, recently displayed in the Ariccia exhibit *I Volti del Potere*, and several other portraits recycle the anchoritic iconography promoted by Alexander VII: the skull and the crucifix in front of the praying pope (fig. 35). A studio copy of Morandi's lost portrait is here on display, but the Baciccio's portrait of Innocent XI, hurriedly painted on August 12, 1689, immediately after the pope's death is nowhere to be found.[33]

The photographic reproduction of Alexander VIII's portrait, now at the Corrado Collection in Venice is insufficient to verify Enggass' attribution to Baciccio, but the handling of the folds of the mozzetta is doubtlessly related to his style. An important portrait of the pope seated and turned toward the left, attributed to Baciccio or to Morandi, is in a private Venetian collection and it is known only through an old photo (fig. 36); the face of the portrait attributed to Morandi displayed in this exhibit is derived from it.

The "portrait of a cardinal" presented in the 1991 *Ritratto Italiano* exhibit as Bernardo Strozzi's, is also related to this same pose which is near to Morandi, with the variation of the eyes turned toward the viewer.[34] The Portrait of Innocent XII by Baciccio has disappeared, while Ludovico David's one, displayed in the 1950 exhibit (Rome, Villa Albani, Prince Torlonia), cannot be tracked down: a replica of Morandi's portrait, with the participation of the studio in the mozzetta, is at Palazzo Chigi in Ariccia.[35]

The more canonical portrait of Clement XI because of its easy and reproducible iconography is the one painted by Pietro Nelli, known through several versions: Urbino's one (at Palazzo Albani), in an attitude of benediction, the drawing in the Museum of Art of Philadelphia, several engravings and copies, and a tapestry from the San Michele Manufactory. Biagio Puccini executed a monumental full-length portrait preserved at the Lateran Museum, with the pope in a blessing pose, seated at a table in a study, whose face is clearly derived from Nelli's portrait (fig. 37): the same can be said for the portrait, perhaps also by Puccini.

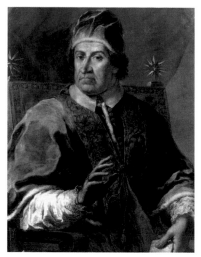

Fig. 38.
*Pier Leone Ghezzi, Portrait of Clement XI.
London, Walpole Gallery*

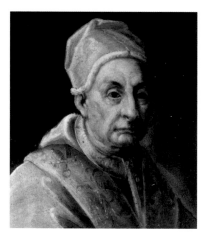

Fig. 39.
*Anonymous XVIII c., Portrait of Benedict XIII.
Genzano (Rome), Jacobini Palace*

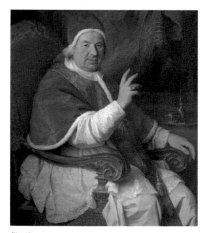

Fig. 40.
*Pierre Subleyras, Portrait of Benedict XIV.
Versailles Castle*

recently acquired by Palazzo Chigi in Ariccia.

The elderly Baciccio painted the pontiff Clement XI as well on a canvas now lost; in this regard, the painting in the Torlonia Collection owes more to Gaulli than to Maratta, although an attribution to Baciccio has been dismissed by Enggass. Nevertheless it is difficult to express an opinion without a direct knowledge of the canvas. The most spectacular pose of this pontiff, however, is certainly that portrayed by Pier Leone Ghezzi (fig. 38), known through similar versions in the Museum of Rome and the Walpole Gallery in London, and the later pose in the Lateran Museum. The large portrait of the seated pope in an attitude of benediction against the backdrop of the Vatican Basilica, on the other hand, displayed in the Urbino exhibit, is assigned to Ludovico Antonio David while the left-half profile portrait of the blessing pope—recently displayed in the Exhibit at Rancate—is attributed to his son Antonio. The portrait by Antonio Odazzi, instead, known through Arnold Van Westerhout's engraving, is lost.[36]

The portrait of Innocent XII by Agostino Masucci has finally reappeared and his first live pose is displayed in the exhibit: it is an important work for the artist's career and for subsequent influences on in 18th century portraiture. In a later three-quarter length official portrait (Rome, private collection), the Roman painter codified the pope's standing pose in an attitude of benediction, heretofore extremely rare. Antonio David's portrait, instead, known only through engravings, executed by Antonio David is still to be found (see index card 27).

Benedict XIII portraiture is rare, although there is a hastily executed almost sketched head in the Carafa Jacobini Collection in Genzano (fig. 39). The portrait of Pope Orsini painted by Pier Leone Ghezzi is yet to be found and perhaps also Masucci's one, which is documented by engravings, with the pope on horseback in an almost caricatural pose.[37]

Pietro Nelli also executed a portrait of Clement XII, as revealed by the signature on the letter in the hands of the pope in the Antony Clark Collection. However, the official portrait of that pontiff was doubtlessly executed by Agostino Masucci: an example of it is at Palazzo Camuccino in Cantalupo in Sabina, of which exist countless copies . Masucci's portrait, perhaps his masterpiece in the portrait genre, holds both the Raphaelesque moderation and the polished style that could already be considered neo-classical. Masucci himself used this pose for the dual portrait with the Cardinal Neri Corsini (private collection), which was also reproduced as a mosaic.[38]

The execution of the official portrait of Benedict XIV, after his election in 1740, was contested between Masucci and Pierre Subleyras. The Frenchman is the ideal winner of this struggle : his portrait is known in replicas and numerous copies, among which the autograph versions in the Château at Versailles and the Musée Condé at Chantilly stand out. The pope is seated almost in profile on the right side, while he gazes at us in the act of blessing: the precious descriptive care of the fabrics and the furnishing offers us a marvelous example of decorative taste and formal brightness (fig. 4). The pope's likeness in the double portrait with Cardinal Valenti Gonzaga in the Museum of Rome, signed by Giovanni Paolo Pannini, is a clear tribute to Subleyras's work. Masucci, on the other hand, portrayed the pope in a solemn erect position, in the act of blessing (Rome, Accademia

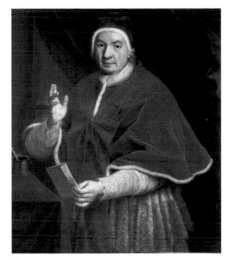

Fig. 41.
Agostino Masucci, Portrait of Benedict XIV.
Rome, Academy of Saint Luke

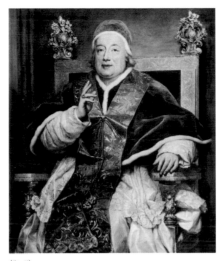

Fig. 42.
Anton Raphael Mengs (?), Portrait of Clement XIII.
Milan, Pinacoteca Ambrosiana

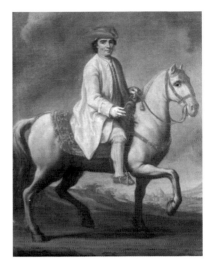

Fig. 43.
Giovan Domenico Porta,
Portrait of Clement XIV.
Castel Giuliano, Patrizi Palace

di San Luca), according to a rare scheme experimented with Innocent XIII's pose: this portrait, too, enjoyed considerable iconographic success, in view of the numerous existing copies (fig. 41).

Giuseppe Maria Crespi depicts Pope Lambertini in an unusual and unprecedented pose (Rome, Pinacoteca Vaticana): he is standing in front of a table covered with books in the act of sitting down or rising to his feet after having written with a servant in the background pulling the drapes as stage curtains.[39]

The primacy in the portraiture of Clement XIII falls to Anton Raphael Mengs. In the versions at the Pinacoteca Ambrosiana in Milan (fig. 42) and at Ca' Rezzonico in Venice, he portrays the pope in a traditional sitting position in the act of benediction, but with an audacious and original frontal framing inspired by the statue of Saint Peter in the Vatican Basilica; in a later composition (Bologna, Pinacoteca Nazionale), instead, he depicts him with perspective foreshortening in the act of moving his right hand, while clutching a handkerchief in his left. Batoni, on the other hand, portrays

Clement XIII standing by a table, with a missive and his right arm in the act of blessing, but in a more static pose, linked to 17th century cardinals' portraiture and to Agostino Masucci's Portrait of Benedetto XIV, but rotated to the opposite side. However, this is certainly not Batoni's masterwork.[40]

Clement XIV's portraits are decidedly of a more subdued tone . His most usual image is deduced from Giovan Domenico Porta's portrait, known through many replicas, copies and engravings. The painter, certainly not up to the standards of his more talented predecessors, portrayed him on horseback wearing a broad-brimmed country hat (Castel Giuliano, Patrizi Collection), showing one of the pope most beloved pastimes (fig. 43): this unusual equestrian iconography even circulated on print.[41]

Clement's successor, Pius VI, portraiture is even more serialized and he is shown for the first time wearing a white skullcap instead of the traditional camauro. The charming pose by Antonio Cavallucci (London, Trinity Fine Arts) with the pope seated frontally framed but with his face turned toward the left was not successful (fig. 44), unlike the quite

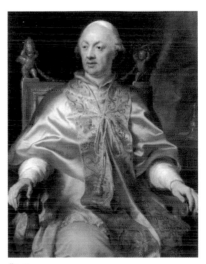

Fig. 44.
Antonio Cavallucci, Portrait of Pius VI.
London, Trinity Fine Arts

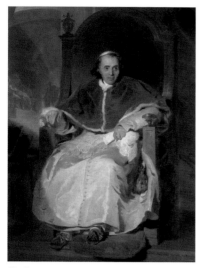

Fig. 45.
Sir Thomas Lawrence, Portrait of Pius VII.
Royal Collection, Her Majesty the Queen

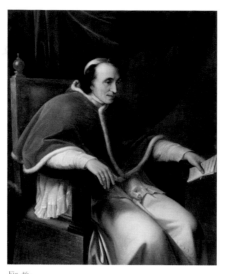

Fig. 46.
Vincenzo Camuccini, Portrait of Pius VII.
Bigetti gallery

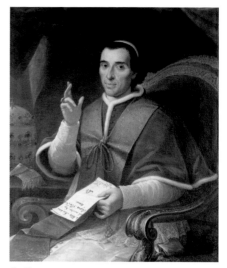

Fig. 47.
Pietro Labruzzi, Portrait of Pio VII.
Rome, Vatican Museums

canonical pose executed by Batoni in 1775-'76 (Turin, Galleria Sabauda; with help from the studio: Pinacoteca Vaticana, Dublin, National Gallery) of which Clark cites numerous copies. Prevails, however, the image that Giovanni Domenico Porta gave of that pope, moving from the large portrait in the Museum of Rome: the pontiff is standing by a table showing the plans for the Vatican Sacristy, which is visible from a window opened on the left: the portrait was reproduced in engravings and in several copies.[42] Pius VII's portraiture, immortalized also by Antonio Canova, is certainly of a more reserved tone. Gregorio Barnaba Chiaramonti was portrayed in Venice by Teodoro Matteini soon after his election to the papacy in 1800 (canvas in the exhibit, Venice, Museo Correr). One finds the same standing blessing iconography in Leo XII's and Pius IX's later portraits. Matteini himself also executed an official throne pose donated by the pope to the San Giorgio Monastery in Venice. Jacques Louis David also portrayed Pius VII in the 1805 signed Louvre canvas: his frontal pose with a stola and missive in his right hand

evokes Mengs' Portrait of Clement XIII. The portrait executed by Sir Thomas Lawrence (Royal Collection, Her Majesty Queen Elizabeth) is extraordinarily alive and original in its vandyckian pose, with the pope seated on the throne affably turned toward his right: it is one of the masterpieces of papal portraiture of all times (fig. 45). Vicenzo Camuccini's portrait, with its traditional and Raphaelesque pose, however, represents the canonical image of Pope Chiaramonti , as one can evince from the many existing copies and derivations of the Vienna (Kunsthistorisches Museum) version (fig. 46). Even more conventional is the seated and blessing pose in Pietro Labruzzi's signed portrait (Vatican Historical Museum, Lateran Palace) (fig. 47).[43]
The modest and rare portraiture of Leo XII chosen as recurrent model an invention by Agostino Tofanelli with the standing and blessing pope reproduced in a lithograph by R. Persichini.[44]
Because of the brevity of his reign the iconography of Pius VIII is very rare. He is better known through medals,

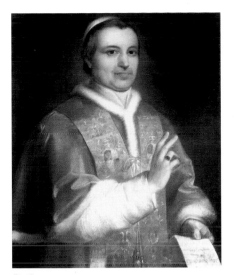

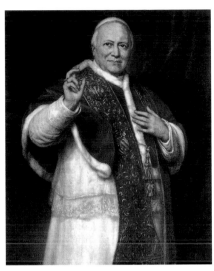

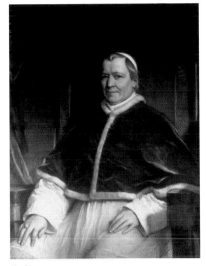

Fig. 48.
Riganti, Portrait of Pius IX.
Rome, Vatican Museums

Fig. 49.
George Peter Alexandre Healy, Portrait of Pio IX.
Senigallia, Mastai Palace

Fig. 50.
Louis Gallet, Portrait of Pio IX.
Rome, Vatican Museums

because of his well-known passion which earned him the reputation of "numismatic pontiff" Nevertheless, Camuccini obtained the title of baron in 1830 thanks to the portrait he took of the pope visiting his workshop. In this painting, hanging in Palazzo Castiglioni at Cingoli, the pope is represented turning to the right, blessing the table. Horace Vernet captures Pius VIII features in a sitting on June 20th, 1829. He inserts the pope in a more articulate and pompous composition: in the Vatican Basilica, between flabellums [ceremonial fans], seated on the Sedia Gestatoria [portable papal throne], but hunched over because of his chronic herpes infection on the nape of his neck. The semi-paralysis on his right side, together with an accentuated form of strabismus, induced his portraitists to take his profile in a side view.[45]

Perhaps the most beautiful portrait of Gregory XVI is the monumental painting by Francesco Podesti who depicted him during a procession, surrounded by his rich court, blessing and sitting on the Sedia Gestatoria between two flabellums (the use of

which was later abrogated by Paul VI). The official portraitist of Pope Cappellari, as one can evince from the many copies existing of his painting in the Jacobini Collection, was the modest Giovanni Busato .[46]

Pius IX's portraiture is very prolific, partly because of his long reign. However, its level appears quite repetitive, rarely achieving the quality that had characterized the preceding centuries. Pope Mastai Ferretti's official image favors the standing blessing pose, although the traditional seated one is diffused as well (figs. 48, 49 and 50). According to a custom still in use, the pontiff sometimes appears fully dressed in a white robe and a short cape, skullcap and pectoral cross, while others he wears the classical mozzetta, camauro edged in ermine and rochet.

The portrait executed in 1871 by the American painter George Peter Alexandre Healy (Palazzo Mastai, Senigallia) best communicates the lively humanity of Pius IX, who is blessing with his left hand resting on his breast. The pose by the Savoyard painter Tommaso Lorenzone (Palazzo Mastai, Senigallia), instead, reflects

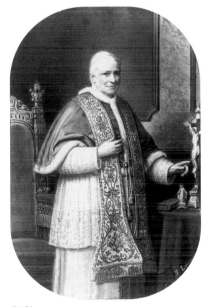

Fig. 51.
Tommaso Lorenzone, Portrait of Pius IX.
Ariccia (Rome), Chigi Palace

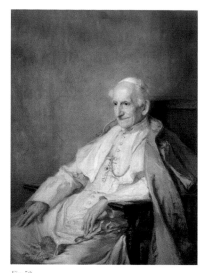

Fig. 52.
Philipp Alexius de László,
Portrait of Leo XIII.
Budapest, Hungarian National Gallery

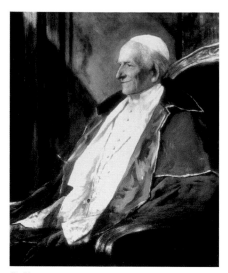

Fig. 53.
Beniamino Constant, Portrait of Leo XIII.
Rome, Vatican Museums

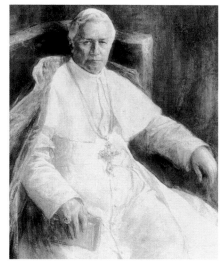

Fig. 54.
Alessandro Milesi, Portrait of Pius X.
Rome, Vatican Museums

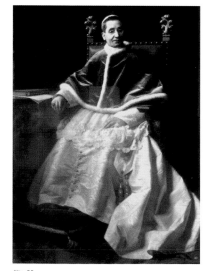

Fig. 55.
Giovan Battista Torriglia,
Portrait of Benedict XV.
Rome, Vatican Museums

the dramatic historical events that marked the end of the Pontifical State. The full-length standing pope points to the crucifix on the table and the statuette of the Virgin is an allusion to the dogma of the Immaculate Conception instituted by Pius IX in 1854. One can also appreciate the beautiful gouache (Palazzo Chigi, Ariccia) (fig. 51) signed by Tommaso Lorenzone and dated 1870 the year of the taking of Rome: Pius IX's gesture refers to his motto "Exsurge Domine iudica causam tuam!" ["Arise, Lord, champion your own cause!"], taken from the gospels and present in the 1870 medal for the defense of the rights of the Church

Leo XIII's portraiture is certainly more varied and with evidence of excellent quality. The pope, breaking with the grave protocol of all the previous portraiture that placed him in a hieratic abstraction and detached from real life, is always smiling or wearing an affable expression. This is an important innovation in papal representation, whose precedents can be traced in the confidentiality of Bernini's bust of Urban VIII (Barberini Collection) and in some portraits by

Baciccio. The exuberant portrait painted by Philipp Alexius de László (Vatican Historical Museum, Lateran Palace) is a jewel. The official pose, which earned international approval, is hanging in the Hungarian National Gallery in Budapest, signed "László F.E. ROME 1900": it restores to us the most human and confidential papal portrait of the modern age seen as an old and affable grandfather (fig. 52). The same year Beniamino Constant executed a similar pose using the same smooth brush strokes with the pope smiling and looking forward and downward (fig. 53).[47]

The portraiture of Saint Pius X is maintained at a good level as well. This level is represented in the present exhibit by the 1905 informal but expressive portrait by Antoon Van Welie, who portrayed the pope by his writing desk, clutching his eyeglasses. The portrait by Alessandro Milesi in the Lateran Museum further asserts itself because of its notable expressive strength and originality, albeit the apparent traditional pose clutching a breviary (fig. 54). Berthold Lippay's 1903 portrait of Pius X on the papal throne, instead, is more academic but also more official.[48]

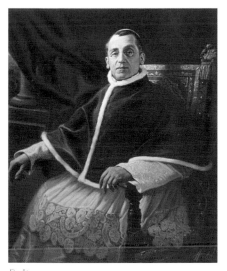

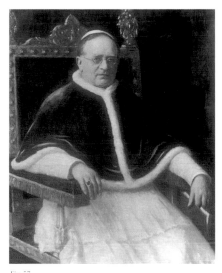

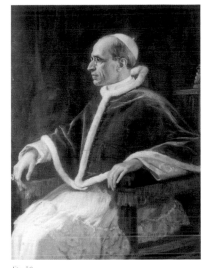

Fig. 56.
Carlo Muccioli, Portrait of Benedict XV.
Rome, Vatican Museums

Fig. 57.
Viktor Scharf, Portrait of Pius XI.
Rome, Vatican Museums

Fig. 58.
Carlo Siviero, Portrait of Pius XII.
Rome, Cancelleria Palace

The portraiture of Benedict XIV is characterized by a certain originality and tendency toward monumentality and is well represented in the this exhibit by the original Giacomo Grosso's composition , with the pope kneeling in prayer. The pose by Giovan Battista Torriglia (fig. 55) is sumptuous for the exuberant presence in the foreground of the folds of the magnificent clothing . Carlo Muccioli, on the other hand, draws on the grand 17th century tradition: the classical seated pose framed from the left, which is also the official image of Benedetto XIV pontificate (fig. 56).[49]

Pius XI entrusted the circulation of his image to the Franciscan Missionaries of Maria. Beginning in 1913 and until approximately 1970, on suggestion of Cardinal Gasparri, first and later of Cardinals Ferrata and Farley, they built a small enterprise for the mass production of pontifical portraits. These paintings used photographic images as prototypes, therefore they show photo-like reproduction quality, but also a certain monotony . The portrait on display here is the official image of that pontificate, reproduced in innumerable copies that were

available to apostolic palaces, nunciatures, religious institutions and bishops' palaces. These portraits, considered more craft productions than artistic expressions, are initialed "FMM" and are to a large degree documented by a photograph album in the Vatican Historical Museum in the Apostolic Lateran Palace. Pius XI, who had known the Missionary Franciscans during the time he was archbishop of Milan and when he directed the Biblioteca Ambrosiana, appreciated the nuns' ability in embroidery. Therefore, once he was elevated to the papacy, he called them to found an *atelier* specialized in the restoration of tapestries, sculpture and religious painting. While the nuns are still active today in the restoration of the tapestries under the direction of the Vatican Museums, the last portraits produced are those of John XXIII and Paul VI. Viktor Scharf's 1926 academic portrait of Pope Ratti, with a Raphaelesque pose, is the best of his pontificate and it has been reproduced in several copies (fig. 57). An opening toward modernity is represented by Arnaldo Tamburini's official portrait, designed by I. Beltrami and L. Monti, with the pope

Fig. 59.
Umberto Romano, Portrait of John XXIII. Roma, Vatican Museums

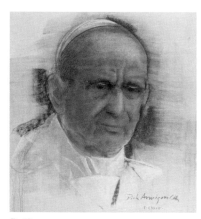

Fig. 60.
Pietro Annigoni, Portrait of Paul VI. Milan, Famiglia Cristiana collection

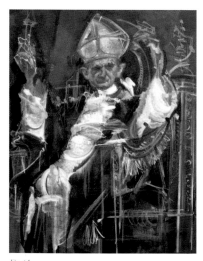

Fig. 61.
Alvaro Delgado, Portrait of Paul VI. Rome, Vatican Museums

seated on his throne in the act of blessing, wearing a cope on his head and the triregnum [tiara] given to him by the people of Milan in 1922.[50] Carlo Siviero executed Pius XII's official portrait and its important preparatory sketch [cartoon], here on display, is inspired by the painting hanging in the Palazzo della Cancelleria (fig. 58). Siviero drew on the great 17th century portraiture, such as Velázquez' Portrait of Innocent X Maratta's Clement IX and Bernini's heroic busts. As a result, this portrait brings the viewer towards an ascetic image of hieratic remoteness and superior decorum. It is not extraneous to the difficulties of the historic moment experienced by the pope, firm in condemning the violation of human rights and barbarity of war, but resolute in dogmatic action. Francesco Messina's statue in the Vatican Basilica is certainly Papa Pacelli's portrait of greater expressive strength . It is the photograph that shows him with his arms stretched out to the people, his white garments bloodstained as he stand in the ruins of San Lorenzo after the bombardments of July 9, 1943, is his most touching image.[51]

John XXIII's pontificate represents, in portraiture as well, the start of a constructive relationship between religious art and figurative avant-garde movements, different from the more institutional relationship characterizing the previous pontificates. The Second Vatican Council (1962-1965), that sanctioned the Constitution on the Sacred Liturgy *Sacrosanct Concilum* (1963), decreed also an opening toward all styles and the recognition of every artistic tendency, if used for the glory of God. Pope Roncalli's official image is Giacomo Manzù's sculpted portrait. The portrait of the pope in profile in prayer, executed expressionistically by Umberto Romano in 1967 (fig. 59) stands out among the paintings of the

Vatican collections because of its iconographic innovation.[52]

The Church opens toward contemporary art's language and heterogeneous experiences with Paul VI . The pontiff's discourse during the Mass for the artists, in the Sistine Chapel on May 7th , 1964, caused enormous stir: "…Noi abbiamo bisogno di voi. Il nosto ministero ha bisogno della vostra collaborazione. Perché, come sapete, il nostro ministero è quello di predicare e di rendere accessibile e comprensibile, anzi commovente, il mondo dello spirito, dell'invisibile, dell'ineffabile, di Dio. E in questa operazione che travasa il mondo invisibile in forme accessibili voi siete maestri… Vi abbiamo talvolta messo un acappa di piombo addosso, possiamo dirlo: perdonateci! E poi vi abbiamo abbandonato anche noi. Non vi abbiamo spiegato le nostre cose, non vi abbiamo condotto nella cella segreta, dove i misteri di Dio fanno balzare il cuore dell'uomo di gioia, di speranza, di letizia, di ebbrezza. Non vi abbiamo avuti allievi, amici, conversatori; perciò non ci avete conosciuto…".[53] Paul VI also opened the new section of contemporary art (Collection of Modern Religious Art) in the Vatican Museums on June 23rd, 1973. The 1999 exhibit in the Braccio di Carlo Magno was dedicated to the many painted and sculpted portraits of Pope Montini. Some of the paintings belong to the formal and traditional style: i.e. those painted by Dina Bellotti. Pietro Annigoni (Milan, Famiglia Cristiana Collection). Ugo Attardi (Vatican, Collection of Modern Religious Art), Alberto Sughi, Emilio Greco or Mimmo Rotella (private collections); but the informal portraits by Alvaro Delgado (Vatican, Collection of Modern Religious Art) and Jean Guitton (Brescia, Collection of Contemporary Art "Art and Spirituality") (figs. 60 and 61) are

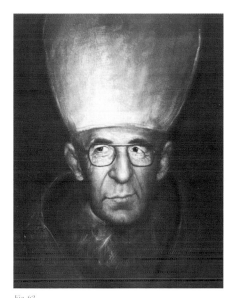

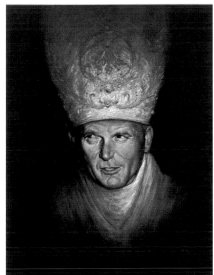

Fig. 62
Mario Russo, Portrait of John Paul I.
Rome, Russo family

Fig. 63.
Mario Russo, Portrait of John Paul II.
Rome, Russo family

absolutely innovative and revolutionary with regard to papal iconographic tradition.[54]

John Paul I's reign was too short to allow the development of portraiture and the few existing images are all *post mortem* and derived from photographs: Natalia Tsarkova painted in 2002 his official posthumous portrait . Mario Russo executed in 1978 the only life portrait of this pontiff, characterized by a curious frontal framing with the pope glancing sideways (fig. 62). Russo also portrayed in the same year a very young John Paul II in an interlocutory attitude, with his illuminated face emerging from the dark, as an apparition in the gloom (fig. 63).[55] Nevertheless, the author of Pope Wojti_a official portrait is Natalia Tsarkova . It was executed according to the 19th century dictates of the Russian academic painting and donated to the Pope on May 10, 2000. The portrait is emblematic of John Paul II pontificate: he is no longer closed up in his private rooms in the apostolic palaces, but unusually in the open, against the backdrop of the

Vatican Basilica holding his pastoral staff, ready for dialogue with the entire world. Dina Bellotti also portrayed John Paul II and the painting was reproduced as a color lithograph. Giancarlo Dughetti, on the other hand, executed a great miniature in ivory in 1980, preceded by numerous preparatory sketches from real life, holding a particular figurative strength (fig. 64).[56]

Fig. 64.
Giancarlo Dughetti,
Studies of a Portrait of John Paul II.
Private collection

Notes

1) The content of this document is the product of the reworking of *I ritratti del potere a Roma tra '500 and '700* [Portraits of Power in Rome from the 16th to the 18th Centuries] by F. Petrucci, 2004b, pp. 13-24, with additions and expansions of some parts. Not included in this treatise are the papal portraits inserted in natural decorations or the serial collections (i.e. the Saint Paul mosaic, whose cartoni [full-scale drawings] are at the Fabbrica di San Pietro or the series of the Palazzo Altieri di Oriolo Romano and the Superga Basilica).

2) See D. Mahon, 1947, p. 243.

3) A scholarly conference at Villa Medici was devoted to the relationship between portraiture and power, its proceedings were published under the oversight of O. Bonfait, B. Marin, 2003.

4) See K. Oberhuber, 2004, pp. 102-104. There is an abundance of copies of the portrait of Julius II, including the one from Raphael's studio (Florence, Uffizi), Titian's (Florence, Palazzo Pitti), the contemporary copy in the exhibition; two copies are found in the storerooms of the Vatican Museums (henceforth, MV, including the works stored in other Vatican sites), a 17th century copy with variations and inscription at Palazzo Chigi at Ariccia.

5) See M. Lucco, 1980. A study of the head of Clement VII by the hand of Sebastiano del Piombo, pope's official portraitist, is still at Capodimonte. The damaged portrait on wood at Galleria Spada (73 x 57 cm), according to Zeri, derived from a model by the Venetian painter. (F. Zeri, 1954, p. 117).

6) About Titian, see J. Wethey, 1971; A. Paolucci, 1990. There are numerous copies of the Capodimonte portrait, two of which are in the storerooms of the Vatican Museums, one at Galleria Spada (F. Zeri, 1954, p. 146). Zeri mentioned also those at Galleria Sabauda in Turin, Palazzo Pitti, National Gallery in Rome (storage), the collection of the Duke of Northumberland at Alnwick in Scotland. In addition to the work displayed in the exhibit, is known also the portrait of the pope with Ottavio Farnese by Jacopino del Conte, published by Zeri, which now is in the A. Barsanti collection in Rome (see E. Zeri, 1957, 1998, fig. 2): a copy of this portrait is recalled by Vannugli in the storerooms in the El Prado Museum, while a quality portrait of Paul III is at Palazzo Communale in Orvieto (see A. Vannugli, entry 4). A curious portrait of Paul III dressed as Saint Joseph, attributed to Francesco Salviati, is enclosed in the Nativity in the Cappella del Pallio at Palazzo della Cancelleria, with several portraits of the Farnese family (see G. Colalucci, 1983, pp. 165-172). A Roman-school full-figure portrait from a Jacopinesque prototype is found in the ex Farmacia attached to the Church of Sant'Ignazio (oil on canvas 137 x 105 cm, photographic archive negative, Soprintendenza per i Beni Artistici e Storici, no. 132063).

7) Raphael's portrait of Leo X is, in fact, almost exclusively the official image of the pontiff. Several copies are known, including the one on exhibit with the pope alone (Vatican Historical Museum, Lateran Palace), two in the Vatican Museums, storerooms, including one with the face alone, MV inv. 41350.

8) The portrait of Marcellus II, oil on canvas, 123 x 91.5 cm, is classified with MV inv. 41199; for later portraits of his, see L. von Pastor, 1927, pp. 335-336, note 4. Julius III portraiture is poor: there are only engravings and medals, the beautiful frescoed portrait at Galleria Spada, which Zeri attributed to Jacopino, Venusti or Siciolantei (1954, p. 116), a painting in Vienna from the Ambras collection (see L. von Pastor, vol. VI, 1927, pp. 36 and 37, note 7). The official portrait of Paul IV is the 1558 Niccolò Beatrizet woodcut, while the bronze bust in the passageway of the sacristy of Saint Peter's is his best effigy (see. L. von Pastor, vol. VI, 1927, note 1).

9) See A. Pinelli, 2000, pp. 761-768, 879-882. On the statues of popes in a blessing pose, see A. Muñoz, 1917, pp. 1-17. Later portraits of Pius IV are cited by Vannugli (entry 6), among which are: Rome, Pinacoteca Capitolina; Uffizi, young series, Cristoforo dell'Altissimo (S. Meloni Trkulja, 1979, p. 650); Santa Maria in Trastevere, Cappella Altemps, with the pope near the cardinal nephew Marco Sittico Altemps, a work by Pasquale Cati (C. Strinati, 1998, fig. 25); Pinacoteca Ambrosiana (Haidacher, 1965, p. 407).

10) For Passerotti's portrait, see F. Zeri, 1967, vol. II, pp. 382 and 383; A. Ghirardi, 1990, pp. 152-154, no. 5. The portraits of Pius V are: now in the Marchese Marignoli Collection, Spoleto, mentioned by Federico Zeri as a contemporaneous replica and copy; Anonymous, Vatican Historical Museum, Lateran Palace, MV inv. 4644, oil on canvas, 108 x 82 cm; Anonymous, Vatican Museums, Nunziatura Estera, MV inv. 42050, oil on canvas, 135 x 100 cm; Anonymous, Vatican Museums, storerooms, MV inv. 41206, oil on canvas, 124.5 x 88 cm. The half bust portrait in the Vatican Museums (storerooms, MV inv. 4561, oil on canvas, 55 x 43 cm) is wearier. In an other portrait in the Vatican Museums (storerooms, MV inv. 42403, oil on canvas, 172 x 123 cm) the pope holds in his hand the papal bull of April 3rd, 1566.

11) See V. Martinelli, 1958, pp. 99-109; F. Petrucci, 1999, pp. 89-102. For the Neri's portrait, see O. Melasecchi, 1990, pp. 177-191. For Ghezzi's portraits, see A. Lo Bianco, 1985; G. Sestieri, 1994, vol. II, fig. 472.

12) "He came to Rome as a young man in the days of Gregory XIII and devoted himself to producing portraits, and excelled in that sort of painting producing such portraits that could be compared to those of Scipione da Gaeta."

13) See Rome, 1950, p. 18, no. 58. There is a half-bust portrait of Gregory XIII in the storerooms of the Vatican Museums, MV inv. 41194, oil on canvas, 70 x 54.5 cm. For the portraiture of Federico Zuccari, see C. Acidini Luchinat, 1999.

14) A portrait of Sixtus V attributed by Antonio Vannugli to Scalvati, related to the Lateran canvas, but with numerous variations and the arm raised in blessing, is at the Accademia di San Luca and displayed in the 1950 exhibition (no. 59, p. 18; see G. Incisa della Rocchetta, 1979, p. 100; A. Vannugli, 2002, pp. 267-290). A portrait that mirrors Cavagna's, perhaps traceable to his workshop because of the stylistic affinities, is in the storerooms of the Vatican Museums, inv. 41207, oil on canvas, 74 x 61 cm.

15) On the portrait of Urban VII in the Koelliker Collection, see F. Moro, entry in F. Caroli, 1998, p. 115; A. Vannugli, 2002, pp. 267-290; S. Marra, entry 25, in F. Petrucci, 2004, pp. 105-106. A later portrait of Urban VII is pointed out by Moro in the National Museum of Buenos Aires, while Vannugli recalls the Lateran Museum's one attributed to Jacopino del Conte, which was transformed from a cardinal portrait (see D. Redig de Campos, 1941-'42, pp. 175-182; A. Haidacher, 1965, pp. 474-475; C. De Vita, 1991, pp. 308, 318).

16) See A. Vannugli, 2002, p. 288, note 67. Pastor mentions two later portraits of Clement VII in the Aldobrandini and Mattei palazzi in Rome, while a two-third figure portrait, attributed to Ottavio Leoni by L. Barroero (1990, p. 148), is in the Sacristy "dei Beneficianti" in San Giovanni in Laterano. Vannugli mentioned a copy of the Aldobrandini canvas at the Porträtsammlung of Gripsholm in Stockholm (A. Haidacher, 1965, pp. 482 and 483). A canavs at the Uffizi, instead, shows another pose (E. Micheletti, in S. Meloni Trkulja, 1979, p. 619, n. Ic125). Vannugli pointed out also two portraits in Fano (Aa.Vv., 2000).

17) About the portraits of Leo XI, see AA.VV., 1930, p. 9, no. 3; D. Redig de Campos, 1937, pp. 11-18; G. Incisa della Rocchetta, 1951, p. 133; idem, 1951a, p. 63; C. De Vita, 1991, pp. 308, 318; A. Vannugli, 2002, pp. 274 and 275. The Uffizi canvas, published by S. Meloni Trkulja as a copy done by Scalvati (1979, p. 750, no. Ic970) refers to another pose.

18) "He introduced it before Pope Paul VI, who was portrayed by him seated."

19) See M. Marini, 2002, no. 67, pp. 262 and 263, 490-492. About the copy, see P. Della Pergola, 1959, no. 117. For the Vatican portrait of Paulo V, inv. 41201, oil on canvas, 125 x 98 cm, see K. Herrmann Fiore, 1990, no. 54. A copy of the painting by Caravaggio limited to the face is preserved at the Palazzo Chigi in Ariccia, inv. 532, oil on canvas, 61 x 48 cm. A curious portrait of Paulo V is at Camaldoli, modest but of a rare iconography, with the pope standing near a table, his hands on a missal (M. Valenti, 2003, p. 55).

20) See S. Pepper, 1984, no. 82; L. Salerno, 1988; E. A. Safarik, 1981. A full-figure monumental portrait of Gregory XV seated is found at the Seminario Maggiore in the Lateran, MV inv. 41872, oil on canvas, 236 x 147 cm, in a series with the portraits of Clement IX and Innocent XII, but dating back to the end of the 17th century.

21) See. R. E. Spear, 1982, p. 227, no. 74. For the Neri, see O. Melasecchi, 1990, pp. 177-191. For Masucci's portrait, see G. Sestieri, 1994, vol. III, fig. 725.

22) See M. Chiarini, 1983, pp. 11-15; G. Briganti, 1962, 1982; P. Massini, entry 26, in A. Lo Bianco, 1997, pp. 322-323. The Lateran portrait is identified with MV inv. 4366, oil on canvas, 133 x 98 cm. For the Bernini portraits of Urban VIII, see V. Martinelli, 1987, pp. 251-258. F. Petrucci, 2003, pp. 143 and 144. From the Berninian prototype was derived the oil-on-copper portrait, 27.4 x 20.9 cm of the Galleria Pallavicini that Zeri attributes to Jan Miel (F. Zeri, 1959, pp. 180 and 181). For the portrait by Abbatini, see V. Martinelli, 1958, no. 2, pp. 99-109. The painting at the Accademia di San Luca, signed on the memorial by the modest Giacomo Grandi, derived from Abbatini's portrait (see G. Incisa della Rocchetta, 1979, no. 477, p. 100), while a still clumsier free derivation of it is the canvas in the portrait room at Palazzo Canonicale of Santa Maria Maggiore.

23) "everyone copied it as a study and they considered it like a marvel."

24) "sketched and unfinished . . . half-length figure"

25) See further the vast bibliography of Antonio Vannugli, 1996; also see M. Marini, 1990, pp. 109-125. Among the innumerable copies of Innocent X by Velázquez, we should point out the one in the storerooms of the Vatican Museums. Concerning the portrait by Mola, see V. Martinelli, 1973, pp. 283-

292; F. Petrucci, entry 33, in M. Fagiolo dell'Arco, F. Petrucci, 1998, pp. 131 and 132. For the canvas by Abbatini, see V. Martinelli, 1958, pp. 99-109. For the pose related to the Kircher volume, see G. Capitelli, 1998, pp. 96-99. The canvas in the Roman private collection is an oil painting 79 x 64.5 cm. A portrait of Innocent X in a seated blessing pose is at San Carlo in Corsica, together with the portraits of popes from Paul V to Innocent XI (see A. Spiriti, 1995, p. 277).

26) "... and the first portrait made of that new Pontiff was full length, seated in a room at a table in the act of giving a blessing, by Luigi Gentile ..."

27) "Don Flavio, after these hot days, have our portrait done by Pietro da Cortona with the head uncovered"

28) "... about our portrait with the head covered with Cope by Cortona"

29) "... the Portrait of the holy memory of Pope Alexander the Seventh by Cortona"

30) The portrait of Alexander VI by Cousin is in the process of being published in *Bollettino – Monumenti Musei e Gallerie Pontificie*; regarding the quotation and the painter, see G. B. Passeri, 1934, pp. 243 and 244; D. Bodart, 1970, pp. 154-167. Concerning Morandi, see F. Petrucci, 1998, pp. 131-174; idem, 1999, pp. 89-102. Several copies of Morandi's portrait engraved by François Spierre are known: Vatican Historical Museum, Lateran Palace, MV inv. 41205, oil on canvas, 73 x 62 cm; now Rocchetta del Tanaro, Collection of Oddone Incisa della Rocchetta; now in Rome, Francesca Chigi Collection. Sotheby's auctioned in Rome an autograph version, improperly attributed to Carlo Maratta, with a monumental Berninian frame, May 18, 2004, Lot 479, from Palazzo Chigi in Rome and later Ariccia (F. Petrucci, 2001, pp. 113, 123 and 124). For the portrait by Gaulli, see F. Petrucci, 1999, and entry 5, in M. Fagiolo dell'Arco et al., 1999, pp. 97, 107-109. Three replicas with variation are derived from the Messinger canvas: Baltimore, Walters Art Gallery; Castel Fusano, Mario Chigi Collection; Udine, Civic Museum. Other copies are in Siena, Palazzo Pubblico, Stockholm, Nationalmuseum; Castel Fusano, Mario Chigi Collection. A studio copy without the arm in a blessing pose and with the stola is at Palazzo Chigi in Ariccia (F. Petrucci, 2003a, entry 9, pp. 65 and 66). A monumental portrait signed by Pietro Paolo Vegli and derived from Morandi is at Palazzo Chigi in Ariccia (F. Petrucci, 1992, pp. 118 and 119).

31) See S. Rudolph, entry 6, in E. Borea, 2000, vol. II, p. 462 and 463. A monography by Rudolph, still to be published, refers about the copies of Maratta's Portrait of Clement IX. There are several copies of the portrait by Baciccio (also copied in two different engravings), in part reported by R. Enggass (1964, pp. 149-151). They all derive from the canvas in the Accademia de San Luca, which is a replica without the arm raised in blessing: Boston Museum of Fine Arts; Terni, Federico Cianfarini Collection (Iccd, E 35428); London, Dickens Collection; London, Miss G. Frere (London, Witt Library, as Maratta's); London, Christie's, Steward Sale, July 28-29, 1927, no. 130, as Maratta's; Vatican Historical Museum, Lateran Palace, MV inv. 36498, 17.9 x 14 cm (copy in small format donated by Erik Larsen); Rome, Galleria Pallavicini (F. Zeri, 1959, pp. 123 and 124); Rome, Orlando Castellano Collection; Rome, Babuino auction, October 14, 2004, no. 67; Versailles, Musée National du Château. About the lost portrait by Voet, see F. Petrucci, 1995, p. 283-306. A different iconography of Clement IX is at the Palazzo Canonicale in Santa Maria Maggiore, Portrait Room; a full-length portrait incorrectly identified as Clement IX (it is Clement X) is in the Museum of Rome: it's attributed to Morandi (C. and R. Enggass, in N. Pio, 1977, p. 256; G. Sestieri, 1994, vol. I, p. 132; F. Petrucci, 1998, p. 172, note 19),but derives in the face from Gaulli; a studio copy by Morandi is at Palazzo Chigi in Ariccia (F. Petrucci, 2003a, entry 16, pp. 71-73), while the canvas in the Rospigliosi Collection is derived from the engraving by Morandi's (A. Negro, 1999, entry 79, p. 279). Still uncertain is the attribution to Pietro da Cortona of the portrait in a private English collection presented in the 1997 exhibit, a more finished version of which is found in Baltimore, Walters Art Gallery; Fagiolo dell'Arco's attribution to Morandi or Ferri is still less convincing (A. Lo Bianco, 1998, entry 64, pp. 386 and 387; M. Fagiolo dell'Arco, 2001, pp. 81 and 82). The three-quarter pose of Clement IX at the Accademia di San Luca falls within the general Gaullian scope (the pope is erroneously identified with Innocent XI, but the presence of the lozenge on the armchair reveals that this is Pope Rospigliosi. See M. V. Brugnoli, 1949, p. 238; R. Enggass, 1964, p. 167).

32) See F. Petrucci, entry 11, in M. Fagiolo dell'Arco et al., 1999, pp. 113-115. There are several versions of the portrait of Clement X by Baciccio: Florence, Uffizi, Griphsolm, Castello; Lima, Alexander Kossodo Collection; Rome, Maurizio Marini (now Massimo Collection). The portrait in the collection of the popes at Palazzo Altieri in Oriolo Romano is a copy of the model by Baciccio, from which an engraving by Pierre Simon is also derived. A studio copy is at Yale (USA), private collection (London, Witt Library, like the Maratta school); an excellent quality one was at Oriolo Romano, Palazzo Altieri (M. Fagiolo dell'Arco, F. Petrucci, 2001, p. 20; ICCD E 89789); a studio copy is found in the storerooms of Palazzo Pitti; a later replica or copy was auctioned by Christie's in New York on January 23, 2004, Lot 192. A modest

portrait is at the National Gallery of Ancient Art, inv. 1743 (now Chigi Collection); the portrait auctioned by Sotheby's (Milan, June 1, 2004, Lot 109) as Roman school shows a different iconography.

33) A portrait of a standing Innocent XI in an attitude of benediction, with a memorial in his hand, is in the storerooms of the Pinacoteca Vaticana, MV inv. 40843, oil on canvas, 132 x 95 cm; a 19th century portrait of the pope clutching a breviary, executed by Francesco Paolo Michetti, in the Storerooms of the Vatican Museums (MV inv. 42601, oil on canvas, 140 x 69 cm) is of noteworthy quality. A curious portrait is at Geronico (Brianza), Lucia Valerio Collection, with the head of Pope Odescalchi mounted on the body of Maratta's Clement XI, to whose studio it can probably be connected; a portrait derived at least in the face from the lost Morandi, with the pope seated in an attitude of benediction turned toward the left, is in the collection of Contessa Adriana Rosa Durini di Monza in Milan. A portrait of Innocent XI kneeling in meditation in front of a crucifix, attributed to Antonio Nessi and identified with Saint Aloysius Gonzaga (F. Titi, 1987, vol. II, fig. 999; a drawing of the same composition is in the collection of Italo Faldi)is in the Roman church of the Holy Names of Mary, on the altar of the first chapel on the right. The portrait of Innocent XI, recently acquired by the Museum of Rome, attributed to Baciccio by Beatrice Canestro Chiovenda (see B. Canestro Chiovenda, 1996, pp. 70-75; S. Guarino, entry I B.8, in R. Leone et al., 2002, p. 58), is influenced by Gaulli. Ms. Chiovenda also published a portrait attributed to Giuseppe Zanatta in the sacristy of the Basilica dell'Isola di San Giulio in Orta (idem, 1996, p. 72). For Baciccio's lost portrait, see R. Pantanella, *Regesto documentario*, in M. Fagiolo dell'Arco et al., 1999, p. 336.

34) See R. Enggass, 1964, p. 159. For Morandi's portrait, see F. Matitti, 1995, fig. 2; idem, 1997, p. 218, fig. 4; F. Petrucci, 1998, p. 168, fig. 25. For the pose exhibited in Florence, see Antonio Vannugli, 1927, p. 125, table XVIII. A portrait of Alexander VII attributed to Maratta was found in Bologna in a private collection (in *Cronache d'Arte*, January-February 1926, p. 25).

35) For the portrait of Innocent XII by Ludovico Antonio David, see Antonio Vannugli, 1950, no. 76; S. Capelli, *I David a Roma* ["The Davids in Rome"], in A. Spiriti, S. Capelli, 2004, p. 77. A portrait of Innocent XII, erroneously identified with Alexander VIII, signed Bernardino Tonci, is in the Vatican Historical Museum, Lateran Palace, MV inv. 41190, oil on canvas, 133 x 95 cm. A full-length monumental portrait of the pope seated with a memorial in his hand, accompanied by the portraits of Gregory XV and Clement IX, is at the Seminario Maggiore in the Lateran, MV inv. 41871, oil on canvas, 237 x 148 cm. The Windsor Castle drawing, inv. No. 5531, is a sketch for the lost portrait by Gaulli *(Roman Drawings XVII and XVIII Centuries*, no. 156).

36) For the portraits of Clement XI by Nelli, see A. Busiri Vici, 1982. For other portraits, see G. Cucco, 2001, pp. 138-143. For the Torlonia portrait, see Antonio Vannugli, 1950, no. 78; R. Enggass, 1964, pp. 166 and 167; a copy of this work is at the Seminario Maggior in the Lateran Museum, MV inv. 41732, oil on canvas, 134 x 88 cm, while the three-quarter length version, with the pope seated, in the Accademia di San Luca is a poor derivation thereof (G. Incisa della Rocchetta, 1979, p. 100); Pier Leone Ghezzi's portrait, with a half-length figure of the pope in the act of blessing is in the Vatican Historical Museum, Lateran Palace, MV inv. 41208, oil on canvas, 109 x 84 cm; a modest portrait of the pope, a copy of the lost original, is in the Accademia dei Lincei, now Chigi Collection (National Gallery of Ancient Art, inv. 1730). For the portrait by Antonio David, see S. Capelli, entry 32, in A. Spiriti, S. Capelli, 2004, pp. 172 and 173.

37) See S. Marra, entry 22, in F. Petrucci, 2002, pp. 53 and 54. The engraving of the portrait of Benedict XII by Ghezzi is the work of Gerolamo Rossi (Istituto Nazionale per la Grafica, FN 15571[81]).

38) For the portrait of Clement XII by Nelli, see A. Busiri Vici, 1982. Regarding the Masucci portrait displayed in the exhibit, see the entry by Pier Paolo Quieto (no. 28). A copy is in the storerooms of the Pinacoteca Vaticana, MV inv. 42407; a copy with the pope in an attitude of benediction in the Vatican Historical Museum (Lateran Palace, MV inv. 3576) derived from Masucci; a copy was auctioned at Babuino, December 9-12, 2003, Lot 27.

39) See O. Michel, P. Rosenberg, 1987, pp. 248-253. For the copy by Pannini, see R. Leone, entry IB.22 in R. Leone et al., 2002, pp. 76 and 77. For Masucci's portrait, see P. P. Quieto, entry 32, in F. Petrucci, 2004, pp. 112-114, where are mentioned later portraits of the pontiff by Masucci in Imola and Milan, Poldi Pezzoli Museum. a portrait with a frontal pose of Benedict XIV, doubtfully attributed to Subleyras (O. Michael, P. Rosenberg, 1987, p. 252) is at the Museum of Monaco. A copy by Crespi is in the storerooms of the Vatican Museums, MV inv. 43347, where there's also a juvenile portrait , inv. MV 990, oil on canvas, 80 x 62 cm. Among the copies by Masucci, we can cite: Vatican Historical Museum, Lateran Palace, MV inv. 692; Rome, National Gallery of Ancient Art, Storerooms, inv. 1710 (now Chigi Collection). At Palazzo Chigi at Ariccia, there is a later pose attributed by Quieto to Agostino Masucci, different from the preceding one, inv. 1236 (F. Petrucci, 2003a, entry 67, p. 108).

Later portraits of Pope Lambertini are in the Museum of Faenza, in the Piersanti di Matelica Museum, in San Nicolò di Bari, in the Hospital at Kues on the Meuse (L. von Pastor, vol. XVI, 1933, p. 28, note).

40) See S. Roettgen, 2001, entrys 85-87, pp. 260-265: a study by Mengs limited to Clement XIII's face alone is in the collection of the Duke of Wellington at Stratfield Saye, taken as a model by Piranesi for an engraving and by Canova for the funeral monument. The Baltimore portrait in Walters Art Gallery, similar to the one in Bologna but with the variation of the arm raised in blessing, is by Mengs' workshop (F. Zeri, 1976, no. 424). A later version in a reduced format of Mengs' portrait in a frontal pose is in the Galleria Gasparrini in Rome (oil on canvas, 100 x 75.5 cm), while a studio pose limited to a half bust, of Rospigliosi provenance, is in a Roman private collection (F. Petrucci, 2002, entry 24, p. 54). An unfinished portrait, perhaps done by the workshop, is at the Museum of Stockholm (H. Voss, *Malerei*, pp. 658, 660). For Batoni's portrait, see A. M. Clark, 1985, entry 227. A derivation of Batoni's portrait with the pope seated in a blessing pose is at the Vatican Historical Museum, Lateran Palace, MV inv. 40453, oil on canvas, 118 x 94.5 cm (Alinari, 28156); two copies derived from Mengs are in the storerooms of the Vatican Museums, MV inv. 41189, oil on canvas, 158 x 129 cm, and MV inv. 41471, oil on canvas, 171 x 123 cm; a portrait with the pope erect and in a blessing pose turned toward the left is at the Accademia Ecclesiastica, MV inv. 41715, oil on canvas, 91 x 73 cm. Two portraits of Clement XIII (one by Batoni) are in the Episcopal Palace of Coira, one in San Niccolò di Bari, one at the Galleria dell'Accademia in Venice, one in the Sagrestia Maggiore in the Bishop's Palace in Padua (L:. von Pastor, XVI, 1933, p. 478).

41) See S. Rudolph, 1983, fig. 582, p. 795; E. Marconcini, entry ID.19 in R. Leone et al., 2002, p. 114. In the portrait of Clement XIV in the act of blessing in the Accademia dei Lincei, Porta literally reproduces the pose of Benedict XIV of Subleyras, with the variation of the standing figure clutching a sheet of paper in the left hand (National Gallery of Ancient Art, inv. 1729, now Chigi Collection); a later portrait of the head on canvas, with a variation because of the pose of the bust, is in Palazzo Chigi in Ariccia, inv. 1237 (F. Petrucci, 2003a, entry 68, p. 110).

42) See A. Clark, 1985, entry 391, pp. 339 and 340; G. Sestieri, 1994, vol. II, fig. 237; R. Leone, entry I A.9, in R. Leone et al., 2002, pp. 40 and 41. A perhaps posthumous portrait similar to Pius VII by Camuccini, but with the pope in a blessing pose, is in the Accademia Ecclesiastica, MV inv. 41730, oil on canvas, 100 x 72 cm. Several copies with the pope in the act of benediction are derived from Porta: Rome, Accademia Ecclesiastica, MV inv. 41716, oil on canvas 99 x 73 cm; three in Roman private collections. A portrait by G. P. Pozzi by Batoni is in the Museo Napoleonico (see Antonio Vannugli, 1950, no. 86; L. Capon, 1986, 48).

43) For the painting by Matteini, see R. De Feo, entry I.15, in S. Androsov et al., 2004, pp. 136 and 137. A copy of David's painting is at Palazzo Jacobini at Genzano (S. Marra, entry 26, in F. Petrucci, 2002, p. 55), while the painting signed in the upper right-hand side "LUD. DAVID PARISIIS 1805" in Carol Gerten's Fine Art appears to be a replica. For Camuccini's portrait, done in at least five versions, see the additional bibliography of I. Sgarbozza, entry VI.1, in AA.VV., 2003, p. 173: a later replica is in a Roman private collection, while a study for the face alone is in the Lemme Collection (F. Petrucci, 2004, entry 34, pp. 114 and 115). Angelo Bertini engraved the portrait by Camuccini. The portrait by Pietro Labruzzi is in the Vatican Historical Museum, Lateran Palace, MV inv. 43609, oil on canvas, 115 x 86 cm. A sketch by G. B. Wicar is in the National Gallery of Perugia (see AA.VV., 1950, no. 89). The Vatican collections contain several portraits of Pius VII: Anonymous, Storerooms of the Vatican Museums, MV inv. 41543, oil on canvas, 43 x 33 cm; Anonymous, Storerooms of the Vatican Museums, MV inv. 41982, oil on canvas, 75 x 62 cm; Anonymous, Congregazione dei Sacramenti, MV inv. 43063, oil on canvas, 61 x 48.5 cm (by Camuccini); Anonymous, Nunziatura Estera, MV inv. 43343, oil on canvas, 100 x 80 cm. There is a splendid group portrait by G. B. Wicar depicting *Cardinal Consavli Presenting the Ratification of the Concordat with France to Pius VII*, now hanging at Palazzo Apostolico in Castel Gandolfo, MV inv. 42799, oil on canvas, 275 x 394 cm. A portrait of Pius VII by Camuccini is in Camaldoli (M. Valenti, 2003, p. 69).

44) Three portraits of Leo XII derived from Tofanelli are indexed in the Vatican collections: Storerooms of the Vatican Museums, MV inv. 41613, oil on canvas, 74 x 60 cm; Accademia Ecclesiastica, MV inv. 41736, oil on canvas, 75 x 60 cm; Congregazione dei Sacramenti, MV inv. 43065, oil on canvas, 62 x 48.5 cm. The portrait in the Gherardo Noce Benigni Olivieri Collection in Rome, oil on canvas, 73 x 60 cm, from the Marchesi Lolli Benigni Olivieri of Fabriano, with a long dedicatory inscription, perfectly matches the lithograph by Persichini.

45) See G. Castellani, 1929, pp. 175-185; I. Julia, entry 53, in AA.VV., 1980, pp. 81 and 82. Vernet's composition is known through the painting in the Château at Versailles (MV inv. 1821) and a reduction replica at Amiens, Museo della

Picardia (inv. 2072). A modest portrait of Pius VIII hangs in the Congregazione dei Sacramenti with a Camuccini-like pose, MV inv. 43066, oil on canvas, 63.5 x 49.5; a portrait by the hand of Ferdinando Cavalleri is found in Rome, in the collection of Engineer Edoardo Lombardi (see AA.VV., 1950, no. 91).

46) The portrait by Podesti is in the Vatican Historical Museum, Lateran Palace, MV inv. 40454, oil on canvas, 197 x 147 cm. The prototype is in Ancona, Pinoteca Comunale, with the Pope seated in a blessing pose (Polverari, 1996, p. 51). Several portraits of Gregory XVI are known: Giovanni Busato (?), Castel Gandolfo, Banca di Credito Cooperativo Castelli Romani; Anonymous, Storerooms of the Vatican Museums, MV inv. 41414, oil on canvas, 74 x 62 cm; Anonymous, Pontificio Collegio Etiopico-Vaticano, MV inv. 42522, oil on canvas, 28 x 24 cm. A copy by Busato is in Camaldoli (M. Valenti, 2003, p. 70), while a beautiful oil on copper is currently in the possession of the Antiquary Giuseppe d'Angelo in Rome.

47) See AA.VV., 2004, pp. 80 and 81. Portraits of Leo XIII by László (Marlia, Contessa Pecci Blunt) and Chartan (Roman, Contessa Moroni Pecci) were displayed in the 1950 exhibit (see AA.VV., 1950, nos. 95 and 96). We list the portraits of Leo XIII from the Vatican collections: Paolo Tadolini, Vatican Historical Museum, Lateran Palace, MV inv. 54947, oil on canvas, 88 x 121 cm (frontal sitting, left arm on the table); Giuseppe Ugolini, Storerooms of the Vatican Museums, MV inv. 44610, oil on canvas, 238 x 153 cm (seated on the papal throne, with a view of Saint Peter's); A. Palombi, Storerooms of the Vatican Museums, MV inv. 44436, oil on canvas, 60 x 48 cm; Paolo Tadolini, Tribunale Sacra Rota, MV inv. 44257, oil on canvas, 235 x 180 cm (signed and dated "Rome 1902," standing by a table, hand on the breviary and eyeglasses in the left hand); Philipp Alexius László von Lombons, Vatican Historical Museum, Lateran Palace, MV inv. 43539, oil on canvas, 57.5 x 42.5 cm (signed "Rome 1900"); Paolo Tadolini, Seminario Minore in the Vatican, MV inv. 3258, oil on canvas, 74 x 96 cm (frontal framing); Cecilie de Wentworth, Pontifical Lateran University, MV inv. 43247, oil on canvas, 240 x 148 cm (full-length standing figure, smiling, in the act of benediction); Giuseppe Ugolini, Seminario Maggiore in the Lateran, MV inv. 43194, oil on canvas, 240 x 155 cm (similar to the other one with a view of Saint Peter's, dressed with a white robe); Giuseppe Ugolini, Accademia Ecclesiastica, MV inv. 43129, oil on canvas, 148 x 110 cm (same pose, but in a room, with mozzetta, camauro and breviary); Giovanni Cingolani, Vicariate of Rome, MV inv. 43100, oil on canvas, 150 x 100 cm (standing in the act of benediction, by a table with a memorial); Anonymous, Sacra Congregazione dei Sacramenti, MV inv. 43068, oil on canvas, 128 x 97 cm; Beniamino Constant, Vatican Museums, MV inv. 42600, oil on canvas, 112 x 87 cm (pictorial with the face turned toward the left); Campanili, Storerooms of the Vatican Museums, MV inv. 42480, mosaic, 50 x 60 cm.

48) The following portraits of Pius X are in the Vatican collections: Guido Greganti, Storerooms of the Vatican Museums, MV inv. 57266, tempera on canvas, 412 x 287 cm (standard); Missori, Storerooms of the Vatican Museums, MV inv. 57270, tempera on canvas, 350 x 250 cm (standard: Pius X is painted in the fiery nimbus); Anonymous, Pontifical Commission for Emigration and Tourism, MV inv. 44515, oil on canvas, 150 x 123 cm; Barazzuttii, Sacra Congregazione Orientale, MV inv. 44402, oil on canvas, 150 x 100 cm (posthumous portrait: the pope is seated with an aureola); F. Zonghi Lotti, Accademia Ecclesiastica, MV inv. 44313, oil on canvas, 35 x 25 cm; Anonymous, Tribunale Sacra Rota, Palazzo della Cancelleria, MV inv. 44252, pastel and oil on canvas; De Witten, Tribunale Sacra Rota, Palazzo della Cancelleria, MV inv. 43383, oil on canvas, 70 x 60 cm (quality portrait, with the pope with a right profile); Anonymous, Storerooms of the Vatican Museums, MV inv. 43288, oil on canvas, 62 x 51 cm; Anonymous, Seminario Maggiore in the Lateran, MV inv. 43198, oil on canvas, 240 x 150 cm (seated with frontal framing, with an intense gaze turned toward the viewer, hand on the right arm of the chair); Anonymous, Vicariate of Rome, MV inv. 43114, oil on canvas, 75 x 60 cm (blessing pose, like Pius IX); Berthod Lippay, Vatican Historical Museum, Lateran Palace, MV inv. 42723, oil on canvas, 176 x 119 cm, seated on throne. Was displayed in the 1950 exhibit: AA.VV., no. 97); Alessandro Milesi, Storerooms of the Vatican Museums, MV inv. 42598, oil on canvas, 134 x 105 cm; Antoon Van Welie, Vatican Historical Museum, Lateran Palace, MV inv. 42581, oil on canvas, 79.5 x 52 cm (work in the exhibit).

49) The following portraits of Benedict XV are present in the Vatican collections: Storerooms of the Vatican Museums, MV inv. 42777, oil on canvas, 128 x 104 cm (was displayed in the 1950 exhibit no. 98); R. Mandola, Pontificio Collegio Etiopico Vaticano, MV inv. 44490, oil on canvas, 80 x 60 cm (frontal framing, with the pope dressed in white); Anonymous, Accademia Ecclesiastica, MV inv. 44310, oil on canvas, 120 x 80 cm (seated, framed from the left, left hand on the arm of the chair and right hand on his lap); Rodolfo Mandola, Storerooms of the Vatican Museums, MV inv. 43560, oil on canvas, 88 x 74 cm (dressed in white, frontal framing); G. Ughini, Seminario Maggiore

in the Lateran, MV inv. 43216, oil on canvas, 157 x 110 cm (the pope is seated, frontal, with missal); F. Zonghi Lotti, Seminario Maggiore in the Lateran, MV inv. 43191, oil on canvas, 100 x 80 cm (in the act of benediction, seated toward the left); Anonymous, Accademia Ecclesiastica, MV inv. 43140, oil on canvas (seated toward left, looking sideways); Anonymous, Vicariate of Rome, MV inv. 43115, oil on canvas, 75 x 60 cm; C. Palmieri, Storerooms of the Vatican Museums, MV inv. 42937, oil on canvas, 80 x 63 cm (portrait while reading a bull and gazing at us); Giuseppe Brugo, Cancelleria Penitenziaria Apostolica, MV inv. 42932, oil on canvas, 74 x 64 cm; Giovan Battista Torriglia, Pontifical Commission for Emigration and Tourism, MV inv. 42725, oil on canvas, 188 x 126 cm; Giacomo Grosso, Storerooms of the Vatican Museums, MV inv. 42599, oil on canvas, 189 x 123 cm (displayed in the exhibit); Bartolo Lippay, Storerooms of the Vatican Museums, MV inv. 42509, oil on canvas, 222 x 162 cm (seated on the throne gazing at us).

50) For Pius XI's triregnum, see L. Orsini, 2000, pp. 122, fig. 3, 145-146. Concerning the Franciscan Missionaries of Mary and their painting *atelier* see FMM, 1937: it opened in Rome in 1987, at the Casa Generalizia at Via Giusti 12, starting with two altarpieces for the church at Riese ordered by Pius X in 1908, but it took up the execution of portraits in 1913. Between 1916 and 1922, the painting sisters executed portraits of Leo XIII, Pius X and Benedict XV. In 1922, with the election of Pius XI, they executed many more portraits, including those at the Circolo San Pietro, at the Congregazione degli Studi, at the Holy Office and at the Seminario Lombardo. The activity continued during the reigns of Pius XII, John XXII and Paul VI. A portrait of Pius XI by Viktor Scharf was displayed in the 1950 exhibit (Rome, Marchesa Maria Luisa Persichetti Ugolini Ratti, AA.VV., 1950, no. 99). The following portraits of Pius XI are present in the Vatican collections: Viktor Scharf, Storerooms of the Vatican Museums, MV inv. 42597, oil on canvas, 129 x 99 cm; C. Palmieri, Palazzo dei Tribunali, Vatican City, MV inv. 42865, oil on canvas, 138.5 x 97 cm (frontal, in an act of benediction); Anonymous by Scharf, Sacra Congregazione Educazione Cattolica, MV inv. 42923, oil on canvas, 128.5 x 90 cm; Franciscan Missionaries of Mary, Congregazione dei Missionari, MV inv. 42935, oil on canvas, 105 x 84 cm (this is the same pose as the painting in the exhibit); Anonymous by Scharf, Sacra Congregazione dei Vescovi, MV inv. 43055, oil on canvas, 128 x 97.5 cm; Anonymous by Scharf, Sacra Congregazione dei Sacramenti, MV inv. 43069, oil on canvas, 128 x 97 cm; Anonymous by Scharf, Sacra Congregazione Religiosi, MV inv. 43071, oil on canvas, 128 x 97 cm; Tito Ridolfi, Storerooms of the Vatican Museums, MV inv. 43082, oil on canvas, 130 x 97 cm (seated, gazing at us, with a plan on the table); Ugo Galvagni, Pontifical Academy of Sciences, MV inv. 43088, oil on canvas, 181.5 x 106.5 cm (seated, frontal with breviary); Renghini, Vicariate of Rome, MV inv. 43116 (identical to the painting in the exhibit, without the hands); Franciscan Missionaries of Mary, Seminario Maggiore in the Lateran, MV inv. 43187, oil on canvas, 150 x 112 cm (this is the same pose as the painting in the exhibit, but with a full-length figure); Franciscan Missionaries of Mary (?), Pontificio Collegio Etiopico, MV inv. 44492, oil on canvas, 80 x 60 cm (this is the same pose as the painting in the exhibit, in a half bust); Franciscan Missionaries of Mary (?), Sacra Congregazione dei Vescovi, MV inv. 44444, oil on canvas, 200 x 120 cm (standing pose); Zelli, Sacra Congregazione Orientale, Palazzo dei Convertendi, MV inv. 44398, oil on canvas, 155 x 103 cm (standing in a blessing pose); F. Zonghi Lotti, Accademia Ecclesiastica, MV inv. 44312, oil on canvas, 40 x 30 cm (this is the same pose as the painting in the exhibit, in a half bust); Arnaldo Tamburini (?), Sacra Congregazione dei Vescovi, MV inv. 43554, oil on canvas, 219 x 166 cm (blessing pose, with triregnum, on the throne); Spiridon, Storerooms of the Vatican Museums, MV inv. 43475, oil on canvas (signed, pope in blessing pose, hyper-realistic); G. Marchetti, Lateran University, MV inv. 43261, oil on canvas, 220 x 140 cm (monumental portrait, on throne, blessing with Episcopal mitre); Fallenberg, Storerooms of the Vatican Museums, MV inv. 43259, oil on canvas, 162 x 104 cm (seated, frontal, slightly toward the right); Franciscan Missionaries of Mary, Congregazione dei Missionari, MV inv. 51985, oil on canvas, 132 x 132 cm (signed "FMM Rome 1925," the pope is seated, engrossed in writing; acquired 2003); Franciscan Missionaries of Mary, Vatican Historical Museum, Lateran Palace, MV inv. 56208, oil on canvas, 175 x 125.5 (frontal pose, seated). In the Tapestry Restoration Laboratory in the Vatican; there is a later portrait present of Pius XI painted by the Franciscan Missionaries of Mary.

51) A portrait of Pius XII owned by Count Camillo Orlando Castellano was displayed in the 1950 exhibit (AA.VV., 1950, no. 1001). A beautiful portrait of the pope in profile of a contemporaneous sensibility is the posthumous portrait by Mario Russo, still in the possession of the heirs (see M. Greco, 1981, p. 178). The following portraits of Pius XI are present in the Vatican collections: Carlo Siviero, Pontifical Commission of Sacred Art, Palazzo della Cancelleria, MV inv. 43472, oil on canvas, 151 x 120 cm; Xavier Bueno, Storerooms of the Vatican Museums, inv. ARM24493, oil on canvas, 180 x 86

cm (standing dressed in episcopal garb, praying); Anonymous, Santissima Congregazione dei Sacramenti, MV inv. 43070, oil on canvas, 97 x 70 cm (derived from the work by Siviero, in a half-length figure without hands); G. Ferranti, Accademia Ecclesiastica, MV inv. 43130, oil on canvas, 83 x 62 cm; Franciscan Missionaries of Mary, MV inv. 43099, oil on canvas, 75 x 62 cm (this is a copy of Ferranti); Francesco Torsegno, Storerooms of the Vatican Museums, MV inv. 43379, oil on canvas, 88 x 73 cm (copy of Siviero); G. Maltzeff, Nunziatura Estera, MV inv. 43378, oil on canvas, 83 x 78 cm (blessing pose); Leonard Boden, Vatican Historical Museum, Lateran Palace, MV inv. 43380, oil on canvas, 280 x 192 cm (seated with hands crossed in prayer, missal opened on his lap, with the pope gazing at us); "Sister cor Mariae-Foley-Marianite of Holy" (1957), Storerooms of the Vatican Museums, MV inv. 43390, oil on canvas, 275 x 200 cm (allegorical portrait); Herman Jacobs, Vatican Historical Museum, Lateran Palace, MV inv. 44227, oil on canvas; Mario Agrifoglio, Storerooms of the Vatican Museums, MV inv. 44196, oil on canvas, 140 x 106 cm (similar to the portrait by Boden, with variations); R. Fantuzzi, Storerooms of the Vatican Museums, MV inv. 50039, oil on canvas, 77 x 65 cm (profile, in an oval frame); S. Vanegalli, Vicariate of Rome, MV inv. 54509, oil on wood, 78 x 60 cm; Franciscan Missionaries of Mary, Storerooms of the Vatican Museums, MV inv. 51982, oil on canvas, 85.5 x 68 cm; Franciscan Missionaries of Mary, Storerooms of the Vatican Museums, MV inv. 51983, oil on canvas, 50 x 39 cm; H. Bairenscheen, 1947, Pontificio Collegio Etiopico, MV inv. 44481, oil on canvas, 140 x 100 cm (frontal, with left hand on breast touching cross); C. Palmieri, Storerooms of the Vatican Museums, MV inv. 44451, oil on canvas, 138 x 100 cm (following Siviero, but with the gaze toward the viewer); B. Paradiso, Storerooms of the Vatican Museums, MV inv. 44435, oil on canvas, 75 x 60 cm (copy of Siviero in half bust); R. Brailowska, Sacra Congregazione Orientale, Palazzo dei Convertendi, MV inv. 44418, oil on wood, 65 x 53; Leggeri 1939, Sacra Congregazione Orientale, Palazzo dei Convertendi, MV inv. 44399, oil on canvas, 150 x 98 cm (seated in a frontal pose in the act of benediction); Biagio Cascone, Storerooms of the Vatican Museums, MV inv. 52916, oil on canvas, 48.4 x 40.5 cm; Polverini, Vatican Historical Museum, Lateran Palace, MV inv. 56206, oil on canvas, 137 x 109 cm (bottom part similar to Siviero, face toward the viewer, pictorial, a quality work). In the Tapestry Restoration Laboratory, in the Vatican, there is a portrait of Pius XII painted by the Franciscan Missionaries of Mary.

52) Mario Russo executed a portrait of John XXIII in profile, still in the possession of the heirs (see M. Greco, 1981, p. 184). The following portraits of John XXIII are present in the Vatican collections: Aldo Carpi, Storerooms of the Vatican Museums, MV inv. 50621, oil on canvas (allegorical portrait with Christ and child); Umberto Romano, 1967, Vatican Museums, MV inv. 24687, oil on canvas; Felice Carena, Storerooms of the Vatican Museums, MV inv. 433377, oil on canvas, 144 x 115 cm (seated, pictorial, looking toward the left). Present in the Tapestry Restoration Laboratory are portraits of Pius XI, Pius XII, John XXIII and Paul VI painted by the Franciscan Missionaries of Mary.

53) ". . . We need you. Our ministry needs your collaboration. Because, as you know, our ministry is that of preaching and rendering accessible and understandable, and thus motivating, the world of the spirit, of the invisible, of God. And in this operation that transforms the invisible world into accessible, intelligible forms, you are the masters. . . . Perhaps we dressed you in a cloak of lead, so we say: forgive us! And then we even abandoned you. We did not explain our things to you, we did not introduce you into the secret cell, where the mysteries of God cause man's heart to leap with joy, hope, happiness, bliss. We did not have you as pupils, friends, conversationalists; therefore, we did not come to know you . . .".

54) For the vast portraiture of Paul VI and references to his conception of art, see the exhaustive research by E. Briviio, M. Ferrazza, 1999.

55) For the portraits of John Paul I and John Paul II by Russo, still in the possession of the heirs in Rome, see M. Greco, 1981, pp. 170, 185. The following portraits of John Paul I are present in the Vatican collections: N. Tsarkova, Vatican Historical Museum, Lateran Palace, MV inv. 57165, oil on canvas, 80 x 60 cm (work on display in the exhibit); G. Razzicchia, 1978, Storerooms of the Vatican Museums, MV inv. 45512, oil on canvas, 78 x 59 cm (posthumous, from a photo).

56) See C. Cremona, 1980. The following portraits of John Paul II are present in the Vatican collections: Natalia Tsarkova, Vatican Historical Museum, Lateran Palace, MV inv. 56666, oil on canvas, 180 x 120 cm (work displayed in the exhibit); Diane R. Friedman, Vatican Historical Museum, Lateran Palace, MV inv. 52747, oil on canvas, 198 x 122 cm (the pope is seated, smiling); Ugo Cutilli, Storerooms of the Vatican Museums, MV inv. 44516, oil on canvas, 230 x 175 cm (painted hyper-realistically; the pope is standing and praying, with a table, furnishings and drapes in the background); Malgari, 1978, Sacra Congregazione Orientale, Palazzo dei Convertendi, MV inv. 44417, oil on canvas, 115 x 85 cm (in prayer, with profile toward the left).

PAPI
IN
POSA

500 Years
of Papal Portraiture

Anonymous nineteenth century sculptor

Saint Peter
bronze, polychrome marble, 48 x 17 x 17 cm
Rome, private collection

Bibliography: S. Marra, in *Papi in posa…*, 2004, p. 48

The small bronze exhibited here repeats on a reduced scale and with certain variations a more famous and venerated statue of Saint Peter. The original, slightly over life-size, has been on public view in its current location since the seventeenth century: at the end of the central nave in St. Peter's basilica in the Vatican, against the pier that houses Bernini's statue of *Saint Longinus*. Despite the considerable fame of this work and its great significance for scholars of papal iconography, the Vatican *Saint Peter* raises difficult questions of dating and attribution. Proponents of an early date assign the statue to the fifth century AD, but many more scholars endorse the attribution proposed by Wickhoff, who in 1890 traced the work to the circle of Arnolfo di Cambio, thus dating it to the second half of the thirteenth century (1).

The composition of the statue is straightforward: the saint is enthroned in a frontal position, with his right hand raised in blessing; the right foot, extended from the plane of the body, is the only hint of movement in the otherwise rigid figure. Peter wears his customary tunic and pallium, and embodies the typology established by the third century bishop Eusebius of Caesarea, who recorded that Peter had short, curly hair and a short, frizzy beard. In his left hand Peter holds the keys to the kingdom of heaven, symbolizing the promise Jesus made to the apostle when he proclaimed Peter his Chosen One: "You are Peter and on this rock I shall build my Church." With this simple declaration Christ identified Peter as his earthly Vicar, the first Pope of the Christian Church.

The small reproduction exhibited here, like its Vatican prototype, rests on a pedestal decorated with marble panels, but without the gilded frames present in the Roman example. The throne and the tall pedestal of the Vatican *St. Peter* date to the eighteenth century. Chracas mentions the replacement of the old marble throne with one commissioned in 1754 by Benedict XIV. Sources indicate that the architect Luigi Vanvitelli designed the work, which was then executed by Carlo Marchionni in Vanvitelli's absence. Marchionni probably followed Vanvitelli's general design but interpreted it according to his personal taste. The stonecutter Giannini carved the decorative details and handled the acquisition of marble. The result was a work inspired by Baroque expressionism mixed with the late eighteenth-century taste for the revival of archeological motifs. The intrusive presence and decorative exuberance of the throne met with numerous criticisms, and for this reason it was replaced after only two years. For the new work, fifteenth-century in inspiration, Marchionni took his cue from the original but did not create a faithful copy. This work corresponds to the throne currently in place (2). The Vatican *Saint Peter* would provide the source for scores of papal portraits, inaugurating a model of widespread popularity for future papal iconography in which the pontiff is enthroned with his hand raised in benediction. Successors to Peter, the first Pope, continue to be portrayed in this manner.

Susanna Marra

1) See A. Pinelli, 2000
2) See F. Petrucci in E. De Benedetti, 2001, pp.45,46.

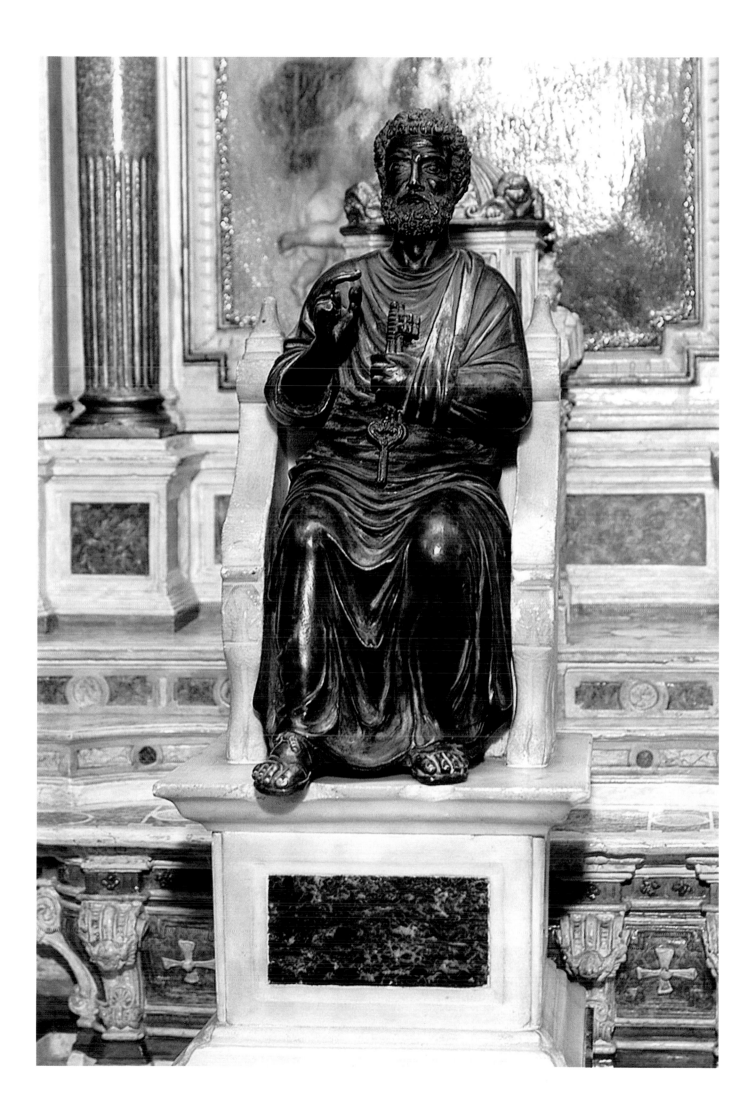

Anonymous seventeenth century painter, after Raphael

Portrait of Julius II (Giuliano della Rovere, 1503-1513)
oil on canvas, 108 x 82 cm.
Ariccia (Rome), Chigi Palace, inv. 460

Bibliography: unpublished

This painting is a variant copy of the celebrated portrait of Julius II painted by Raphael in 1511-12, today in the National Gallery of London. Upon its completion, Raphael's original was displayed for eight days on the altar of the Roman church of Santa Maria del Popolo. The excitement it generated is recorded by a Venetian correspondent: "It bore a great resemblance to [the Pope]...All Rome rushed to see it; it was like a Holy Year, so many people went there." (Sherman, 2003, I, n. 1513/13).

Numerous copies of the painting are known, and Raphael's original, for all intents and purposes the official image of Julius's pontificate, became a crucial point of reference for all successive papal portraiture. The presence of a copy in the Chigi collection attests to the relationship between the Sienese family and the Pope: in 1507 Julius II gave the banker Agostino Chigi (called Agostino "the Magnificent") and his brother Sigismondo permission to quarter the Chigi coat of arms with the heraldic impresa of the della Rovere family in exchange for Chigi's able management of papal finances.

The oval frame is decorated with oak branches that allude to the della Rovere family. An inscription at the bottom reads: "IVLIVS II PONTIF. MAX. QVI. SIGISMVNDVM/ CHSIVM GENTILITIO ROBORE. AC PRONOMINE/ DONAVIT. IN HAC TABVLA REVIVISCIT./ SVIQUE EFFIGIE IMMORTALIS BENEFICIY̆/ AVGET MONVMENTVM". The Chigi canvas is larger than Raphael's original.

The painting is recorded in the March 1931 "inventory of furniture and paintings in Prince Chigi's Villa at number 15 Cola da Rienzo [Street]" as "an oil painting on canvas representing Pope Julius II" (Ariccia, Archivio di Palazzo Chigi), hung at the entrance of the building.

Giuliano della Rovere (1443-1513) was born near Savona to a family of humble origins. He entered the Franciscan Order, dedicated himself to law studies and was noted for his vast erudition and culture. In 1471 he was created Cardinal by his uncle, Pope Sixtus IV, from whom he also obtained important political appointments. He was a gifted military tactician, repelling the Aragonese near Rome. When his bitter rival Rodrigo Borgia became Pope Alexander VI, Giuliano withdrew to France and remained there until the death of the Borgia Pope.

The conclave of October 31 1503, in which Giuliano delle Rovere was elected Pope with the support of Spain and of Cesare Borgia, was the shortest in papal history. Nevertheless after his election Julius declared war to the Borgia, depriving them of the territories of the Romagna. His adversaries called him *"terribile"* [frightful or awe-inspiring] for his strong temperament and his great physical energy, traits alluded to in his new name and its deliberate reference to Julius Caesar.

In 1506 the Pontiff issued a bull against simony and condemned the Dominican friars who were opposed to the theory of the Immaculate Conception. He promoted the League of Cambrai against Venice, which occupied the cities of the Romagna region, and reclaimed Bologna for the Papal States. In 1510 he granted the kingdom of Naples to Ferdinand of Aragon; the following year he formed the Holy League to expel the French from Italy. In 1512 he convegned the Sixth Lateran Council for Church reform.

Julius II is remembered as a great patron of art, commissioning Donato Bramante to rebuild the Vatican Basilica, Michelangelo to paint the ceiling of the Sistine Chapel, and Raphael to decorate a suite of rooms in the Vatican Palace. Julius's tomb in the church of San Pietro in Vincoli does not begin to suggest the monumentality and grandeur of the free-standing sepulchre Michelangelo designed for the Pope, originally intended for St. Peter's.

Francesco Petrucci

1) See G. Cugnoni, 1881, pp. 22, 66-68

IVLIVS II PONTIF. MAX. QVI SIGISMVNDVM
CHISIVM GENTILITIO ROBORE. AC PRONOMINE
DONAVIT. IN HAC TABVLA REVIVISCIT.
SVIQVE EFFIGIE IMMORTALIS BENEFICY
AVGET MONVMENTVM

Anonymous seventeenth century painter

Portrait of Julius II dressed as a Condottiere (Giuliano della Rovere, 1503-1513)
oil on canvas, 28.5 x 35 cm.
Ariccia (Rome), Chigi Palace, inv. n. 461

Bibliography: C. von Chtedowski, 1912, p. 182, tab. f.t.; G. Incisa della Rocchetta, 1951, XXV, pp. 130-131; D. Petrucci, sheet 21, in F. Petrucci, 2004, pp. 102-103

This painting, published in 1912 when it was at the Chigi Palace at Rome (today seat of the Council of Ministers of the Presidency), is cited in the 1931 inventory of the Villino Chigi located on Via Cola di Rienzo* as "a small oil on canvas representing Julius II at the siege of Mirandola in a golden frame" (Ariccia, Chigi Palace Archives). The painting has been at Ariccia since the end of the Second World War.

The anonymous painter of this portrait, which records the appearance of the Pope in 1511, the year he laid siege to the French forces at the Mirandola fortress, produced a successful image known through some copies. Julius II became Pope on November 1ˢᵗ 1503, after the very brief papacy of Pius III. His ideals, aimed at protecting the Italian states, captured the votes of the Italian cardinals; additionally, he made use of Cesare Borgia to obtain the support of Spain, and finally even France supported his candidacy in the hope of a change. With these prospects his election was certain even before the cardinals met for the conclave, and his was one of the quickest elections recorded in Church history. In his political activities, Giuliano della Rovere sought to restore the autonomy of the Papal States, claiming its independence and striving especially to loosen the grip of foreign powers on the country.

On January 2, 1511 Julius II, at the age of sixty-seven, astonished everyone by appearing on the battlefield during the famous siege of Mirandola. In adverse conditions, with icy cold and snow that reached higher than the horses' knees, the Pope, accompanied by the Cardinals Isvalies, Corsaro and Aragona and by the architect Donato Bramante, led his army in laying siege, striking a weak point in the city walls until they were breached on the 14ᵗʰ of the month; Julius and his army entered the city in triumph on the 21ˢᵗ. This legendary siege drastically redimensioned Louis XII's demands, becoming one of the most significant political and military actions of the sixteenth century. (1)

The painting is a valuable document of Julius II at that very delicate time, revealing a Pope who was self-assured, energetic, and not at all afraid of danger. It is clear why his contemporaries said of him, before his election to the See of Peter, that he was hated by many and feared by all. The Pope is shown in profile, dressed in armor with a sheepskin fur over it, which also covers the helmet in a sort of hood while the face remains uncovered. The profile portrait highlights his dark complexion and his hard and determined features. The deep eyes are sternly focused forward, intent on the battle; the lips are closed tightly and a large wart is evident on his left cheek.

The bibliography on this painting records a version owned by the Countess della Rocca de Candal, one in the Bruschi Palace at Corneto (which appears different from the preceding one, contrary to what is argued) and another in the collection of the Duke Giacomo Salviati at Rome. As Giovanni Incisa della Rocchetta maintained, the painting, which could not have had an official function, probably derived from a live sketch executed by an artist of Leonardo da Vinci's school such as Bernardino de' Conti, as Incisa suggests, or by Ambrogio de Predis, as proposed by Federico Zeri. (2)

Daniele Petrucci

1) See L. Pastor, Rome 1932, vol. III pp. 751-770
2) See J. Klaczko, 1902, pp. 281-282

TRANSLATOR'S NOTE: VIA COLA DI RIENZO IS THE STREET IN ROME ON WHICH THE VILLINO CHIGI ("SMALL CHIGI VILLA") IS LOCATED.

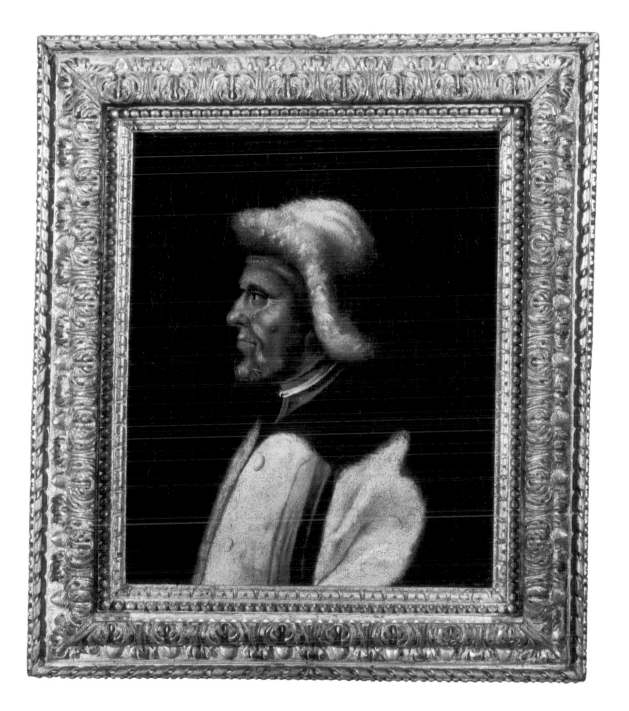

Attributed to Jacopino del Conte, copy after Raphael
(Florence 1513 – Rome 1598)

Portrait of Leo X (Giovanni de' Medici, 1513-1521)
oil on panel, 109 x 85.5 cm.
Milan, Baratti Gallery

Bibliography: unpublished

This painting is a copy, limited solely to the figure of the Pope, of the famous *Portrait of Leo X with the Cardinals Giuliano de' Medici and Luigi de' Rossi* executed by Raphael around 1518 (Florence, Uffizi), a true icon of Renaissance portraiture. Numerous derivations of Raphael's masterpiece are known, among them the one executed by Giuliano Bugiardini in 1520 on a commission from Cardinal Cybo (Rome, National Gallery of Ancient Art), noted by Vasari; it later passed into the collection of Cardinal Silvio Valenti Gonzaga, at which time Cardinal Innocenzo Cybo was inserted in place of Cardinal de' Rossi. Another copy was commissioned from Andrea del Sarto by Federico Gonzaga (Naples, Capodimonte Museum) and yet another in 1536 from Vasari himself. The present portrait was sold in a Semenzato auction (Milano, 1989, lot n.o 72) as made by Vasari, but his lost painting included the portraits of two other men, like the Raphael's original. (1)

A copy like the one under examination limited only to the Pope is located in the Vatican Museums (inv. MV 42073). Executed in oil on canvas, it appears to be a subsequent derivation, perhaps dating to the second half of the sixteenth century if not to the early seventeenth century. Two other copies again depicting only the Pontiff, one limited only to the face, are today in the Vatican Museums' storage (MV 41350). Therefore Raphael's portrait is indeed the sole official image of the Medici papacy. (2)

This version, besides being painted on panel like the original, is characterized by remarkable pictorial independence, with a refined smoothness and use of metallic tones; it demonstrates a clear tendency towards the abstract, typical of a strong personality not immune to the influence of Michelangelo. Indeed, it appears to be a clear and obvious work of the Mannerist school, which does not exclude a master such as Jacopino del Conte. Such an attribution must be advanced with due caution, because the painting is a copy in which individual style is less evident due to the presence of a model.

Giovanni de' Medici (Florence, 1475 – Rome, 1521), second son of Lorenzo the Magnificent (so called for the splendor of his reign and his refined patronage of the arts), was able to leave his mark on an era, so much so that his papacy recalls an entire century. He was created Cardinal by Innocent VIII in 1488 at only thirteen years of age, on the condition that the nomination was kept secret for three years, during which he dedicated himself to the study of theology and canon law, building upon a solid foundation of humanistic education acquired at his father's court under the guidance of Bibbiena and Poliziano. It was not a coincidence that he had himself depicted in Raphael's portrait holding a lens to an illuminated manuscript, to reflect his interests as a bibliophile.

After his family's temporary fall into disgrace, he took educational trips throughout Europe. He was elected Pope on March 11, 1513 and celebrated the event with various festivities, including a parade of wild beasts and jesters led by a white elephant, at the enormous cost of one hundred thousand *scudi.** Leo X is remembered for the infamous sale of indulgences and for the excommunication of Martin Luther on January 3, 1521, after the German monk had posted his thesis on indulgences at Wittenberg. Profoundly affected by Raphael's death in April 1520, Leo died in December of the following year, with Christian Europe already on the road to schism. (L. von Pastor, vol. IV, 1926).

Francesco Petrucci

1) See M. Pomponi, sheet 1, in O. Calabrese, C. Strinati, 2003, p. 154; M. C. Guardata, in R. Morselli, R.Vodret, 2004. About Vasari see P. Barocchi, *Vasari Pittore*, Firenze 1964, p. 92
2) See F. Petrucci, 2004b, pp. 24, 42 note 7; S. Guarino, in M. E. Tittoni, F. Buranelli, F. Petrucci, 2004, p. 52
 On Jacopino, See F. Zeri, 1957; I. Cheney, 1970; idem, 1996; A. Vannugli, 1998

TRANSLATOR'S NOTE: A *SCUDO* (PL. *SCUDI*) WAS THE MONETARY UNIT IN USE AT THE TIME IN FLORENCE

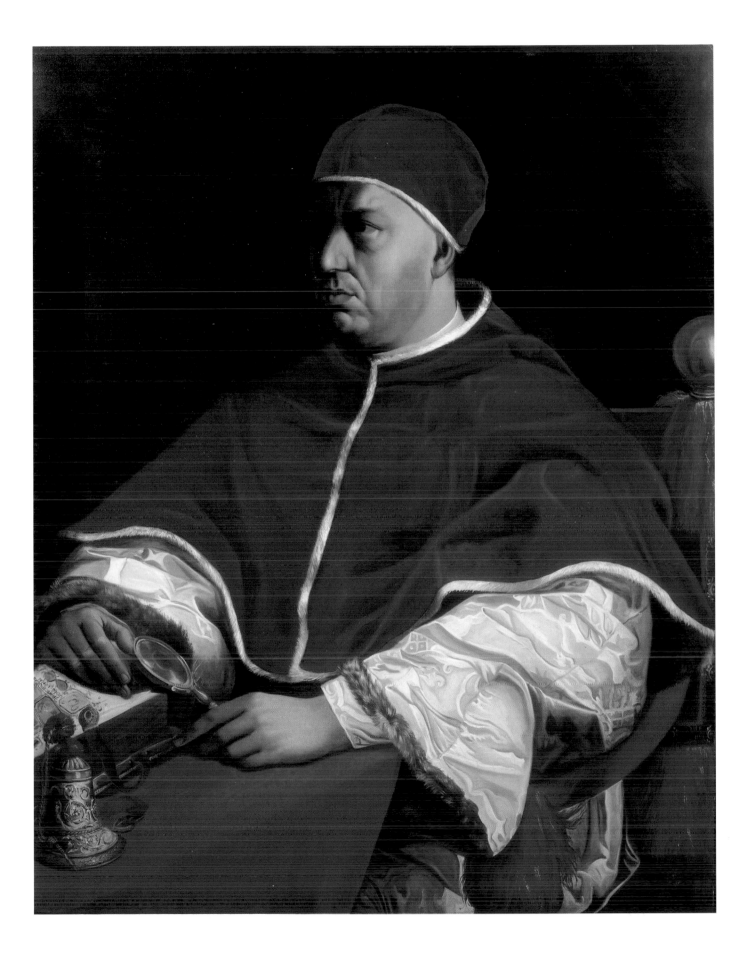

Sebastiano Luciani, called "Sebastiano del Piombo"
(Venice 1485 – Rome 1547)

Portrait of Clement VII (Giulio de' Medici, 1523-1534)
oil on slate, 105.4 x 87.6 cm.
Los Angeles, The John Paul Getty Museum

Bibliography: *Acquisitions/ 1992*, in "The J. Paul Getty Museum Journal", 21, 1993, p. 116, no. 2; B. B. Fredericksen, D. Jaffé, D. Allen, D. Carr, P. Stein, 1995, no. 9; P. Mould, 1995, pp. 72-74, fig. 19-20; D. Carr, in *Masterpieces...*, 1997, p. 30, no. 13; Bonn, 2000, p. 234; A. Kirsh, R. S. Levenson, 2000, p. 58, if. 61, n. 63; C. Dawson, in S. Ferino-Pagden, 1997, pp. 98-102, no. I.38

The portrait, which comes from the collection of Sir Robert Henry Herbert, twelfth Earl of Pembroke, was sold on June 1st, 1861 with other works from that collection at a Christie's auction held at London (lot no. 69). Passing through the antiques market, it was purchased by the Getty at Agnew's in London in 1992.

Sebastiano del Piombo, a student of Giovanni Bellini and Giorgione, came to Rome in 1511, working for the banker Agostino Chigi in the decoration of the Villa Chigi alla Lungara, in close contact with Raphael; but he was especially subject to Michelangelo's influence, executing works according to that master's drawings. After Raphael's death, he became a leading figure in the papal city. He was a great portraitist, executing pictures of members of the Doria, Medici, Farnese and Gonzaga families.

The painter depicted Clement VII several times: from the painting at the National Museum of Capodimonte in Naples, which shows the Pope clean-shaven with face turned to the left, to the panel at the Parma National Gallery of Ancient Art that portrays him in the act of benediction, seated before a table with a youth next to him; to the head, sketched in profile, again at the Capodimonte Museum, which seems to have a close relationship to the Getty Museum's slate. The American portrait, derived from this last image of the face, presents characteristics of a more official nature than the preceding versions, with the Pope enthroned according to a scheme derived from Raphael's *Julius II*. The artist introduces the variation of memoirs in the Pope's right hand in place of the handkerchief, and drapes the background; the Pope is not looking down pensively, but is gazing far away toward distant horizons. Luciani thus codifies a scheme, in a courtly and very dignified image, which would later meet with great success. The rigid and mechanical method of representing the hands, almost robotic, would also be copied by many imitators.

A version with the same composition, but painted in a loose, Titianesque style, is conserved at the Kunsthistorisches Museum of Vienna (Oil on canvas, cm. 92 x 74). (1) The Vienna portrait is cut off on the left side; the drapery is absent and the Medici coat of arms appears in the upper right. The *mozzetta* and the *camauro* are rendered in earthy tones.

A similar portrait was tendered by the artist in a British Museum drawing depicting the Pope with Emperor Charles V, while a poorly preserved version in the Spada Gallery seems to be a workshop copy limited to a half-figure. (F. Zeri, 1954, no. 391). In a letter dated July 22, 1531 Sebastiano tells Michelangelo that the Pope visited his workshop to see his new portrait on canvas, perhaps a first version of this painting on slate, a medium that the artist began to adopt around 1530.

Giulio de' Medici (Florence 1478 – Rome 1534) had a brilliant career, aided by his cousin, Leo X: after being named archbishop and later governor of Florence, he became a Cardinal in 1513. He was noted for his diplomatic abilities and the rigor of his character, which led him to be elected Pope in November 1523 with the name of Clement VII. His was a difficult papacy, aimed at thwarting the hegemonic ambitions of the Hapsburg leader Charles V and Francis I of France, with whom he allied himself in 1526 forming the Holy League known as the "Cognac League." One consequence was the devastating Sack of Rome of 1527, in which the city was put to the sword and to flame and the Pope had first to barricade himself in the Castel Sant'Angelo and then flee to Orvieto. Thus Clement was forced to crown Charles V Emperor in 1530 and in 1533 to celebrate the marriage of his niece Catherine de' Medici to Henry II of France. He distinguished himself as a patron of the arts, promoting the organization of the Vatican Library and the continuation of work on Saint Peter's Basilica. He is buried in the Church of Santa Maria sopra Minerva in a monument designed by Antonio da Sangallo and executed by Baccio Bandinelli and his workshop (L. von Pastor, IV, 1929).

Francesco Petrucci

1) See C. Dawson, in Vienna, 1997, pp. 98-102, no. I.38

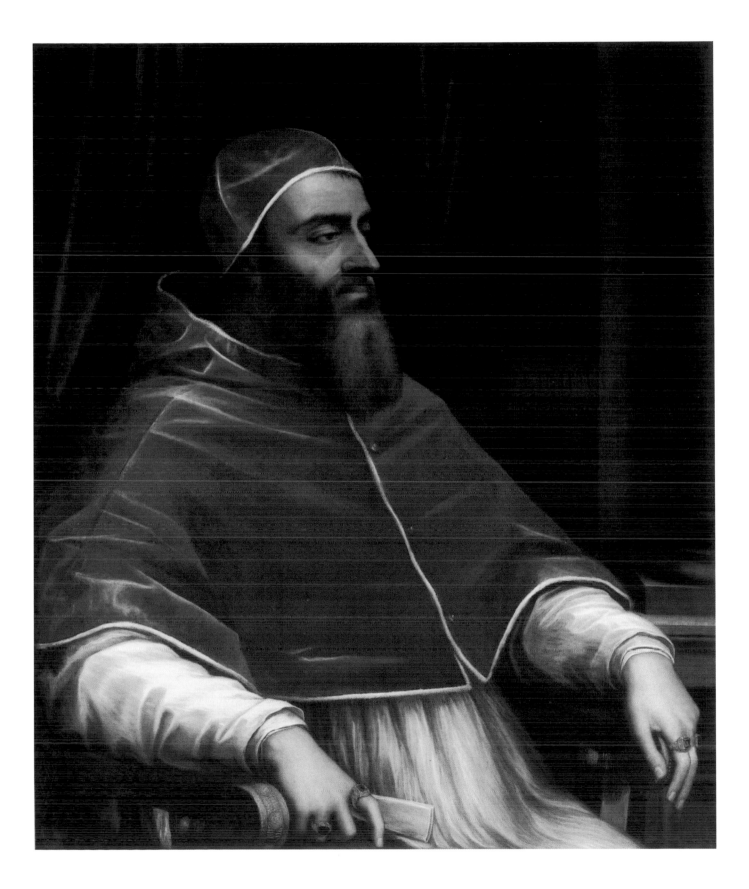

Anonymous, Copy after Titian

Portrait of Paul III (Alessandro Farnese, 1534-1549)
oil on canvas, 120 x 95 cm.
Rome, Vatican Museums

Bibliography: H. E. Wethey, 1971, no. 72; F. Petrucci, 2004b, p. 42, note 6

This canvas is a copy of the celebrated *Portrait of Paul III* painted by Titian, today at Naples in the Capodimonte Museum (106 x 85 cm.). That image, indisputably the official image of the Farnese papacy, is known to have numerous copies, among which, in addition to two in storage at the Vatican Museums, are those at the Spada Gallery, the Sabauda Galley at Turin, and the Pitti Palace; a copy is in storage at the Rome Gallery of Ancient Art, and another is in the Duke of Northumberland's collection at Alnwich House.

Titian's prototype was painted in 1543 and matches the canvas listed in Cardinal Farnese's Roman inventory of 1568, recalled by Vasari: "The year that Pope Paul III went to Bologna, and thence to Ferrara, Titian went to the court and made a portrait of said Pope; which was a very beautiful work." Aretino wrote to the painter about the Pope's enthusiasm for the portrait, praising "how alive it is, how it resembles him and how real it is." Indeed, this is the most informal and private image of a Pope produced until that time: Titian, while deriving the composition from Raphael's prototype of Julius II, presents the Pope curved under the weight of years, without the *camauro*, and meeting the viewer's gaze rather than looking into the distance or elsewhere. The painting is remarkable for its free execution and capacity for introspection, rendered by its intense expression. The portrait is the first of the paintings executed by the Venetian master for the Pope, including the version with the *camauro* and with his nephews close to him, also in the Capodimonte Museum. (1) Alessandro Farnese (1468-1549), created Cardinal by Alexander VI in 1493, was elected Pope on October 13, 1534, taking the name of Paul III. He continued the arduous work of mediating between Francis I and Emperor Charles V; he excommunicated Henry VIII of England; authorized the Jesuit Order; and opened the Counter-Reformation with the convocation of the Council of Trent. He was a patron of Michelangelo, who became Architect of the *Reverenda Fabbrica di San Pietro** and whose *Last Judgment* was completed during Paul's pontificate; the Pope also commissioned Michelangelo's last frescoes for the Pauline Chapel in the Vatican. He died on November 10, 1549, after a fifteen-year papacy. (L. von Pastor, vol. V, 1931).

Francesco Petrucci

1) See H. E. Wethey, 1971, pp. 28-29, 122, no. 72; sheet 34, in Venice, 1990, p. 246

TRANSLATOR'S NOTE: THE *REVERENDA FABBRICA* DI SAN PIETRO IS THE VATICAN AGENCY RESPONSIBLE FOR THE CONSTRUCTION OF SAINT PETER'S BASILICA; THE NAME IS NOT TRANSLATED INTO ENGLISH, GENERALLY, IT IS REFERRED TO SIMPLY AS "THE *FABBRICA*"

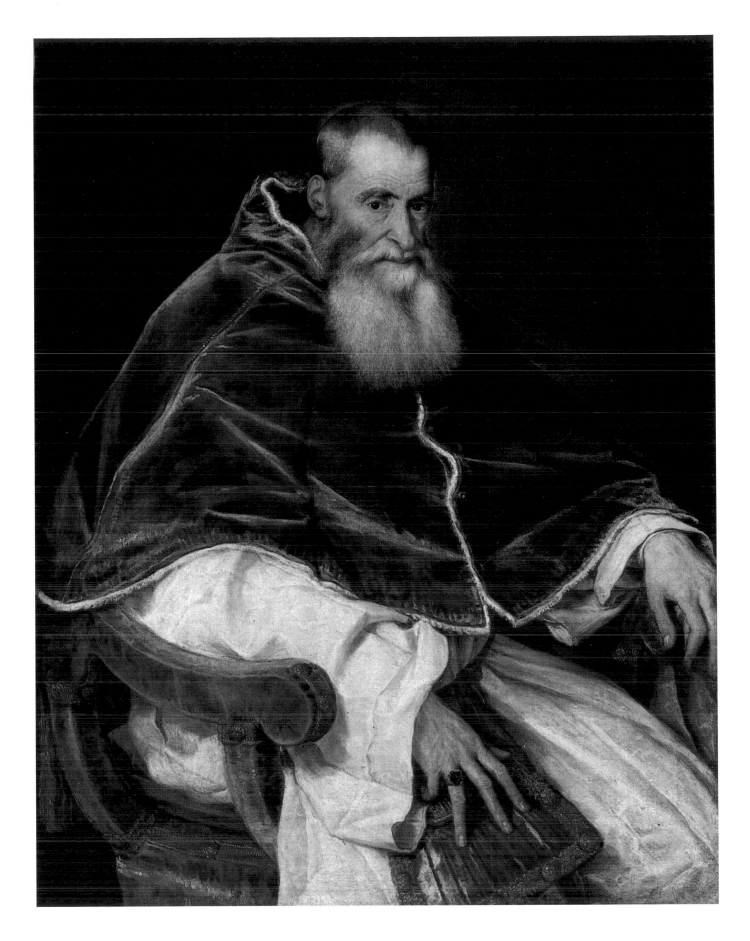

Titian. Portrait of Paul III. Naples, Museo Nazionale di Capodimonte

Attributed to Siciolante da Sermoneta
(Sermoneta 1521 – Rome 1580)

Portrait of Julius III (Giovanni Maria Ciocchi del Monte, 1550-1555)
detached fresco on masonite support, 90 x 64.3 cm.
Rome, Spada Gallery

Bibliography: X. Barbier de Montault, 1870, 26, p. 441; F. Hermanin, 1925, 67, no. 40; A. Porcella, 1931, 82, p. 169; L. Carmassi, 1932, 90, p. 488; E. Lavagnino, 1933, 93, pp. 6, 13; F. Zeri, 1954, p. 116, no. 40; M. L. Vicini, 1998, pp. 50, 51 fig.

This portrait is listed in the 1759 Spada inventory as "a painting of 4 *palmi* and 5 in feet... representing Julius III, in poor condition, work by Titian, 40 *scudi*." Attributed to Scipione Pulzone by Barbier de Montault, with confirmations from Hermanin, Porcella, Carmassi and Lavagnino, it was published by Zeri as "Seventeenth century Roman School."
The painting acquired its current form between 1910 and 1925 with the removal of its painted oval frame. Zeri notes stylistic relationships with such painters as Jacopino del Conte, Marcello Venusti and Gerolamo Siciolante, without making a judgment on attribution. According to the Roman scholar, the fresco perhaps was originally located on a wall of the old Spada Palace, executed by the Apostolic Chamber during the papacy of Julius III.
Without a doubt it is a portrait of remarkable quality, characterized by its classical elegance and simultaneously by a strong naturalistic impulse in the rendering of the figure, worthy of an expert. The rendering of the light effect on the satin cloth and in the *mozzetta's* folds is original and assured; it is almost a precedent for successive works of the Roman school for the clear construction of its design. The painting offers a synthesis between the styles of Raphael and the Venetian school as interpreted by Sebastiano del Piombo; nevertheless it is not unrelated to the approach of Michelangelo and the Mannerists, which brings it closer to Jacopino and Venusti. It seems feasible to propose an attribution to Siciolante da Sermoneta, a portraitist who first trained in the workshop of Leonardo da Pistoia and later in that of Perin del Vaga; they were students of Raphael, but Siciolante's work also reveals his sensitivity to the Venetian school and to Titian, evident in both style and composition. Siciolante was, moreover, a worthy fresco artist. The attribution to him is shared by Antonio Vannugli, who is undertaking monograph studies on Jacopino and Pulzone. (1)
Giovanni Maria Ciocchi del Monte (1487-1555), bishop of Manfredonia and Pavia, governor of Rome, auditor general of the Tribunal of the Apostolic Chamber, and governor of Bologna and Romagna, was created Cardinal by Paul III at the 1536 concistory. He participated actively in the preparation and execution of the Council of Trent, as a legate and as president of the sessions. He was elected Pope in February 1550 after a long conclave, choosing the name of Julius III. His papacy's activities were principally linked to matters relative to the Counterreformation, pursuing a political balance between France and the Holy Roman Empire. He died on March 23, 1555. His artistic patronage was primarily focused on the execution of his family's villa, designed by Vignola (L. von Pastor, vol. VI, 1927).

Francesco Petrucci

1) J. Hunter, 1983; idem, 1996

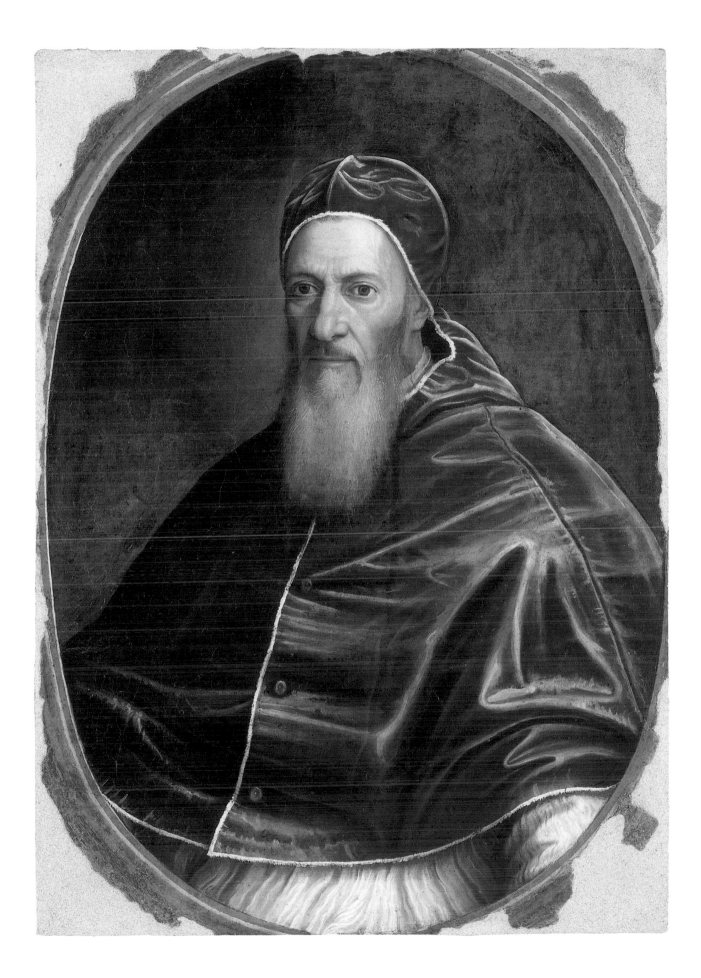

Anonymous seventeenth century painter

Portrait of Marcellus II (Marcello Cervini, 1555)
oil on canvas, 123 x 91.5 cm.
Vatican City, Vatican Museums, inv. MV 41199

Bibliography: F. Petrucci, 2004b, pp. 24, 42 note 8, fig. 8

This picture employs compositional elements derived from previous papal portraits starting with Raphael's *Julius II*, whose pose the artist used here, a seated Pope with his right side facing the viewer, but without a *camauro* as in Titian's *Paul III*, and with the innovation of the right hand extended in an offering gesture in the manner of the Venetian master's portraiture. The robe wrinkles at the point of contact with the arm of the papal throne, as in Sebastiano del Piombo's papal portraits, whose work is recalled also by a certain rigidity and mechanical quality in the hands.

Portraits of Marcellus II are very rare, due principally to the briefness of his papacy. A portrait of him as a Cardinal, in which only the face relates to the papal portrait, is located at the Vatican's Apostolic Library, of which Cervini was the Librarian. This portrait appears to be posthumous, perhaps even dating from seventeenth century. (1)

According to Vannugli, the present picture would derive from a lost original by Jacopino del Conte. It is certainly a posthumous work, probably derived from an earlier Cardinal portrait, as due to his shy nature and the brevity of his reign this Pope was surely unable to pose for a portrait.

Marcello Cervini (1501-1555) was born at Montepulciano near Siena. He was Secretary of State and held the presidency of the Council of Trent. A man of great moral integrity and spiritual rigor, he was elected Pope by acclamation after a swift conclave on April 9, 1555. Resolving to remain true to himself and to continue as Pope the work he had begun as a Cardinal, he retained his own baptismal name. The celebration following his election was extremely simple, as he had ordered that the sums allocated by the Curia for this event be donated to the poor. The great expectations resting on him for the moralization of the papal court were disappointed by his sudden death, only twenty days after his nomination, perhaps due to apoplexy. In his honor, the great musician Giovanni Pierluigi da Palestrina composed one of his happiest compositions, the *Missa Papae Marcelli* (L. von Pastor, vol. VI, 1927).

Francesco Petrucci

1) See B. Jatta, 2005

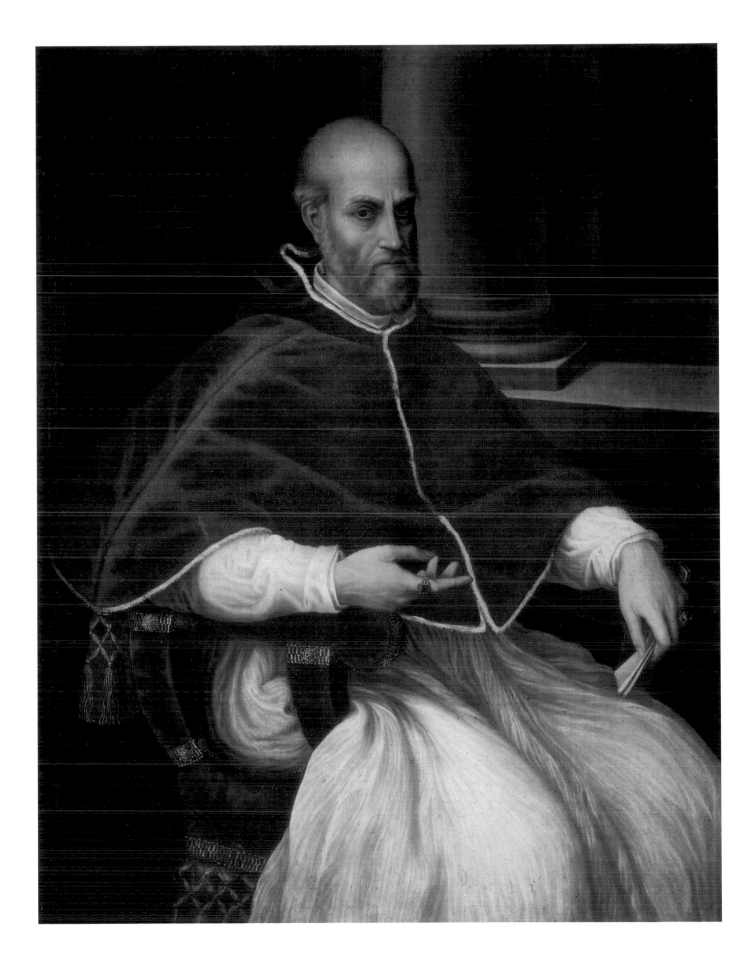

Anonymous seventeenth century sculptor

Bust of Paul IV (Giovanni Carafa, 1555-1559)
bronze
Vatican City, St. Peter's Basilica, Vatican Sacristy

Bibliography: L. von Pastor, vol. VI, 1927, p. 347, note 1; F. Petrucci, 2004b, p. 42 note 8

As a consequence of the *damnatio memoriae* of Paul IV, sadly remembered for the creation of Rome's Jewish Ghetto and for his excessive intransigence, images of this Pope are extremely rare despite his almost five-year reign. Extant portraits include a bronze bust in the Vatican Sacristy; the head of a statue erected in his honor on the Capitoline Hill in Rome, later demolished, that was exhibited at the *Papal Portraits Exhibition* held at Rome in 1950-51 and is today at the Museum of Castel Sant'Angelo; and an engraving by Niccolò Beatrizet: everything else was destroyed or lost. The fragment of the head from the honorary statue (inv. no. 26/IV, marble, 25 x 40 x 45 cm.), executed by Vincenzo de' Rossi around 1558, was recovered from the Tiber river near Castel Sant'Angelo. It portrays the Pope with a beard and the papal tiara. (1)

Giovanni Carafa (1476-1559) was born at Benevento to a noble family. He was papal ambassador to England and Spain before undertaking a brilliant ecclesiastical career. Having joined the Theatine Order, he was created Cardinal by Paul III in December 1536; he distinguished himself as a principal figure of the Counterreformation, participating in the committee for revision of the papal court and assuming a leading role in the organization of the Inquisition in Italy.

Despite Charles V's strong opposition, Carafa was elected Pope in 1555 after the extremely brief papacy of Marcellus II. Aligning himself with France against Spain and England, he exercised a strong nationalistic policy. His excessive rigor and willingness to reform the Church's customs made him unpopular with the Curia, leading him to imprison several cardinals. In 1555, with the papal bull *"Cum nimis absurdum"* he created the Ghetto of Rome, to which Jews were relegated and forced to live in isolation. Pius IX ordered its gates opened and its walls demolished, but only in 1870 with the unification of Italy was the Ghetto suppressed and, finally, completely demolished in 1885. Paul IV died in Rome on August 18, 1559 and was provisionally buried in Saint Peter's. His body was later transferred to the Carafa Chapel in the church of Santa Maria sopra Minerva, to a tomb designed by Pirro Ligorio (L. von Pastor, vol. VI, 1927).

Francesco Petrucci

1) See Various Authors, 1950, p. 17; F. Petrucci, 2004b, p. 42 note 8

Circle of Titian, circa 1560

Portrait of Pius IV (Giovanni de' Medici, 1560-1565)
oil on canvas, 104 x 79 cm.
Cantalupo in Sabina, Camuccini collection

Bibliography: F. Petrucci, 2004b, pp. 24-25, fig. 9

This portrait constitutes the official image of Pius IV's papacy, as demonstrated by the existence of copies derived from it, including the panel from the Vatican Museums displayed at the *Papal Portraiture* exhibition held at the Braschi Palace in Rome in 2004.

The canvas entered the papal collections in 1871 as a gift to Pius IX. Its attribution to Jacopino del Conte, recorded in the registry of the Vatican Museums, was accepted by De Vita in 1991. Vannugli at first supported this attribution (1998), and later rejected it with reference to the painting's pictorial characteristics (2004). (1)

The Roman scholar notes different portraits of the Pontiff, all more or less connected to an identical image proposed to derive from a lost work by Jacopino del Conte; according to Vasari, the Tuscan artist had painted portraits "from Pope Paul III to the present, of all the Popes that have existed."

This hypothesis was called into question by the rediscovery of this portrait, which has all the characteristics of a prototype. The painting has obvious Titianesque and Venetian features, demonstrated by its technical and compositional characteristics (a painterly, expressive style, in which form is constructed with color rather than with line). Titian's prototype of Paul III provides the Mannerist technique of lengthening and greatly enlarging the figure, the method of highlighting the *mozzetta* (including the reproposition of some details in its folds), the Pope's sidelong glance towards the viewer, and the identical shape of the papal throne. Reference is made instead to Raphael's portrait of Julius II, from which derives the composition of almost all sixteenth century papal portraits, with the right hand holding a handkerchief and the left gripping the end of the chair's arm.

Among portraits of Pius IV, Vannugli cites: the panel by Cristoforo dell'Altissimo in the Uffizi's Jovian series (S. Meloni Trkulja, 1979, p. 650, no. Ic373); the canvas by Pasquale Cati in the Altemps Chapel in the Church of Saint Cecilia in Trastevere (C. Strinati, 1998, pp. 121, 124-126, 145 fig. 25); the three-quarter portrait in the Pinacoteca Ambrosiana of Milan (A. Haidecher, 1965, p. 407); the full figure portrait in the Luigi Hardouin collection at Gallese attributed to Ottavio Leoni (P. Petraroia in *Palazzo Altemps*, 1987, pp. 253 fig. 381, 300); the oval counterpart in the Pinacoteca Capitolina (R. Bruno, 1978, p. 97 no. 2359); the seventeenth-century canvas in the Church of the Annunciation at Milan's Ospedale Maggiore (M. Oliva, 1985); the mosaic portrait in San Paolo fuori le Mura; one in the Collegio Borromeo at Pavia; and one at the Zapucky Castle in Bohemia.

Giovanni Luigi Angelo de' Medici (1499-1565) was born in Milan, son of the notary Bernardo de' Medici and Cecilia Serbelloni. After his law studies, he dedicated himself to a career in the Church, becoming Apostolic Protonotary and Commissioner of Rome, Bishop of Ragusa, Commissioner of the Smalcadica League, and Cardinal in 1549. In opposition to Pope Paul IV for his anti-Spanish policy, he was named Pope on Christmas night 1559 after a controversial conclave that lasted a good four months, taking the name Pius IV in reference to the gentleness that he wished to inspire his actions.

His papacy was oriented towards diplomacy, and he was able to re-establish good relations with the reigning European houses and mitigate the actions of the Inquisition. He opened proceedings against the nephews of Paul IV Carafa, who were arrested in 1560 and condemned to death; these included Cardinal Carlo Carafa, who was executed at Castel Sant'Angelo. He protected his nephew and confidant Charles Borromeo, whom he named Cardinal and Archbishop of Milan, and who distinguished himself for his noble moral and humane gifts. Pius reopened and concluded the Council of Trent (1562-1563). He employed several artists, among them Giovanni da Udine, Daniele da Volterra, and Pirro Ligorio, who designed the Casino of Pius IV in the Vatican gardens. Michelangelo designed the Porta Pia, his last architectural work, for Pius IV, and transformed part of the Baths of Diocletian into the Church of Santa Maria degli Angeli. (L. von Pastor, vol. VII, 1928)

Francesco Petrucci

1) See C. De Vita, 1991, pp. 308, 310 fig.; A. Vannugli, 1998, p. 601; idem, in *Papi in posa...*, 2004, p. 58

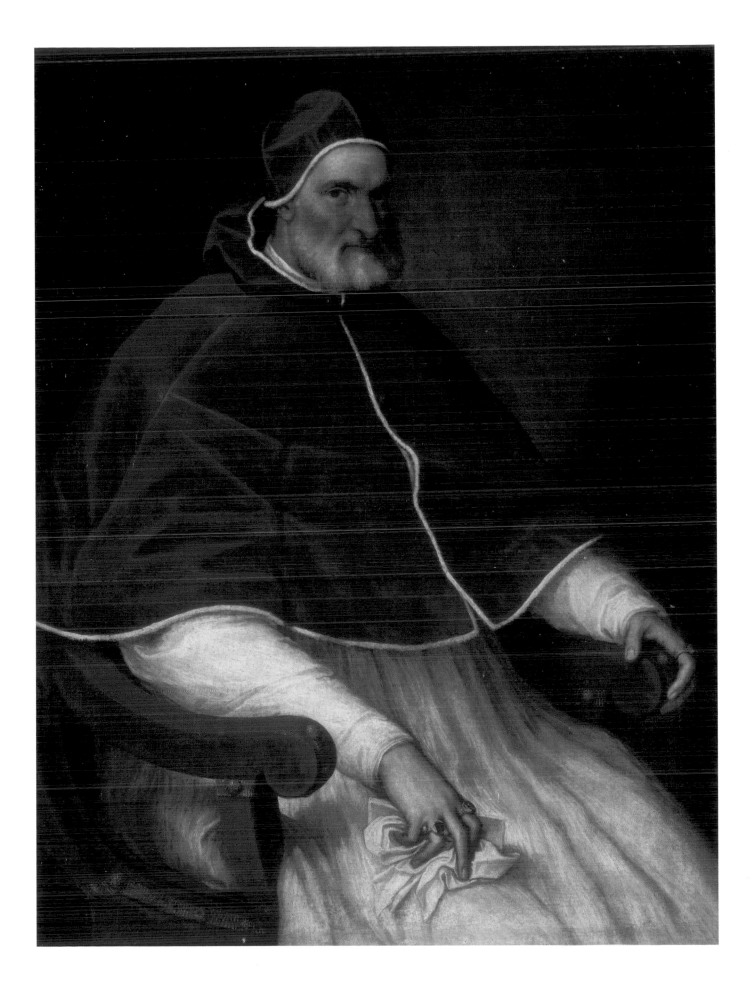

Bartolomeo Passerotti
(Bologna 1529-1592)

Portrait of Pius V (Michele Ghislieri, 1566-1572)
oil on canvas, 129 x 94.5 cm.
Baltimore, Walters Art Gallery

Bibliography: F. Zeri, 1976, vol. II, no. 258, p. 382; A. Ghirardi, 1990, no. 5, pp. 152-154

This portrait originates from the Prince Ercolani Gallery at Bologna where it was recorded in 1780 by J. Calvi; it passed into the collection of Don Marcello Massarenti at Rome, from which it was acquired by Mr. Henry Walters in 1902 together with other works from that collection. Charles Sterling attributed the painting to Bartolomeo Passerotti in a 1939 letter. It was published with this attribution by Federico Zeri in the catalog of the Walters Art Gallery and included in the monograph on the artist by Angela Ghirardi.

The Ghislieri coat of arms is present on the back of the papal throne. The horizontal inscription below contains errors and is a later addition.

Passerotti's biographer, Raffaello Borghini (*Il Riposo*, Florence 1584, p. 566) mentions the papal portrait painted by the artist, identified in the literature as the American canvas, for which a date of 1566 is proposed. In fact, the historian says that Passerotti executed the portrait of the Pope after leaving Taddeo Zuccari, when his brother Federico Zuccari returned to Rome in January 1566 after having worked in Florence throughout 1565. Moreover, Passerotti returned to Bologna the same year; therefore, as Zeri argues, it appears that the portrait must have been executed immediately after the papal election that occurred on January 6, 1566. Zeri underlined the relationship of this painting to works by Titian and Jacopino del Conte, but also noted the stylistic elements that characterize Passerotti's painting.

In the *Portrait of Pius V* the Bolognese painter introduces some significant variations on previous schemes for papal portraiture, all linked to the archetype of Raphael's *Julius II*: firstly, the Pope shows his left side and not his right, as was customary; secondly, Passerotti introduces the blessing gesture of the right arm on the model of the statue of Saint Peter in the Vatican Basilica and the iconography of the *Salvator Mundi*; thirdly, for the first time, the Gospels are included as a symbol of the Pope's spirituality and as a guide for his political actions. Of course, the presence of the raised arm required a reversal of the figure, to avoid having the arm cover the Pope's face. From this image derive several successive papal portraits showing the Pope in the act of benediction.

For the Pope's biography, see the datasheet of the portrait by Giulio Clovio.

Francesco Petrucci

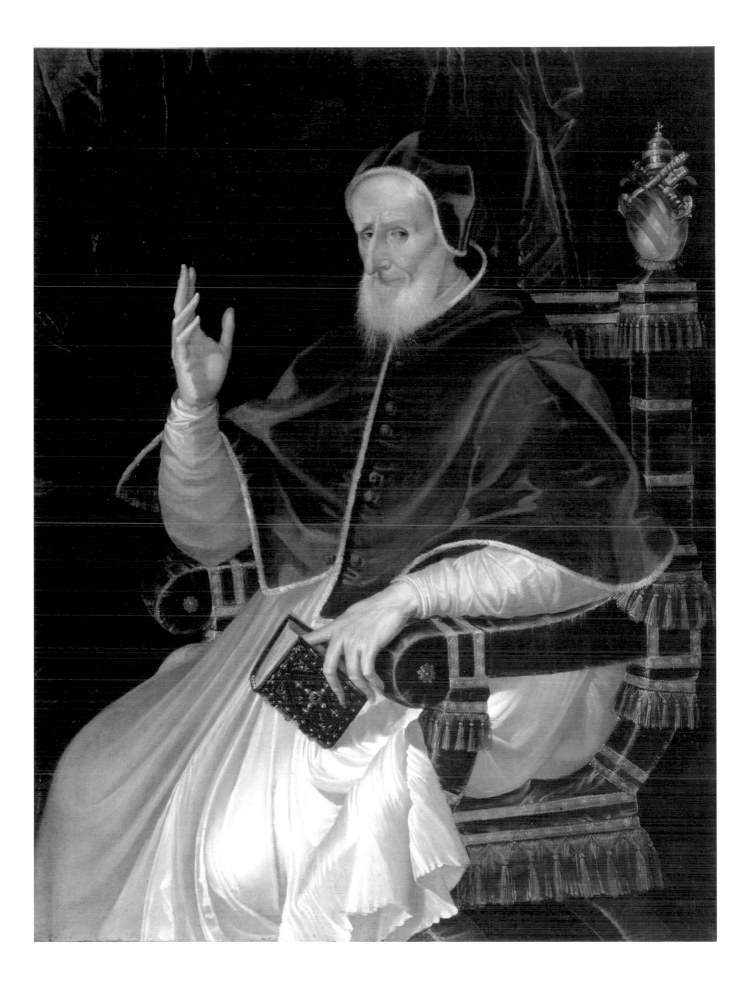

Bartolomeo Passerotti
(Bologna 1529-1592)

Portrait of Pius V (Michele Ghislieri, 1566-1572)
oil on canvas, 56 x 42 cm.
Rome, private collection

Bibliography: unpublished

Originally from a Bolognese collection, this oval portrait recently entered a private collection in Rome. The frame bears an inscription, perhaps from the nineteenth century: "Previously in the Palace at Bologna".

The very high quality of the painting is revealed in the softness and sensitivity of the flesh tones, in the nimble, sure brushstrokes of the *mozzetta*, and in the meticulous depiction of the beard. The face is clearly connected to a canvas in the Walters Art Gallery of Baltimore, and it may be a precursor of that work, with the borrowing limited to the face for its extremely high quality. (F. Zeri, 1976, vol. II, no. 258, p. 382; A. Ghirardi, 1990, no. 5, pp. 152-154). Indeed it was customary for portraitists to paint only the model's face from life and complete the figure later in the studio. If such were the case here the Baltimore canvas would be the official version, for which this work was perhaps the first live sitting or possibly a contemporary replica.

Zeri noted a composition identical to the Baltimore painting in the Marignoli collection at Spoleto in 1971: he was undecided whether to classify it as a replica or a workshop copy, but recently I was able to verify that it no longer exists. As Ghirardi recalled, the eighteenth and nineteenth century sources cite numerous autograph versions of the painting, kept at Bologna, Rome and Modena, all lost, including the portrait mentioned by Adolfo Venturi (1933, p. 751) in the Pinacoteca of Bologna. The scholar published an autograph replica, limited solely to the face, kept at the Seminary of Modena (1990, p. 154, fig. 5a), which is closely related to the canvas under examination. I have reported numerous copies and derivations of Passerotti's prototype in the Vatican collections that demonstrate the absolute importance of this portrait, from which the visage of Pius V in Giulio Clovio's portrait of the Pope, today in the Koelliker collection, also derives. (1)

Passerotti's *Portrait of Pius V*, dour and pitiless in its realistically rendered figure and profound in its psychological and spiritual characterization, "reveals an ironic and grotesque mood, typical of some of Passerotti's work in these years" (Ghirardi). This was a turning point in the expressionist nature of papal portraiture, a genre previously characterized by a strong emphasis on idealism. For the biography of Pius V, see the sheet accompanying the portrait by Giulio Clovio.

Francesco Petrucci

1) See F. Petrucci, 2004b, p. 42, note 10; S. Marra, sheet in *Papi in posa...*, 2004, p. 60

Giulio Clovio
(1498 – Rome 1578)

Portrait of Pius V (Michele Ghislieri, 1566-1572)
oil on canvas, 112, x 84 cm
Milan, Koelliker collection
Inscriptions: Signed on the ring of the index finger of the right hand: MR CLOVIUS P

Bibliography: F. Moro, cat. entry in F. Caroli, 1998, p. 113; S. Marra, cat. no. 22 in Petrucci, 2004, p. 103;
id., in *Papi in posa…*, 2004, p. 60

This striking portrait focuses the attention of the viewer entirely on the figure of the elderly pontiff. It is without such incidental elements or conventional formulas as a curtain drawn to one side behind the sitter or a window opening onto a landscape; even the back of the chair, a structural detail that alludes to power while supporting and framing the shoulders of the enthroned Pope, is absent. Despite his advanced age and the haggard features of his withered face, the figure of the Holy Father retains an evident power, translated physically into the exaggerated dimensions of his shoulders and hands. His silhouette emerges from the surrounding shadow, revealed by a light that throws his face and hands into strong relief even as the outlines of his crimson *mozzetta* and the vaporous white of his pleated rochet dissolve into the background.

A soft glow, both literal and metaphorical, condenses around the head of the pontiff in reference to his sanctity. This explicit allusion to the Ghisleri Pope's future canonization might lead one to infer wrongly that the portrait is posthumous. According to papal historian Ludwig von Pastor, Pius V lived in the odor of sanctity and was already venerated by contemporaries: "…With his death there was a general feeling that a saint had abandoned this world…the inhabitants of [Rome] rushed by the thousands to be near the body lying in state in St. Peter's. Everyone sought to have as a precious relic something that had belonged to the deceased.…". The Pope's asceticism is suggested by his wrinkled hands, in the brittle hairs of his beard and in his gaunt face, its furrowed brow the legacy of time and mental activity. Nonetheless the sunken eyes preserve a certain gentleness, and the head is inclined almost imperceptibly in blessing. The composition of the portrait is indebted to the sixteenth century convention initiated by Raphael, and repeats the gesture of benediction found in Arnolfo di Cambio's statue of *Saint Peter*. The influence of Sebastiano del Piombo's *Portrait of Clement VII* (Capodimonte, Naples) is evident in the hand that holds the scroll.

The characteristic profile of Pius V, revealed here by the light that falls on him from an unseen source at the upper left, lent itself to easy reproduction. In addition to a wealth of oil portraits, including one by Passerotti (A. Ghirardi, 1990) that serves as a prototype for other paintings of Pius V, the Pope's appearance is recorded in copper engravings by Beatrizet, Niccolò Nelli, Filippo Soius, and one in Zenoi's *Images*. A medal by Giovan Antonio Rossi and a cameo, mentioned by Pastor and today in the Museo Cristiano in the Vatican, also confirm the pontiff's countenance. A marble bust of Pius V, formerly adorning the tomb of Cardinal Carpi in the church of Trinità dei Monti, has been lost.

Other sculpted portraits include a statue of the kneeling pontiff in the church of Santa Croce in Bosco Marengo, and the marble sculpture by Lionardo da Sarzana for Pius's tomb in Santa Maria Maggiore, which depicts the Pope enthroned (1).

Giulio Clovio is the Italianized name of Jure Glovocic, who came to Italy from Croatia in the first quarter of the sixteenth century. He moved to Venice and Mantua before settling in Rome in 1560, a guest of his illustrious patron Cardinal Alessandro Farnese. He was a prolific miniaturist who enjoyed great fame in his own lifetime and maintained important friendships with Giulio Romano and El Greco, whose portrait of Clovio is now in the Capodimonte Museum in Naples.

Pius V (1566-1572), born Michele Ghislieri, conducted his ecclesiastic career with modesty and great religious fervor. He took the Dominican habit while very young and devoted himself to teaching. With the advent of heresies north of the Alps, he was named Grand Inquisitor General and continued an extremely harsh campaign, fruitful in its achievements and initiatives, to eradicate heresy during his papacy. He oversaw the application of the decrees of the Council of Trent, published the Roman Catechism, established the unified Roman Liturgy, and was an enlightened man and a merciful pontiff. Profoundly devoted to Mary, he instituted the Feast of the Rosary. He was an ardent sponsor of the celebrated Battle of Lepanto, in which Christian forces defeated the Turks in 1571. He was canonized on May 22, 1712 by Pope Clement XI.

Susanna Marra

1) L. von Pastor, 1929, vol. VIII . For more information on the iconography of Pius V, see the essay by F. Petrucci in the catalogue

Scipione Pulzone
(Gaeta 1550 – Rome 1598)

Portrait of Gregory XIII (Ugo Boncompagni, 1572-1585)
oil on canvas, 136 x 112 cm.
Frascati, Villa Sora

Bibliography: M. B. Guerrieri Borsoi, 2000, pp. 128-129, fig. p. 49

Maria Barbara Guerrieri Borsoi published this portrait in her book on Villa Sora at Frascati. It probably is an autograph replica of Pulzone's original oil portrait on panel, previously in the Boncompagni Ludovisi collection and displayed at the *Exhibition of Papal Portraits* held at Palazzo Venezia in 1950-51 (p. 19). The attribution was acknowledged by Antonio Vannugli, whose monograph on the painter from Gaeta is forthcoming. The Pope is holding a letter inscribed: "to His Holiness Gregory XIII". The dragon of the House of Boncompagni appears on the rivets of the throne.

The seventeenth-century artist biographer Giovanni Baglione praised Pulzone's canvas, noting: "he made an exquisite portrait of Pope Gregory XIII, reproduced from life with masterly skill." Not by Pulzone, although it approaches the painter's style, is another important portrait of the Boncompagni Pope, known through various replicas including a canvas exhibited at the Ariccia exhibit *The Faces of Power*, in which the Pope is bestowing a blessing (both are displayed in this exposition). That canvas and a half-figure replica of it formerly in the Boncompagni Ludovisi collection have been attributed to Pulzone's foremost pupil, the painter Pietro Fachetti of Mantua. (1)

A bust-length portrait in the *Papal Portraiture* exhibition, attributed by Emilio Negro to Ludovico Carracci, also derives from Pulzone's portrait. The Carracci picture is documented by a nineteenth century print published by Pietro Litta (1836, XXXV, tab. XXXV), who attributed it to the Bolognese painter.

As was his custom, Pulzone created the artifice of a portrait canvas within the present painting, highlighted by the drapery hanging to one side, a fiction within a fiction that anticipated the illusionism of the Baroque. The unusual composition, with the Pope seated facing left, was employed also by Passerotti in his portrait of Pius V. The present example highlights the letter in the Pope's left hand.

Ugo Boncompagni (1502-1595) was born at Bologna and elected Pope in 1572, taking the name of Gregory XIII. His thirteen-year papacy was fruitful for the Church. This Pope is known for the reformed calendar he defined as "Gregorian" (the previous calendar, known as the "Julian" calendar, had erroneous calculations that caused it to lag behind the solar year count); he supported Counter-Reformation policy throughout Europe through the application of the principles established by the Council of Trent; he promoted the doctrinal and theological codification of Catholicism, and led a push for missions to the Orient (L. von Pastor, vol. IX, 1929).

Francesco Petrucci

1) See F. Petrucci, 2004b, p. 26, fig. 14, 15

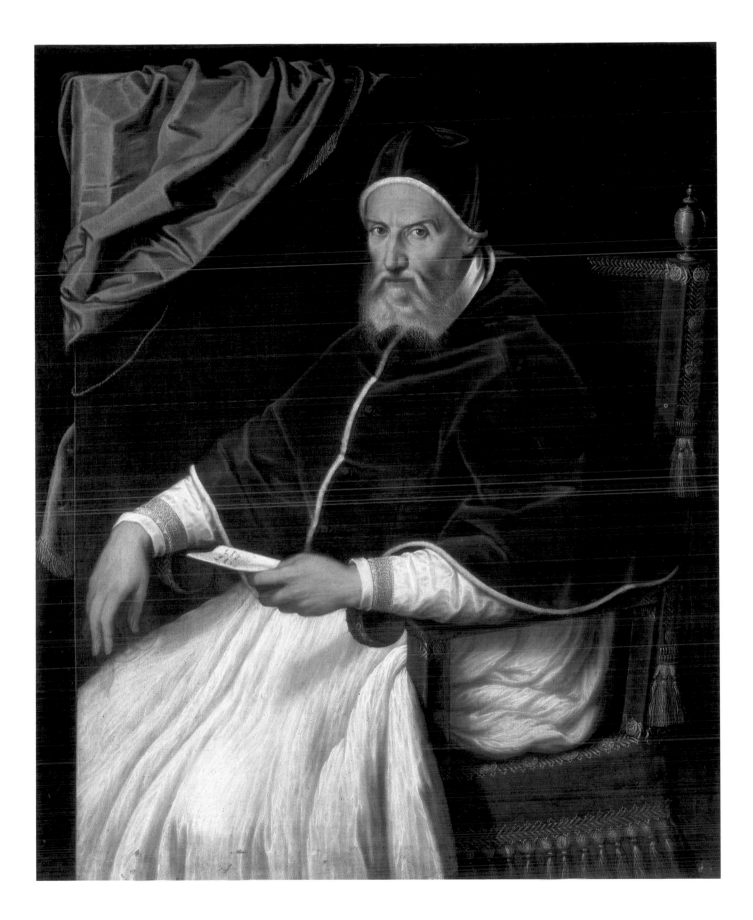

Attributed to Pietro Fachetti
(Mantua 1541 – Rome 1619)

Portrait of Gregory XIII (Ugo Boncompagni, 1572-1585)
oil on canvas, 140 x 107 cm.
Rome, private collection

Bibliography: A. Borromeo, J. Martinez Cuesta, sheet 235, in Various Authors, 1998, pp. 191, 513; A. Bacchi, S. Tumidei, 2002, p. 168; S. Marra, sheet 24, in F. Petrucci, 2004, pp. 104-105

The traditional attribution of this painting to Scipione Pulzone was reconfirmed in recent bibliography on the painting. Antonio Vannugli, whose monograph on the painter is forthcoming, rejects this attribution. The emergence of Pulzone's true portrait, recently published by Guerrieri Borsoi (2000) and displayed in the exhibit, affirms the need to reevaluate the present work. In my critical essay for the *Papal Portraits* exhibition catalogue, I proposed that the painting and its derivations be attributed to Fachetti, foremost student of the master from Gaeta.

According to Lorenzo Sabatini, the only painters who had the privilege of portraying Gregory XIII from life were he and Bartolomeo Passerotti. This statement is contradicted by the emergence of several other papal portraits, among them one by Scipione Pulzone that the artist's biographer Baglione underlined was "taken from life with masterly skill," and the portrait in the exhibition with its replicas. Although the painting demonstrates contact with the work of Federico Zuccari, its clear descent from Pulzone, Northern Italian pictorialism and Venetian culture make the new theory plausible. In particular, the painting is similar to a portrait of Sixtus V in a Roman private collection (F. Petrucci, 2004, p. 27, fig. 17) and to the portrait of Urban VII in the Koelliker collection; the previous attribution of the latter to Pulzone must be reviewed, as suggested by Vannugli and as confirmed by the undersigned. This is a group of stylistically homogenous portraits, very close to Pulzone's manner but executed by other hands. Therefore the Fachetti hypothesis seems to be the most convincing at this time, supported by Baglione's assertion: "He came to Rome as a youth, in the time of Gregory XIII, and he dedicated himself to portraiture; indeed in that genre of painting he was very worthy; and he did paint some portraits, which were worthy of being compared to those by Scipione of Gaeta". (1)

Francesco Petrucci

1) See G. Baglione, 1642, p. 127

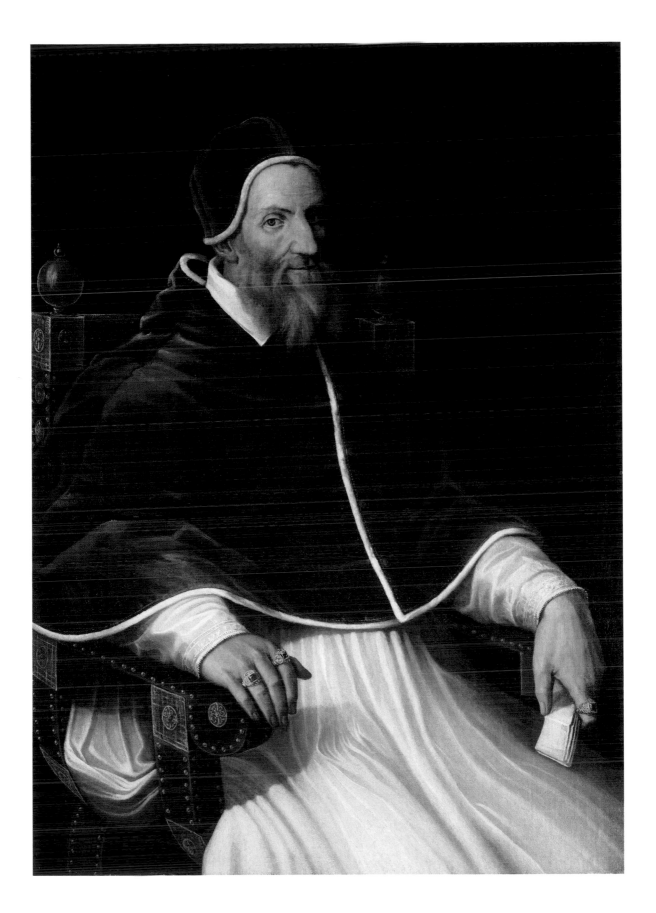

Attributed to Pietro Fachetti
(Mantua 1541 – Rome 1619)

Portrait of Gregory XIII (Ugo Boncompagni, 1572-1585)
oil on canvas, 50 x 40 cm.
Rome, private collection

Bibliography: F. Petrucci, 2004b, p. 26, fig. 15

The face in this half-figure portrait is derived from a larger painting of Gregory XIII seated in a three-quarter view today in a Roman private collection (see sheet 15), with the variation of the arm raised in benediction. It is also related to a similar portrait, without the blessing gesture, previously in the Boncompagni Ludovisi collection. For this a precedent is found in the portrait of Clement VII by Sebastiano del Piombo (Parma, Pinacoteca Nazionale) and also in Bartolomeo Passerotti's *Pius V*, in which the composition is reversed. (Baltimore, Walters Art Gallery).

The canvas is characterized by the paint's softness and by the vigorous rendering of the figure. The traditional attribution to Pulzone, whose securely attributed portrait of the Boncompagni Pope is displayed in this exhibit, must in this case be rectified in favor of his greatest student, Pietro Fachetti.

The Mantuan painter's specialty in portraiture and the significance of his Roman works are recalled by Baglione: "He came to Rome as a youth, in the time of Gregory XIII, and he dedicated himself to portraiture; indeed in that genre of painting he was very worthy; and he did paint some portraits, which were worthy of being compared to those of Scipione from Gaeta. This man painted portraits of almost all the Roman Ladies, and acquired much fame. He also did a great number [of portraits] of Gentlemen, and of the Roman Nobility; and earned fame and profit; and in sum, to state the truth, his portraits were not only resemblances, but were executed with good taste and perfect design." The group portrait fresco depicting Sixtus V approving the plans for the Vatican Library (Vatican City, Vatican Apostolic Library, *Salone Sistino*) is emblematic of his talent for physiognomy and meticulous descriptive attention in the late Mannerist tradition. Among the works securely attributed to Fachetti are two signed canvases: the portrait of Maria de' Medici recently published by Francesco Solinas and the portrait of Antonio Possevino at the Pinacoteca of Siena. Recent attributions accepted by critics include the portrait of Michele Peretti which can be dated after 1605 (Rome, National Gallery of Ancient Art, Corsini Palace); the portrait of Sixtus V in the Lateran Historical Museum; and the group portrait of the family of Alfonso III Gonzaga of Novellera in the Colonna Gallery. Antonio Vannugli has added the portrait of Solderio Patrizi from the Patrizi collection, and proposes to return the controversial portrait of Urban VII from the Koelliker collection to Fachetti, which had instead been attributed to Pulzone by Zeri and Franco Moro. (1)

Francesco Petrucci

1) See G. Baglione, 1642, p. 127; C. Tellini Perina, 1988, 1989, Vol. II, p. 733; F. Solinas, 2001, pp. 113-118; A. Vannugli, 2002, pp. 267-289; S. Alloisi, sheet 56, in F. Petrucci, 2004, pp. 143-144.

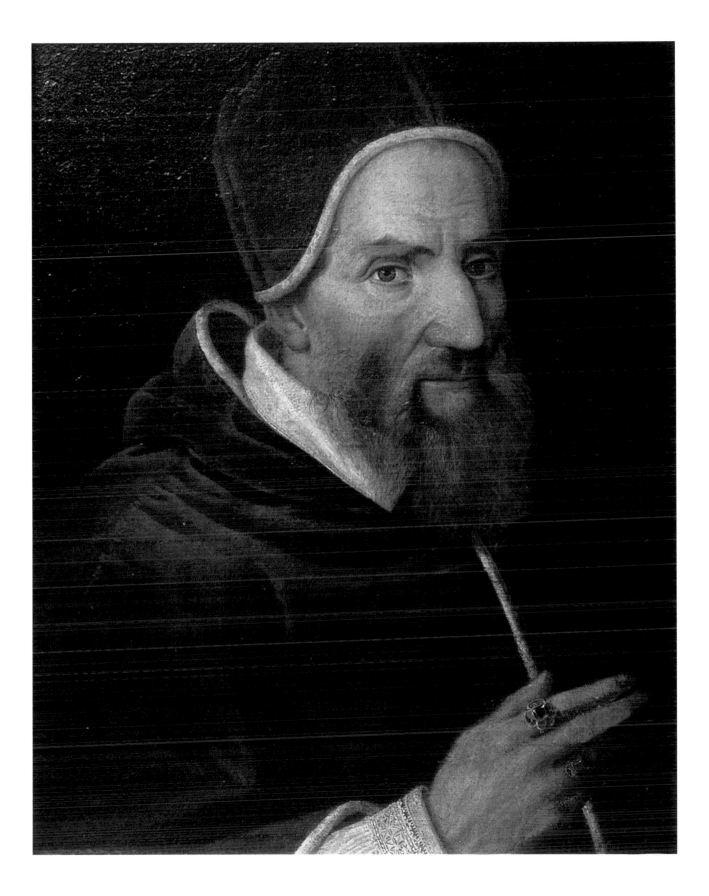

Giovanni Battista Cavagna
(active Rome 1569 – Loreto 1613)

Portrait of Sixtus V (Felice Peretti, 1585-1590)
oil on canvas, 128 x 99 cm.
Cantalupo in Sabina, Camuccini Collection

Bibliography: F. Petrucci, 2004b, p. 27, fig. 16

The tiny image on the table in this painting bears the signature of the artist: "By Gio: Batta Cavagna." It is therefore a rare portrait by the Roman painter and architect Giovanni Battista Cavagna, and may be considered the best example of Sistine portraiture.

Various effigies of Sixtus V are known, but all are of inferior quality: these include the portrait by Pietro Fachetti in the Lateran Historical Museum and one attributed to Scalvati by Vannugli and conserved at the Academy of Saint Luke; another with a different composition, again similar to Fachetti's, is in a Roman private collection. (F. Petrucci, 2004b, p. 27, fig. 17). A painting that is an exact mirror image of Cavagna's but decidedly inferior in quality is in storage at the Vatican Museums (inv. MV 41207).

Cavagna's portrait is characterized by its originality of formulation and its very high quality; although the composition can be traced back to Raphael, Cavagna raises the viewing point, thus avoiding obscuring the Pope's face behind the right arm raised in benediction. The bell on the table, the accurate depiction of the armchair, its high back and seat decorated with fringe, and the drapery on the left are a reference to the rigid setting of Raphael's papal portraits. The movement of the arm raised in blessing instead recalls Sebastiano del Piombo's *Clement VII*.

Felice Peretti was born at Grottammare in the Piceno region on December 13 1521 to a family of humble origins. He was a Pope of great energy and moral force; he reorganized the Roman Curia, suppressed brigands and excommunicated the Calvinist King Henry of Navarre, who later found himself forced to convert to Catholicism.

He made a notable commitment to the urban reconstruction of Rome with the cooperation of the architect Domenico Fontana. He executed significant church restorations in anticipation of the Jubilee Year and created the straight roads linking the major basilicas of Rome. These became the principal axis for the city's expansion and a point of reference for Baroque urban planning. He completed the Cupola of Saint Peter's, built the Sistine Library, the Lateran Palace, the *Scala Santa**[church], and the *Mostra dell'Acqua Felice** [aqueduct] in addition to the monumental Sistine Chapel in the Basilica of Santa Maria Maggiore where he is buried. (L. von Pastor, vol. X, 1928).

Francesco Petrucci

TRANSLATOR'S NOTE: THE NAMES "*SCALA SANTA*" ("CHURCH OF THE HOLY STAIRCASE", LOCATED OPPOSITE THE BASILICA OF ST. JOHN LATERAN IN ROME) AND THE "*MOSTRA DELL'ACQUA FELICE*" (AN AQUEDUCT BUILT BY THIS POPE AND NAMED FOR HIMSELF USING HIS BAPTISMAL NAME, FELICE) ARE NOT GENERALLY TRANSLATED INTO ENGLISH

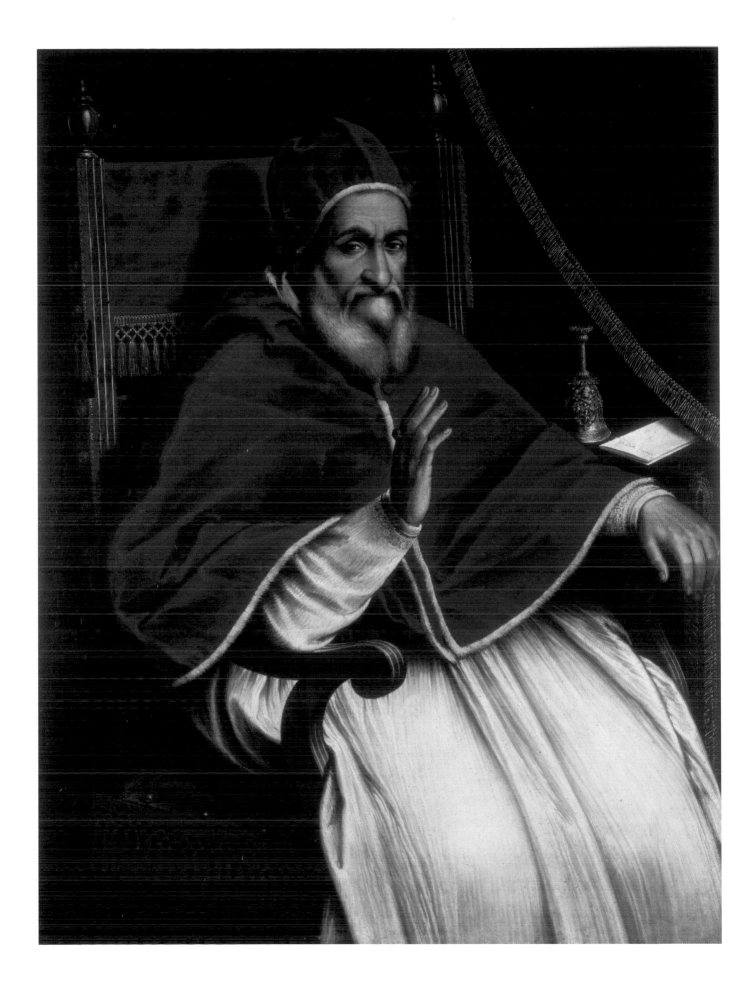

Scipione Pulzone
(Gaeta 1550 – Rome 1598)

Portrait of Urban VII (Gianbattista Castagna, 1590)
oil on canvas, 131 x 99 cm.
Milan, Koelliker collection

Bibliography: F. Moro, sheet, in F. Caroli, 1998, p. 115; A. Vannugli, 2002, pp. 267-290; S. Marra, sheet 25, in F. Petrucci, 2004, pp. 105-106

Strongly committed to the defense of Catholic orthodoxy during the post-Tridentine period, Giovanni Battista Castagna was created cardinal by Gregory XIII and succeeded Sixtus V in the government of the Church, taking the name Urban VII (1590). The Pope is portrayed in a dignified pose with a letter in his hand, almost rigid in his chair. The painting's execution is certainly later than his extremely brief papacy; he fell ill immediately after his election, and held the See of Peter for a mere twelve days. For this reason it is a very rare image, identified as Urban VII by comparison to another portrait today in the Buenos Aires National Museum of Fine Arts. It appears that the face in the portrait of this Pope attributed to Francesco Bassano exhibited at the *Papal Portraits* exhibition held at the Braschi Palace in 2004 derives from this same portrait, however, it is characterized by a completely different painting technique. The sitter is identified here on the right side of the chair, which reads URBAN VII, and on the lace of the vestment, CASTAGNA.
The portrait is executed with minute attention and great delicacy in the application of color. The rigor and composure in the upper part of the canvas is matched with the effect played on the pleated vestment, displayed in the small pleats flowing in different directions and amassed in a tangle against the chair's arm.
The author of the portrait was clearly identified in 1995 by Federico Zeri, who wrote in a letter to the owner of the work, "This is the famous portraitist Scipione Pulzone of Gaeta, known as *Il Gaetano**…who became the fashionable painter of secular and religious high society in late sixteenth-century Rome…" (1) Franco Moro confirmed this attribution in the catalog of the exhibit *The Soul and the Face*, in which the work was displayed in 1998.
Antonio Vannugli attributed this portrait to Pietro Fachetti; nevertheless, the work has been recognized as having maximum tangency with Pulzone's style. (2)

Susanna Marra

1) F. Zeri, letter to owner of the portrait, April 25, 1995
2) In A. Vannugli, 2002, pp. 267-290

TRANSLATOR'S NOTE: "IL GAETANO" MEANS A MAN WHO IS A NATIVE OF GAETA, A TOWN IN THE LAZIO REGION NOT FAR FROM ROME

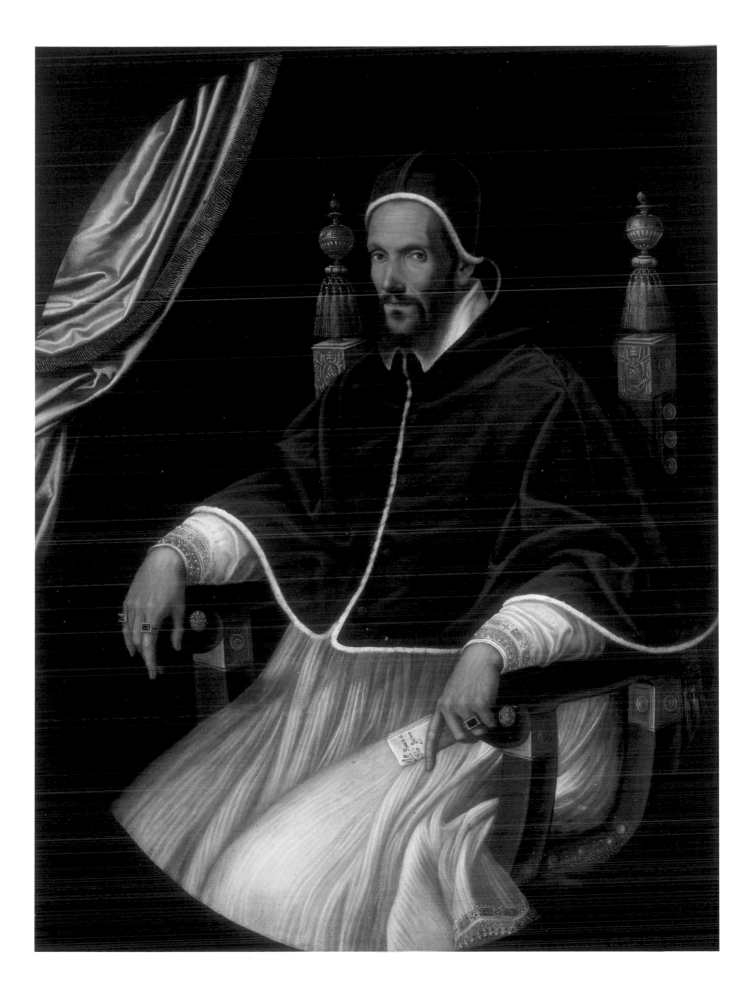

Francesco Bassano
(Bassano 1510/1515-1592)

Portrait of Urban VII (Giambattista Castagna, 1590)
oil on canvas, 66.5 x 49 cm
Rome, Gallerie Antiquarie Bennucci

Bibliography: S. Starnotti, in *Papi in posa…*, 2004, p. 68

Urban VII (1521-1590) was born in Rome to a family of Genoese origin and christened Giovan Battista Castagna. Archbishop of Rossano, governor of Perugia, Apostolic Nuncio to Spain, Venice, and Poland, he was a papal legate to the Council of Trent (1561-1563) and became a fervent supporter of Counter-Reformation principles. In 1583 he was created Cardinal by Gregory XIII; following the death of Pius V, with whom he worked closely, he opened the conclave on September 7, 1590. Despite strong opposition from supporters of Marcantonio Colonna, he was elected Pope on November 15th.

His investiture marked a profound reversal of custom in papal elections, with his fellow cardinals risking to elect a prelate who was not from a noble family and who had a solid background in canon law. Already suffering from malarial fever on November 18th Urban died on the 27th of that month and was buried in St. Peter's. According to tradition, on the occasion of the Pope's sudden death, Brother Paolo Sarpi exclaimed the following words, praising his Christian fervor and his moral integrity: *Ideo raptus est ne malizia mutaret intellectum eius* (1). On September 21, 1600 Urban's remains were transferred to the church of Santa Maria Sopra Minerva, site of the Confraternity of the Annunciation, to which he had bequeathed 30,000 *scudi*. The features of Urban VII are known from painted portraits, one attributed to Scipione Pulzone (2), another by Jacopino del Conte today in the Vatican Pinacoteca, and from the sculpted effigy by Ambrogio Buonvicino on the Pope's funerary monument. The present picture, a half-length portrait of the seated pontiff, displays a physiognomy already struck by illness, very unlike Pulzone's portrayal.

The painting is undoubtedly the work of Francesco Bassano, as confirmed verbally by Ballarin. Bassano's style, from the time he became established in Venice in the 1580s, exhibited the dark tonality clearly borrowed from his teacher and father Jacopo, and certainly also influenced by Tintoretto. In this Venetian phase, Francesco Bassano also achieved great success with his night scenes. His connection to Rome is confirmed by the commission for an *Assumption* for the church of San Luigi dei Francesi, which he executed between 1585 and 1590. Thus finding himself in Rome during the brief period of Urban VII's papacy, perhaps to deliver the work created for the French church, Bassano may have had the opportunity to portray the short-lived Pope.

Simone Starnotti

1) For the complete biography of Urban VII, see *Enciclopedia dei papi*, published by the Istituto dell'Enciclopedia Italiana, Rome, 2000
2) Milan, Koelliker collection. See S. Marra, cat. no. 25, in F. Petrucci 2004, pp. 105-106

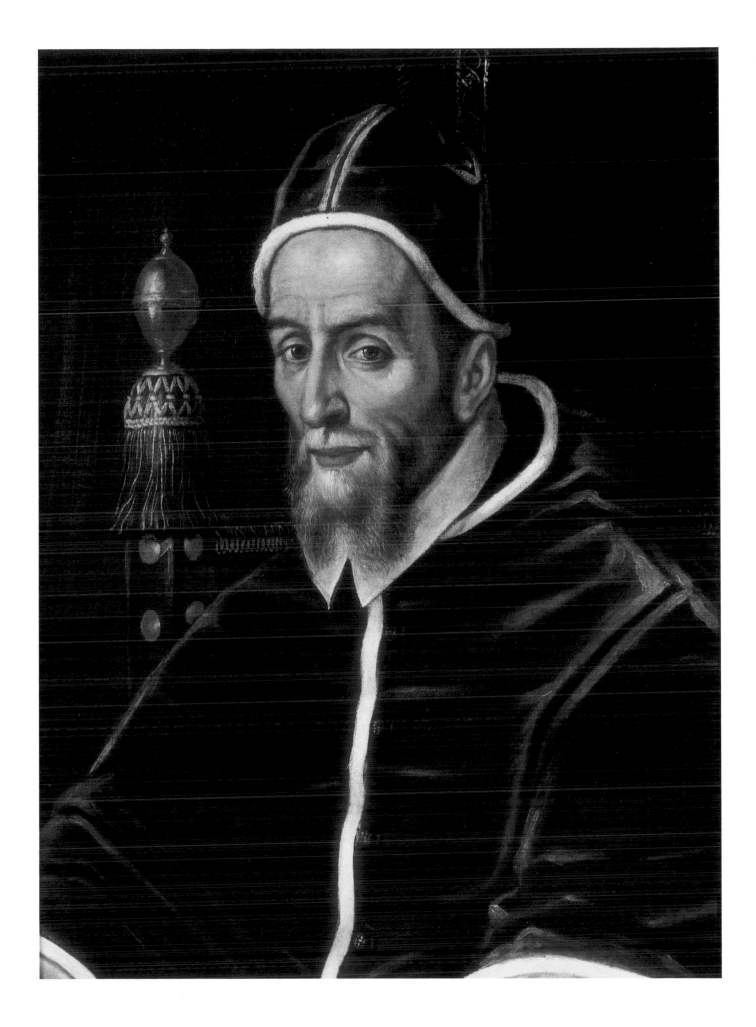

Circle of Jacopino Del Conte
(Florence 1513 – Rome 1598)

Portrait of Gregory XIV (Niccolò Spondrati, 1590-1591)
oil on panel, 93 x 72 cm
Rome, private collection

Bibliography: A. Vannugli, in *Papi in posa…*, 2004, p. 70

This painting, formerly owned by the Del Drago family and previously in the Dall'Ora collection, is an extremely rare image of the Sfondrati Pope, possibly joined only by the elegant bronze bust by Bastiano Torrigiani in the Rijksmuseum in Amsterdam and by a print reproduced by Haidacher (1965, pp. 478-479), the latter a counterpart not necessarily deriving from this canvas, which was painted from life. The nineteenth century mosaic portrait in St. Paul's Outside the Walls is also different. Attribution of the present painting, exhibited here for the first time, is problematic because of the outdated formal refinement of the picture, seen in the vertical elongation of the smiling figure, the highly artificial elegance of the tapering hands, and the summary treatment of the surplice with its flickering highlights in lead white.

We can assume that the artist was a late follower of the so-called "*grande Maniera*" of the mid-sixteenth century, probably trained in Tuscany, and, judging from the treatment of the hands, working in the style of Francesco Salviati. A frequently cited claim that Jacopino del Conte portrayed all the Popes of his time, that is up to Clement VIII, who was pontiff at the time of the artist's death in 1598, derives from a passage in Baglione (1642, p. 75). In reality the Roman biographer limited himself to retelling what had already been mentioned by Vasari (1568 ed. 1906, VII, p. 576), so that this statement should be considered valid only with regard to the pontiffs from Paul III to Pius IV.

Thus the attribution to del Conte of the portrait of Urban VII Castagna in the Vatican collection, now in the Lateran Palace (De Vita, 1991, pp. 308 and 318) is without stylistic or documentary support.

Born on February 11, 1535 in Somma Lombarda to a family originally from Cremona – his father, Francesco, was a Milanese senator who became a cardinal – Niccolò Sfondrati was named Cardinal of Santa Cecilia in 1583 and Pope on December 5, 1590.

Sfrondati was a leading figure in the Church after the Council of Trent, with personal ties to the reformer Charles Borromeo and to the congregation of the Oratorio di San Filippo Neri. In the ten months of his brief pontificate, he supported the Catholic League against Henry IV of Navarre, whom he wished to depose as king of France in favor of Philip II Hapsburg (A. Borromeo, in *Enciclopedia dei Papi*, 2000, pp. 230-240, with bibl.). He died on October 15, 1591 and is buried in St. Peter's. His undecorated tomb, originally intended to be only provisional, is located opposite the monument to Gregory XIII Boncompagni.

Antonio Vannugli

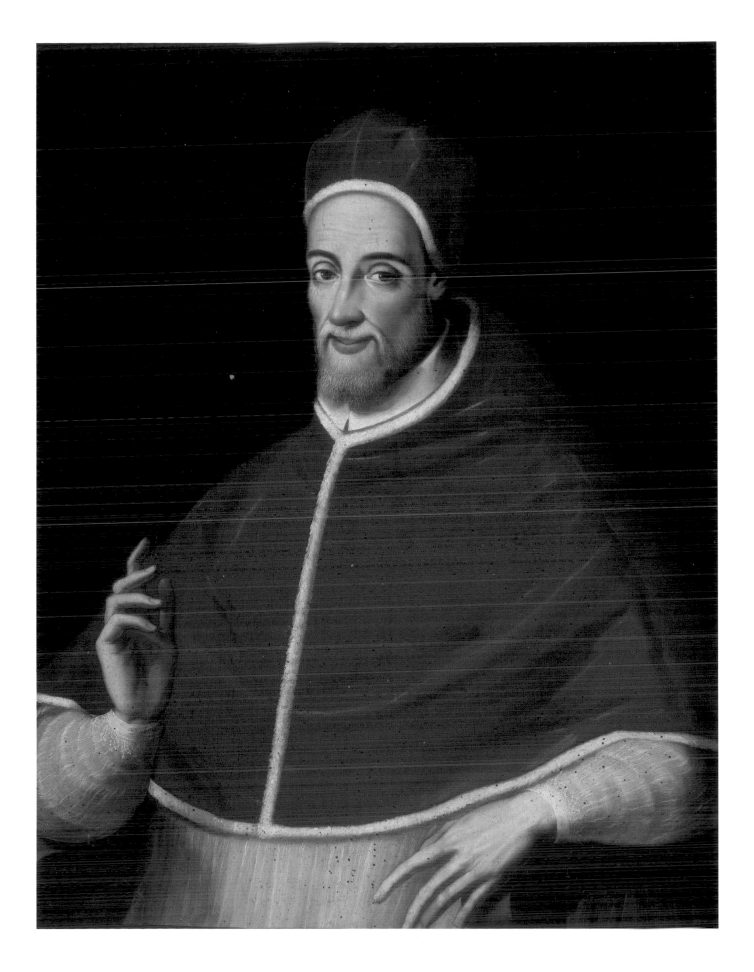

Attributed to Antonio Scalvati
(Bologna 1557 – Rome 1622)

Portrait of Clement VIII (Ippolito Aldobrandini, 1592-1605)
oil on canvas, 148 x 106 cm.
Spoleto, private collection

Bibliography: F. Petrucci, 2004b, p. 27, fig. 18

This painting was published by the undersigned as a possible work by Antonio Scalvati before its restoration, based on its comparison to the portrait of Clement VIII in the Villa Aldobrandini at Frascati, in its turn attributed to the Bolognese painter by Antonio Vannugli. The face is the same in both, the official image of the Aldobrandini Pope as demonstrated by its numerous copies and derivations. (1)

Its cleaning has magnified the painting's pictorial quality, especially precious in the light effects on the satin of the *mozzetta*. In this regard Baglione is fairly explicit, arguing that Scalvati was the only painter who could depict the Pope and execute various replicas to meet the numerous requests: "he dedicated himself to making portraits, and in particular, that of Pope Clement the Eighth, whose image he depicted and expressed with great similitude. And it was very difficult to make a portrait that had such a resemblance; since the Pope never wanted to be portrayed from life, indeed Antonio had to toil greatly to reach natural and true perfection. In fact the entire Court, and all the Princes of Rome, wanted Scalvati's Pope." Numerous portraits of the Pope, of similar dimensions, are recalled in the Aldobrandini inventories, but without specifying the name of the artist. (P. Della Pergola, 1960). Documents confirm payment for a portrait of Clement VIII on July 17, 1596 establishing a possible date for the canvas within the first years of his papacy. (2)

Securely attributed to Scalvati is the portrait on slate of Leo XI kept at the Church of Sant'Agnese fuori le Mura, [Saint Agnes-outside-the-Walls], to which Vannugli has added the *Sixtus V* from the Academy of Saint Luke. Kristina Herrmann Fiore instead attributed to him the portrait of Paul V from the Vatican Museums. Therefore this is a painter to be explored, with extremely scant terms of comparison; we add here another portrait of Paul V which had its preview showing in the exhibit. (3)

The composition of the present portrait is clearly related to the portrait of Gregory XIII by Pulzone (Frascati, Villa Sora; see sheet) with the left arm extended, displaying a book of memoirs and the other resting on the chair's arm with the right hand hanging loosely. But compared to the abstract smoothness of the master from Gaeta the painting here is even softer in its pictorial and flickering style, recalling Scalvati's first teacher Passerotti also in the pastel tones of the flesh. The Bolognese master's *Gregory XIII* is recalled also in the composition and in the identical papal throne. Compared to Pietro Fachetti's clean, sharp angles the form here is built up more loosely, so much so that it makes the proposed attribution to Scalvati logical, and therefore it would become an important point of reference for understanding the work of a portraitist who is still mysterious and enigmatic.

The most beautiful portrait of Clement VIII remains the extraordinary bronze bust by Taddeo Landini in the Villa Aldobrandini at Frascati, in which the sculpture resembles a work of decorative art. The Pope is portrayed with the same tired and detached expression found in Scalvati's portrait, in contrast to the characterization of willfulness that has been passed down to us. (4)

Ippolito Aldobrandini (1536-1605), born at Fano to a Florentine family, was elected Pope on January 30, 1592. His papacy's greatest success was the conversion of Henry IV of France to Catholicism, which allowed the Church to rebalance its position within the circle of European political powers. The Pope played an important role in mediating between France and Spain in 1598 for the signing of the Treaty of Verviens; he admitted Ferrara to the Papal States and fortified it. During his papacy, Caravaggio, Annibale Carracci and the Cavalier d'Arpino were at work, the latter commissioned to decorate the great dome of Saint Peter's with mosaic. Clement ordered numerous restorations to Roman churches for the Jubilee Year of 1600, while his nephew, to whom he did not deny economic assistance, built the splendid Villa Belvedere at Frascati. His imposing funeral monument is located in the Pauline Chapel in the Church of Santa Maria Maggiore. (L. von Pastor, XI, 1929).

Francesco Petrucci

1) See A. Vannugli, sheet in *Papi in posa…*, 2004, p. 72
2) See J. A. F. Orbaaan, 1920, p. 269, no. 1
3) See K. Herrmann Fiore, 1990, no. 54; A. Vannugli, 2002; F. Petrucci, 2004b
4) See P. Cannata, sheet 26, in F. Petrucci, 2003, p. 107

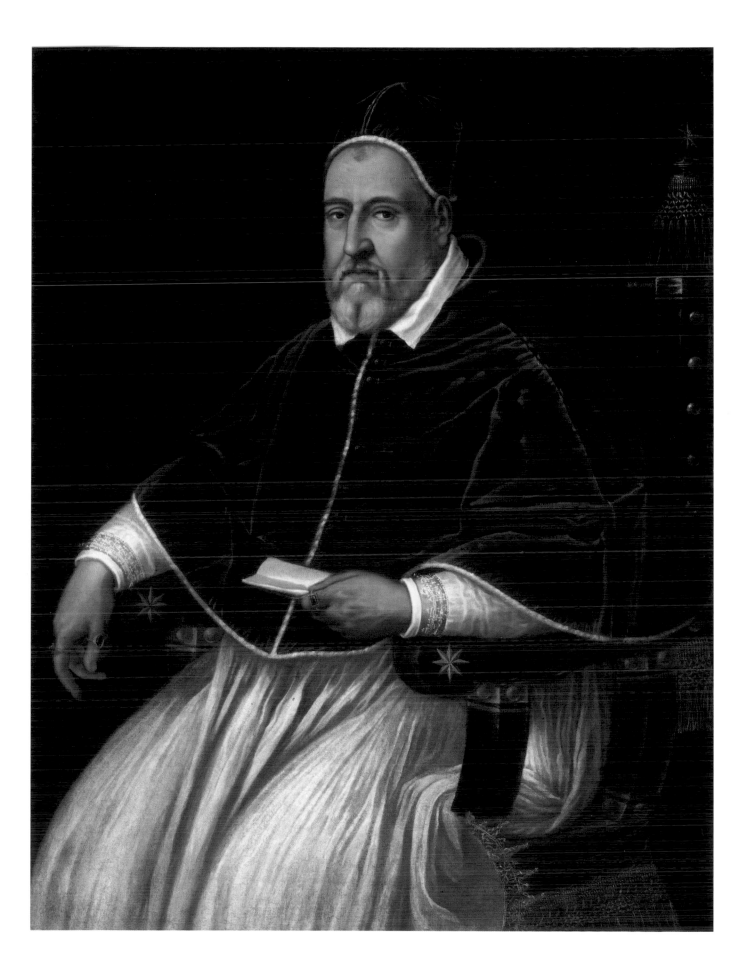

Attributed to Antonio Scalvati
(Bologna 1557 – Rome 1622)

Portrait of Paul V (Camillo Borghese, 1605-1621)
oil on canvas, 140 x 95 cm.
Milan, Baratti Gallery

Bibliography: unpublished

This painting passed from the Sangiorgi antiques gallery in Rome into the collection of Rodolfo Conti, who kept it in Lucien Bonaparte's apartments in the Nuñez-Torlonia Palace in Rome; in the 80s its current owner acquired it from the antiques dealer Paolo Volponi.

The composition of the portrait is uncommon in images of Paul V, the visual record of whom is extraordinarily vast compared to that of all his predecessors. The richness of this record is a result of the lengthy papacy of the Borghese Pope and of his unquestionable interest in celebratory portraiture.

Important sculpted portraits include those by Silla Longhi, Cordier, and Bernini; the Pope's image is also known through paintings executed by Caravaggio and Guido Reni (lost) and through a number of canvases by unknown artists.

Pepper had initially attributed this portrait to a young Guido Reni; later he placed it closer to the Carracci (written communications with the owner). I agree with the Bolognese origin of the work, but I do not believe that these references are relevant. It seems to me that the painting presents stylistic affinities of composition and technique with some portraits by Scalvati, such as the *Sixtus V* at the Academy of Saint Luke, which has the same gesture of benediction and an identical, but reversed, composition, but above all with the portrait of Clement VIII Aldobrandini presented in the exhibition. The painting has an identical softness, with a pictorial touch that is absent in other works by contemporary portraitists then working in Rome. There are also some similarities to the painting of the Borghese Pope attributed to Scalvati by Kristina Herrmann Fiore, today in the Vatican Museums. (1)

The biographer Giovanni Baglione underlined the specific and intense activities of the Bolognese painter within the framework of papal portraiture: "And again, with the same toil as the other (the portrait of Clement VIII) he executed the portraits of Pope Leo the Eleventh, and Paul the Fifth, and he expressed and painted them with great verisimilitude. And in that of Paul he did his work well, and earned a good wage." Scalvati was a student of Bartolomeo Passerotti and later of Tommaso Laureti, whom he accompanied to Rome under Gregory XIII to execute frescos in the Room of Constantine in the Vatican Palace. According to Baglione's testimony, he executed various papal portraits, with more produced as replicas, so many as to constitute his principal source of work. As Baglione also noted, Scalvati executed the portrait of Leo XI in the second chapel on the right in the Church of Sant'Agnese Fuori le Mura [Saint Agnes-outside-the-Walls], of which a version today in the Lateran Historical Museum is a copy. Vannugli, who attributed to him the portrait of his great patron Sixtus V conserved in the Academy of Saint Luke, is also inclined to consider the portrait of Clement VIII in the Villa Aldobrandini at Frascati an autograph work by Scalvati. (2)

Francesco Petrucci

1) See K. Herrmann Fiore, 1990, no. 54; F. Petrucci, 2004b, p. 28
2) See G. Baglione, 1642, p. 172; U. Thieme, F. Becker, 1935, p. 522; A. Vannugli, 2002, pp. 275-277, 287-288

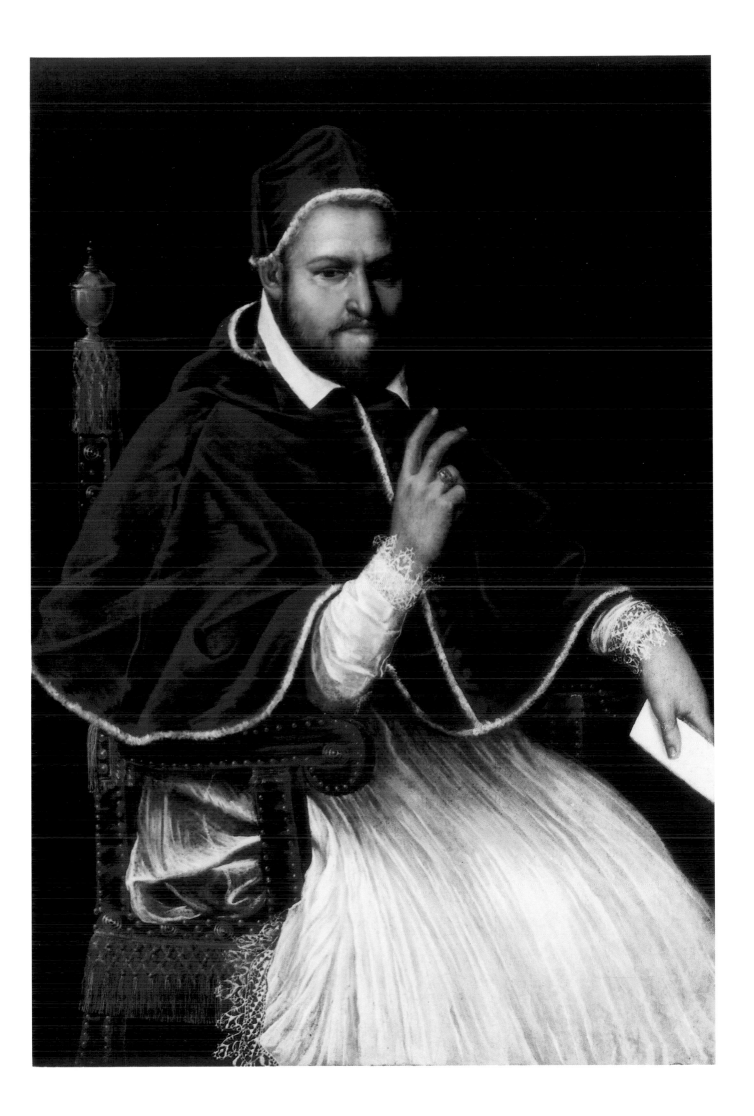

Anonymous seventeenth century painter

Portrait of Paul V (Camillo Borghese, 1606-1621)
oil on canvas, 125 x 113.5 cm
Artena, Collection Don Andrea Scirè Borghese

Bibliography: D. Petrucci, cat.no. 20, in F. Petrucci, 2002, pp. 52-53; A. Vannugli, in *Papi in posa…*, 2004, p. 74

The identity of the subject of this portrait is revealed by the letter in the right hand of the sitter, on which are written the words "S.D./Paulo." The painting may be that listed in the *Inventory of furniture and other items in the Palace of Montefortino*, present-day Artena, conducted January 1, 1760, and described as "A portrait of Pope Paul V in a walnut frame, 3 x 2." The present canvas is a fine example of a portrait that exists in many versions, including a painting currently on display in the museum at Santa Maria Maggiore, in which the dragon decorating the back of the chair is completely different and less accurate with respect to Borghese heraldry.

The many images of Paul V culminate in superlative portraits from the beginning and end of his pontificate. The finest early example is the extraordinary canvas of 1605 today in the collection of Camillo Borghese in the Palazzo Borghese in Rome. The authorship of this painting is still debated; Solinas attributes it to Ottavio Leoni (Solinas 2002, pp. 244 and 260, note 9, with bibl.) while Marini, with greater foundation, gives it to Caravaggio (Marini 2001, pp. 44, 262-263 and 490-492, note 67, with bibl.), based on its identification with a portrait, mentioned by Manilli (1650, p. 77) and later by Caravaggio's biographer Bellori (1672, 1976 ed., p. 224), that the Lombard artist made of the newly-elected Borghese Pope. No less exceptional is the small marble bust sculpted between 1617 and 1618 by the young Giovanni Lorenzo Bernini, now in the Borghese Gallery (Coliva 1998, pp. 102-109). A fine anonymous portrait of the pontiff, today in a private collection in Lucca, is also from this period.

Less artistically important are two monumental statues of Paul V in Santa Maria Maggiore. The first, by Paolo Sanquirico, is located on the grand staircase leading to the loggia and was mentioned by Baglione (1642, p. 323); the other, at the center of the Pope's funerary monument in the Pauline Chapel, is by Silla Longhi, an artist from Viggiù.

Camillo Borghese was born in Rome on September 17, 1552, son of the Sienese nobleman Marcantonio I Borghese. He was elevated to the cardinalate in 1596 by Clement VIII, whom he succeeded on May 16, 1605, after the extremely brief pontificate of the Medici Pope Leo XI. An excellent jurist, as Pope he attempted a difficult path of neutrality between France and Spain, trying to reconcile these two powers and pleading the age-old cause of a new crusade against the Turks. His early reign was marked by an interdict against the republic of Venice and by the grave international crisis that followed.

Under his rule numerous new religious orders were established, and following the Inquisition's condemnation of Galileo, he guaranteed the astronomer's safety. Although his personal conduct was above reproach, he is known for his nepotism. The principal recipient of this favor was his sister Ortensia's son, Scipione Caffarelli, whom Paul promoted to the rank of cardinal immediately after his own election. As a patron, he resumed the urban planning policies of Sixtus V, commissioning and bringing to conclusion the nave and façade of St. Peter's. Other building projects include the Pauline Chapel in Santa Maria Maggiore, where he was buried after his death on January 28, 1621, and the fountain of Acqua Paola on the Janiculum hill. In his private life he was responsible for the construction of his family palace in Campo Marzio and, through his nephew Scipione, a splendid villa outside the Porta Pinciana. He also acquired new estates and various villas in the Castelli Romani region, turning Frascati and its surroundings into the preferred papal retreat. (V. Reinhardt in *Enciclopedia dei Papi*, 2000, pp. 277-292, with bibl.).

Antonio Vannugli

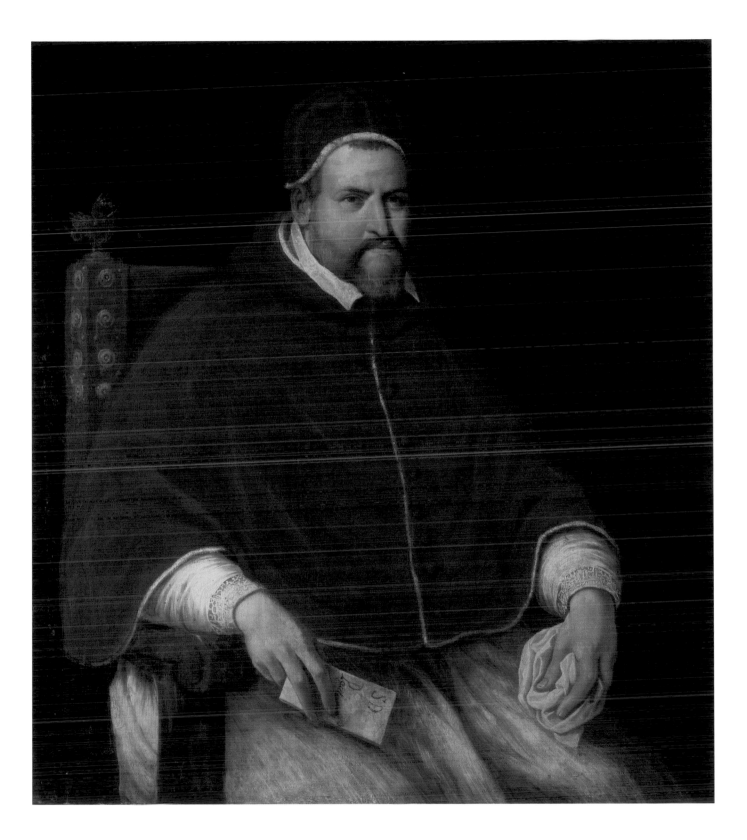

Attributed to Ottavio Leoni
(Padua circa 1578 – Rome 1630)

Portrait of Gregory XV (Alessandro Ludovisi, 1621-1623)
oil on canvas, 136 x 112 cm.
Frascati, Villa Sora

Bibliography: M. B. Guerrieri Borsoi, 2000, pp. 128-130

Maria Barbara Guerrieri Borsoi published this painting in 2000, also with a proposed attribution to Ottavio Leoni. This canvas and three others that once formed part of the interior decoration of Villa Boncompagni Ludovisi became the property of the Salesian Order when the building was sold to the Order 1896. Leoni's picture appeared for the first time in a 1777 inventory of the villa with its size noted as "in emperor canvas."

The artist's biographer Giovanni Baglione recalls that for the portrait of Gregory XV, in which "Leoni portrayed him with great resemblance and animation; so much that the Pope was very pleased with it," the artist was "honored with knighthood [in the *Cavalieri di Cristo*, or Knights of Christ], and acquired much credit for his works, and reputation." In 1628 the painter executed another papal portrait, a half-figure in a different pose, for the Academy of Masters of the Pantheon, of which he had been a member since 1621.

Leoni was the portraitist *par excellence* in Rome in the first half of the seventeenth century. His portrait drawings are innumerable, while the most recent studies are compiling a *corpus* of painted portraits. According to Baglione's testimony, Leoni depicted all the men who were of some importance in the Rome of his times, including popes. Elected President of the Academy of Saint Luke in 1614, around 1621 Leoni began to dedicate himself to engraving his portraits (about forty engravings are known), challenging himself to portray the leading artists, scientists and intellectuals of his time. A good number of his drawings are conserved in the "Leoni Album" at the Marucelliana Library of Florence (See Florence, 1984), but examples are also found in various graphic collections, from the Albertina at Vienna to the museums of Munich, Edinburgh, London, and Oxford. Several drawings are today in public and private collections in the United States. (1)

Alessandro Ludovisi (1554-1623) was born in Bologna on January 9, 1554. After studying law in Rome, in 1612 he became Archbishop of Bologna and a Cardinal in September 1616. He was elected Pope on February 9, 1621 and took the name Gregory XV. Elderly and in bad health, he greatly relied on his "cardinal nephew" Ludovico Ludovisi during his reign.

Gregory was able to turn the events of the Thirty Years' War in his favor, undertaking effective political action against Lutherans and Calvinists and improving relations with England and other European nations. He reformed papal election methods, [instructing that voting in the conclave would henceforth be by secret ballot.] In 1622, he founded the *Congregatio De Propaganda Fide* for worldwide expansion of the faith, encouraging missions (he also canonized Saint Ignatius of Loyola). He summoned Guercino to Rome in 1621 and entrusted him with various tasks, which culminated in the execution of the monumental altarpiece, *Burial of Saint Petronilla* for the Vatican Basilica. He died on July 8, 1623 and is buried in the Church of St. Ignatius. (L. von Pastor, vol. XIII, 1931).

Francesco Petrucci

1) See G. Baglione, 1642, pp. 321-322; B. Sani, 1989-1990, pp. 187-194; H-W. Kruft, 1991, pp. 183-190; B. Sani, 1997, pp. 55-84; M. T. Rizzo, 1999, pp. 100-113; idem, 2002, pp. 100-113

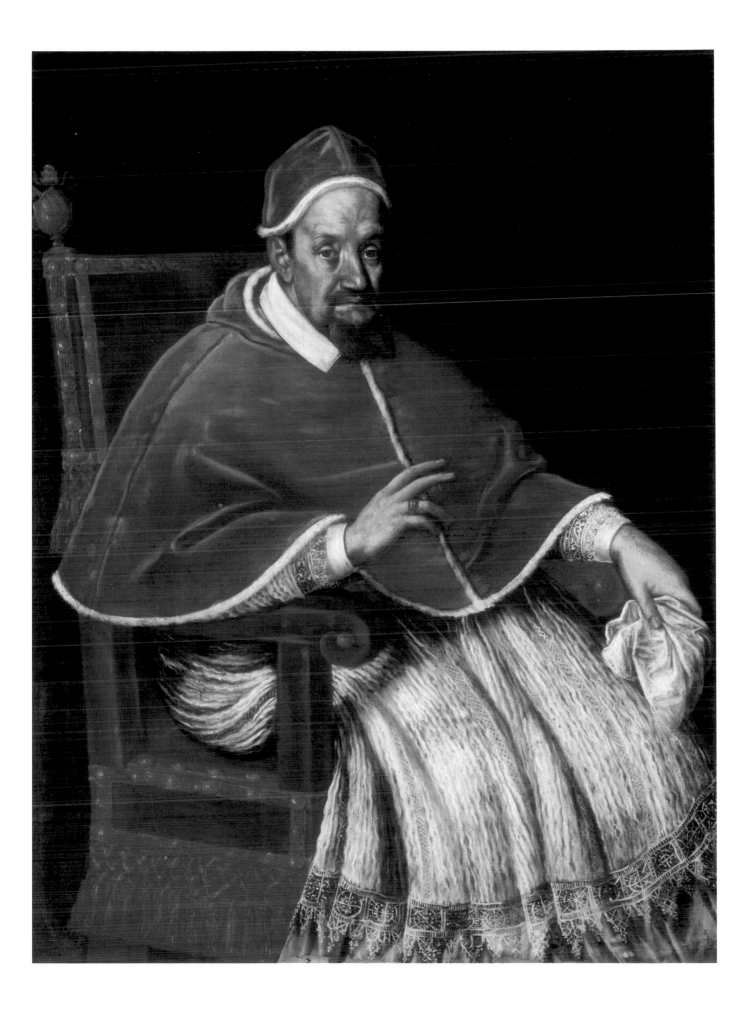

Giovan Lorenzo Bernini
(Naples 1598 – Rome 1680)

Cast by Gregorio de' Rossi (?)
(Modena, circa 1570 – Naples circa 1637-43)

Bust of Gregory XV (Alessandro Ludovisi, 1621-1623)
bronze, 75 x 69 cm., base 17.5 x 23 x 20 cm.
Bologna, Medieval Civic Museum

Bibliography: A. Muñoz, 1916, p. 104; I. Faldi, 1953, pp. 311-313; V. Martinelli, 1955, pp. 653-661; idem, 1956, pp. 15-23, tab. V, fig. 2; R. Wittkower, 1966, 1981, pp. 179-181; idem, 1990, p. 236-237; T. Montanari, sheet 19, in A. Di Lorenzo, 2002, pp. 116-119; F. Petrucci, in in *Papi in posa…*, 2004, p. 76

This bust, first published in 1916 by Antonio Muñoz, is closely connected to three other bronze busts of identical manufacture: one kept at the Doria Pamphili Palace in Rome and noted by Stanislao Fraschetti in 1900; a bronze today in the Carnegie Institute in Pittsburgh, once in the collection of the architect Antonio Muñoz, who published it in 1911, previously in the Stroganoff and Ludovisi collections; and the bronze in the Jacquemart-André Museum in Paris, originally in the Borghese collection and corresponding to the one cast by Sebastiano Sebastiani for Cardinal Scipione Borghese in 1621-22 (Faldi). The base of the bust exhibited here is original. It differs from the Muñoz version but is identical to the other two, with an escutcheon bearing the Ludovisi Pope's coat of arms flanked by two lateral volutes like those decorating the base of Bernini's bronze bust of Paul V (Copenhagen, Ny Calrlsberg Glyptotek).

According to Valentino Martinelli and Rudolph Wittkower, the chasing of the Bologna and Doria Pamphili versions of the portrait is inferior to the finishing of the former Muñoz bust, which may be the best of the four. Bernini's execution of three portraits of the pope, in marble and in metal, is attested by a passage in Francesco Bernini's diary dated November 18, 1622, while the sculptor's biographer Filippo Baldinucci cites a marble bust and a bronze bust at the Ludovisi residence. As a sign of his appreciation and satisfaction with the portrait, the Pope invested Bernini with the Cross of a Knight of Christ on June 30, 1621 (Schütze). The marble bust and its bronze version were therefore executed between February 9, the date on which Gregory was elected to the papacy, and June 30, 1621.

Muñoz and Martinelli argued that the bronze busts derive from a marble original, an assertion with which Rudolph Wittkower disagreed. The marble in question is identified by critics as a recently rediscovered bust that was acquired by the Art Gallery of Ontario at Toronto. (1)

Tommaso Montanari suggests that the Toronto version is a marble copy, carved by Bernini in 1627 for Cardinal Ludovico Ludovisi and destined for Zagarolo. In both the marble and bronze versions, the pope wears a pluvial decorated with images of Saints Peter and Paul and fastened in the center with a large morse similar to the one in Bernini's bronze portrait of Paul V. The casting of the Bologna, Pittsburgh and Rome busts is perhaps the work of Gregory de' Rossi, whose name appears in Fioravante Martinelli's 1644 guidebook to Rome associated with a description of the bronze bust of Gregory XV in the Ludovisi collection, a connection also noted by Montanari. (2)

In this respect it is noteworthy that the Bologna bust's measurements are not those reported by Martinelli (repeated by Wittkower, h. 60 cm., similar to the other versions of the portrait). The disparity has been explained as the result of a second casting of Bernini's metal original. Moreover, firsthand viewing confirms that the Bologna bust has the same high level of finish as the others, as Montanari has recently pointed out. An "Appraisal of Statues" conducted around 1660 for Prince Ludovico Ludovisi records two metal busts of Gregory XV, suggesting that the original provenance of this portrait bronze may be the Ludovisi palace. (3)

Bernini's careful attention to the decorative flourishes of the pluvial reveal his fluency in the sculptural language of decorative *objets d'art* in which sixteenth-century papal busts participated. New here is the sense of vitality implicit in the slight turn of the head, a hint of movement alien to examples of the previous century but nascent in Bernini's small marble bust of Paul V (Rome, Borghese Gallery) in its break with rigid symmetry and axial composition. The upturned gaze present in the Ludovisi bust conveys the heightened spirituality of Gregory XV and reveals Bernini's esteem for the style of the painter Guido Reni, who had portrayed the Pope in a more official and less emotionally engaged pose. It was a theme Bernini had already explored in his *Blessed Soul* of 1620, here applied innovatively to portraiture.

Francesco Petrucci

1) See S. Schütze, sheet 41, in M. G. Bernardini, M. Fagiolo dell'Arco, 1999, p. 326
2) See C. D'Onofrio, 1969, p. 317; T. Montanari, in A. Di Lorenzo, 2002, p. 118
3) See L. G. Pelissier, 1894, pp. 21, 27

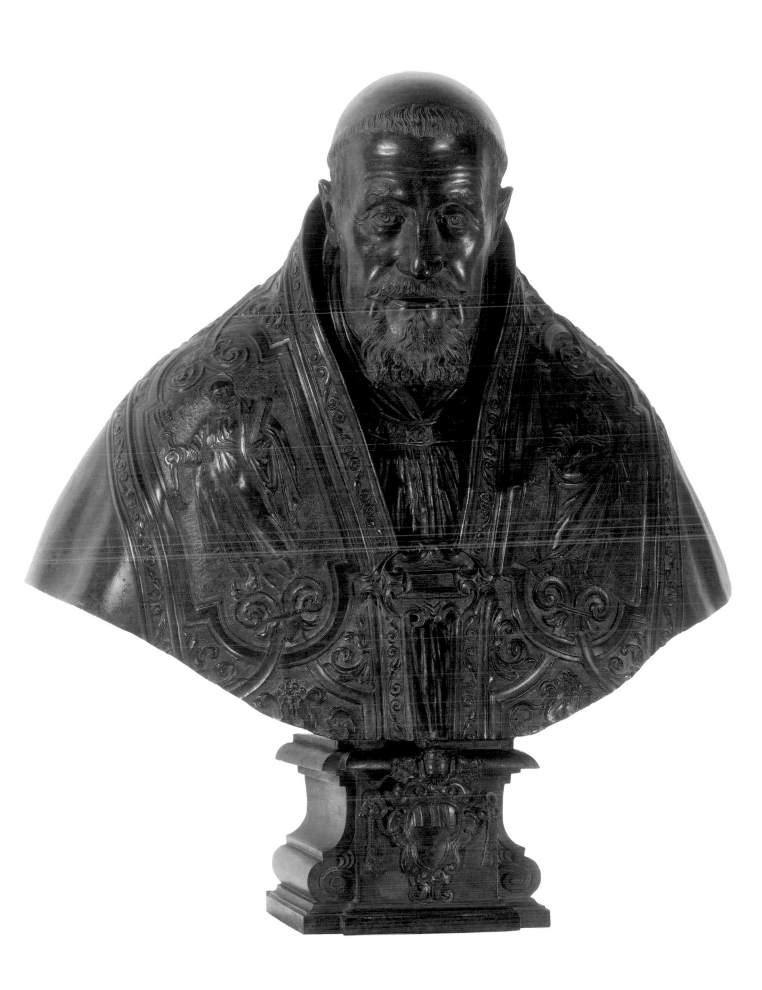

Giovan Lorenzo Bernini
(Naples 1598 – Rome 1680)

Portrait of Urban VIII (Maffeo Barberini, 1623-1644)
bronze, h 81 cm. (without pedestal)
Camerino, Municipal Palace

Bibliography: S. Fraschetti, 1900, p. 406; V. E. Aleandri, 1902, pp. 44-45; R. Wittkower, 1955, p. 186; idem, 1981, p. 188; idem, 1990, pp. 243-244, no. 19.6; V. Martinelli, 1956, tab. XVI, fig. 1; M. and M. Fagiolo dell'Arco, 1967, no. 97; M. Worsdale, 1981, p. 114; S. Schütze, 1998, p. 248

This bust is a bronze casting derived from Gianlorenzo Bernini's famous marble portrait of Urban VIII executed in Rome in the summer of 1632, while the Pope was on holiday at Castel Gandolfo. A poem, a manuscript dialog and above all a letter of June 4, 1633 written by Lelio Guidiccioni in celebration of the sculpture allow us to date the work securely. (1)

Two editions of the marble bust are known: one published by Rudolph Wittkower in 1969 and acquired in 1974 by the National Gallery of Canada, and a second at the National Gallery of Ancient Art of Rome in the Barberini Palace. All scholars accept Wittkower's theory regarding the origins of the busts, which proposes that, as occurred with the bust of Cardinal Scipione Borghese, a vein in the marble forced Bernini to execute a second, identical version. In fact, a large cross vein runs diagonally from left to right through the *mozzetta* of the Ottawa marble bust, while a break in the marble runs horizontally through the lower zone. (2)

Bernini was also commissioned to execute a bust in bronze, derived from the more official marble in the National Gallery of Rome. Two castings, held to be autograph, are recorded in the literature: one noted in 1902 at the Vatican Apostolic Library (previously at the Barberini Palace Library, where it had been since autumn 1632) and the other at the Municipal Palace of Camerino. The bronze at Camerino was commissioned by the municipal council on January 11, 1643 through the offices of Cardinal Angelo Giori, and sent from Rome on the following February 24; Bernini directly supervised the casting and the finishing of the bronze, as demonstrated by the payment of 300 *scudi* to him. The bust was published by Fraschetti as a workshop piece, while Aleandri returned it to Bernini on the basis of documentation, with confirmations by Wittkower and Martinelli followed by bibliography. Also at Camerino, on a wall in Cardinal Giori's Villa Maddalena, there is a red chalk portrait drawing of Urban VIII by Bernini; the cardinal also owned a marble bust of the Pope by the Roman master. (3)

The portrait is undoubtedly a masterpiece, in which for the first time Bernini perfected a fundamental type of papal portraiture. The slight wrinkling of the *mozzetta* on the left side and the subtle turn of the head break the monotony and static nature of previous portraiture, alluding to an arm raised in blessing, and the gaze is directed laterally as though toward a visitor. Guidiccioni's letter testifies that he assisted in the work's execution. A composite model was repeated by Bernini himself and by his numerous followers (Melchiore Caffà, Domenico Guidi, Giuseppe Mazzuoli, and others) in subsequent papal portraits.

Above all it is the vivacity of expression and the complex sentiments expressed in the portrait (as Guidiccioni also noted) that make it a turning point in the history of portraiture, papal and otherwise; before Bernini papal portraiture, if one excludes Titian's portrait of Paul III with his nephews, was marked by courtly composure. I believe that the only possible comparison to Bernini would be the Venetian painter's masterpiece, today at the Capodimonte Museum in Naples.

Maffeo Barberini (1568-1644) was born at Florence in April 1568. After a brilliant ecclesiastical career in which he held the positions of Referendary, Apostolic Protonotary, Nuncio at Paris, Prefect of the *Segnatura* (the highest papal court) and Cardinal, Barberini ascended to the Papal See on August 6, 1623. He was a strenuous defender of papal temporal power, annexing the Duchy of Urbino to papal territory and undertaking the long and costly War of Castro against the Farnese family. He was also the last great nepotistic Pope, favoring the careers and rapid enrichment of his relatives. A poet and writer, he was an enlightened patron of the arts, commissioning the *Barcaccia* [fountain] in Piazza di Spagna, the Triton Fountain, the *Baldacchino* in Saint Peter's Basilica and his own funeral monument in the Vatican Basilica, all from Bernini. As a Cardinal he had been a patron of Caravaggio; during his pontificate he commissioned works from Poussin, Pietro da Cortona and many other great painters. One of the most negative events of his long papacy was the trial of Galileo Galilei, which concluded with the scientist's condemnation in 1633. He died on July 29, 1644 (L. von Pastor, vol. XIII, 1931).

Francesco Petrucci

1) See C. D'Onofrio, 1967, pp. 381-386
2) See R. Wittkower, 1969, pp. 60-64; C. Johnston, G. Vanier Shepard, M. Worsdale (editor), 1986, pp. 76-77; S. Schütze, 1998, pp. 246-251
3) See V. Martinelli, 1950, p. 181; S. Corradini, 1977

Pietro da Cortona
(Cortona 1597 – Rome 1669)

Portrait of Innocent X (Giovanni Battista Pamphilj, 1644-1655)
oil on canvas, 96.5 x 68 cm
Ariccia, Palazzo Chigi, Fagiolo collection

Bibliography: M. Fagiolo dell'Arco, 1981, p. 49, fig. 4; M. Marini, 1992, p. 123, fig. 20; id., 1992 ((b), fig. 4; M. Fagiolo dell'Arco, 1997, p. 327; id., 1998, pp. 65, 71, note 11; A. Cipriani, entry 32 in AA.VV., 1999, pp. 116-117; M. Fagiolo dell'Arco, 2001, pp. 58-59, 63 note 11; F. Petrucci, 2001, p. 91; id., in *Papi in posa...*, 2004, p. 80

Recently it has been possible to verify the original provenance of this painting, which was part of the Barberini collection until the 1940s when it was acquired by the restorer Pico Cellini. In 1998 the work moved to the collection of the late scholar Maurizio Fagiolo dell'Arco, who suggested the connection, later repeated by Angela Cipriani, to a painting listed in the 1679 inventory of Cardinal Francesco Barberini: "a large, unframed canvas with a half-figure of His Holiness Pope Innocent by the hand of Pietro da Cortona, sketched out but unfinished." The unusual dimensions of the painting (neither small nor the large size common to state portraiture), its explicitly unfinished state, the secure provenance and stylistic considerations confirm this important attribution. (1)

In 1981 Fagiolo, citing the unfinished nature of the painting and its undoubted placement within the context of the Roman Baroque, tentatively attributed the canvas to Bernini, a suggestion later repeated by Maurizio Marini. Stylistic elements weaken this hypothesis. Although the painting shows affinities with the style of Pierfrancesco Mola, the volumetric and sculptural qualities of the figure are at odds with the pure pictorialism of that painter from Ticino and, on the contrary, suggest characteristics of Bernini and above all Cortona. The sinuous outline of the *mozzetta* (the short clerical cape) with the broad "s" curve on the left sleeve recalls the highly movemented and artificial drapery style favored by Bernini and Cortona, a Baroque idiom also adopted by Borgognone and Baciccio.

The Teylers Museum in Haarlem houses an India ink portrait of Innocent X (199 x 155 mm, inv. N. A74) once owned by Queen Christina of Sweden and later in the Odescalchi collection. It has been attributed variously to Alessandro Algardi and Pier Francesco Mola, undoubtedly based on its relationship to the painting under examination here. Cortona was friendly with both artists; he collaborated with Mola, and Algardi was present at the drafting of Cortona's will. The drawing depicts the Pope in a bust-length oval. It is notable that an inventory of July 17, 1737 of the collection of the painter Antonio David included "Two small oval works, one depicting Urban VIII, the other Innocent X Pamphili, a copy after Diego Velazquez and an unframed work by Pietro da Cortona, with the same provenance [from the aforementioned bequest]...". This further demonstrates that there was a portrait of the Pamphili Pope by Cortona, perhaps also oval in shape or copied into an oval. (2)

Another portrait of the pontiff by Cortona is listed in the June 20, 1713 inventory of the Roman house of Astolfo Galloppi, notary of the Apostolic Chamber, described as "An imperial-size painting on canvas depicting Innocent X by Pietro da Cortona with a gilded frame," which could be a finished version of the Barberini sketch.(3)

The painting develops a formula that was uncommon in papal portraiture until that time, with the pontiff depicted in three-quarter view from the left and in the act of benediction, a composition used previously for portraits of Pius V and Urban VIII. I believe that this pose derives from an image of Innocent X that antedates the Velazquez portrait of 1650, known through a portrait belonging to the papal series by Oriolo and today in a Roman private collection (see Petrucci 2001), and through the engraving in Athanasius Kircker's volume *Obeliscus Pamphilius.*

The present painting is an oil sketch, clearly unfinished in certain areas, but with extraordinary expressive power and of a quality that undoubtedly signals the brush of a master as great as Cortona (note the skillful chiaroscuro of the left hand resting on the armrest). The definitive version of the portrait for which the present study would have provided the model has yet to be discovered.

Cardinal Giovanni Battista Pamphili (Rome 1574-1655) was an eminent jurist, papal nuncio to Naples and Madrid, and had a pro-Spanish political stance. He sponsored missionaries and combated Jansenism. After trying the Barberini for embezzlement, he came under the negative influence of his sister-in-law Olimpia Maidalchini, and like his predecessor Urban VIII he was not above nepotism. He commissioned Bernini to create the Fountain of the Four Rivers and Borromini to design various buildings.

Francesco Petrucci

1) See M. Aronberg Lavin 1975, p. 360, no. 180
2) *Inventarium bonorum hereditorum bone memorie Antonimi David factum ad instaticum Illustrimorum Domini Carli, Domini Can.ci Francisci, et Josephi de David Fratrum, et her....* State Archives, Rome, Notai Tribunale, A.C. vol. 7219 (Provenance Index Databases, The J. Paul Getty Trust)
3) State Archives, Rome, Notai Segretari e Cancellieri R.C.A., vol. 1960, f. 602 (Provenance Index Databases, The J. Paul Getty Trust)

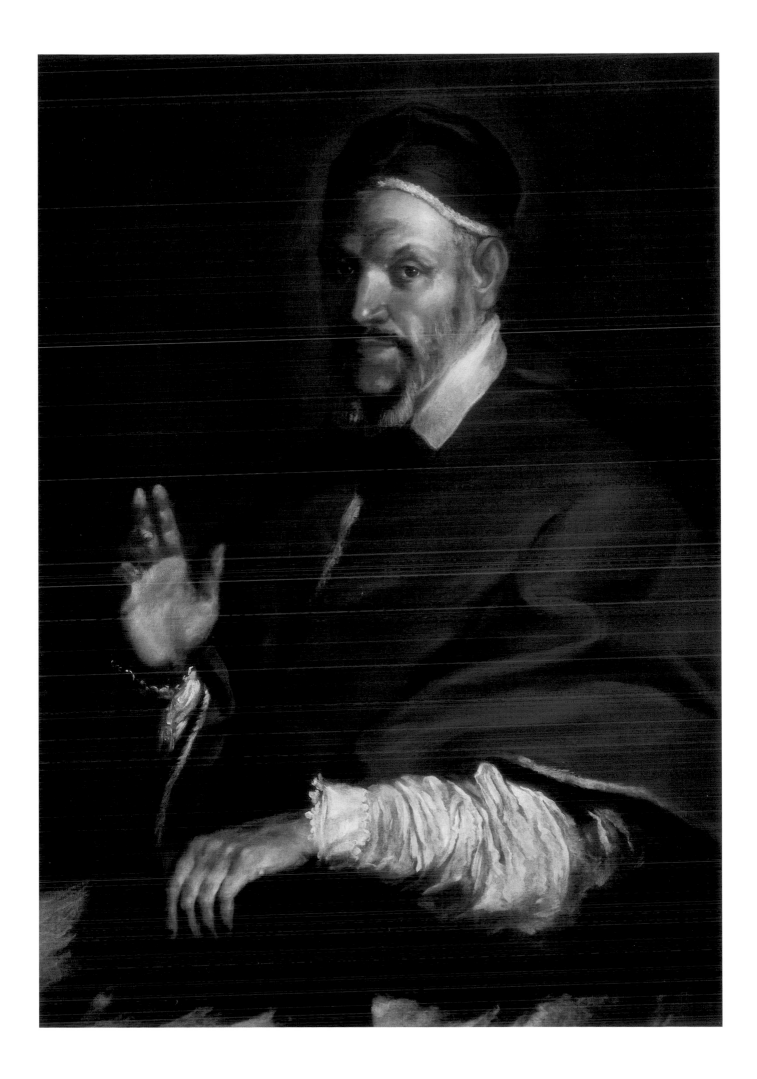

Pietro Martire Neri, copy after Velázquez
(Cremona 1591 – Rome 1661)

Portrait of Innocent X (Giambattista Pamphilj, 1644-1655)
oil on canvas, 144.5 x 119.5 cm
Ro Ferrarese, Cavallini – Sgarbi Foundation

Bibliography: O. Melasecchi, 1990, p. 177, fig. 10; B. Dondi, 1994, pp. 224-241; T. De Antonio, 1996, pp. 41-59; G. Capitelli, sheet D5, in C. Benocci (editor), 1998, p. 258; V. Sgarbi, sheet 27, in F. Petrucci, 2004, pp. 107-108

The painting, signed on the letter held in the Pope's hands, is a faithful replica by Pietro Neri of the celebrated portrait of Innocent X by Diego Velázquez, today in the Doria Pamphili Gallery of Rome. Neri executed another version of the portrait, introducing a sinister figure dressed in black standing to the right, perhaps a counselor or a prelate; this version is known to have three replicas, all signed. The meeting with Velázquez, perhaps during his first, and certainly during his second trip to Rome, was a decisive factor in the Northern Italian painter's artistic development.

Neri distinguished himself above all as portraitist at Cremona, Mantua, Bologna and Rome. He worked at the court of Innocent X, painting numerous portraits of the Pope, among them the monumental portrait still in the Doria Pamphili Palace of Rome, while he signed with Velázquez, with whom he became a collaborator, the *Portrait of Cristoforo Segni majordomo of Innocent X* now in the Kisters collection at Kreuzlingen (Switzerland). In 1650 he was accepted into the Academy of Saint Luke, of which he became President in 1654, at the apex of his career.

It was certainly during those years that Pietro Martire executed the beautiful painting under examination, on a prime canvas and in a perfect state of conservation, in which he displayed all his admiration for Velázquez, without being able to fully understand the great Spanish painter's pictorial revolution. Instead, he shared his very powerful psychological intuition, his energy, the absolute certainty of power expressed in the penetrating gaze. In a different, more benign spirit here Velázquez's invention is reproduced, the truth of the flesh translated into paint. Pietro Martire Neri does not falter; he is able to meet the challenge. But when he has to measure himself against mystery he prefers the more comfortable road: it is in the miraculous red drapery that Velázquez placed behind the Pope, like a screen upon which disquieting shadows are stamped. The Spanish master's execution is rapid, impressionistic, even informal.

Velázquez reserved a decisive role for that space that was completely misunderstood by Neri. Thus, as though he hadn't seen it, he replaces the drapery with a theatrical damasked curtain which alludes to a sumptuous environment, one that does not contain fear and anxiety.

The atmosphere evoked by Velázquez is dissolute. The Pope's solitude is reabsorbed into a comfortable situation where power, not its torment, is celebrated. Neri replicated what he could, not what he was unable to see and understand, about Velázquez. The change in the drapery marks an insufficiency, a limit in comprehension, a return to order. Pietro Martire Neri normalized Velázquez, defusing the tension which had been discharged in the irregularity of the design, in the freedom of the brushwork, in the unstable breath of shadows of uncertain origin, shadows of conscience, not of bodies or things. In Neri's portrait everything is recomposed, the image returns to being static, the Pope is firmly on his throne. Who knows who else besides Velázquez will have perceived the difference, even while admiring the commitment and the passion of his diligent follower? Too diligent, so much so as to dare to correct him by rehabilitating the rhetoric of power that Velázquez had raised to a crisis of conscience and of history. Individual torment is here an affirmation of the Church's power, like all powers, cruel.

Vittorio Sgarbi

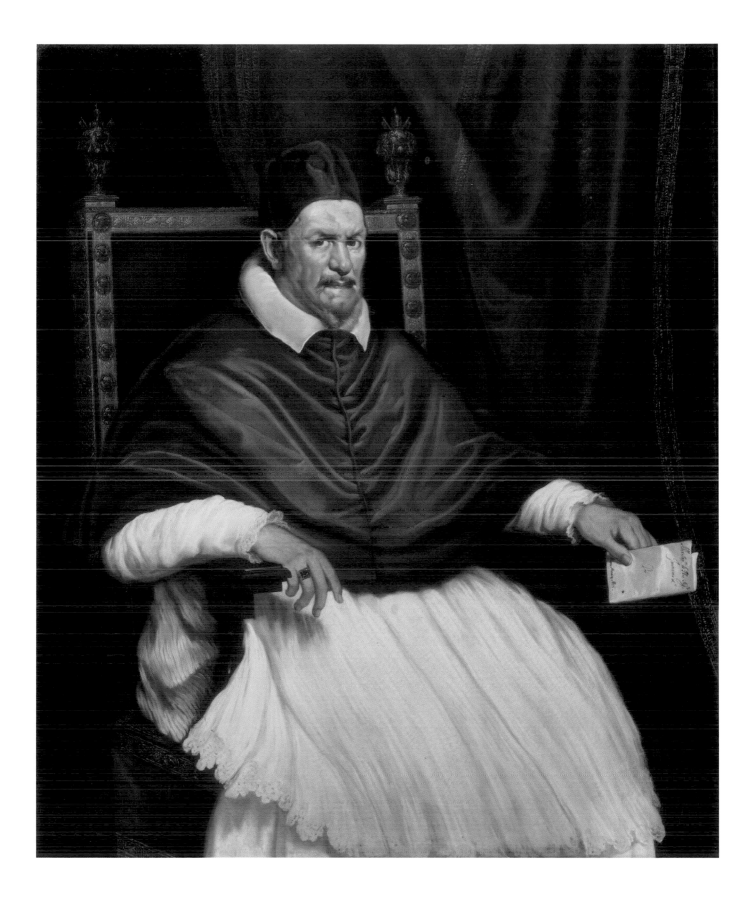

Louis Cousin, called Luigi Gentile or Luigi Primo
(Brievelde, Ninove 1604/1607 – Brussels 1667)

Portrait of Alexander VII (Fabio Chigi, 1655-1667)
oil on canvas, 163 x 121 cm.
Vatican City, Vatican Museums, inv. MV 41244

Bibliography: F. Petrucci, 2004b, p. 31, fig. 31

This painting was bequeathed to the Vatican collection by monsignor Clement Munghia. It bears an apocryphal inscription with an unlikely attribution to Domenichino and a previous identification as Pope Gregory XV. Its stylistic motifs and its perfect correspondence with a passage in Giovanni Battista Passeri's *Lives* make certain the painting's attribution to the Flemish portraitist Louis Cousin, known as "Luigi Gentile or as Luigi Primo". (1)

It seems that the portrait represents the first official image of the newly elected Pope, as testified by Passeri: "... and the first portrait made of the new Pope, seated in a room at a small table in the act of benediction was made by Luigi Gentile..." Therefore it was presumably executed in the spring of 1655.

The construction of the form in pictorial terms, the softness of its treatment, the small dabs of pigment and running brushstrokes recall other paintings by the artist, such as the portrait of Mario de Gayassa, Marquis of Massanova in the Musée Royaux des Beaux-Arts at Bruxelles or that of Jacques de Barthos in the National Gallery at Rome, recently improperly attributed to David Beck. (2)

The painting therefore represents an important work in the very vast corpus of images of Alexander VII, who was portrayed in sculpture by Bernini, Caffà, Guidi, Mazzuoli and Fioriti, and in paintings by Mola, Giovanni Maria Morandi, Abbatini and Baciccio, but also in untraced canvases by Pierre Mignard, Pietro da Cortona, Bernardino Mei, Guglielmo Cortese "il Borgognone", Denis Duchesne, and Alessandro Mattia da Farnese. The present work seems to have inspired the portrait of Innocent XI in the Sacchetti Palace, perhaps attributable to Giuseppe Passeri. (3)

The Flemish painter was in Rome from 1626 to 1656, and served as President of the Academy of Saint Luke in 1651-52. Passeri specified that "in making portraits, he was the equal, perhaps the better, of all others, because we see in him a certain precision in design and composition..." An engraving by Pierre de Jode instead documents a lost portrait of Clement IX. Despite Louis Cousin's vast production of portraits, very few examples remain. Extant paintings include the portrait of Saint Winok painted in 1640 for the brotherhood of San Giuliano dei Fiamminghi [St. Julian of the Flemish], where it is still found today, those of Jacques de Barthos (Rome, National Gallery of Ancient Art), of Jean Poplawski (Warsaw, National Museum), of Mario de Gayassa, Marquis of Massanova and of Marie-Louise de Crombrugge (Bruxelles, Musée Royaux des Beaux-Arts). I recently proposed attribution to him of the portrait of Cardinal Nicola Albergati Ludovisi (private collection). (4)

Fabio Chigi (Siena 1599 – Rome 1667), after a brilliant career which led him to serve as Apostolic Nuncio at Cologne, plenipotentiary for the Peace of Westphalia and Secretary of State for Innocent X, ascended to the Papal See with the name of Alexander VII on April 7, 1655. He fought against Jansenism and welcomed Queen Christina of Sweden to Rome, but he distinguished himself principally for his great artistic patronage, with particular attention to urban planning and architecture. He commissioned great works from Bernini, Borromini and Pietro da Cortona: from the layout of St. Peter's Square, Piazza Colonna and Piazza del Popolo, to the restoration of the Pantheon and of the churches of Santa Maria della Pace and Santa Maria del Popolo. His ambitious urban planning program prompted famous pasquinades jesting that he was afflicted by "stone disease" (in fact he did suffer from kidney stones) and that he was a "Pope of great edification." (L. von Pastor, vol. XIV, 1932).

Francesco Petrucci

1) See G. B. Passeri, ed. 1934, pp. 243-244; L. Van Puyvelde, 1958, pp. 629-637; D. Bodart, 1970, pp. 154-167; G. Jansen, P. C. Sutton, 2002, pp. 18, 22-23, 26; F. Petrucci, 2005, sheet 8, p. 45
2) See G. Capitelli, sheet 24, in R. Morselli, R. Vodret, 2005, pp. 176-177
3) See S. Guarino, sheet in in *Papi in posa...*, 2004, p. 90
4) See F. Petrucci, 2005, p. 45

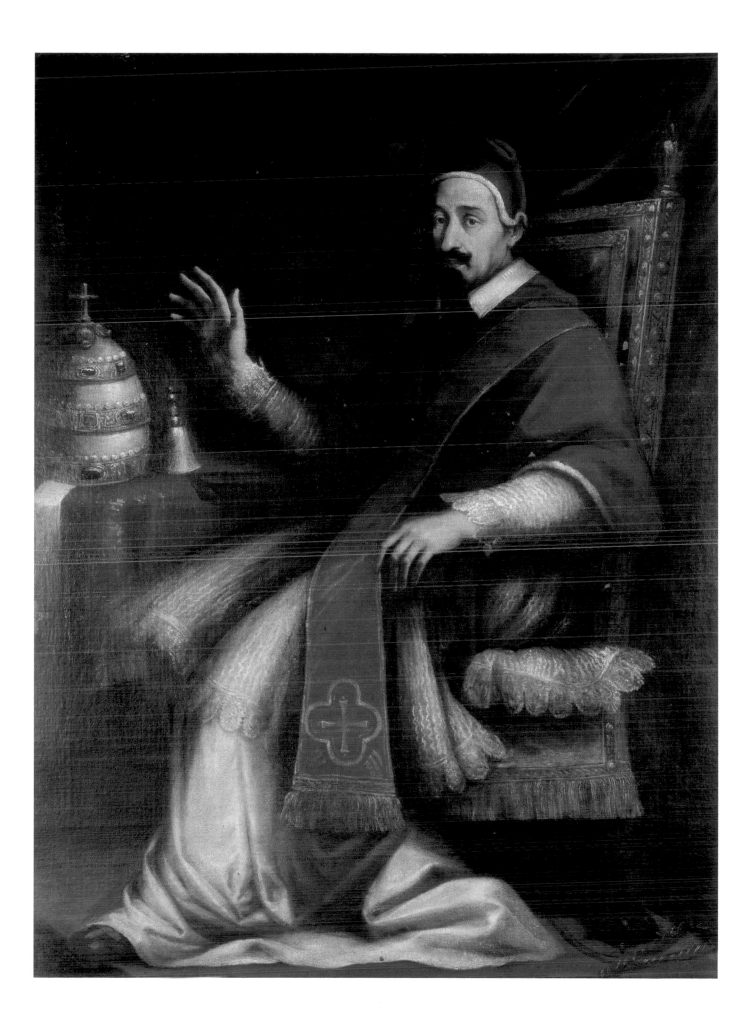

Giovanni Battista Gaulli, called "il Baciccio"
(Genoa 1639 – Rome 1707)

Portrait of Alexander VII (Fabio Chigi, 1655-1667)
oil on canvas, 90.1 x 76.7 cm.
Baltimore, Walters Art Gallery

Bibliography: E. van Esbroeck, 1897, no. 350; R. Enggass, 1964, p. 131; F. Zeri, vol. II, 1976, pp. 452-453; F. Petrucci, 1994, p. 95; M. Fagiolo dell'Arco, sheet 34, in M. Fagiolo dell'Arco, F. Petrucci, 1998, p. 133, fig. c p. 135; F. Petrucci, sheet 5, in M. Fagiolo dell'Arco, D. Graf, F. Petrucci, 1999, p. 107, fig. p. 108

This portrait was acquired at Rome in 1902 by Mr. Henry Walters together with other works in the collection of Don Marcello Massarenti. The painting's provenance is probably from the Chigi collection, along with the portrait of Sigismondo Chigi in the uniform of the Grand Prior of the Order of the Knights of Malta in the same museum, also by Gaulli but previously attributed by Zeri to Voet. (1)

Considered by Suida as a Baciccio original (oral communication, 1939), the portrait was published by Enggass as a "good studio copy" and by Zeri as "Workshop of Baciccio." Its quality was reconsidered by Fagiolo dell'Arco (who withheld judgment because he had not personally viewed the painting); it was attributed to the Genovese master by the undersigned in the catalog of the 1999 monographic exhibition at Ariccia.

The original prototype was the lost canvas previously in the Messinger collection at Rome, of which several replicas and very many copies are known. Nevertheless, all the replicas are derived from a model that introduced an extension of the *mozzetta*, inserting six pairs of buttons instead of six and conferring a monumentality upon the figure that is absent in the Messinger canvas. Among the best versions are the portrait at the Civic Museum of Udine, the one in the Chigi collection at Castel Fusano (previously at London, Heim Gallery) and of course the American canvas, which introduces a lightening in the color of the *mozzetta*. Versions that can be attributed to the workshop are in the Chigi collection at Castel Fusano, in the Chigi Palace at Ariccia, in the Stuttgart National museum, and in the town hall of Siena. (2)

However, it is necessary to point out that among the papers of Cardinal Flavio Chigi two replicas of 1667 and 1671 are documented, while others may have been requested by princes and cardinals, as was the custom. The portrait dates back to December 1666, as recalled in a passage from the Pope's diary dated December 19th. On the following December 25th, Ugo Rangoni, correspondent of the Duke of Modena at Rome, testified to the instant success of the portrait: "The Pope has allowed himself to be painted and Your Highness may be sure that never has a more beautiful [portrait] been made."

The picture shows the Pope seated before a table, conferring benediction with one hand and holding a letter in the other, in an innovative marriage between Passerotti's *Pius V* and Guercino's *Gregory XIII*; however, the face is distinguished by the particular vivacity of its expression and the sense of vitality that demonstrate an assimilation into painting of Bernini's innovations in portraiture. The rapid heightening of color in linear strokes is characteristic of Baciccio and serves as a formal reference for many other portraitists who would imitate the style of the Genovese master.

Francesco Petrucci

1) See F. Zeri, 2 vol., 1976, p. 456; F. Petrucci, 1994, p. 93
2) See F. Petrucci, 1999, pp. 106-107

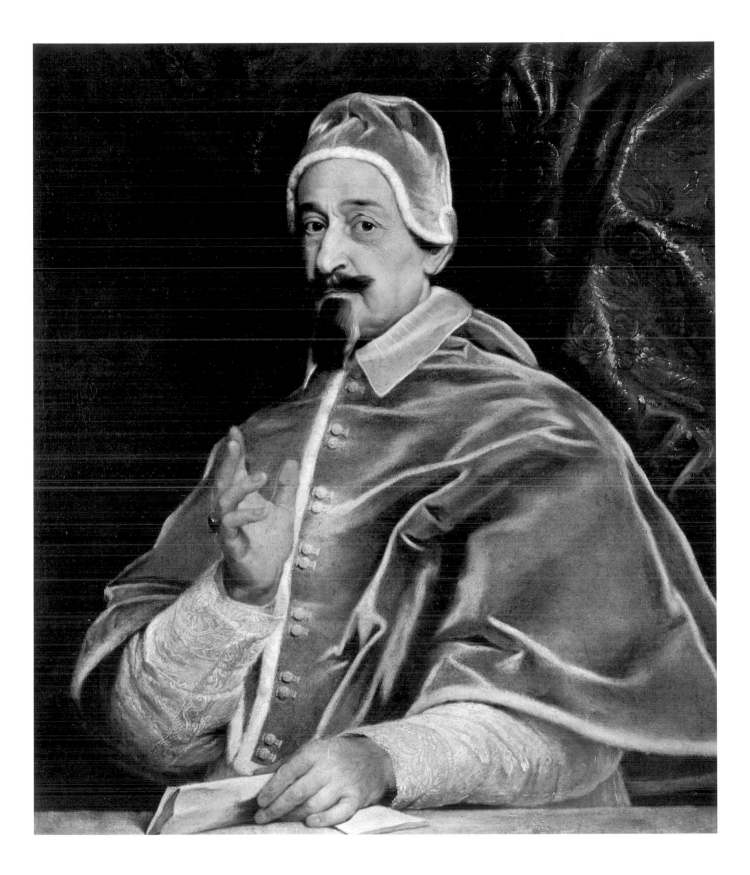

Giuseppe Mazzuoli
(Volterra 1644 – Rome 1725)

Bust of Alexander VII (Fabio Chigi, 1655-1667)
marble, 77.5 x 71 x 37.5 cm.
pedestal in marble, h 19.5 cm.
Ariccia (Rome), Chigi Palace, inv. 1268

Bibliography: R. Wittkower, 1955, p. 227 (also in subsequent editions); V. Martinelli, 1956, pp. 44-46; F. Petrucci, 1993, p. 95; A. Bacchi, 1996, p. 823; A. Angelini, in M. Fagiolo dell'Arco, F. Petrucci, 1998, pp. 80-81; F. Petrucci, 1993, sheet 79, p. 119

This portrait, included by Rudolph Wittkower in the list of "Berninesque busts" of Alexander VII, was considered by Valentino Martinelli to be a derivation of the bust in the Incisa della Rocchetta collection, which he attributed to Mazzuoli. It was returned to the Tuscan sculptor by the undersigned on the basis of documentation, with confirmations by Andrea Bacchi and Alessandro Angelini. The bust is one of the three known versions of Mazzuoli's portrait of Alexander VII, two of which are kept in the Palace at Ariccia, while the one in the Incisa della Rocchetta collection, stolen in a robbery, remains lost. They probably formed part of a collection of papal busts recorded in the Chigi Palace at Rome in 1707: "several busts of Alexander VII and other notable persons of the House of Chigi executed by Bernini and by other famous sculptors." (1)
In the 1692 inventory of the cardinal Flavio Chigi was "Un Busto della S. Me. di papa Alessandro 7° mano del S.r Giuseppe Mazzuoli senese con il suo piedestallo di pero dorato". Documented among the "Statues of the Excellent House" in the 1693 inventory of the Chigi Palace of Rome were "A Portrait of Pope Alexander VII of sacred memory, in marble with a square base, and a pedestal of black pearwood, with several gilt decorations"; number 98 among the "Statues in the estate of Signore Cardinal Flavio Chigi, of cherished memory" is "A Portrait of Pope Alexander VII of sacred memory, in marble with similar squared base, and pedestal in black pearwood, with metal decoration." We do not know if these are Mazzuoli's, although one of the two Ariccia busts was present in the "antechamber of prince Ludovico" in the Palace at Piazza Colonna prior to its sale to the State, as documented by photograph of about 1914. (2)
The execution of the papal portrait by the Sienese sculptor is remembered by Pascoli, who said that Mazzuoli, once he had finished the monument to Clement X in the Vatican Basilica, "put his hand to the portrait of Alexander VII and of two cardinal nephews, and once they were completed, they were highly appreciated." Archival documents published by Golzio and by the undersigned reveal that the Chigi family commissioned at least six busts of Alexander VII from Mazzuoli. Payments in 1680 and 1681 in Flavio [Chigi]'s account books concern two busts, one of which was sent to the Cetinale Villa at Siena. Between 1678 and 1682 Agostino Chigi paid Mazzuoli for four more busts of the Pope. (3)
This portrait, inspired in its idealized approach by Melchiorre Caffà's bust today in the Palace at Ariccia, is distinguished from Mazzuoli's other bust at Ariccia by the absence of pupils [in the eyes]. Mazzuoli's Pope is monumental in stature, with an erect chest and an imposing presence. In this it differs from Melchiore Caffà's realistic bust, which represents Alexander as thin and sickly with stiff shoulders, but with a very vivid expression.

Francesco Petrucci

1) See R. Lefevre, *Chigi Palace*, Rome 1973
2) Vatican Apostolic Library, Chigi Archive, no. 700, p. 146, no. 1805, pp. 150, 155; F. Petrucci, 2001, pp. 110, 121
3) See V. Golzio, 1939, pp. 232-233; F. Petrucci, 1993, pp. 93-95

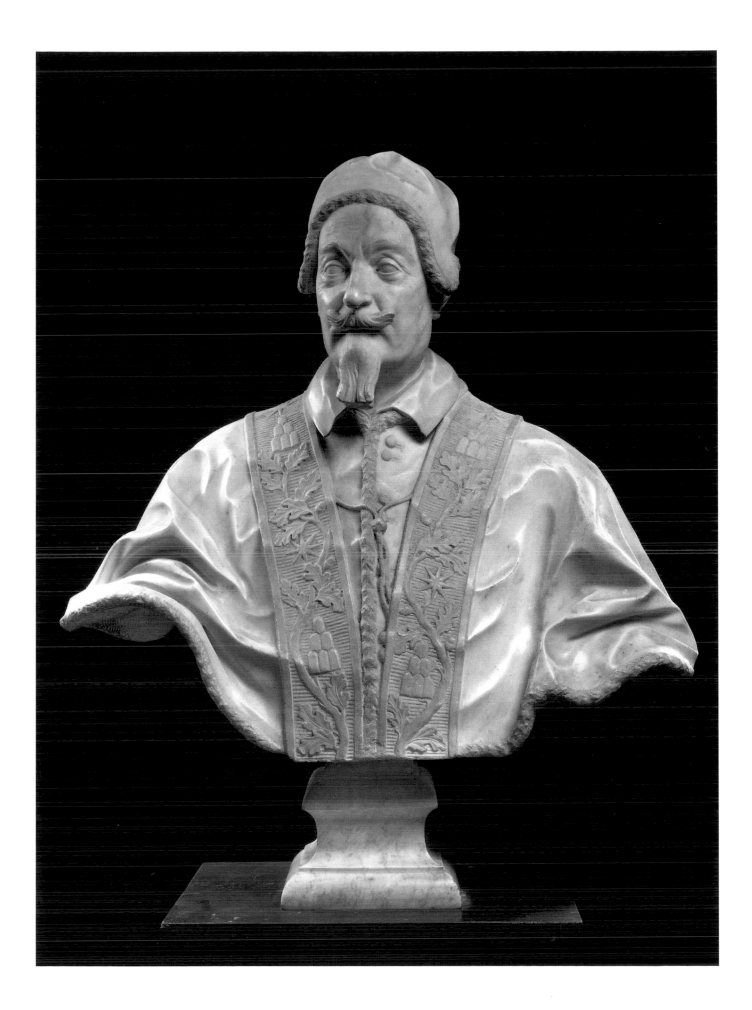

Giovanni Battista Gaulli, called "il Baciccio"
(Genoa 1639 – Rome 1707)

Portrait of Clement IX (Giulio Rospigliosi, 1667-1669)
oil on canvas, 74 x 60 cm.
Ariccia (Rome), Chigi Palace, inv. 1238

Bibliography: E. Waterhouse, 1937, p. 68; M. V. Brugnoli, 1949, p. 238; F. Zeri, 1955, p. 55; idem, 1959, p. 124; R. Enggass, 1964, p. 81; F. Petrucci, 1992, p. 113; idem, 1994, p. 92; M. Fagiolo dell'Arco, R. Pantanella, 1996, no. 5, p. 41; F. Petrucci, 1997, p. 43; A. Negro, sheet 39, in M. Fagiolo dell'Arco, F. Petrucci, 1998, pp. 145-147; idem, 1999, p. 59; M. Fagiolo dell'Arco, sheet 6, in M. Fagiolo dell'Arco, D. Graf, F. Petrucci, 1999, pp. 109-110; idem, in C. d'Afflitto, D. Romei, 2000, p. 83; F. Petrucci, 2003, p. 71; F. Checa Cremades, 2004, III.3, fig. pp. 293-294

This portrait, which certainly represents the masterpiece of Baciccio's already astonishing portraiture production, distinguishes itself as a benchmark of the Roman Baroque, and as one of the greatest achievements of seventeenth century portraiture. The painting's significance is highlighted by its extraordinary carved wooden frame, with gilded molding and red velvet trim, executed by the great Berninian carver Antonio Chicari perhaps according to a design by Carlo Fontana or Giovanni Paolo Schor. (1)

Ellis Waterhouse, Maria Vittoria Brugnoli and Robert Enggass have cited the painting as an autograph replica of the canvas at the Rome National Gallery of Ancient Art. The portrait was exhibited in 1951 at the *Papal Portraits Exhibition* without a published image; Federico Zeri, who unlike the other scholars had viewed the work several times, was the first to recognize that its quality was superior to all other versions: "the Clement IX series [is] exemplified by this stupendous work in the Chigi Collection at Ariccia." The undersigned published the first image of the painting in 1992, in a critical essay on Gaulli's works for the House of Chigi that appeared in the *Bollettino d'Arte* [Bulletin of Art], which also featured the work on its cover. Its unique qualities were also exalted by Angela Negro and Maurizio Fagiolo dell'Arco. Ferdinando Checa requested the portrait for *The Courts of the Baroque* exhibition held at Rome at *Le Scuderie del Quirinale* [Quirinal Palace Stables] in 2004, and published two images of it.

The painting must be linked to a payment to Bacciccio from Cardinal Flavio Chigi dated October 7, 1667, just three months after the papal election. It was displayed under the *baldacchino* in the Throne Room reserved for the Pope in the Chigi Palace located at Piazza Santi Apostoli [Rome], designed for the cardinal by Bernini. (2)

The portrait's introspective force is remarkable, which renders well the Pope's spirituality, but also the fragility of his health. The flesh tones are extraordinary, as are the ripples in the satin *mozzetta* under the vibration of the light (the portrait must have been executed during the summer) and the sure and rapid definition of the blessing hand and the embroidered cuff. Its expression is intense, obtained by translating the "glassy" veiled glance typical of an elderly person and even the senescent pink flesh tones. The portrait therefore demonstrates a supreme synthesis of reality and artifice (witness the Baroque sinuosity of the *mozzetta*), an amalgam between naturalism in the Flemish tradition and its descent from Van Dyke, typical of Gaulli's Genovese training (exemplified in the adoption of delicate glazes) and the search for the instant vitality of Bernini's Baroque.

As underlined by Fagiolo dell'Arco, the painting probably is the first sitting from which derives the also very remarkable replica at the Rome National Gallery of Ancient Art. The precedence is justified by the fact that Flavio Chigi contributed in a determinant manner to the election of the Pope, also grateful to Alexander VII for the privileges granted to him. Compared to the cornerstones in the Chigi and Rospigliosi collections all other versions, including those from the Pallavicini Gallery and the Academy of Saint Luke in Rome, seem to be workshop production or modest derivations.

In this case the Genoese painter, pupil of Bernini, achieves a level that is comparable to such great portraitists as Rubens, Van Dyck and Velázquez. The composition is linked to Baciccio's previous portrait of Alexander VII, but with a reduction in size to the half bust format, without the left arm in evidence.

Giulio Rospigliosi was born at Pistoia in 1600. After having served as Apostolic Nuncio in Spain and Secretary of State for Alexander VII, who made him a Cardinal, he was elected Pope on June 20, 1667. His papacy lasted just two years and is remembered more for his patronage of the arts (the apse of the Church of Santa Maria Maggiore, the Ponte Sant'Angelo), his literary and poetic talent and his love of the theatre (he was the author of religious plays), than for his actual spiritual and political significance. (L. von Pastor, vol. XIV, 1932).

Francesco Petrucci

1) On the frame, see F. Petrucci, 2003, sheet 86, p. 125
2) See V. Golzio, 1939, pp. 60, 289

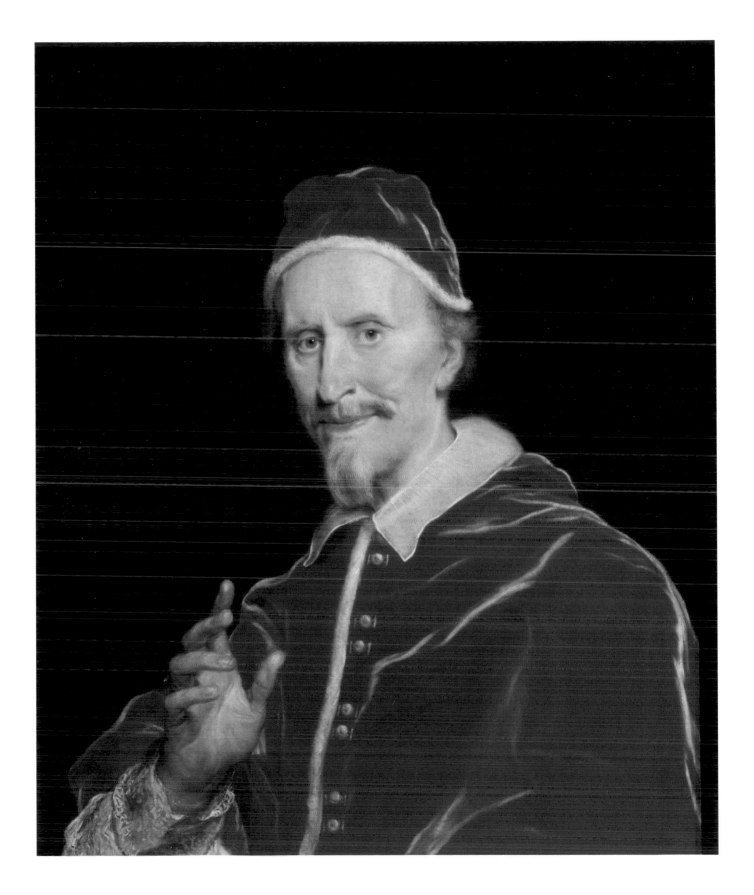

Attributed to Giovan Lorenzo Bernini
(Naples 1598 – Rome 1680)

Bust of Clement X (Emilio Bonaventura Altieri, 1670-1675)
bronze, h 91.4 x 71.5 x 36.1 cm.
Minneapolis, The Minneapolis Institute of Arts, inv. 59.7

Bibliography: J. T. Spike, 1984, pp. 34-41, 98-99, cat. 28; E. Villa, 1996, pp. 141152; F. Petrucci, sheet 59, in M. G. Bernardini, M. Fagiolo dell'Arco, 1999, pp. 344-345

This bust, which Anthony Clark believes to be the work of Lucenti, was attributed to Guidi by Merribell Parson and assigned to Bernini by the undersigned, with confirmation in oral communications of Maurizio Fagiolo dell'Arco, Oreste Ferrari, Alessandro Angelini and other scholars. Spike theorized that its provenance may be from the choir of the Church of Santa Maria in Montesanto, although the plaster cast kept there and probably derived from a lost bust is something else entirely.

In 1688 Nicodemus Tessin recalled actually having seen two busts by Bernini depicting Pope Clement X (1670-1676) at the Altemps Palace: one in bronze and one in marble. Most probably, the bronze remembered by Tessin is the one whose casting in all of its phases was overseen by Bernini's student and collaborator Giovanni Battista Gaulli, called "il Baciccio", in 1671.

In confirmation, the bronze from the American museum is striking in the Pope's vigorous expression and frown, such as to deem it a youthful portrait from life. It is a work of very high quality, which melds sharp firsthand observation and vitality with an attempt at idealization, such as to exclude without doubt its attribution to Guidi. In fact, Guidi's portraiture evolved in the classical sense and with a measured religiosity derived from his teacher Algardi, and although he shared in the great innovations brought to the genre by Bernini, he cooled the tones according to the rules for balance and the search for symmetry, with a tendency to schematization.

The recent rediscovery of the marble bust of the youthful Alexander VII by Alessandro Angelini establishes a strong continuity between these two portraits, models for subsequent papal portraiture in the dynamic emphasis of the overdone crumpling of the *mozzetta*, with a notable pyramidal development of the composition. The long stole has the same extraordinary design, with the crossed papal keys hovering foreshortened in the empty space between the palm-leaf decoration. The raised right arm, a feature of papal sculptural iconography that was expressed for the first time in Bernini's bust of Urban VIII and above all in that of Alexander VII, here finds a moment of disclosure through the casting of models in bronze, of which this one was probably not the only example.

Emilio Bonaventura Altieri (1590-1676) was born in Rome on July 13, 1590 to a Roman family of ancient origin. After having served in several nunciatures, he was created Cardinal by Clement IX in 1669. He was elected Pope on April 29, 1670 at age 79, and chose the same name as his predecessor in his honor. He delegated papal administration to his relative by marriage, Cardinal Paluzzo Paluzzi Altieri, to assist him in those duties that he was unable to fulfill due to his advanced age. He gave financial assistance to Jan Sobieski in the war against the Turks and tried to pacify relations between France and Spain, but without success. He proclaimed the Jubilee Year of 1675, during which the tabernacle of the Holy Sacrament, executed by Bernini in the Vatican Basilica, was inaugurated. He died on June 22, 1676 (L. von Pastor, vol. XIV, 1932).

Francesco Petrucci

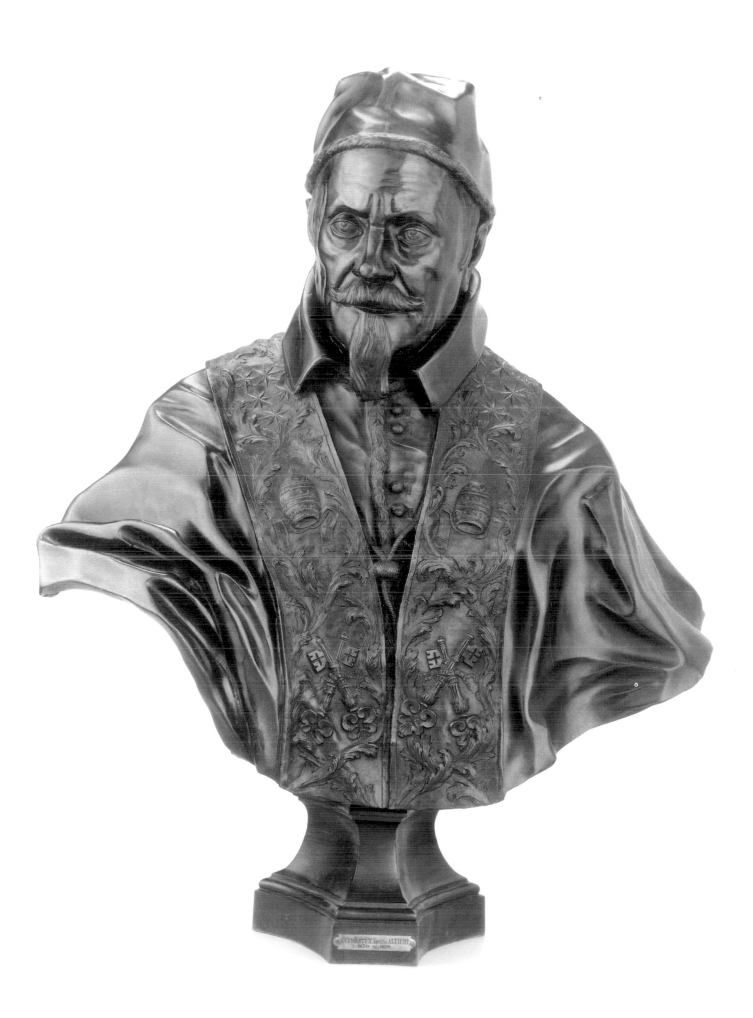

Giovanni Battista Gaulli, called "il Baciccio"
(Genoa 1639 – Rome 1709)

Portrait of Clement X (Emilio Altieri, 1670-1676)
oil on canvas, 69.5 x 57.5 cm.
Florence, Uffizi Gallery, inv. 1890/2635

Bibliography: S. Meloni Trkulia, 1979, p. 746; E. Villa, 1996, p. 149, no. 36; F. Petrucci, 1999, p. 113, sheet 11a; idem, 2001, pp. 20-21, fig. b; M. Fagiolo dell'Arco, 2001, p. 20; M. A. Nocco, in *Papi in posa...*, 2004, p. 88

This painting, cited by Villa and conserved in the Uffizi's storerooms with the generic attribution "Florentine School", was recently attributed to Gaulli by Petrucci, with confirmation from Maurizio Fagiolo dell'Arco, and displayed in the monographic exhibition at Ariccia in 1999. As of this date, six other versions of this painting exist, inserted by scholars into the *corpus* of Gaulli's portrait paintings: the Palazzo Pitti painting, like the one from the Uffizi, originating from the Medici family collection (F. Petrucci 1999, p. 113, sheet 11 b); the signed work from Maurizio Marini's collection (M. Fagiolo dell'Arco, S. Carandini, 1977, p. 263); the one from H. Alexander Kossodo's collection at Miraflores (Lima) returned to Gaulli by Brugnoli (1966, p. 73; F. Petrucci, 1999, p. 114 sheet 11a); the version kept at Stuttgart in Gripsholm Schloss is considered an original Gaulli (E. Villa, 1966, p. 143, fig. 8; A. Haidacher, 1965, p. 626); a copy is exhibited in the Gallery of Papal Portraits in Palazzo Altieri at Oriolo Romano (E. Villa, 1996, p. 143, 149, fig. 10; F. Petrucci, 1997, a, p. 49) and yet another version of the painting (kindly brought to my attention by Petrucci) recently passed from Christie's New York (January 2004, lot 192) with an attribution to the Genovese painter. Distributed among museums and private collections, the seven portraits, including the canvas examined here, appear very similar, especially in the layout of the composition. Only the measurements differ, making it difficult to distinguish-at least until new documentary evidence is found-between the original and the signed replicas or workshop copies. The difficulty increases due to the impossility of a direct comparison between the numerous versions and because some of the pictures, today in private collections, are known only through black and white photographs. As revealed by the *post mortem* inventory by the painter's son Giulio, written in 1761 by Ludovico Mazzanti (along with Giovanni Odazzi, a faithful student of the Genovese painter) it was not unusual for Gaulli to execute and keep, perhaps for didactic reasons, some replicas of his successful paintings; in the house-workshop located on Via del Parione there were moreover about forty *memorie* [reduced-scale portraits, retained as treasured keepsakes] of celebrated portraits commissioned from the artist by the leading figures of the day, from the *"Portrait of Pope Albani"* to *"Two portraits, one of Pignatelli, the other of Pope Albani"*, the effigies of Popes Innocent XII and Clement XI and those of his patrons Gian Lorenzo Bernini, Giovan Paolo Oliva and Queen Christina of Sweden. (M. Fagiolo dell'Arco, R. Pantanella, 1996, pp. 26, 32).

Furthermore, over the course of his life, the artist had had the privilege of painting the portraits of seven Popes-from Alexander VII Chigi to Clement XI Albani (L. Pascoli, 1730-36, p. 280) – and from these portraits had later derived the numerous versions. These include *"Two portraits of Our Lord Pope Clement X in canvas of three* palmi [in height]" and *"A head made on a large canvas in said Pope's Antechamber"* commissioned from the Genovese painter in June 1671 by Cardinal Flavio Chigi for the palazzo at SS. Apostoli (V. Golzio, 1939, p. 291, no. 1411), and *"A portrait of Clement X of sacred memory, by Baciccio's hand"* (J.A.F. Orbaan, 1920, p. 517) recorded in the inventory of Cardinal Camillo Massimi and presently in the Marini collection. With respect to the numerous replicas, the Genovese biographer Carlo Giuseppe Ratti – after having recalled the high esteem that Gaulli enjoyed from Clement IX, Clement X and Innocent XI – cites *"the many portraits of them that he had to do"* (C.G. Ratti, 1769, p. 82). In addition to the biographical data, Gaulli's portrayal of the Altieri Pope is recorded in an engraving by Pierre Simon kept at the British Museum (No. 1876 -7-8-111; fig. 5) and published by Petrucci (2001, p. 20, sheet 11 a, b), which is certainly derived from one of the numerous versions of Clement's portrait.

The Uffizi painting can be dated circa 1671, as evidenced by the two Chigi portraits executed and documented in the same year and of which ours could be a derivation or even one of the two originals. Its pictorial accuracy is evident above all in the calligraphic description of the wrinkles of the *mozzetta* and in the pronounced bags under the eyes, which, in tandem with the heightened expressive intensity of the subject, makes its attribution to Baciccio a certainty. Having Bernini's hallmark in its extremely lively and engaging interpretation of the subject, who carefully "scrutinizes" the observer instead of passively allowing himself to be admired, the Florentine canvas portrays the Pope in three-quarter view according to that particular manner recalled by Ratti: *"after having scrupulously drawn that portrait that he was blocking out, he allowed the subject complete freedom to speak, to laugh, and even to move his head"* (N. Ratti, 1769, p. 88). The pinkish-grey tones of the face pass to the ruby-red tones of the *camauro* and the *mozzetta* and the white tones of the ermine border and the transparent organdy collar. Typical of the Genovese painter is this treatment of drapery, wrinkled and crumpled, over free and expansive backgrounds as in the portraits of Cardinal Neri Corsini, Cardinal Leopoldo de' Medici or that of Alexander VII. (1)

Maria Antonia Nocco

1) See for references in the text. M. Fagiolo dell'Arco, S. Carandini, 1977, p. 263; M.V. Brugnoli, 1966, p. 173; E. Villa, 1996, pp. 143, 149 no. 36, figs. 8, 9, 10; F. Petrucci, 1997, pp. 47, 54, figs. 28, 57; A. Haidacher, 1965, p. 626; J.A.F. Orbaan, 1920, p. 517; C.G. Ratti 1769, p. 82, 88; M. Fagiolo dell'Arco, 1997, fig. p. 449; Christie's New York 1/23/04, lot 192.

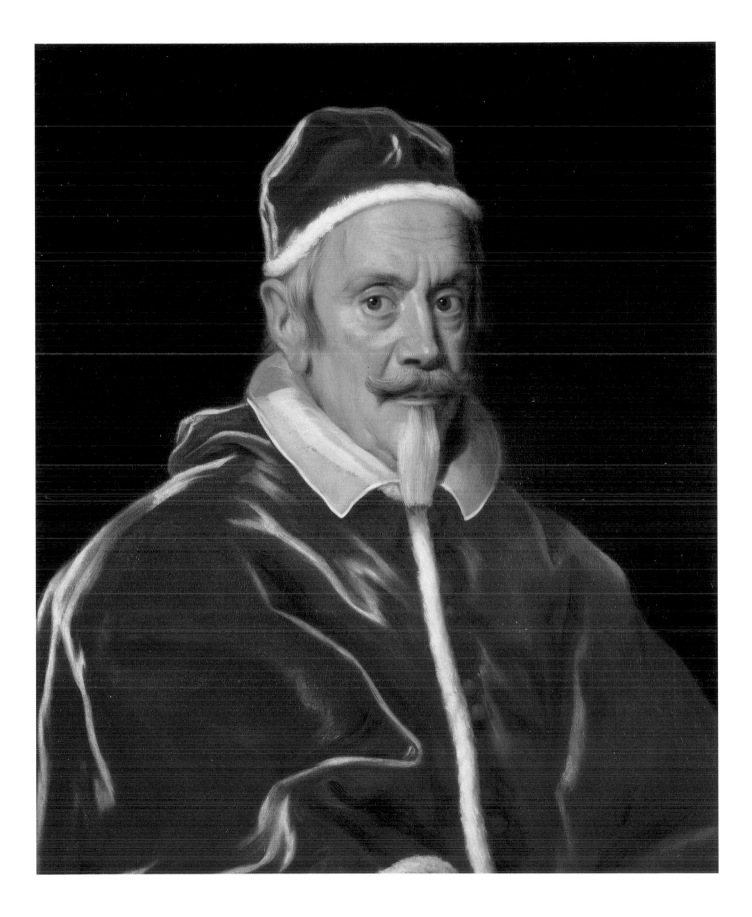

Workshop of Giovanni Maria Morandi
(Florence 1622 – Rome 1717)

Portrait of Innocent XI (Benedetto Odescalchi, 1676-1689)
oil on canvas, 65 x 51 cm.
Ariccia (Rome), Chigi Palace
Recovered by the Financial Police, Archeological Patrimony Protection Group

Bibliography: F. Petrucci, 2004, sheet 30, pp. 111-112; id., in *Papi in posa…*, 2004, p. 92

Innocent XI's portrait, stolen from a private collection in 2000, was recovered by the Archeological Patrimony Protection Group of the Financial Police as it was about to be put on the art black market. At the time of its recovery the oil [painting] revealed serious damage to the support with a relative loss of color, restored – during the organization of the previous exhibition *Papi in posa* in 2004- by the Palazzo Braschi restoration laboratory. It had an advance showing last spring at the exhibition *The Faces of Power*, held at Chigi Palace in Ariccia, prior to the conservation effort in 2004 which allowed an improved reading of the painting. The portrait was donated to the Chigi Palace in Ariccia by Dario De Martinis in june 2005, thanks to the interst of Financial Police, Archeological Patrimony Protection Group.

The picture is a workshop copy of the lost *Portrait of Innocent XI* executed by Giovanni Maria Morandi, known through the two oval engravings by Albert Clouwet published by Giovan Giacomo De Rossi. In both engravings, printed on facing pages (Rome, Gabinetto Nazionale delle Stampe, CL 21185/525 and FC 121257), Morandi is credited with the design.

A portrait of Innocent XI was purchased by Livio Odescalchi in 1677, while two autograph portraits of the Pope by Morandi *"in tela da tre palmi"* (on canvas, measuring three *palmi*, ie., 75 centimeters or about 29.5 inches) are recorded in the Odescalchi inventory of 1713-1714.

Given the Pope's unwillingness to be painted, Morandi probably did not obtain the privilege of a live sitting and as the iconographic comparison demonstrates, had to base his work on the portrait painted by Jacob Ferdinand Voet (Rome, Palazzo Odescalchi), in turn derived from the portrait of Odescalchi as a Cardinal (Milan, Poldi Pezzoli Museum; Munich, Staatsgemäldegalerie).

The painting, attributed to Carlo Maratta on the label atop the frame, is of inconsistent quality: the face is superbly executed, while the *mozzetta* is painted more mechanically, in keeping with common workshop practice of the seventeenth century.

Francesco Petrucci

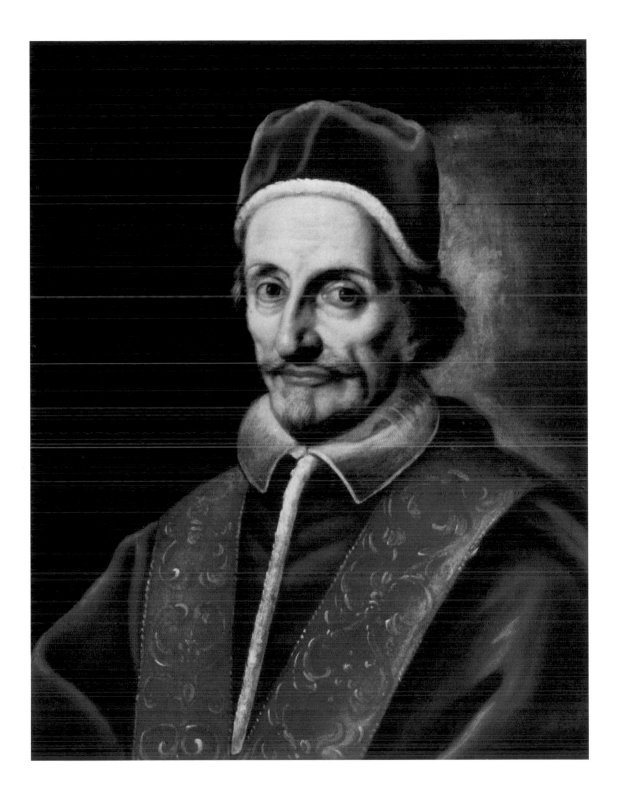

Anonymous Roman Sculptor, late eighteenth – early nineteenth century

Bust of Innocent XI (Benedetto Odescalchi, 1676-1689)
marble, 53 x 50 x 23 cm.
Rome, Convent of Santa Francesca Romana

Bibliography: unpublished

This small bust is conserved in a parlor in the convent of Santa Francesca Romana in Rome, and so far as I am aware it has never been published. The Pope is portrayed in a symmetrical frontal pose, wearing the *mozzetta* and *camauro* and a stole bearing the heraldic symbols of the House of Odescalchi: the eagle, the lion, and a censer.

The Pope's physical features are standardized in keeping with the abstract formalism common to all Innocentian portraiture, evidence of Innocent's disinterest in art and a product of his disdain for ostentation and for the custom of posing [for state portraiture]. For these reasons many portraits of Innocent XI are posthumous. All his painted portraits and, I believe, also those executed in sculpture derive from Ferdinand Voet's portrait of Odescalchi as a Cardinal, the latter known through engravings beginning with that of François Spierre. Sculpted portraits of Innocent XI include a terracotta in the Doria Pamphili Palace of Rome, a bronze bust in Rome's Vallicelliana Library and one previously at the Church of Santa Maria in Montesanto; the marble busts in the cathedral of Como, in the *Ambrosiana Library* and one still in the Odescalchi residence in Rome. To these are added bas-relief portraits in the Copenhagen Art Museum, the Kunsthistorisches Museum of Vienna and the Lanckoroski Palace at Vienna, in addition to numerous versions that passed through the market, some attributed to François Etienne Monnot. The French sculptor was the official portraitist of the House of Odescalchi: he executed portraits of the Pope's nephew Livio Odescalchi and the effigy on the Pontiff's funerary monument in the Vatican Basilica, signed and dated 1700. (1)

It would seem that this small bust is a derivation of the face in that portrait, while the folds of the *mozzetta* reveal the evolution of Bernini's abstract drapery style that characterized the late Roman Baroque period.

Benedetto Odescalchi was born at Como on May 19, 1611. Schooled by the Jesuits in his native city, he later studied law at Rome and Naples. He was nominated apostolic protonotary by Urban VIII, was president of the Apostolic Chamber, commissioner at Ancona and governor at Macerata. Created Cardinal by Innocent X in the consistory of March 6, 1645, he was prefect of the Tribunal for the Assignment of Pardons and legate at Ferrara in 1648. He became bishop of Novara in 1650, then Chamberlain of the Sacred College of Cardinals. He was elected Pope on September 21, 1676. Innocent XI is remembered for his strenuous fight against nepotism and for the strict moral rigor of his papacy. He distinguished himself by supporting the fight against the Turks and by condemning Quietism and Jesuit Probablism. His break with France and Louis XIV, whom he accused of excessive support for the autonomous ambitions of the Gallican Church that sought to limit papal authority in secular matters, was sensational. He died at Rome on August 12, 1689. (L. von Pastor, vol. XIV, 1932).

Francesco Petrucci

1) See A. Bacchi, 1996, pp. 826-827.

124
Papi in Posa
Catalogue

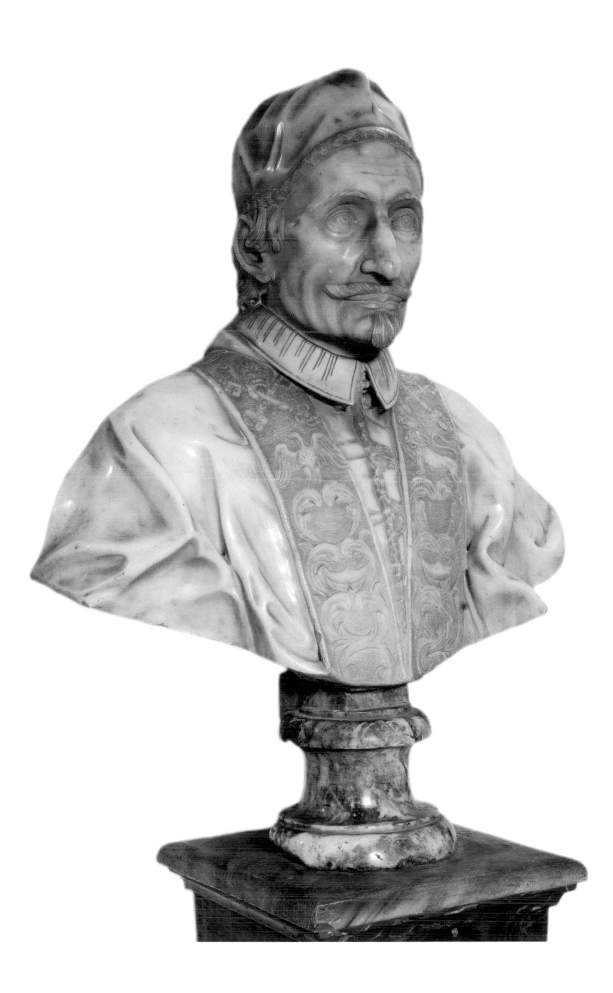

Giovanni Hamerani
(Rome 1649-1705)

Medallion with portrait of Alexander VIII (Pietro Ottoboni, 1689-1691)
bronze, diameter 172 mm.
Medallion with portrait of Alexander VIII (1689-1691)
gilded bronze, diameter 119 mm.
Rome, Antonio Pettini collection

Bibliography: unpublished

The first medallion (a plaque or plaquette, since the verso is not decorated) portrays the Pope in profile to the right, wearing the *mozzetta* and *camauro* and a stole decorated with the papal tiara and the two-headed eagle of the House of Ottoboni. Encircling the half-figure are the words "ALEXANDER. VIII. P[ONTIFEX]. O[PTIMUS]. M[AXIMUS]. CREATVS DIE 6 OCTO[BER] 1689" (The year appears beneath the figure at the bottom of the plaque, oriented with respect to the viewer rather than following the inscription). The gilded medallion bears an identical inscription, but in a smaller frame and with the Pope's face turned to the left.

The portraits on this pair of medallions are similar to those found on the many coins and medals honoring Alexander VIII. The plaques can be attributed to Giovanni Hamerani, whose position as official medallist of the Ottoboni papacy was instituted with a chirograph dated December 23, 1690. The markedly inferior quality of the bronze plaque suggests the participation of a workshop.

Painted portraits of Alexander VIII are rare. A portrait attributed to Giovanni Maria Morandi, formerly in a Venetian private collection, may have been modeled on a painting of the same person included in the *Papal Portraits* exhibition that in fact refers to Ottoboni's period as a Cardinal. (1)

There are instead several portraits in sculpture. The best likeness is the bust by Domenico Guidi, known through the terracotta at the Los Angeles County Museum of Art, the bronzes at the Victoria & Albert Museum of London and in the Ottoboni collection at Rome; Guidi also executed the bust of Pietro Ottoboni as a Cardinal today in the Museum of Rome. Also attributed to Guidi is a marble medallion in the John Paul Getty Museum, encircled by foliate motifs and supported on a base of gray *bigio antico* marble carved in the shape of the Ottoboni eagle. A marble bust by Lorenzo Ottoni is conserved at the Liebieghaus Museum of Frankfurt am Main, while a similar one at the Detroit Institute of Arts is attributed to Guidi. I believe the Detroit bust is by Ottoni, a suggestion supported by Alan Darr. Another marble bust by Orazio Marinali is in the Cathedral of Brescia, while a statue of the Pope is located at Urbino, and another is found at Padua at Prato della Valle, the latter executed in 1787 by Giovanni Ferrari. The statue executed by Angelo de'Rossi for Alexander VIII's funerary monument in the Vatican Basilica is posthumous. (2)

Pietro Ottoboni (1610-1691) was born at Venice on April 22, 1610, to a family of noble origin. An excellent jurist, he was Referendary of two *Segnature* (the highest papal court), Auditor of the Rota and Cardinal in 1652. He was elected Pope on October 6, 1689. His papacy was marked by the return of the nepotism his predecessor had fought against, with the nominations of his nephew Antonio as General of the Holy Roman Church, his nephew Pietro as Cardinal and his nephew Marco as Superintendent of Papal Forts and Prisons. Nevertheless, he was a good Pope, firm in the condemnation of Jansenism and of the French Church's ambitions toward independence; he forced France to return the county of Avignon to papal control and encouraged missions to China. He increased the collections of the Vatican Library by the acquisition of precious books that had belonged to Queen Christina of Sweden. He died on February 1, 1691 (L. von Pastor, vol. XIV, 1932).

Francesco Petrucci

1) See F. Matitti, 1997, p. 218, fig. 4; F. Petrucci, 1998, pp. 166 fig. 25, 168; idem. in *Papi in posa...*, 2004, p. 94
2) See L. von Pastor, vol. XIV, 1932, p. 393; A. Bacchi, 1996, p. 811; E. B. Di Gioia, 2002, pp. 186-194

Giovanni Maria Morandi and workshop
(Florence 1622 – Rome 1717)

Portrait of Innocent XII (Antonio Pignatelli, 1691-1700)
oil on canvas, 68.5 x 58 cm.
Ariccia (Rome), Chigi Palace, inv. 464

Bibliography: F. Petrucci, 2003, sheet 17, pp. 73-74

This portrait is closely related to engravings derived from Morandi's portraits of Antonio Pignatelli (1615 –1700), both as Cardinal and as Pope. Some iconographic trivia: he was the last Pope to have a beard. An earlier engraving by Arnold van Westerhout printed by Jacopo De Rossi carries the words: "[G]Io[vanni]. Mar[i]a Morandi Pinxit", documenting the existence of a lost portrait of Pignatelli as a Cardinal. The painting on display perfectly matches the face depicted in the portrait engraving. Two other engravings also modeled on Morandi's portrait depict Pignatelli in papal vestments. The first, like the painting, shows the Pope glancing to the right (Roma, National Institute for Graphic Arts, FN 17530), while the second is a mirror image. Both engravings surround the figure with an oval frame, and both were printed by Domenico De Rossi.

The sensitive treatment of the face in the present picture makes an attribution to Morandi plausible, while the schematic quality of the *mozzetta* reveals the work of shop assistants. As was the custom, this is certainly one of many replicas derived from the portrait of the Pignatelli Pope, whose election was supported by the political weight of Cardinal Flavio Chigi. The ninth entry in a 1693 inventory of the "Paintings of the Excellent House" of Agostino Chigi lists a portrait of his kinsman Alexander VII, and nearby "Another of Pope Innocent XII". (1)

Perhaps it was from this portrait that Pietro Paolo Vegli executed a copy, documented in Cardinal Flavio [Chigi]'s accounts on May 30, 1692. (2)

Antonio Pignatelli, member of an illustrious Neapolitan family, was born at Spinazzola Castle at Bari on March 13, 1615. Inquisitor at Malta, nuncio to Florence, Poland and Vienna, he became a Cardinal in 1681 and Archbishop of Naples in 1687. He succeeded Alexander VIII on July 12, 1691 after a lengthy conclave. He was known for his generous and charitable character, his love for the poor, whom he called "my nephews", his rigor in reforming the habits of the clergy, his strong battle against nepotism, and his condemnation of the Quietist doctrine (1699). He was able to diplomatically resolve the question of the Gallican Church of France. He was so beloved that on his return from a trip to Civitavecchia, he was forced to descend from his carriage and was carried towards Rome in the arms of a number of peasants. His papacy was also distinguished by the notable encouragement given to public works of a social nature, such as the Hospice of St. Michael, the Innocentian Curia of Montecitorio, and the port at Anzio. He died the night of September 27-28 1700, believed to be a saint. (L. von Pastor, XIV, (2) 1932).

Francesco Petrucci

1) Vatican Apostolic Library, Chigi Archive, n. 1805, p. 108
2) See V. Golzio, p. 300

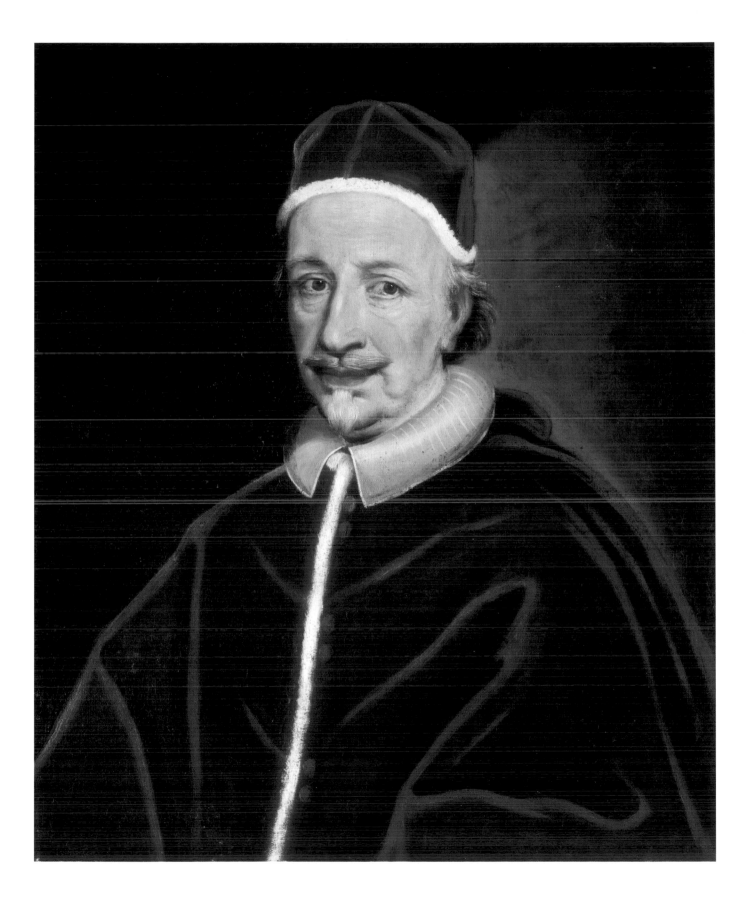

Pier Leone Ghezzi
(Rome 1674-1755)

Portrait of Clement XI (Gianfrancesco Albani, 1700-1721)
oil on canvas, 127 x 78 cm.
Rome, Museum of Rome, inv. MR 38876
Inscriptions: on the letter in the Pope's left hand, it reads:
"To His Holiness Our Lord Pope Clement XI by Pier Leone Ghezzi, Painter at Rome"

Bibliography: N. Pio, 1724 (ed. 1977), p. 154; F. Moucke, 1762, p. 222; A.M. Clark, 1963, p. 11; F. Negri Arnoldi, 1970, p. 67; J. Winckelmann, 1975-76, p. 52; E. Ricci, 1982, p. 60: F. Pansecchi, 1984, p. 729; A. Lo Bianco, 1985, p. 105; A. Pamplone, 1985, p. 47; A. Lo Bianco in M. Fagiolo, M.L. Madonna, 1985, p. 444; A. Pampalone, 1990, p. 72; G. Sestieri, 1994, p. 82; A. Lo Bianco, 1999, p. 111; idem, 2001, p. 148; R. Leone et al., 2002, sheet I B. 17, p. 69; A. Lo Bianco, in *Papi in posa…*, 2004, p. 98

The Museum of Rome acquired this painting in 1977 from antiques dealer Fabrizio Apolloni. It was published in 1970 by F. Negri Arnoldi who traced it back to a Roman collection in which it had been located for some time. However it is not possible to re-construct the work's previous history even if a provenance from the Albani family appears to be the most plausible. The only information on its origin is the citation in Nicola Pio's biography that recalls it as a particularly representative example of Pier Leone Ghezzi's skill in portraiture: *"He took great pleasure in making some portraits...As seen in that of Pope Clement XI."* Based on this passage, Clark, who believed it was lost, considered it indispensable for understanding Ghezzi's portrait paintings.

Gianfrancesco Albani, born at Urbino in 1649, was elected Pope in November 1700 and died in March 1721, after an extremely long papacy. The portrait depicts him in three-quarter pose, seated on an elaborate crimson chair surmounted by stars, the heraldic emblems of the Albani family. Despite the official nature of the pose and the clothing, the composition has an absolutely informal tone, evident in the marked and irregular facial features, in the unruly curls that escape from the *camauro*, in the plump hands. Everything seems to exude the deep familiarity that linked the Pope and one of his favorite artists. Clement XI had already reserved this preference to Father Giuseppe [Chiari], also a painter, but his appreciation of Pier Leone is evidenced by commissions for important works and such honors as his nomination as Painter of the Apostolic Chamber in 1708. Among commissions, we recall the series of large canvases on the *Life of Clement XI*, today at the National Gallery of Urbino, which was only partially executed by the painter; the imposing altarpiece for the Albani Chapel in the church of St. Sebastian-outside-the-walls in 1712 and his participation in the papacy's most prestigious endeavors, the decoration of the naves of the churches of St. Clement and St. John in Lateran, in 1716 and 1718, respectively. But this relationship was extended to all the members of the Albani family whose portraits the artist executed, as in the case of Carlo and Annibale Albani, and even to numerous, benevolently realistic, caricatures.

In publishing the painting, Negri Arnoldi proposed a date after 1708, the year of Ghezzi's nomination as Painter to the Apostolic Chamber, but not after 1710-12. This conclusion is demonstrated by the comparison of a marble medallion by an unknown artist in the Museum of Rome that depicts the Pope in the sixth year of his papacy to Carlo Maratti's portrait, probably executed shortly after his election to the See of Peter, kept at Villa Albani in Rome. Compared to the latter, Ghezzi's work highlights the modernity of his ideas with respect to the sense of classical decorum supported by Maratti. Ghezzi substitutes the older master's artificial and rarified pose with a deliberately unbalanced one that captures the vital instant of a barely restrained gesture, of a flicker in the face's expression. Accentuating these preferences are the rapid and transparent drafting of the painting and the agitated and serpentine draperies that accompany the composition's sense of movement. Trained according to Maratti's ideals of academic classicism, Ghezzi distances himself with a very personal and eccentric reinterpretation of the official portrait, vital and pulsating, that seems to shorten the distance between the subject and the viewer.

A replica of the painting is kept in the Papal Museums and Galleries (inv. 1208). This is probably a preparatory version since it is more concise and limited to the bust but rich in its chromatic drafting. A second one, signed on the scroll, cut just slightly closer but having a very refined execution, is recorded by Sestieri in the Walpole Gallery in London.

On the basis of the testimony in Valesio's *Diary* (1701-1741, December 10, 1707, ed. 1977-79, III, VI, p. 926) F. Pansecchi points out the likely existence of another portrait of the Pope by Ghezzi's hand, cited relative to an exposition in San Salvatore in Lauro church, not identifiable with ours due to the difference in clothing. Valesio in fact wrote: *"...there seeing exhibited the portrait of His Holiness in Greek habit painted by Pietro Ghezzi on order by Monsignor Albani."*

There are also numerous portraits of the Pope engraved from Ghezzi's drawings: *Clement XI in His Study* (Rome, National Institute of Graphic Arts, Vol. Ital. Sec. XVIII F: F.C.) engraving by Frezza; *Portrait of Clement XI*, frontispiece of the volume *Six Homilies of Our Lord Pope Clement the Eleventh Expressed in Verse* by Alessandro Guidi, engraving by Rossi (Pampalone), and many others in the *Life of Clement XI*, dated 1726, engraved in part by Masini and Allet (Lo Bianco, 1985-86, 1/2, pp. 13-42).

Anna Lo Bianco

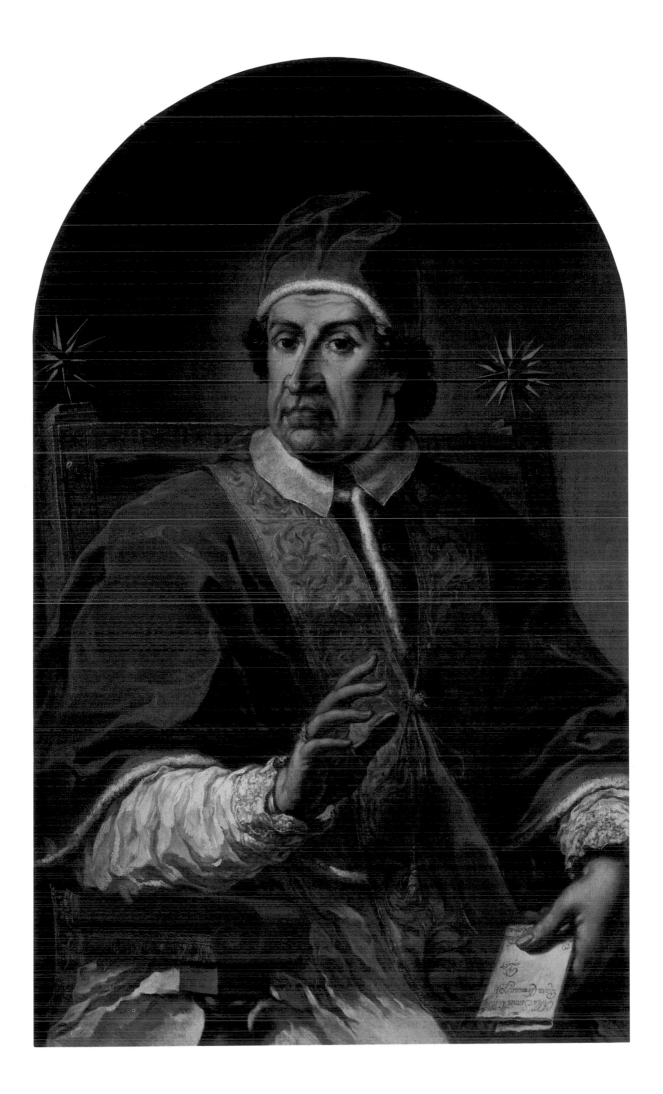

Giuseppe Mazzuoli (attr.)
(Volterra 1644 – Rome 1725)

Bas-relief with Portrait of Clement XI (Gianfrancesco Albani, 1700-1721)
Carrara marble (relief), black Aquitania marble (background)
37 x 29 cm. (46 x 38 cm. with frame; 26.3 x 20 cm. profile)
Genzano (Rome), Jacobini Palace

Bibliography: unpublished

This relief portrait depicts the profile of Clement XI in Carrara marble on a black Aquitania marble background, inserted into a Roman *Salvator Rosa* frame (a type characterized by alternating convex and concave moldings) decorated with three types of intaglio.

The exquisite craftsmanship of this work distinguishes it from the prolific but not often excellent sculpted portraiture of the Albani Pope. The best portrait of Clement XI is still the painting by Pier Leone Ghezzi, who describes the strong, almost caricatured, facial features of the Pope with the extraordinary vivacity common to *grotteschi*.

The profile portrait recalls medals honoring Clement XI that depict him similarly attired in papal tiara, pluvial, *camauro*, and *mozzetta*, executed by Giovanni and Ermenegildo Hamerani immediately following the papal election of 1700. Clement's appearance is documented in numerous coins, with compositional variations and changes to the Pope's vestments. These variations also occur in the monumental oval bas-relief in the Albani Palace at Urbino, in which the Pontiff is depicted wearing the cope, stole, and papal tiara rather than the *mozzetta* and *camauro*. (1) Clement's features, represented rather schematically in the Urbino relief, are described here with great sensitivity.

It seems to me that Ermenegildo Hamerani's 1706 medal celebrating the construction of the Port of Ripetta represents a turning point in medallion portraiture of Clement XI, for until then profile portraits bore only a slight resemblance to the model. Hamerani's image of the Pontiff was characterized by a new realism, an approach repeated in later medals. The portrait in the medal of 1706 is closely related to the marble image exhibited here, although the Ripetta example is a mirror image, with the profile turned to the left. The execution of a papal portrait that served as the model for Hamerani's medallions and for the marble under discussion must therefore be dated around 1706. We know that Giuseppe Mazzuoli executed an important sculpted portrait of Clement XI, unfortunately now lost. (2)

For stylistic reasons, it is reasonable to suggest that Mazzuoli's lost portrait provided the model for the marble here exhibited, limited now to a profile relief. The naturalism of Berninian origin and the tendency to articulate drapery using large faceted folds are characteristic of Mazzuoli's mature style, and continue throughout his long career. The marble relief, then, may represent a reduction of Mazzuoli's lost original, destined for the private apartments of some prelate, noble or for the Pope's own family, to be treasured as a rare and precious object.

Francesco Petrucci

1) On this Pope's iconography, see G. Cucco, 2001, sheets 1-8, 9, 19-21, pp. 139-143, 148, 159-173
2) See L. Pascoli, 1992 ed., with critical notes edited by M. Petroli, p. 933, note 35, p. 943. On Mazzuoli, see A. Bacchi, 1996, pp. 821–823

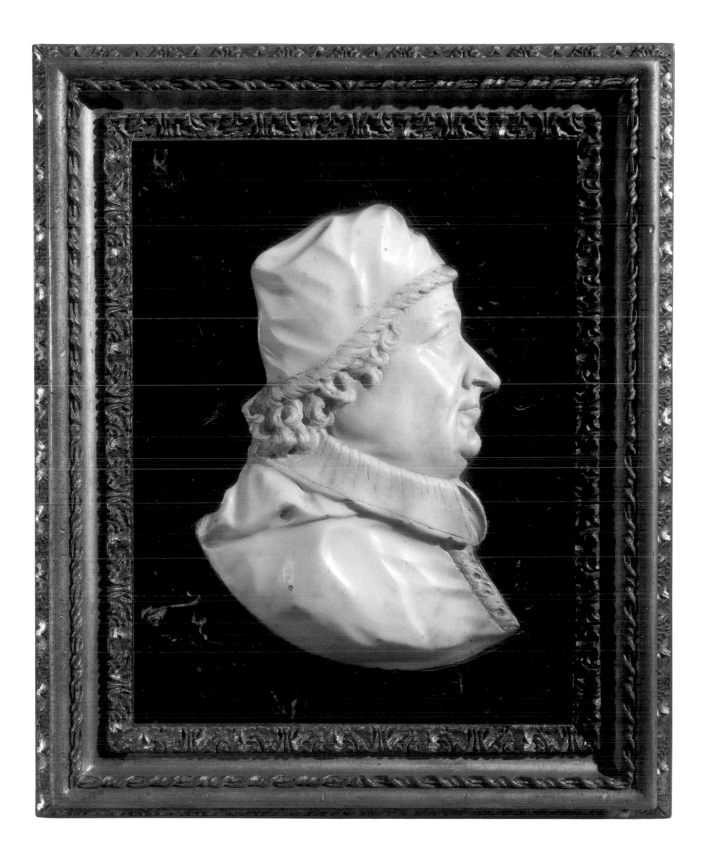

Circle of Camillo Rusconi
(Milan 1658 – Rome 1728)

Bust of Clement XI (Gianfrancesco Albani, 1700-1721)
polychrome stucco on a gilded and carved wooden base,
cm 123 x 95 x 41.5 (pedestal: cm 122.2 x 68 x 53)
Rome, Benucci Gallery

Bibliography: R. Valeriani, sheet 31, in F. Petrucci, 2004, p. 112

The features illuminated in this bust of Clement XI suggest that the portrait was produced in the first years of his papacy. Gianfrancesco Albani, born at Urbino in 1649, was elevated to the See in 1700, thus at a relatively young age that appears to be reflected in the countenance exhibited here. The recent exhibition on the Albani family and their relationship to their native city addressed the theme of Clement XI's portraiture, a subject studied previously by Noè, who identified two fundamental types. The first is more severe and cold, with features almost of a hardened character, while the second, although still marked by the rigor that is the trademark of Clement XI, allowed a certain humanity to show through.

The terracotta under examination here seems to belong to this second family of portraits, of which one of the best examples is the full-length standing figure of the Pope sculpted by Francesco Moratti around 1708, today in the Cathedral of Urbino. At the same time, our bust may resemble a prototype that was not sculpted but painted: the great canvas attributed, in the aforementioned exhibition, to Antonio David. It displays features which, compared to the various marbles outlined here, are rather more youthful.

As mentioned, there are many three-dimensional portraits of Clement XI and it seems plausible, given the characteristics noted, to attribute this work to the circle of Camillo Rusconi, a sculptor who worked on several portraits for the Albani family.

There are not many papal portraits in polychrome terracotta, a medium that allowed a particular veracity of the image, notable in the vibrant colors of the vestments that contrast with the pink flesh tones. One of the few surviving eighteenth-century images of this type is a portrait of Benedict XIII by Pietro Bracci, today in the Museum of Palazzo Venezia. Our piece is endowed, additionally, with an interesting element of decoration, a high base resembling a plinth with the Albani coat of arms, which might indicate a provenance for the work from one of the family's residences.

Roberto Valeriani

1) G. Cucco, 2001, pp. 140-141

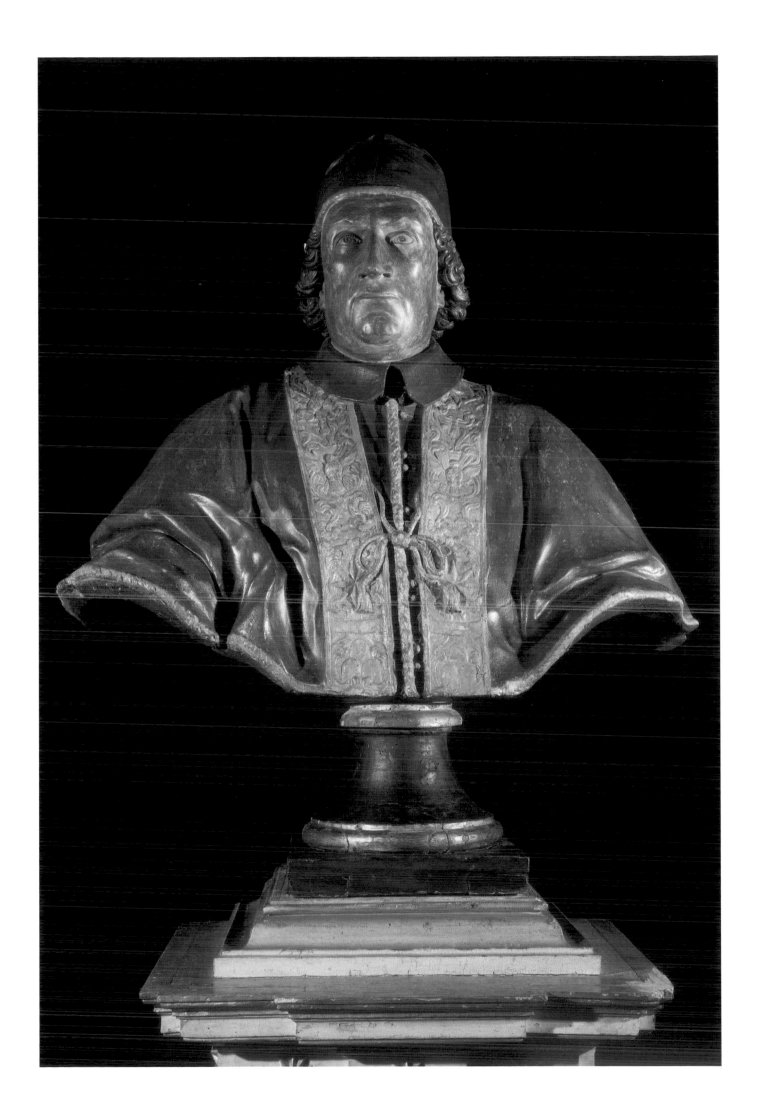

Agostino Masucci
(Rome 1691 – 1758)

Portrait of Innocent XIII (Michelangelo Conti, 1721-1724)
oil on canvas, 96 x 70.5 cm.
Rome, private collection

Bibliography: unpublished

Its iconographic rarity and the quality of its stylistic interpretation give this extraordinary portrait remarkable significance. The brief duration of this pope's reign, his ill health, a certain shyness in his character and also, perhaps, some disappointments in his choices of religious polices that did not meet expectations raised at his election, did not encourage the distribution of the image of this pope of noble origin.

Michelangelo Conti was born on May 13, 1655 in Poli, a small town near Rome, an estate belonging to his family that had already had the privilege of giving the Church a predecessor in Innocent III (1198). His rapid and zealous diplomatic career began under Pope Alexander VIII Ottoboni (1689-1691), and had a brilliant conclusion at the Lisbon nunciature; upon his return [to Rome] he was created Cardinal and protector of Portugal at the Holy See by Pope Clement XI Albani (1700-1721), becoming his immediate successor, as well as continuing his institutional projects, undertaken with shaky leadership but with unswerving moral rectitude.

This element of his personality clearly emerges from the portrait, which is austere but not severe in its official pose, disquieting in its psychological and physical resemblance. Although the three-quarter pose was meant to occupy a living space according to the tradition of 17th century portraiture, the pope is immobilized in the pose. His gaze is fixed toward the viewer, ideally placed in a lowered zone; the memoirs in his left hand and his right hand raised in blessing depict him in a moment of public duties, when he offers himself with an apparent emotional detachment that hides the weakness of his temperament.

This set of factors, through which an ideal, but not idealized, image of reality is presented, endows the portrait with "veracity", an interpretative talent recognized in Masucci by his contemporaries, here amplified by a representation at close quarters in which grandiosity and essential expression are made clear, uncompromised by superfluous details; the only obligatory concession is found in the lace on the sleeve and in the stole's decoration, which includes an eagle, the heraldic symbol of the House of Conti.

This portrait was considered the official prototype for the divulgation of the pope's image; this is indicated in the few iconographic records, starting with the beautiful engraving by Jakob Frey dated 1722 (Rome, National Office of Prints), from which the date of the work is deduced; it was commissioned by Nicolò del Giudice, prefect of the Holy Apostolic Palaces, who, to reiterate the painting's significance, had ordered inserted into the background – neutral in the painting – drapery behind which a column is glimpsed. The addition of this narrative detail reconfirms the public duty of the pope, who suspends his activities in the Vatican Apartments and goes beyond the curtain to appear before and bless the faithful. From this engraving Pietro Ferloni derived the tapestry made for the *Pontificia Manifattura di San Michele* [*Papal Factory of Saint Michael*] (Rome, Vatican Historical Museum, Lateran Palace), in which variations in the decorative details appear in the stole, decorated not with lozenges, but with vegetable racemes, among which appears the heraldic eagle. The engraving was also the model for the *Portrait of Innocent XIII*, a work by an unknown artist of the 19th century (Rome, Duke of Torlonia collection), in which the stole's ornamentation repeats that of the tapestry.

Certainly, neither the tapestry nor the engraving reproduces the extremely high quality of the original, exquisitely executed, painting. The correctness of the design, always irreprehensible in Masucci, is accompanied by a rich application of color, smooth in its chalky compactness; the static nature of the color might at times almost reach the purity of porcelain, not lucid and brilliant as in the paintings of Giovan Battista Gaulli, one of the greatest exponents of seventeenth century portraiture, but delicate, composed of transparencies and glazes, like those placed on the face, of much-praised and unadorned beauty. In this effective synthesis of form and color, the artist proclaims himself heir to the academic and classical tradition which through Carlo Maratti went back to Raphael, who was named as the most authoritative of painters by Masucci himself. The existence of these cultural elements, matured by the artist over the course of a career marked by successes, also in works with a religious theme, opened the way for him to obtain other commissions for papal portraits (Clement XII Corsini and Benedict XIV Lambertini); of leading persons from the Curia and Italian and international high society, but above all, these works represented an absolutely necessary point of reference for a new generation of artists, from Pompeo Batoni to Anton von Maron, classifying his art as a basis for the Neo-Classical school.

We highlight a portrait of this pope kept in the Superga Basilica at Turin; it is an 18th century mannerist painting, without great facial resemblance, but interesting because it was derived from the half-bust portrait of Innocent XIII, now in another Roman collection, recently published and attributed to Masucci although it is very different in its portrayal. (1)

Antonella Pampalone

1) F. Petrucci, in *Papi in posa...*, 2004, p. 100, with reference bibliography and other iconographic information. For an updated historical-critical profile on Innocent XIII, see G. Benzoni, *Innocenzo XIII [Innocent XIII]*, in *Enciclopedia dei Papi*, [*Encyclopedia of Popes*] Treccani, Rome, 2000, pp. 420-429, in which the paintings from Turin and the Torlonia collection are reproduced

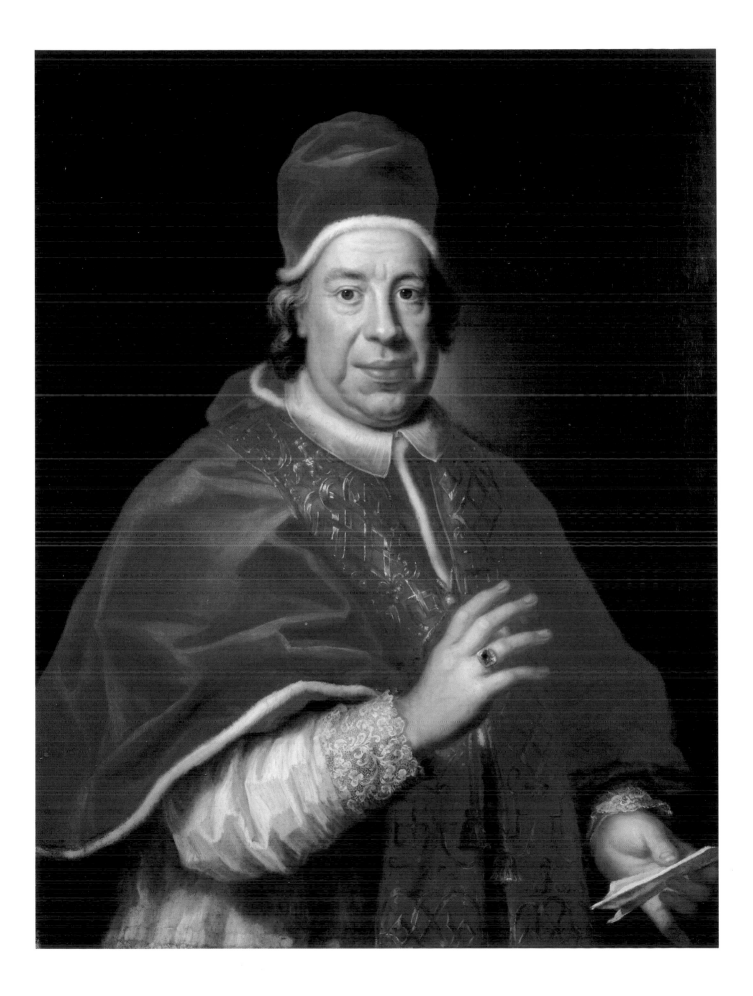

Pietro Bracci
(Rome, 1700-1773)

Bust of Benedict XIII (Pietro Orsini, 1724-1730)
polychrome terracotta, 41 cm.
Rome, Palazzo Venezia, National Museum, inv. PV 980

Bibliography: F. Hermanin, 1929-30, pp. 259-62; A. Riccoboni, 1942, pp. 291-9; F. Hermanin, 1948, p. 282; A. Santangelo, 1954, p. 79; Settecento Romano, 1959. p. 67; S. Zamboni, 1964, p. 215; H. Honour, 1971, p. 620; P. Cannata, 1984, p. 449; A. Radcliffe, 1992, p. 140; B. Boucher, 1998, p. 78; B. Boucher, 2001, p. 238; P. Cannata, in *Papi in posa...*, 2004, p. 102

This terracotta portrait is a model executed by Pietro Bracci to be transformed into the slightly larger official version in pure white marble. The sculpture, although it is not included in the diary of works that the artist began recording in 1725, is believed to have been executed in that Holy Year, when the chapter and canons of Santa Maria Maggiore erected a marble memorial portrait of Benedict XIII in the sacristy of the basilica in gratitude for the Pope's sponsorship of the restoration of the church's roof beams, which were damaged by water and at risk of being ruined. The small monument was later transferred to the right side of the baptistry. For some scholars, the terracotta could be "a slightly humorous, magnificent portrait" while for others, it recalls "Bernini's and Pier Leone Ghezzi's caricature sketches in ink."

Although Ghezzi himself depicted the Orsini Pope with great piety, portraying him in a triumphal act of blessing in the frescos in the salon of the Torrimpietra Castle (1725) as well as drawing the Pontiff, with his usual wit, on his deathbed (1730, Vatican Library, *Cod. Ottoboniano Latino* 3116, folio 167), it should be noted that Bracci's terracotta portrait lacks any humorous, satirical or blasphemous intent; its purpose is not to emphasize the facial characteristics, altering them to allude to differences with the Pope's character. The small bust, in addition to being a model, is to be considered a quick *bozzetto* made by the artist in order to reproduce the physical features with greater accuracy (note the vague and cursory execution of the stole's embroidery); it is the preparatory study that the Roman sculptor would later use for all other portraits of the Pope, whether they were executed during the five years of his papacy or in subsequent years. These include three bronze busts (Palazzo Venezia Museum, St. Peter's Sacristy in the Vatican, previously Ugo Novelli collection), a marble bust in the Thyssen-Bornemisza Collection at Lugano (circa 1762-73), and finally the statue on the Pope's funeral monument in the church of Santa Maria sopra Minerva, desired by the Dominican Order for the official celebrations planned for their founding saint's Chapel (1734).

Except for the slight baroque emphasis that accentuates the *mozzetta's* movement at the level of the arms, in the terracotta the sculptor paid great attention above all to the description of physical traits, reproducing the lackluster and melancholy gaze, the mouth marked with bitterness, the dense web of wrinkles: it is not the artist who is embellishing Benedict's features, but nature, events, and even more so, time; if then the outlines of the nose and mouth, pointed and close together, can inspire laughter, the humanity Bracci evoked in the figure of the elderly Pope will be sufficient to invite respect.

Finally, the vividness of the polychromy emphasizes the naturalness of the portrayal, with results similar to those of some eighteenth-century wax portraits, works that are often disquieting in their pitiless reproduction of real life.

Benedict XIII, to whom are attributed works of great social impact (it is sufficient to recall the San Gallicano Hospital, built in only eighteen months for contagious patients rejected by other hospitals), was judged by history to be an excellent cleric but weak in character, gullible and easily tricked (Pastor, XV, p. 638). In the conclave he was selected by the cardinals simply because he lacked any personal interests and was unconnected to the factions' political strategies; his character was fully revealed in the decisions made immediately after his election, minor episodes which clearly expose the meekness and spirituality of his character. He refused to occupy the Papal Apartments in the Vatican, choosing instead a modest apartment to which he ordered the small bed he used during the conclave to be brought on the very night of his election; he refused, over the objections of the Master of Ceremonies, to enter the Vatican Basilica seated on the gestatorial chair, instead choosing to walk over the threshold, and only after having kissed it and having proclaimed himself "unworthy to be counted even among the sweepers of this church"; finally, he refused to stand at the center of the basilica's high altar to receive the cardinals' first homage, instead choosing to place himself off to one side, near the Gospels.

Despite his advanced age, Benedict XIII undertook untiring and very intense pastoral activity, motivated by a fervid faith and rigorous morals, aimed at reforming the habits of both the laity and the clergy (even going so far as to build a special prison for the clergy at Corneto). On the other hand, he demonstrated that he was completely unprepared to direct the Church's complex government, rashly delegating its management to his secretary Niccolò Coscia (whom he created Cardinal in 1725) and to a corrupt and profiteering group of ministers and counselors who caused even his best projects to fail, causing financial disorder in the coffers of St. Peter's and gravely undermining the Church's prestige. For this reason very heated satires were launched against Benedict XIII, which led to defining his Papacy as a period of vacancy in the Holy See.

Pietro Cannata

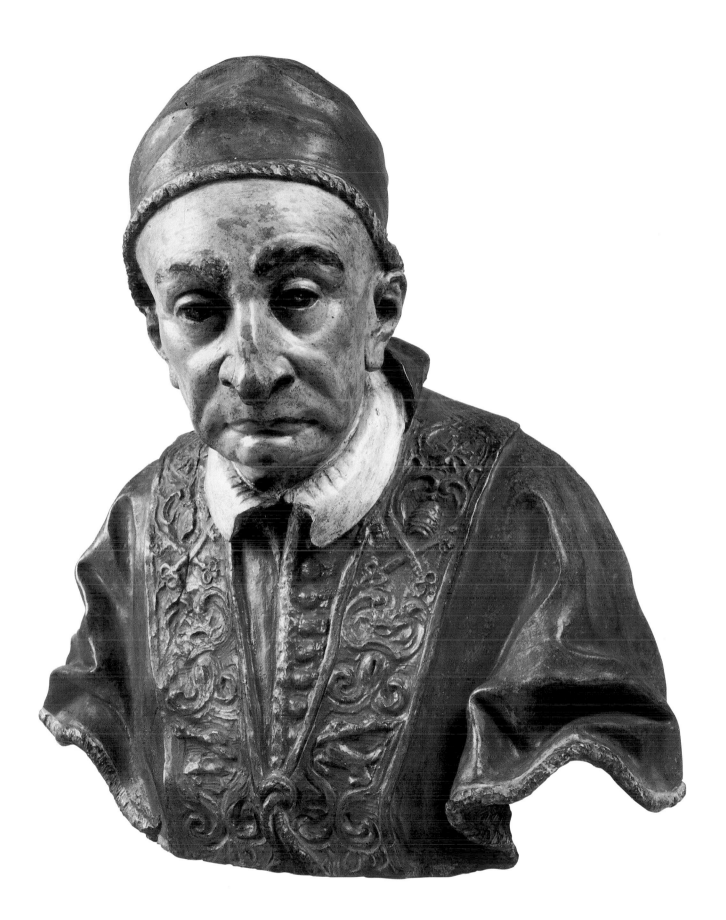

Agostino Masucci
(Rome 1691-1758)

Portrait of Clement XII (Lorenzo Corsini, 1730-1740)
oil on canvas, 111 x 81 cm.
Cantalupo, Camuccini collection

Bibliography: A.M. Clark, 1963(a); idem, 1967; idem 1970; idem 1976; I. Faldi, 1974; J. Urrea Fernandez, 1977; S. Rudolph, 1983; V. Casale, 1974; P.P. Quieto, 1988; idem, 1994; idem, 1994; L. Barroero, 1990; idem, 1998; G.C. Sestieri, 1994; E.P. Bowron, J.J. Rishel, 2000, p. 401; P. P. Quieto, in *Papi in posa...*, 2004, p. 104

The fame of Agostino Masucci, Carlo Maratti's favorite student, was already at its apex when in 1736 Masucci became President of the Academy of Saint Luke. Agostino was one of the masters closest to the Via della Lungara milieu, and moreover, was very good friends with the Portuguese ambassador, José Maria de Fonseca d'Evora, a great scholar and theologian who in those years became the hub around which rotated the vast program of commissions for the numerous works of Mafra and Lisbon desired by the Portuguese sovereign João V, Arcadian Pastor under the name of Arete Melleo. The sovereign loved Italian art and painting, and in particular, as revealed by his correspondence with his ambassadors, "....*Masucci's painting is much more to my liking than that of any other painter in Rome....*" And in fact the Roman master executed important works for the Lusitanian king.

Agostino Masucci, son of Francesco, was born in 1691 in the heavily populated Monti district of Rome, in the parish of San Salvatore. In February of his twenty-eighth year he married Francesca Palozzi at the Church of St. Francis de Paul in the Monti district, whose lunettes he later painted. He lived at Monte Magnanapoli, close to the Church of St. Bernardino, in a three-story building which belonged to the nuns of St. Catherine of Siena, where Corrado Giaquinto also lodged; nearby was the house of a certain Father Giuseppe, who was the nuns' confessor. The ground floor of the building, presumably the location of Masucci's workshop, faced a busy street and the ancient heart of the city where daily life unfolded within its shops: a barley-seller, a tavern, a grocer's, and a junk dealer, bordered by the Fratte corner, which enclosed a vegetable garden. His marriage produced ten children, six sons and four daughters, among whom Lorenzo, born around 1727, became a painter and collaborator. Upon his death, Masucci was buried at San Salvatore, his lifelong church and parish, after a solemn funeral in which the catafalque, illuminated by twelve candles, was surrounded by artists and academics. His son Lorenzo had a plaque installed to the left of the central altar, still *in situ*, with a fresco portrait of his father executed by Lorenzo himself. Masucci, a great portraitist from his earliest youth, was called upon by Clement XII in 1731 to execute this official portrait, thereby pursuing his specialty with renewed success. Portraits from his hand include a picture of Vittoria Altoviti Corsini, a painting that I had the pleasure of seeing again recently; a portrait of the Pope with Cardinal Neri that was to be translated into mosaic; and portraits of Cardinal Banchieri, King João V of Portugal, his friend Filippo Juvarra, Benedict XIV, James, Count of Findlater and Seafield, of the *Lady with a Fan* of Baltimore, in addition to a series of red chalk portraits which were subsequently engraved, and those inserted into large paintings such as the *Marriage of James Stuart and Clemetina Sobietska*, or the splendid canvas of the *Ecstasy of Saint Catherine of Ricci*, among others. A payment to Masucci for this portrait or one of its replicas was found in the accounting books of Bartolomeo Corsini, dated March 20, 1731. (1)

In this portrait, Masucci expresses a perfect balance between dignity and elegance, with a profound analysis that tends, as Gaulli had also done, to portray the subject's psychology, providing a great example of "introspective" portraiture. Nevertheless, if the messages conveyed by the portraits appear to differ each time, there are formal characteristics that tend to repeat themselves. The person whose portrait is being painted is effectively screened by the canvas which the painter must stand in front of, effecting brief, repeated observations. Professor Donald Crietcheley, noted neurologist and author of various studies on the relationship between science and art, analyzed the psychological relationships that are created when a painter executes a portrait and orients it in space, revealing that an artist's cultural information is added to the visual perceptions generated at the moment his gaze meets that of the sitter; if the person being portrayed is not present but is painted in effigy through the contemplation of another image, a very different relationship is created. It appears evident that this portrait was painted from life. The psychological connotations are revealed well beyond the canvas. The master does not have time for formal drafting, but appears to be conditioned in his interpretation by the unique properties of a face, by an expression conveyed by a tightly closed mouth, by the nature of a gaze, the dynamism of a demeanor captured in that instant. In substance, the artist's idea emerges immediately from the natural, from the sitter's living body and face. We can recognize this by comparing two autograph portraits by Agostino Masucci, this vivid and expressive one of Clement XII, executed from life, and the portrait of Filippo Juvarra modeled on another image, certainly more static and flattened. The Cantalupo canvas clearly derives from Raphael, both in its color scheme and in the ecstatic silence that exalts the play of light. Masucci's mastery certainly places this portrait among the most vivid of its time, for the clarity of its inspiration, the sobriety of its composition and coloration, together with a naturalism that is a suggestion, a description and not a filter of the figure's essentiality that gives a sense of knowledge through a purity of execution that is clearly humanistic. A replica of this portrait, certainly from the workshop, is conserved at La Granja, and there is another at Drummond Castle, probably the work of the artist's son Lorenzo.

Masucci's students Pompeo Batoni and Anton Raphael Mengs, linked by a deep admiration and reverence for antiquity, revolutionized the field of portraiture through application of the master's teachings; they perfected his technique and later provided even greater examples of grace and beauty, which one of them derived from Reni and the other from Raphael.

Pier Paolo Quieto

1) See M.L. Papini, 1998, pp.37, 45, note 44, 258. Unpublished information on the Masucci present in the sheet will be included in the undersigned's monograph, whose publication is in progress

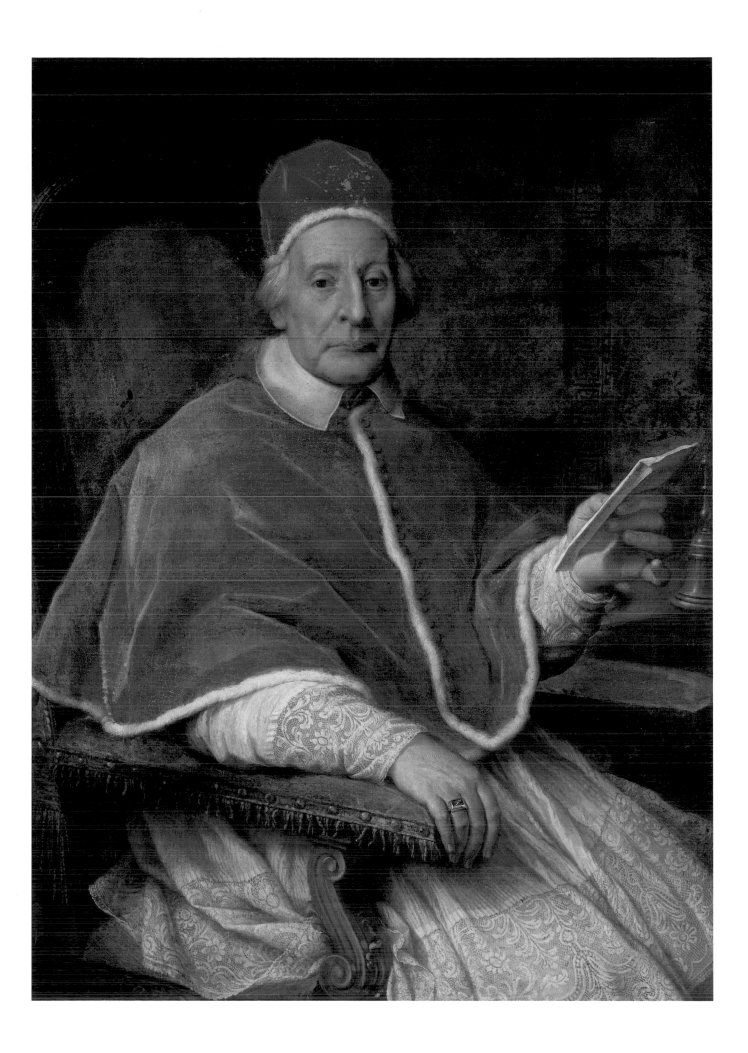

Agostino Masucci
(Rome 1691-1768)

Portrait of Benedict XIV (Prospero Lambertini, 1740-1758)
oil on canvas, 127 x 93 cm.
Rome, Academy of Saint Luke

Bibliography: A. M. Clark, 1967; I. Faldi, 1968; G. Incisa della Rocchetta, 1979, pp. 100-101; A. M. Clark, 1981; O. Michel, P. Rosenberg, 1987; E. P. Bowron, J. J. Rishel, 2000, p. 401; P. P. Quieto, sheet 32, in F. Petrucci, 2004, pp. 112-115

This portrait was commissioned around 1740-41 from Agostino Masucci, the most important painter then working in Rome. The purchasers also hired Pierre Subleyras, whose *Portrait of Benedict XIV* is today at Versailles (Musée National du Chateau). The painting anticipates the type that would be standardized by Pompeo Batoni for portraits of Popes and Cardinals, and classifies Masucci as one of the official portraitists of Pope Lambertini, demonstrated by other, smaller portraits today at Ariccia, Imola, and Milan (Poldi Pezzoli Museum). In this example Masucci subtly conveys not only the tactile quality of the velvets edged with ermine, but also the psychological characteristics of the Pope. Masucci's intention to celebrate the Pope in the Roman tradition of eighteenth-century state portraiture is achieved through the skillful exploitation of chiaroscuro, producing complementary passages of light and shadow.

The unusual composition of the picture, with the Pope standing rather than seated on the papal throne, derives from seventeenth-century Cardinal portraiture.

The painting exalts Masucci's own standard of quality, a standard he later transmitted to his disciples Pompeo Batoni, Raphael Mengs and Gavino Hamilton. Through the medium of portraiture, Masucci, a great exponent of the genre in the tradition of Maratti and Gaulli, follows Algarotti, who argued that the artist must express the thoughts and feelings of his subject through facial expressions. And it is precisely in this "truthful" portrait that Masucci expresses this concept. Unlike Batoni, Masucci's portraits are characterized by a certain adherence to nature, while Batoni strove to express the ideal and the universal through the generalization of features.

Prospero Lambertini was born at Bologna on March 31, 1675. Bishop of Theodosia, archbishop of Ancona and then of Bologna, he was responsible for the Institute of Sciences and became a Cardinal in 1728. He became Pope after a good six months of conclave, on August 17, 1740. He was probably the most educated Pontiff of the eighteenth century, above all distinguishing himself as a scholar of canon law. He supported the sciences, creating chairs in physics, chemistry and mathematics at the University of Rome, and acquired many books for the Vatican Library. He was an archeologist and supported excavations in Rome, also halting the decay of the Colosseum caused by the removal of materials. He was an excellent politician who favored relations with all the European states. He assumed a position of cautious balance toward other religions, nevertheless condemning the Freemasons and the Chinese and Malabaric rites tolerated by the Jesuits. He died on May 3, 1758 and is buried in Saint Peter's Basilica, in a tomb executed by Pietro Bracci.

Pier Paolo Quieto

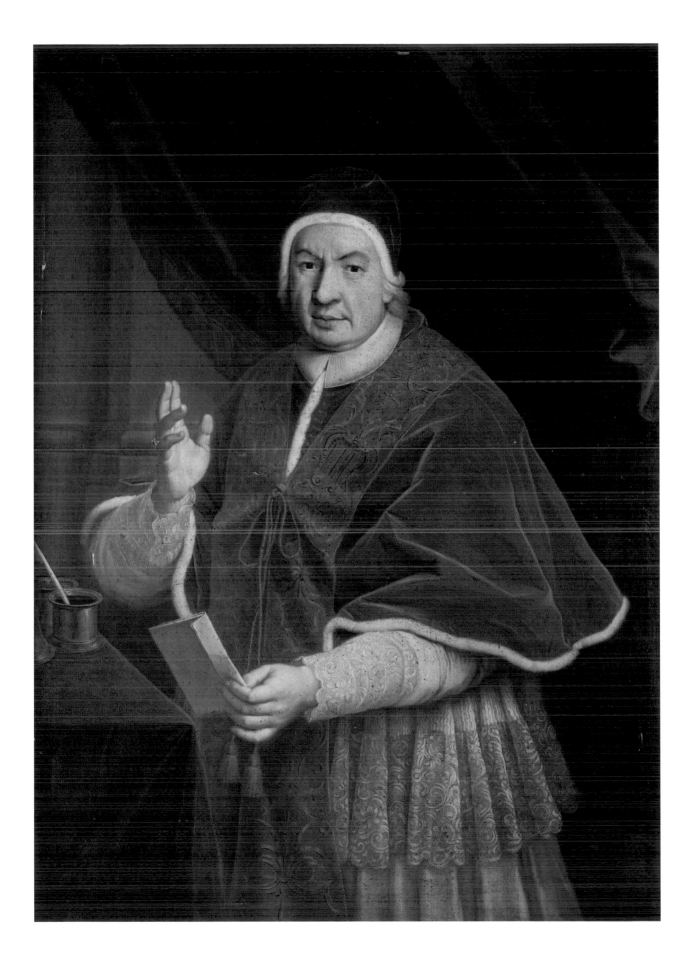

Attributed to Andrea Piserni
(Rome 1685 – after 1748)

Portrait of Benedict XIV (Prospero Lambertini, 1740-1758)
oil on canvas, 74 x 60.5 cm.
Ariccia (Rome), Chigi Palace, inv. 1236

Bibliography: F. Petrucci, 2000, pp. 93, 94 fig. 10; idem, 2003, sheet 67, pp. 108-110

This portrait was attributed to Agostino Masucci by Pier Paolo Quieto (verbal communication), whose monographic study of the artist is forthcoming. The extemporaneous execution of the painting is revealed in the changes to the Pope's *berretta*, in the rapid highlights on the *mozzetta*, and by the remarkable pictorial quality of the rosy flesh tones. With this attribution, the undersigned contributed a sheet on the painting to the catalog of the exhibition *Le Stanze del Cardinale [The Rooms of the Cardinal]* (Ariccia, Palazzo Chigi, 2003).

Nevertheless, the face in this canvas appears to be derived from the papal portrait executed by Pierre Subleyras, known through numerous replicas and copies, while the *mozzetta* is independent of that model. It is impossible to think that Masucci's portrait of the Pope (see previous sheet) would repeat the composition his rival used.

The accounts of cardinal Flavio II Chigi document a payment of July 22, 1743 to Filippo Fidanza for a portrait of Benedict XIV, while another payment was made to Andrea Piserni on May 2, 1748 for a portrait of the same Pope "sent to Ariccia by order of His Excellency the Prince". The latter can probably be identified as this canvas, which for a long time hung in the palace at Ariccia; a copy derived from the half-figure portrait by Masucci from the Academy of Saint Luke is also conserved there. Confirmation comes from its comparison to the portrait of cardinal Giacomo Lanfredini of the Leonine College, a work by Piserni or a copy of his portrait documented in an engraving by Nicola Billy: the pose and setting are the same, and the drapery in both examples is executed in linear brushstrokes with crisp, angular cuts. (1)

It is obvious that such a minor painter as Piserni had to be inspired by the most official papal portrait, which was that of Subleyras (see also a copy by Pannini today at the Museum of Rome, in which Cardinal Valenti Gonzaga is pictured next to the Pope).

Another half-figure portrait of Benedict XIV, originally in the Chigi Palace in Rome, was sold to the [Italian] State with part of that building's collections in 1918, and is today in the Corsini Palace, the headquarters of the Accademia dei Lincei. It is another derivation from Masucci's portrait (inv. 1710, neg.vo Superintendent of Museums, 131489).

Francesco Petrucci

1) On Piserni, see S. Pierguidi, 2000, pp. 51–71, fig. 1

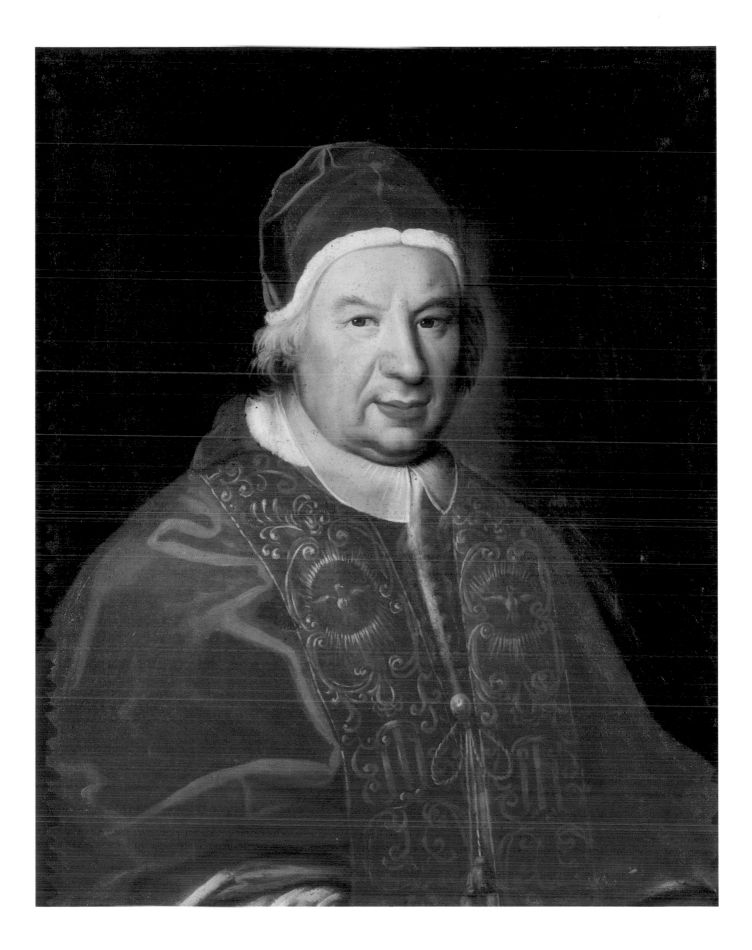

Pompeo Batoni
(Lucca 1708 – Rome 1787)

Portrait of Clement XIII (Carlo della Torre Rezzonico, 1758-1769)
oil on canvas, 134.6 x 93 cm.
Rome, National Gallery of Ancient Art, Barberini Palace

Bibliography: Various Authors, 1929, no. 4, p. 125; E. Emmerling, 1932, no. 14, pp. 99-100; I. Belli Barsali, 1965, p. 200; A. Clark, 1967, p. 115, fig. 141; idem, 1985, no. 227, pp. 278-279; G. Sestieri, 1994, vol. I, p. 22; A. Pavanello, 1998, p. 110

The painting comes from the Sciarra collection and was acquired by National Gallery of Ancient Art of Rome in 1925. The portrait is signed on the memorandum that the Pope holds in his left hand: "To His Holiness / Pope Clement XIII / By / Pompeo Batoni who painted it / in 1760". The date is confirmed in a letter dated August 9, 1790 written by Sir Thomas Robinson, later Lord Grantham, who had just seen the portrait together with the one executed by Anton Raphael Mengs. The letter is also interesting for the comparison made between the two works. Certainly in this case Mengs was superior, and his portrait, especially the version with the frontal pose (See next sheet), became the official image of the Pope known through numerous copies and variations. Batoni, who may have been the greatest portraitist of the eighteenth century, was unfortunate in his papal portraits, which were not successful in accordance with his fame; he was perhaps more at ease portraying English lords in heroic poses in archeological settings than in adhering to the canons of papal portraiture.

A preparatory drawing for the figure of the Pope, excluding the face, formerly in the collection of Anthony Clark, is today at the Philadelphia Museum of Art. The scholar cited several copies of the painting: in the Weyer collection at Cologne, at the Ranghiasci Brancaleoni Palace at Gubbio, at the Staatilche Gemäldegalerie at Kassel, and in the Vatican Pinacoteca. Copies may also be found at the Church of San Gallicano in Rome, in a Roman private collection, and at Wardour Castle (Wiltshire); additional copies were sold in 1932 and 1982 at the Rospigliosi sale and at the Colnaghi Gallery of New York, respectively.

The standing pose Batoni used in this portrait was uncommon at the time, and is clearly inspired by the *Portrait of Benedict XIV* by his teacher Agostino Masucci (see sheet), with the figure turned towards the right instead of the left.

Carlo della Torre Rezzonico (1693-1769) was born in Venice on March 7, 1693. After being created Cardinal in 1737, he was governor of Rieti and Fano and bishop of Padua. He was elected Pope on July 6, 1758 after a disputed conclave, taking the name Clement XIII. He was not as tolerant as his predecessor, and his rigid policies resulted in a papacy characterized by difficult political relations. In the fight against the new ideas of the Enlightenment, he relied much on the Jesuits; in those years, however, the Order entered into open conflict with various European powers, from Portugal, to France, to Spain, to the Duchy of Parma, due to Jesuit interference in the temporal political matters of those countries. Despite the pressure exerted by various kings, the Pope confirmed his full support for the Company of Jesus, whose suppression nevertheless occurred during the papacy of his successor. He died on February 2, 1759 and is buried in Saint Peter's Basilica in a grandiose funeral monument executed by Antonio Canova (L. von Pastor, XVI, 1933)

Francesco Petrucci

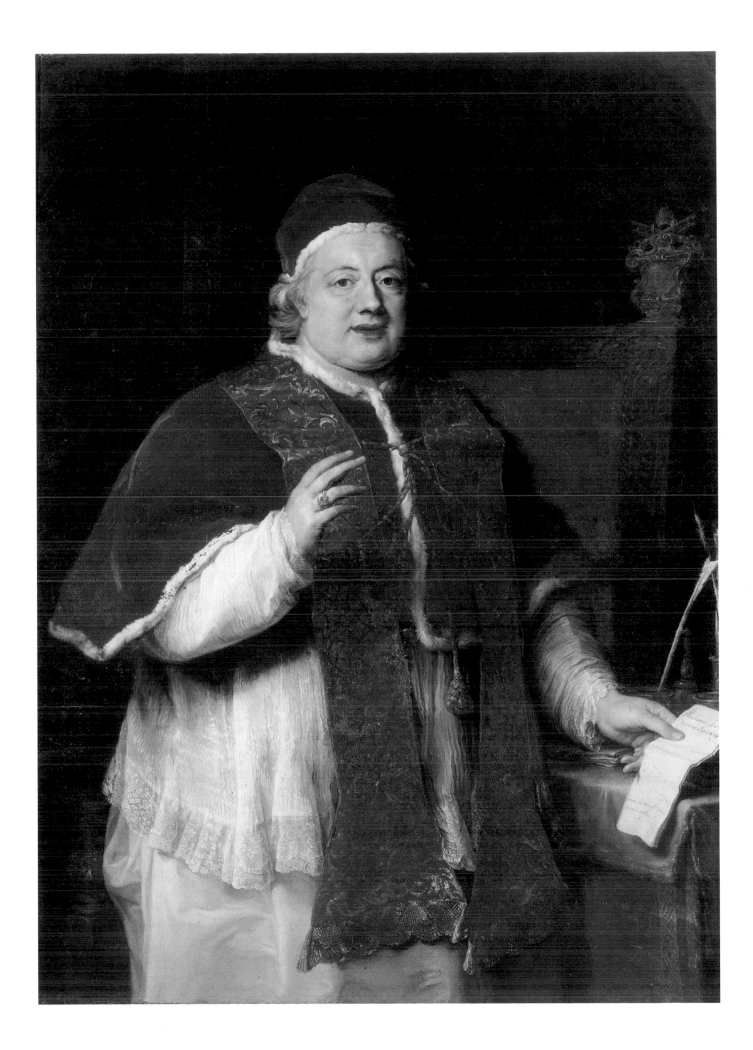

Anton Raphael Mengs
(Aussig, Bohemia 1728 – Rome 1779)

Portrait of Clement XIII (Carlo Rezzonico, 1758-1769)
oil on canvas, 152.5 x 110 cm.
Spoleto, private collection

Bibliography: S. Roettgen, 2003, vol. II, pp. 609-611

Bengs executed two different portraits of Clement XIII: the first was a frontal pose, with the Pope in the act of blessing; the second was a three-quarter view from the right in the tradition of Raphael. For each of the two versions, various copies are known. The original prototype for the first portrait is this painting. It is an absolute masterpiece that recently re-emerged and was published by Steffi Roettgen in her 2003 monograph on the Bohemian painter. The painting was executed following Clement's July 1758 election to the See, and was already completed by December of the same year. The presence of the heavy winter velvet *mozzetta* would suggest that it was painted in the period of November-December. Previously Roettgen had believed that the original was the canvas today in the Museum of Eighteenth Century Venetian Paintings at Ca' Rezzonico, which is smaller in size (oil on canvas, 100 x 85 cm). (1)

In Roettgen's current opinion, the Venetian canvas could be the copy of the painting that, according to Azara's account, a young Venetian brought to Rome between 1779 and 1781. Other copies without the background drapery are found in the Gasparrini Gallery at Rome and at the Pinacoteca Ambrosiana of Milan, which at one time were also held to be the original.

The prototype of the second portrait is the canvas at the Pinacoteca Nazionale di Bologna, exhibited at the *Papal Portraits* exhibition held in 2004 at the Braschi Palace in Rome. A copy is in the Walters Art Gallery in Baltimore. (2)

The present picture, which is identical in composition to the version at the Ca' Rezzonico [museum], in fact surpasses the Venetian canvas in pictorial quality and in its brilliant color. Astonishing is the harmony of the yellows (the gilded intaglio, the gold damask satin, the gold of the fringe, trimmings and embroidery on the stole and on the throne) with the reds (the velvet of the *camauro* and the *mozzetta*, the satin stole, the velvet of the throne's back and arms, the red in the Pope's complexion and lips), in complementary contrast with the cold gray-green tone of the damask drapery and the Pope's hair.

It was not accidental that Heinrich Meyer, whose opinion we learn from Goethe's testimony, put the accent on the painting's relationship with the Venetian color tradition: "Among Mengs's paintings, the one in which his art excels with greatest mastery is the portrait of Pope Rezzonico. In this work, the artist imitated the Venetians in the color scheme and in technique and may be happy to have had a good success; the tonality of the coloring is warm and the expression of the face is animated and clever; the curtain of gold cloth, a background against which the head and the rest of the figure are well highlighted, represents a daring work of skill in the history of painting, but it succeeded in excellent measure, since the painting is given a harmonious aspect which is pleasing to our eye." The painting was also admired by Canova. (3)

The iconographic model Mengs used for inspiration is of course the one that portrays the first among all the Popes, the bronze statue of Saint Peter in the Vatican Basilica attributed to Arnolfo di Cambio. It is an image with a strong communicative and symbolic impact, repeated in numerous statues honoring Popes until the eighteenth century.

Mengs, subverting the canons of all earlier painted papal portraiture, carries out a masterly exercise of foreshortening the figure in a frontal and axial composition. Therefore, the left arm on the chair's arm, the lower limbs, the chair, and even the Pope's face, are foreshortened; the painter faced the risk of a dangerous flattening of proportion and perspective. The Pope was not enthusiastic about the painting and Mengs was forced to carry out a second version, which perhaps was more pleasing to the Roman Curia than to artists, given the lesser number of existing copies. According to Prange in fact: "When he – Mengs – displayed the finished painting to His Holiness, the latter was to have said that this painting would be highly praised, but that he did not find it particularly beautiful". To the flushed and good-natured face of the figure in the first painting, almost in a daze from the long sitting, the Pope preferred the livelier but perhaps less authentic expression of the second version. (4)

Originally the painting had a frame created by the Paduan silversmith Angelo Scarabello, later replaced with the current monumental one in silver-plated wood, crowned with the papal coat of arms, of typical Roman manufacture. The Pope himself sent the painting to his family palace at Venice, to be exhibited under a *baldacchino* in the Audience Room or the Throne Room. It communicated in isolation with Tiepolo's frescos on the vault, allegories of Nobility and Virtues.

The painting was described by Pietro Gradenigo in 1759 and in 1760 when it was recorded at the Ca' Rezzonico in Venice, as well as in the 1767 inventory of the same palace published by Pavanello: "In the Audience Room of the *piano nobile* (the second floor), the portrait of His Holiness, the happily reigning Pope Clement XIII by Monsieur Mens [sic] with a silver bas-relief frame". (5)

Immediately afterwards, the painting was sent to Rome as a consequence of Abbondio Rezzonico's nomination as a senator of Rome in 1765. Included in Abbondio Rezzonico's 1807 testament, the painting is recorded in the Villa Rezzonico at Bassano in 1825. On the reverse of the canvas is an inscription: "55 Chamber of the fireplace Milan", which documents a later transfer at an unspecific date.

Francesco Petrucci

1) See S. Roettgen, sheet 86, 2001, p. 263
2) See R. Leone, sheet in in *Papi in posa...*, 2004, p. 108
3) See J. W. Goethe, 1974, p. 523
4) See M. C. F. Prange, 3 vol., 1786, p. 111
5) See G. Pavanello, 1998, p. 111

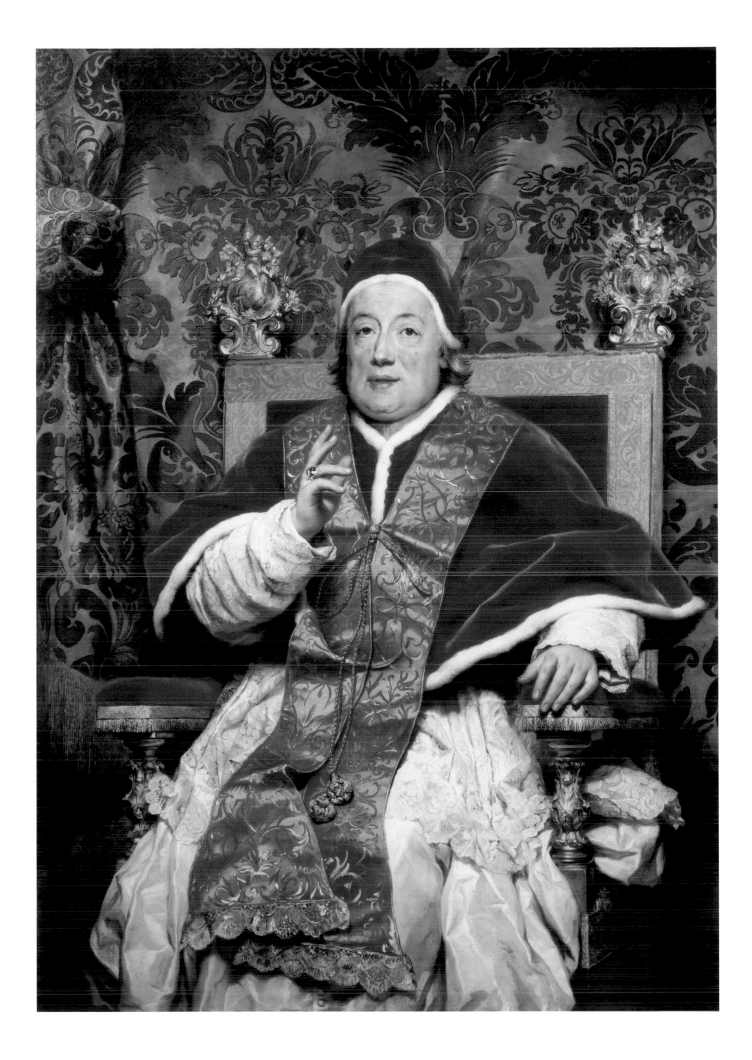

Christopher Hewetson
(Kinkenny 1739 – Rome 1798)

Bust of Clement XIV (Vincenzo Ganganelli, 1769-1774)
marble, h 79 cm.

Milan, private collection
Bibliography: sheet in Altomani & Sons, exhibition catalog, Maastricht Tefaf, 2002

An inscription in capital letters engraved on the shoulders records the name of the Pope portrayed: "CLEMENS. XIV. P.[ONTI-FEX] M.[AXIMUS]", while another inscription on the marble's lower edge unmistakably attests to the paternity of the work: "Chrisf. Hewetson fecit." Two other autograph versions of the bust are known, one at Beningbrough Hall (York, England) and the other at the Victoria & Albert Museum of London; the latter also bears an inscription and the signature of the sculptor, but it is a posthumous work dated 1776. A replica or copy is located at the Center for British Art at Yale University (New Haven, USA), while a plaster cast erroneously published by Elena Bassi as a work by Canova is today at the Civic Museum of Bassano del Grappa. A bust with remarkable variations, of which the most significant is the rotation of the face to the right, is kept at the Museum of Rome and is considered a studio replica. Due to its high quality and its numerous variations with respect to the other busts, in my opinion this must surely be another autograph copy by the Irish sculptor, different from the others. (1)

The portrait by Hewetson is characterized by a remarkable naturalistic force and vitality, the heritage of Bernini's portraiture originally revitalized by Pietro Bracci. It is certainly the best and most effective image of the Ganganelli Pope, whose painted portraits are clearly of less merit than those of his eighteenth century predecessors, which were entrusted to Masucci, Subleyras, Batoni, Mengs and other great masters. Hewtson was born in Ireland but lived and worked his entire life in Rome, where he established himself in 1765 at about the age of twenty-five, and where he died in 1798. He depicted leading figures (Cardinal Giovanni Battista Rezzonico, Luigi Gonzaga, and Anton Raphael Mengs), but especially foreign tourists, the reason why a great number of his works are found outside Italy.

Vincenzo Antonio Ganganelli (1705-1774), a native of Sant'Arcangelo di Romagna, ascended to the Papal See on May 19, 1769 with the name Clement XIV. One of the thorniest problems he had to deal with was resolving the disputes among the various European kingdoms and the Jesuits, especially in Latin America; in August 1773, despite attempts at reconciliation, he was forced to decree the suppression of the Company of Jesus with the brief *Dominus ac redemptor*. He began the construction of the Vatican Museum of Classical Antiquities (later called the Pio-Clementino Museum), in consultation with the great antiquarian Ennio Quirino Visconti, the participation of Anton Raphael Mengs in its decoration and the cooperation of his treasurer, Angelo Braschi, who later became Pope Pius VI and completed it. (L. von Pastor, XVI, (2) 1933).

Francesco Petrucci

1) See R. Leone, sheet in in *Papi in posa...*, 2004, pp. 110–111

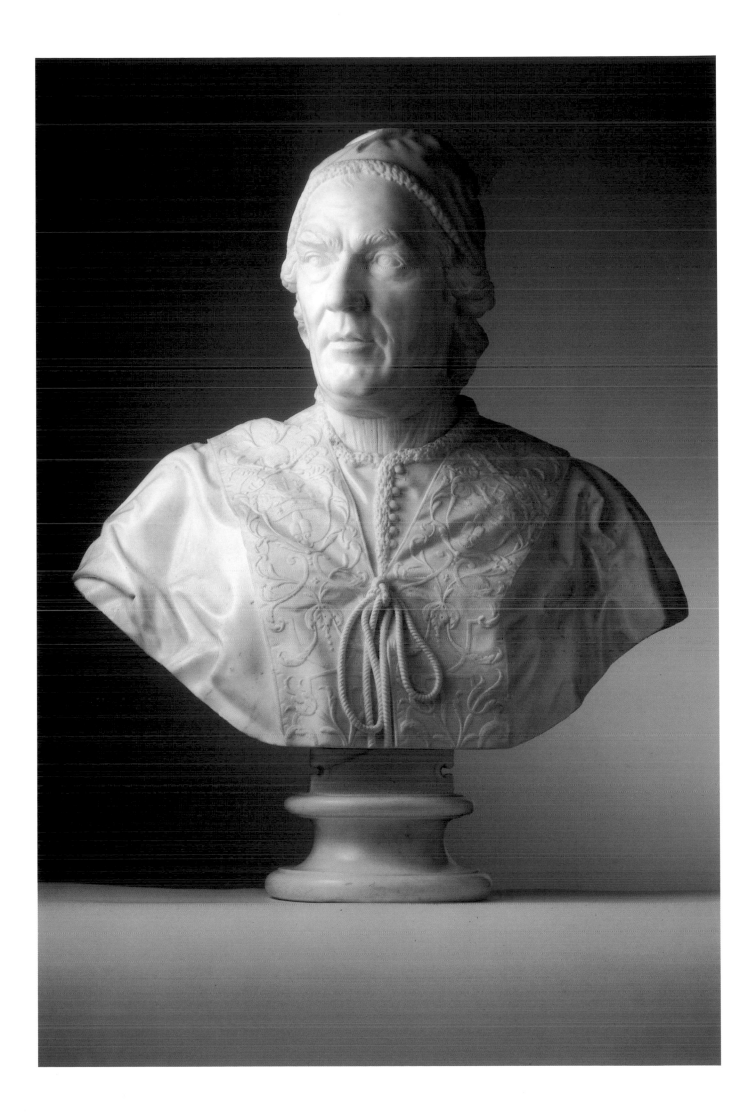

Vincenzo Milione
(Calabria circa1735 – Rome 1805)

Portrait of Clement XIV (Vincenzo Ganganelli, 1769-1774)
oil on canvas, 95 x 72 cm.
Rome, Apolloni Gallery

Bibliography: S. Marra, sheet 33, in F. Petrucci, 2004, p. 114

Of Calabrian origin, Vincenzo Milione arrived in Rome at the end of the 1760s. He produced works on religious subjects, but above all he was a copyist and portraitist during the Braschi papacy, depicting members of the clergy and of the Accademia dell' Arcadia, of which many signed and dated canvases survive. (1)

This work of unquestionable theatrical effect and decorative taste exists in two copies. An identical and signed version exists in a private collection, probably derived from an original by Gian Domenico Porta (1722-1780), official papal portraitist to both Clement XIII and Pius VI and author of many portraits of cardinals. (2)

The appearance of the face draws on the portrait codified by Porta that "stigmatizes" the Ganganelli Pope, portraying him in various situations—standing, on horseback, seated, full or in part—but with his face in an identical expression. A comparison can be made with the half-figure portrait of the Pope conserved at the Chigi Palace. Its 2002 restoration and x-ray revealed the existence of two portraits beneath the present one; the rigid and unnatural position of the head is symptomatic of the recycling of a portrait. The Pope's head is applied to the pre-existing bust in the usual codified version, with a hardly convincing *pastiche* effect.

Clement XIV (1769-1774), an original and vivacious personality, loved to go horseback riding and during his stays at the Castel Gandolfo residence could launch himself into daring rides through the countryside. It is not a coincidence that he had himself portrayed several times in the saddle, and in any case he did not scorn being depicted in such a setting, whether in ceremonial or secular clothing. These images were repeated many times in paintings or engravings, sometimes with the head substituted for that of someone else. An example is the famous image of Gregory XIV on horseback, from which Domenico Cunego produced an engraving of the Pope's cavalcade for the Feast of the Annunciation, an engraving revised in its turn, this time with the face of Pius V.

Susanna Marra

1) See S. Rudolph, 1983, p. 789
2) See S. Rudolph, 1983, pp. 795-796

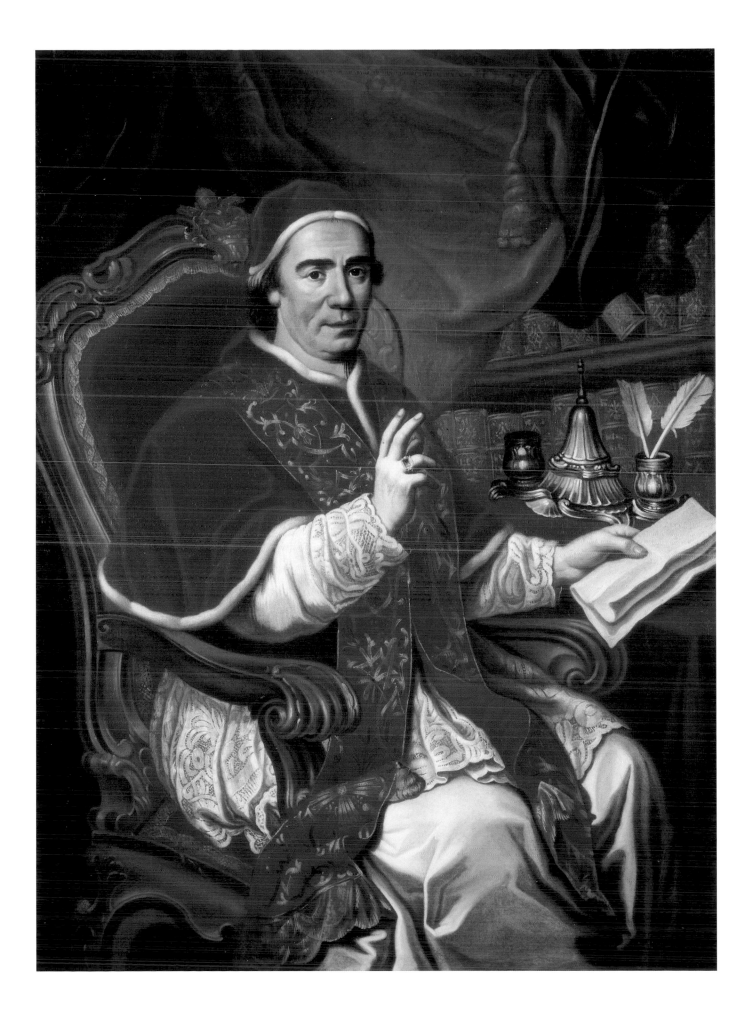

Giuseppe Ceracchi
(Rome 1751 – Paris 1801)

Bust of Pius VI (Giovangelo Braschi, 1775-1799)
marble, 91 x 71 x 37 cm.
Rome, Museum of Rome, inv. MR 45699

Bibliography: M.E. Tittoni, in R. Leone et al, 2002, p.30

Pius VI was born Giovangelo Braschi (Cesena 1717 – Valence 1799) to a noble but impoverished Cesena family. After attending the Jesuit school in his native town, he became a Canon of St. Peter's in 1755, taking Holy Orders in 1758. As Treasurer-General of the Church in 1766 he was created Cardinal by Clement XIV in 1773 with the titular church of Saint Honofrius. Elected Pope in 1775 with the support of Spain and France, that same year he promulgated his first encyclical, *Inscrutabili Divinae Sapientae*, in which he condemned the ideas of the Enlightenment, accusing them of spreading atheism and of wanting to sever the ties between the Church and the states. Emblematic of his intransigent line was the restoration of the anti-Jewish law and the clever policy adopted to counter the autonomous and centrifugal forces of reformers and Jansenists. In 1789, he ordered the arrest of Cagliostro and a small group of Roman and French Masons: the trial at the Office of the Holy Inquisition which led to Cagliostro's death sentence – later commuted to life in prison – struck international public opinion. This, along with his decision to place Alfieri's dramatic works on the Index of Forbidden Books, demonstrated the Pope's increasing rigidity.

Relations with the Italian and European states were also difficult regarding matters of jurisdiction, particularly those with Joseph II of Austria, whose clerical reforms struck at Papal prerogatives and aimed at the creation of a national Church. To convince the emperor to retract his policy, Pius VI traveled to Vienna; he was welcomed by the citizens but obtained no substantial concessions from Joseph II.

At the start of the French Revolution in 1789 the Pope maintained an attitude of prudent preoccupation, however the approval of the civil constitution of the clergy led him to issue the brief *Quod aliquantum* in 1791 in which he condemned all the National Assembly's work, thus reaching a final break aggravated by the subsequent brief, *Charitas*. The death of Louis XVI and the mass emigration of the French clergy further radicalized the conflict between the Papal States and revolutionary France; Bonaparte's victorious Italian campaign forced Pius VI into negotiations with the Directorate to reach the Peace of Tolentino in 1797, which imposed very burdensome conditions upon the Papal States. Events precipitated further; the French army occupied Rome in February 1798 proclaiming the Republic and forcing Pius VI into exile and imprisonment in France where he died in 1799.

His Papacy was characterized by pomp and grandeur, which gave great impetus to artistic and archeological endeavors and research on antiquities, and the presence of many foreign artists and writers confirmed Rome's role as a lively center for neo-classical art and culture. His interest in archeology culminated in the organization of the Pius Clementine Museum, which became the richest archeological collection in Europe and fostered recognition of archeology as an independent discipline promoting planned excavations and exercising the right of choice on their findings. In addition to works in the city sponsored in 1777 he drained the Pontine Marshes; the recovered land, according to his policy of nepotism, was assigned in perpetual lease to his nephew Luigi Braschi Onesti, for whom he commissioned the palace of the same name from the architect Cosimo Morelli.

Giuseppe Ceracchi, a Roman sculptor of notable skill whose political passion and adherence to revolutionary ideas led to negative criticism and ultimately, his death, was commissioned to do a first papal portrait in 1788 by Luigi Braschi, the Pope's nephew. Although it received an enthusiastic review in the "Journal of Fine Arts", the bust was nevertheless rejected by its sponsor. From this prototype came the bust today at Genoa (Palazzo Bianco), signed and dated 1790, while the one from the Museum of Rome, previously recorded in the Braschi family's inventory of assets in 1816 and 1864, derives from the portrait that, according to information provided by the sculptor's biographer Montanari, was commissioned by Monsignor Agresti, Pius VI's Almoner.

The present portrait is characterized by the perfect and masterly elegance of its modeling and the rich decoration of the stole, on which the acanthus fronds encircling the Braschi family's heraldic coat of arms and the dove of the Holy Spirit are enhanced by the complex detail of the cord that replaces the simple knot. In the face's almost smiling expression, the sculptor was able to capture the Pope's jovial features. The bust rests on a simple but refined base, decorated by two small classical volutes on the pedestal. A replica with variations is kept at Terracina in the Municipal Palace, once Braschi property, where Pius VI usually stayed when he traveled to inspect the drainage works on the Pontine Marshes.

Maria Elisa Tittoni

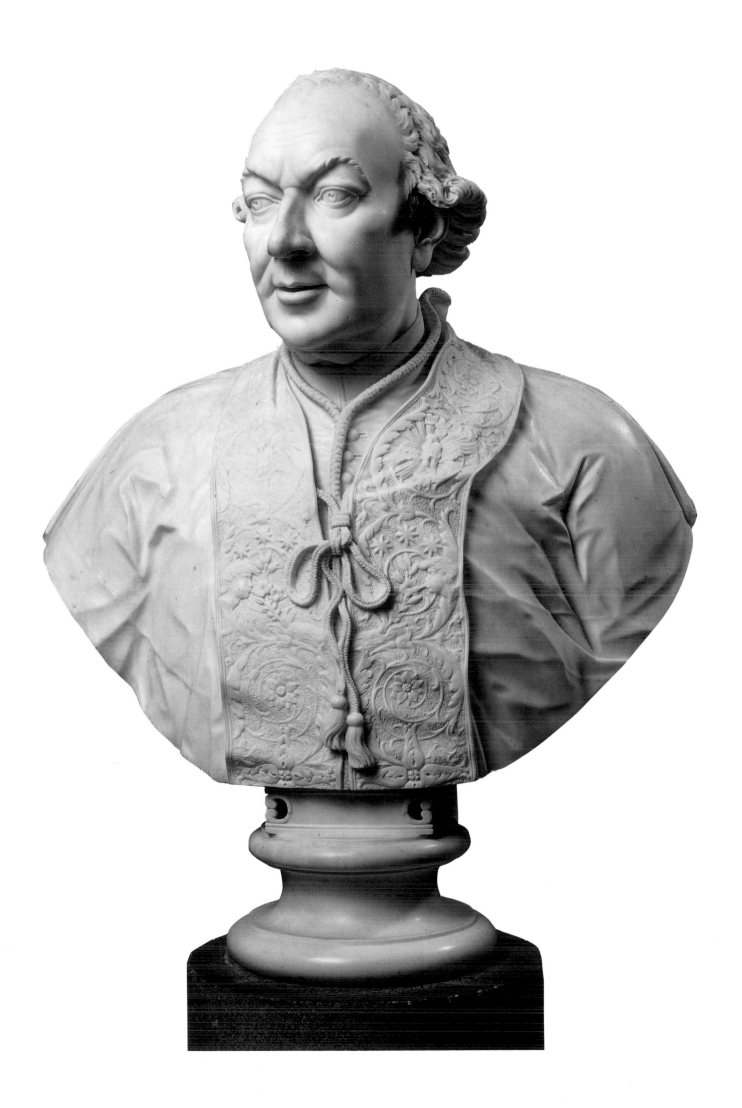

Vincenzo Camuccini
(Rome 1771 – 1844)

Portrait of Pope Pius VII (Barnaba Chiaramonti, 1820-1823)
oil on canvas, 137.5 x 113 cm.
Rome, galleria Bigetti

Bibliography: F. Petrucci, sheet 34, in F. Petrucci, 2004, pp. 114-115

The portrait depicts Pope Pius VII Chiaramonti seated on the papal throne with a pensive, almost absentminded downward glance, while in his left hand he holds a letter bearing the inscription: "BENEVENTO. FREGELLIS. PICENO./ EMILIA. BONONIA. FERRARIA./ PONTIFICALI. OFFICN…RESTITV(TIS) DN. MDCCCXV", in reference to the patrimony returned to the Church after the 1815 Congress of Vienna.

Iconographically speaking, this is a neo-classical revisitation of earlier papal portraiture, moving from Raphael's prototype of Julius II, passing through Velázquez's Innocent X and Batoni's Pius VI.

The painting is an autograph replica of the portrait of Pius VII executed by Vincenzo Camuccini in the summer of 1814, when the Pope, immediately after his return from the Fontainbleau Castle where he had been exiled by Napoleon, sat to the artist at the Apostolic Palace at Castel Gandolfo.

At least five versions of the portrait are documented, among them one given by the artist to Duke Frederic IV of Saxony, the replica commissioned by Cardinal Consalvi, Pius VII's Secretary of State, and another replica executed for prince Chiaramonti, the Pope's nephew. (1)

The prototype was identified by Ulrich Hiesinger as the version painted for Duke Frederic IV of Saxony. This would be demonstrated by an autograph note from the painter dated February 20, 1841 titled "Objects in my possession" where it is written: "The Illustrious Prince of Saxony for having given him the portrait of Pius VII I executed when he returned to Rome in the year (18)14…". (2)

In the Camuccini Palace at Cantalupo in Sabina there is a preparatory drawing for the portrait with the following inscription: "Portrait of Pius VII which I drew at his residence during the Time of His Sojourn at Castel Gandolfo". Perhaps the most outstanding version of the portrait, of remarkable effect, was executed with loose brushstrokes for Cardinal Consalvi and is today found in the Kunsthistorisches Museum in Vienna. (3)

The Vienna painting's expressive strength and highly dramatic style are characterized by the fluid pictorialism of the *mozzetta* and of the face furrowed by wrinkles, in some parts alternating with minute description. The version exhibited here must be considered an idealized portrait of Pius VII, certainly much later, characterized by a smoothness that recalls Batoni and even Raphael. In it one can recognize, more than in the Viennese version (which moreover has the same dimensions: 137 x 113.5 cm.), the pictorial style typical of Camuccini's official compositions, with a tendency towards abstraction and a strong classicising impulse, a softening of the Pope's tense features, a search for neo-classical composure. The brushstrokes are compact, although in the garments and other passages a more rapid execution is noted, with particular softness in the vestment's subtle tones.

Camuccini's portrait of Pius VII immediately met with notable success; it was engraved by Angelo Bertini and copied several times. Copies are conserved at the National Museum of Tarquinia, the Pinacoteca Comunale of Spoleto, and at the Academy of Saint Luke (inv. 190), the latter executed by Virginia Mariani. In 1815 José de Madrazo painted a copy for Cardinal Gardoqui of Bilbao. An autograph version in a smaller, oval format depicted only the face and was clearly a memento created as a chamber decoration. It is in the Lemme collection in Rome. (4)

Barnaba Chiaramonti (1742-1823) was born at Cesena and elected Pope the 14th march 1800, taking the name of Pio VII. His twentythree-year papacy was dramatic for the story of the Church. In 1808 the French army of occupation entered in Rome and in 1809 the Pontifical State was annexed to the France; Pio VII was arrested and sent into exile in Grenoble and then in Fontainbleau. Only in 1814 he could return in Rome and after the Vienna Congress the Pontifical State was established. Under Pius's reign Rome was also the favourite abode of artists. Among these it suffices to cite the illustrious names of Canova, Thorwaldsen, Overbeck, Pforr, Schadow, and Cornelius. Pius VII added numerous manuscripts and printed volumes to the Vatican Library; reopened the English, Scottish, and German Colleges at Rome, and established new chairs in the Roman College. He reorganized the Congregation of the Propaganda, and condemned the Bible Societies. The suppressed Society of Jesus he restablished for Russia in 1801, for the Kingdom of the Two Sicilies in 1804; for America, England, and Ireland in 1813, and for the Universal Church on 7 August, 1814.

Francesco Petrucci

1) See G. Piantoni, 1978, pp. 91-92
2) See U. Hiesinger, 1978, p. 307; G. Piantoni, 1978, pp. 91-92
3) See U. Hiesinger, 1978, pp. 307, 318; Roberta J. M. Olson, 1992, p. 130, no. 21; I. Sgarbozza, sheet VI.1, in Various Authors, 2003, p. 173
4) Various Authors, 1998, p. 274, no. 22

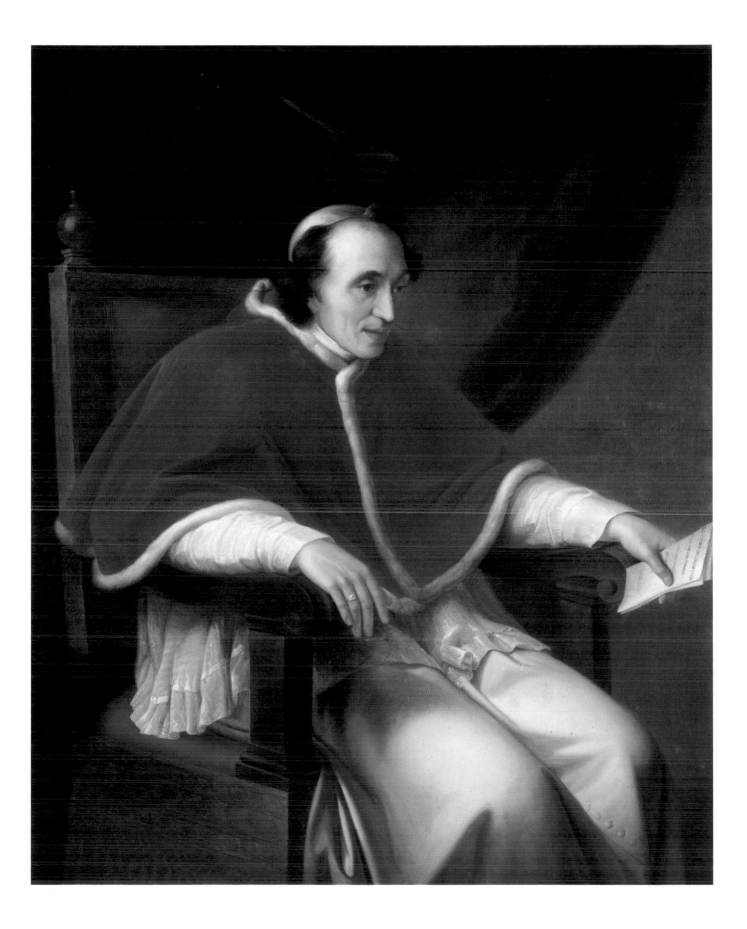

Leopold Louis Robert
(1794-1835)

Portrait of Leo XII (Annibale della Genga, 1823- 1829)
pencil on paper, 18 x 14 cm.
Genzano (Rome), Jacobini Palace

Bibliography: D. Petrucci, in *Papi in posa…*, 2004, p. 118

This drawing appeared on the Swiss antiques market as a work by Leopold Louis Robert, an attribution confirmed when Finarte exhibited the drawing at its auction in Rome on March 24, 2003. Leopold Louis Robert made a name for himself as an engraver and later as a painter, having frequented Jacques-Louis David's workshop in Paris. From 1818 he was in Rome and must have drawn Leo XII in the first years of his papacy. The drawing, with clean and decisive lines, clearly reveals Robert's experience as an engraver. It depicts a Pope of youthful appearance, with regular features, framed in profile with his gaze fixed forward and his short curly hair almost completely covered by the *zucchetto*.

The drawing was perhaps used as a model for medals, and is the best portrait known of Leo XII, of whom some insipid images deriving from Agostino Tofanelli's portrait in the Vatican Museums' Storerooms are also known.

The successor to Pius VII was Annibale Sermattei della Genga, who took the name Leo XII. Born in Ancona of a noble family, Annibale Sermattei was held in great esteem by Pius VI Braschi who named him Bishop of Tyre in 1794. The same Pope had entrusted him with a delicate nunciature in Germany at Lucerne and Cologne for the 1805 Diet of Ratisbon. Napoleon's intervention caused negotiations with Bavaria to fail and the following year at Bratislava della Genga was unsuccessful in securing agreements. In 1808 he was Nuncio at Paris. After Napoleon's defeat, unexpectedly, he was created Cardinal by Pius VII. Forced to refuse for medical reasons the bishopric of Senigallia, he participated in the conclave after the death of the Chiaramonti Pope. The first round of voting ended unsuccessfully; Cardinal Annibale della Genga obtained the 34 votes sufficient for final victory in the second round.

The papacy of Leo XII, or the "Lemon Pope" as he was called for the color of his skin, was not lengthy—he reigned only six years— but it was eventful. Distrustful of change, he sent Cardinal Rivarola to the Romagna to suppress secret associations; disorders followed and the guilty were revealed to be nobles, doctors, lawyers and others. But the happy event to which Leo XII devoted the most sincere efforts of his papacy was the Jubilee of 1825. On that occasion, the Pope spent all his energies so that the celebration would be perfect; he charged himself with reinvigorating the Christian faith, damaged by too many events. The results were extraordinary for the influx of pilgrims and for public order and safety, the latter achieved in part because the infamous bandit gang led by Gasparone was routed from the outskirts of Rome. (1)

Daniele Petrucci

1) See Antonio Muñoz, *Rome in the Early 19th Century*, Rome, 1961, pp. 11-41

Ferdinando Cavalleri
(Rome 1794 – 1865)

Portrait of Pius VIII (Francesco Castiglioni, 1829-1830)
oil on canvas, 138 x 100 cm.
Cingoli (Macerata), Castiglioni Palace

Bibliography: unpublished

This portrait is signed and dated 1829 and has been in the Castiglioni collection since before 1950; this allows us to exclude any possibility of identifying it with Cavalleri's portrait of Pius VIII, also privately owned but not in the Castiglioni collection at Cingoli, which was exhibited at the *Portraits of the Popes* exhibition held at Rome in 1950-1951. The absence in that exhibition's catalog of any reproductions or of descriptions of the works exhibited does not at this time allow us to determine whether that portrait was a replica of ours or if it was a different painting.

Presumably for the execution of this, or these, portraits, Pius VIII granted Cavalleri the decoration of the Order of the Gold Spur. After visiting the studio of Vincenzo Camuccini, another artist who painted his likeness, the Pope granted the title of baron to that painter. Cavalleri also executed a full-figure portrait of Gregory XVI, who invested him, in 1842, with the Order of St. Sylvester.

A painter of historical subjects and portraits, Cavalleri studied at Florence, at Turin and at Rome, the city where he perfected his art thanks to a pension granted him by the Piedmontese government in virtue of the portrait of the *Prince of Carignano* which he executed in 1815. Member of the Turin and Florence Academies since 1828, in 1831 he was nominated as a member of the Academy of Saint Luke in Rome, where he held important positions. He was also a member of the royal academies of Naples and Lisbon. An expert in various artistic techniques, he dedicated himself to experiments to make pigments more brilliant, to speed the colors' drying process and to remove stains from marble. He was also an engraver.

In 1829, P. Guglielmi produced a print from the portrait now under examination for the presses of the Dell'Armi Lithographers of Rome. Cavalleri portrayed Pius VIII in the act of bestowing the apostolic blessing. The barely raised right hand stands out against the tiara, symbol of power, and against the cloud that is seen from the window opened onto Rome and the world. The face, with an intense gaze, absorbed in the solemn rite, is framed by the golden embroidery of the large papal cope, a rich mantle worn by Popes for liturgical services, and by the formal that covers the gilded silver hooks that fasten the cloak in front. The papal coat of arms in the lower left declares that seated on the throne of Peter is the most illustrious descendant of the Castiglioni family of Cingoli.

Francesco Saverio Castiglioni (1761-1830) was a native of Cingoli in the Marche region. Vicar-general at Anagni and Fano and bishop of Montalto, he was exiled for refusing to swear loyalty to Napoleon. He was created Cardinal in 1816; he later became bishop of Cesena and, finally, Pope on March 31, 1829. In his brief papacy he promulgated the encyclical *Traditi humilitati nostrae*, in which he made a claim for papal authority and opposition to atheism. His careful policy of mediation with foreign powers led him to recognize Louis Philippe as the legitimate king of France.

Paolo Appignanesi

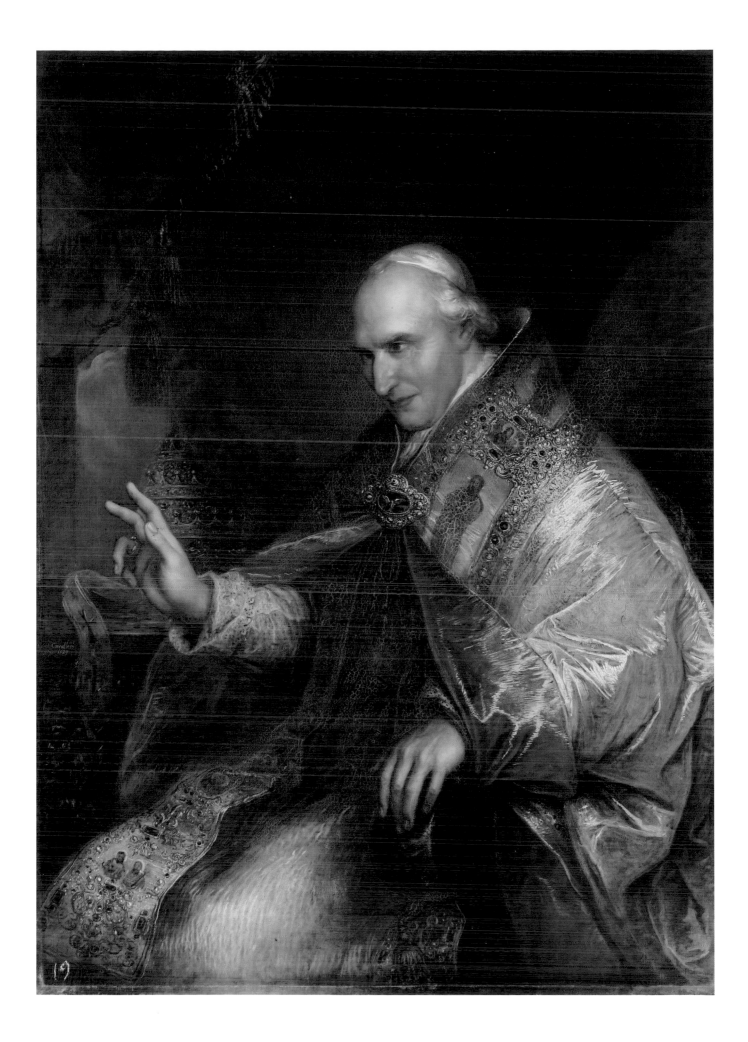

Giovanni Busato
(Vicenza 1806-1886)

Portrait of Gregory XVI (Bartolomeo Cappellari, 1831-1846)
oil on canvas, 72 x 61 cm.
Genzano (Rome), Jacobini Palace

Bibliography: S. Marra, sheet 27, in F. Petrucci, 2002, p. 55; idem, in *Papi in posa...*, 2004, p.122

The portrait displayed in the exhibition is the work of Giovanni Busato, a painter of historical subjects and portraits who trained at Venice, Rome and at the great courts of Europe. A full-figure portrait probably also by his hand is at the Credit Cooperative Bank of the Castelli Romani at Castel Gandolfo.

The Pope is portrayed in the act of blessing. Behind him, a red curtain drawn to one side allows a glimpse of the dome of St. Peter's. The painting is highly detailed and the figure is well-proportioned. The Pope's features are unidealized, revealing Busato's attention to physiognomy in the wrinkles of the face and in the melancholy expression of the sitter.

The masterpiece of Gregorian portrait painting is surely the large canvas at the Lateran Museum, probably drawn from the portrait of the enthroned Pope in the Ancona Municipal Museum, both by Francesco Podesti (M. Polverini, 1996).

Pope Gregory XVI (1831-1846) loved the attractions of the Alban residence at Castel Gandolfo, a retreat that offered the possibility of a simple and tranquil life more in keeping with his nature as an ex-Camaldolese friar.

He was a controversial figure, variously friend or foe of technology: with great curiosity he visited the Jesuit college at Tivoli, where he posed for a photograph, saw the first daguerreotype, and observed some experiments with electrical lighting; on the other hand he blocked the introduction of railroads into the papal states, but only to avoid upsetting traditional economy and customs.

The Nobel Prize winning poet Giosuè Carducci and the Roman dialect poet Giuseppe Gioacchino Belli played significant roles in consigning to history a negative verdict on this Pope (1). Nevertheless, Gregory's important contributions include improving travel by introducing steamboats to the Tiber River, and commissioning the "Bridge of Chains" to improve access to the Castelli Romani region. The bridge, a five-arch structure built between Galloro and Genzano, was completed in October 1843, resulting in the detour of the Via Appia. The bridge was destroyed during World War II and replaced by a road embankment with a single central arch.

Susanna Marra

1) See E. Bonomelli, 1953; L. Devoti, S. Petrillo, 1996

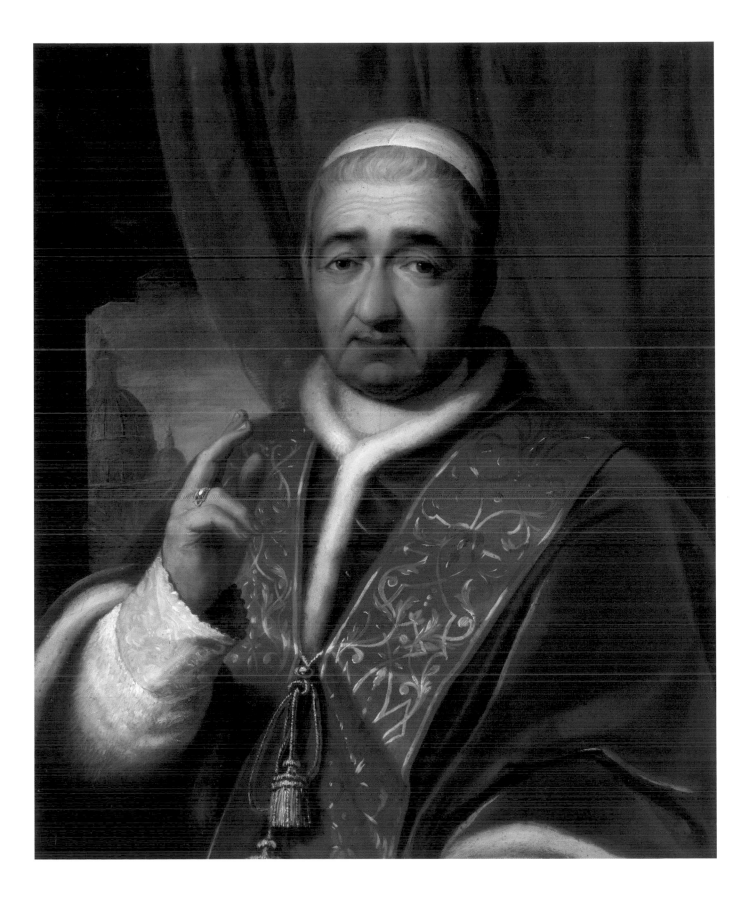

Francesco Podesti
(Ancona 1800 – Rome 1895)

Portrait of Gregory XVI (Bartolomeo Cappellari, 1831-1846)
oil on canvas, 197 x 147 cm.
Vatican City, Vatican Museums, inv. MV 40454

Bibliography: Various Authors, 1932, p. 205, tab. LX; Various Authors,1981, p. 13; C. Pietrangeli, 1993, p. 174, tab. 146; M. F. Apolloni, A. Podesti, sheet 26, in M. Polverari, 1996, p. 158

This portrait, today in the Vatican Historical Museum at the Lateran Apostolic Palace, was a gift from the physician and medical historian Pietro Capparoni (1868-1947) to Pius XI in 1929. Podesti probably bequeathed the picture to his student Silverio Capparoni (1831-1907), Pietro's father.

Podesti's painting is cited in an autobiographical writing, work, document collected by monsignor Carlo Emanuele Muzzarelli as a "Portrait of the Holy Father Gregory XVI in papal vestments, borne on the gestatorial chair". It is, however, omitted from the *Memoirs* of the painter, who left the canvas unfinished, with some parts still only sketched in. The appearance of the face is similar to that in the papal portrait today in the Pinacoteca of Ancona, previously at the city hall, which Podesti completed in November 1834. It is therefore plausible to assume a later date for this painting, which presumably remained in the painter's house unfinished.

Portraits of Pope Cappellari are of rather low quality compared to those of his predecessors. Podesti's portrait is certainly the best, although we do not known if the Pope posed for it. According to Moroni, in fact, "due to his humility, the Pope refused to be painted, so artists copied the few portraits which had his image taken from life, but with scant success; therefore not only was he badly depicted, but sometimes they also deformed him, although this was not due to inexperience or sectarian malice". (1)

Bartolomeo Alberto Cappellari (1765-1846) was born at Belluno and entered the Camaldolese Order in 1783. Later vicar-general of that Order, in 1826 he was created Cardinal and appointed prefect of the Congregation for the Propagation of the Faith. He was unexpectedly elected Pope with the support of Austria in February 1831. Immediately after his installation, he witnessed the drama of insurrections in various cities in the Emilia and in the Marche that proclaimed the end of the Papal States. He reestablished order with the assistance of Austria. He was a conservative Pope, distinguished by his intransigence and his aversion to any type of liberal reform. A learned orientalist and theologian, he encouraged missions especially in North America and in England, openly opposing slavery. He rebuilt Saint Paul's Basilica, founded the Botanical Gardens, the Gregorian Egyptian Museum and the Gregorian Etruscan Museum.

Francesco Petrucci

1) See G. Moroni, 1857, LXXXIII, pp. 67, 68-69

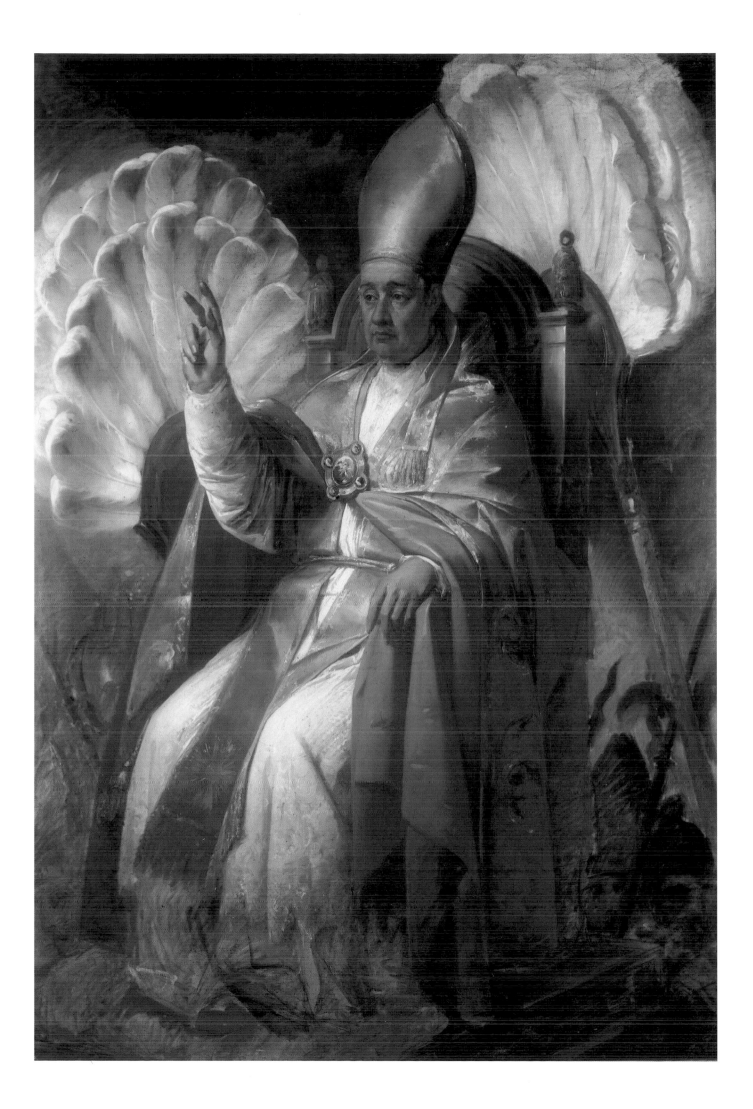

Giovanni Maria Benzoni

(Songavazzo, at Clusone, Bergamo, 1809 – Rome 1873)
Bust of Pius IX (Giovanni Mastai Ferretti, 1846-1878)
Marble, 67 x 65 x 30 cm.
Genzano (Rome), Jacobini Palace

Bibliography: S. Marra, sheet 28, in F. Petrucci, 2002, pp. 55-56

This bust had a preview showing in the *Castles and Castellans* exhibition held at the Chigi Palace at Ariccia in 2002. The marble bears the following inscription carved on the right shoulder: "On the date of 23 February 1857/ S. Pius IX wrote in his hand/on the clay the following motto: PAX". The terracotta model that preceded the execution of the marble is now lost. A woodcarver in his youth, Giovanni Maria Benzoni moved to Rome in 1828 at the behest of his benefactor count Luigi Tadini. He was a student of Giuseppe Fabris and attended the Academy of Saint Luke. In 1829 he won three competitions, in sculpture, anatomy and nudes at that Academy and at the Rome City Hall. In 1832 he finally opened a studio in Rome, with a considerable atelier composed of about fifty assistants. His workshop was frequented by such princes and royalty as the King of Naples, [Queen] Margarita and [King] Umberto of Savoy, the Queen of the Netherlands, the Russian Tsar, the Emperor of Brazil and Pope Pius IX.

There are a great number of sculptures by Benzoni, each with a decidedly classical and purist orientation. In 1832 he executed *The Muse Euterpe* and other works for prince Alessandro Torolonia. In 1840 he produced the busts of Gaetano Donizetti and Alberico da Rosicate for the University of Bergamo, and in 1842 the bust of abbot Agostino Salvioni for the Civic Library of that city. In 1844 he sculpted the *Monument to Emperor Francis I* (Bergamo, Carrara Academy). In 1851 he submitted some works to the Universal Exposition of London held at the Crystal Palace. In 1857 he executed the *Monument to Cardinal Angelo Mai* for the Church of Saint Anastasia in Rome and in 1858 the bust of Torquato Tasso for the University of Bergamo. On a commission from the Papal States he participated in the Antwerp Exposition, exhibiting several marbles. In 1863 he executed the *Veiled Rebecca* for Robert Winthe of London. In 1864 was made a Knight of the Papal Order of Gregory the Great. From 1865 to 1867 he traveled throughout Europe, visiting Switzerland, France, England, Germany and Spain. He died at Rome on April 28, 1873 and is buried in the Church of San Lorenzo al Verano.

Benzoni's works are found in several museums, including the High Museum of Atlanta (*Veiled Rebecca*), the Pinacoteca Ambrosiana of Milan (*Saint Anne and Mary*), the Russel Cates Museum of Bournemouth (*The Morning Prayer*), and the Berkshires Museum at Pittsfield, Massachusetts (*Veiled Rebecca*). He also participated in the execution of the *Monument to the Immaculate Conception* commissioned in 1856 by Pius IX for the Piazza di Spagna. (1)

Francesco Petrucci

1) G. Rota, 1938; *Dizionario Biografico degli Italiani*, [Italians' Biographical Dictionary] vol. 8, Rome 1966, pp. 735-736; B. Belotti, 1978, pp. 183-193

Cesare Fracassini
(Rome 1838- 1868)

Portrait of Pius IX (Giovanni Maria Mastai-Ferretti, 1846-1878)
Pastel, 26 x 17.2 cm.
Genzano (Rome), Jacobini Palace

Bibliography: Various Authors, *Rome in the 19th Century*, Exhibit, 1932, p. 204, no. 1; S. Marra, in *Papi in posa...*, 2004, p. 126

This portrait, signed "C. Fracassini 1869", presents us with the image of a man inspired by God. He gazes toward heaven, trusting in a divine response. The iconography is unusual for papal portraiture; the Holy Father has the ecstatic expression commonly reserved for saints. The Pontiff's white cope is a departure from the traditional red, and the shape of the support is also uncommon, framing little more than the head and part of the shoulders, the oval curve echoing the shape of the papal tiara.

It was Pius IX who, with the Constitution *Ineffabilis Deus* of December 8, 1854, pronounced the dogma of the Immaculate Conception; the dogma of papal infallibility was affirmed at the First Vatican Council, which Pius convened in 1869. His profound religiosity was noted in his own lifetime, and the faithful loved him for his benevolence and generosity. Nonetheless he was viewed negatively by some. To him we owe great liberal enterprises as well as unyielding positions on refusals: upon his initiative, those condemned for political crimes received an amnesty in 1846, and the Constitution was granted during the tempestuous year 1848. He was steadfast in his desire not to enter into war with Austria and absolutely opposed to the loss of the Church's temporal power. With Pius IX an era ended: on September 20, 1870, the breaching of the Porta Pia removed Vatican domination over Rome, and the city was proclaimed the capital of Italy.

With his 1846 proclamation of amnesty for political crimes, Giovanni Maria Mastai Ferretti (Senigalli 1792-Rome 1878), already known for his generosity, aroused great hope in the Italy of the *Risorgimento* period. After the dramatic events of 1848 that forced him into exile at Gaeta as a guest of Ferdinand II of Bourbon, the Ferretti Pope adopted a rigid stance against the new progressive ideologies. He saw the Papal States unravel step by step, despite French support, until the taking of Rome on September 20, 1870. He is remembered especially for proclaiming the dogma of the Immaculate Conception (1854) and defining the dogma of Papal infallibility (1870). On September third of the Jubilee Year 2000 he was beatified by John Paul II, by reason of the Christian virtues to which he bore witness at a moment that was particularly dramatic for the history of the Church.

Susanna Marra

Tommaso Lorenzone
(Pancalieri 1824 – Turin 1902)

Portrait of Pius IX (Giovanni Mastai Ferretti, 1846-1878)
tempera on paper, 32 x 25 cm.
Ariccia (Rome), Chigi Palace, inv. 1369

Bibliography: F. Petrucci, 2004b, pp. 37-38

This is a "memento" or a replica in reduced format of the canvas in the Mastai Palace at Senigallia. The tempera, donated to the Chigi Palace of Ariccia by the architect Francesco Scopellato in June 2000, is signed in the lower right: "T. Lorenzone. 1870." The portrait therefore assumes significant importance with respect to other images of Pius IX, since it was made in Rome immediately after the city was seized by the Savoy militia on September 20, 1870. (1)

Pius IX is shown standing, with the papal throne behind him at the left; to the right there is a table on which are placed the Gospels, a crucifix and a small statuette of the Virgin Mary. With his left hand, the Pope points to the crucifix, in a reference to his motto, a biblical passage included in the inscription on the 1870 medal for the defense of the rights of the Church: *"Exsurge Domine iudica causam tuam"* (Arise, oh Lord, judge your cause, [for a wild boar ravages thy vineyard...]), almost an invocation to the Lord in a difficult moment for the Church. The statuette of the Virgin refers to the dogma of the Immaculate Conception, proclaimed by Pius IX in 1854.

Already in the month of August 1870 Napoleon III was obliged to withdraw the French troops stationed around Lazio, later falling prisoner to the Prussians with the proclamation of the Republic on September 4th at Paris. The Italian government, with popular support, then decided to occupy Rome. Attempts at reconciliation by the Savoy envoy, count Gustavo Ponza di San Martino, came to naught. Under General Rafaelle Cadorna, the Italian army entered Rome through the famous breach in the Porta Pia on September 20,1870. On October 2nd, Rome and the Lazio region were annexed to Italy. A month later, Pius IX issued the encyclical *Respicientes* in which he declared the unlawfulness of the occupation and his own captivity. Thus ended the one thousand five hundred years of papal temporal power.

Francesco Petrucci

1) See C. Mencucci, 1978, p. 77

T. Lorenzone
1870

Attributed to Tommaso Lorenzone
(Pancalieri 1824 – Turin 1902)

Portrait of Pius IX (Giovanni Mastai Ferretti, 1846-1878)
oil on canvas, 115 x 90 cm.
Rome, private collection

Bibliography: unpublished

The face of Pius IX here exhibited repeats the pose and composition of the visage in the portrait by Tommaso Lorenzone, known through the canvas in the Mastai Museum of Senigallia and the *memoria* [a small-scale replica produced as a keepsake] in the Chigi Palace of Ariccia. The Pope is portrayed standing, wearing a *camauro* and a white *zucchetto*, with his left hand against his chest and his right hand in a gesture of benediction.

Repeated here is the most traditional and common image of Pius IX, that of the Pope bestowing the apostolic blessing *Urbi et Orbi* [to the city of Rome and to the world]. This iconography began with the youthful portrait in the Vatican Museums and continued with the canvas by B. Deloose signed and dated 1860 that depicts the seated Pope in the act of blessing with the citation of the 1846 amnesty (Vatican Museums, inv. MV 44225). This was followed by a portrait signed by Riganti, also in the Vatican Museums (inv. MV 43318), and by the 1871 canvas by Healy.

Tommaso Andrea Lorenzone, born at Pancalieri on February 13, 1824, later moved with his family to Turin where, having completed his studies, he registered at the Royal Albertine Academy of Fine Arts. There he completed his classical training with a purist orientation under the direction of Giovan Battista Biscarra and other famous masters. He preferred sacred subject matter, obtaining commissions from religious orders, individuals and also from the King of Sardinia. Among his most important works are the altarpiece of the Basilica of Santa Maria Ausiliatrice commissioned in 1868 by Don Bosco, the *Journey of Saint Joseph* in the Church of San Francesco di Paola at Turin, and three altarpieces in the Church of the Sacred Heart at Pinerolo. He also distinguished himself as a portraitist. He died on June 6, 1902 at Turin, having earned great honors and fame.

Francesco Petrucci

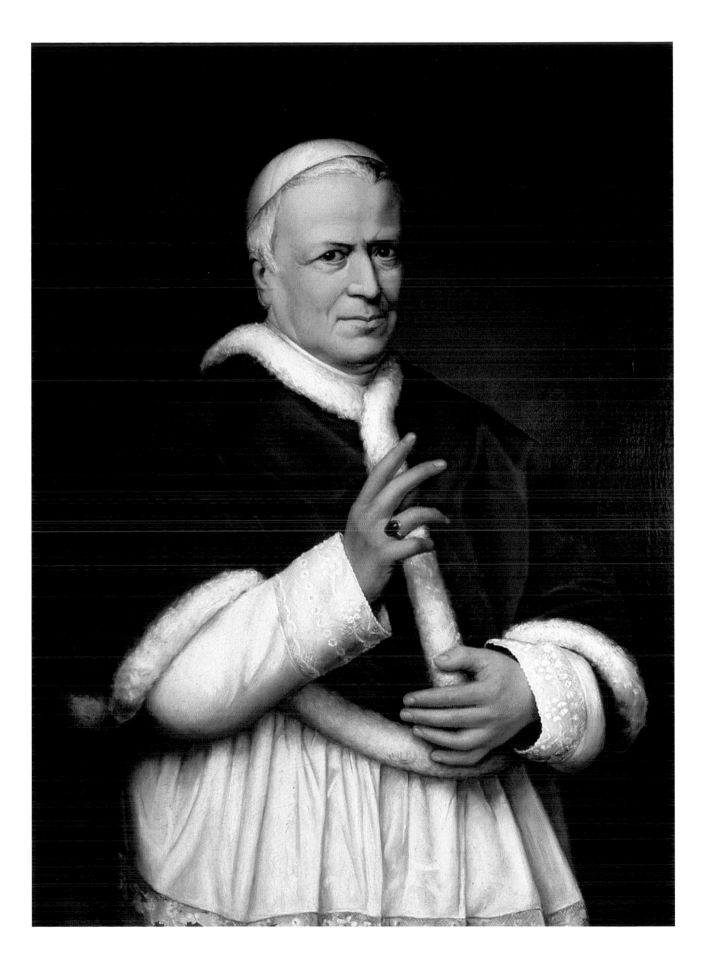

George Peter Alexander Healy
(Boston 1808 – Chicago 1894)

Portrait of Pius IX (Giovanni Mastai Ferretti, 1846-1878)
oil on canvas, 155 x 110 cm.
Senigallia, Mastai Palace

Bibliography: C. Mencucci, 1978, p. 67; G. Flamini, A. Mariotti, 1991, no. 127; F. Petrucci, 2004b, p. 37

This painting is signed and dated 1871 by the artist George Peter Alexander Healy. The portrait repeats the traditional composition that was Pope Mastai's favorite, depicting him standing and in the act of blessing. The sentimental gesture of the left hand over the chest recalls Titian and Van Dyck, and the scarlet drapery and the column to the right have a similarly lengthy pedigree. The human and lifelike quality of the facial expression surpasses that of any other portrait of this Pope.

This American artist, author of portraits and historical paintings, was born at Boston on July 15, 1808. He dedicated himself to painting from a young age, his talent encouraged by the English-born American portrait painter Thomas Sully. At eighteen Healy began to paint portraits, achieving immediate success. In 1834 he departed for Europe, where he studied in Paris with Baron Antoine-Jean Gros until the master's suicide the following year; Healy remained in the Europe fifteen more years. Under the patronage of King Louis Philippe he executed a series of portraits of illustrious Americans for the royal palace at Versailles. His painting *Franklin Urging the Claims of the Colonists before Louis XVI* won him the second-class gold medal at the 1855 Paris International Exposition. Healy returned to the United States and settled in Chicago for about ten years, executing more than five hundred portraits; in 1869 he returned to Europe, working between Rome and Paris for twenty-one years. The present portrait was executed at Rome presumably in the winter of 1871, given the heavy velvet *mozzetta* trimmed with ermine worn by the Pope.

In 1892 Healy made his final return to Chicago, where he died on June 14, 1894. He was the greatest American portraitist of the century, for both the number and the importance of the subjects he portrayed. In addition to Pius IX, the artist depicted such illustrious persons as Presidents Franklin Pierce and Abraham Lincoln, generals Grant and William T. Sherman, Louis Philippe of France, the poet Longfellow, Franz Liszt, Lord Lyons, Cardinal McClosky and many others. In his large-scale painting *Webster's Reply to Hayne* (Boston, Faneuil Hall) no less than one hundred thirty portraits appear: an exercise in physiognomic virtuosity. He was a member of the National Academy of Design and wrote the book *Reminiscences of a Portrait Painter* (Chicago, 1894). His paintings are in many important American museums, from the Metropolitan Museum of Art in New York to the Museum of Fine Arts of San Francisco. His self-portrait is in the Uffizi [Galleries].

Healy's enormous success was a product of his captivating style, marked by a vivacious naturalism not exempt from the influence of French academic painting. He did not disdain to use new media that technology placed at his disposal, including photography.

Francesco Petrucci

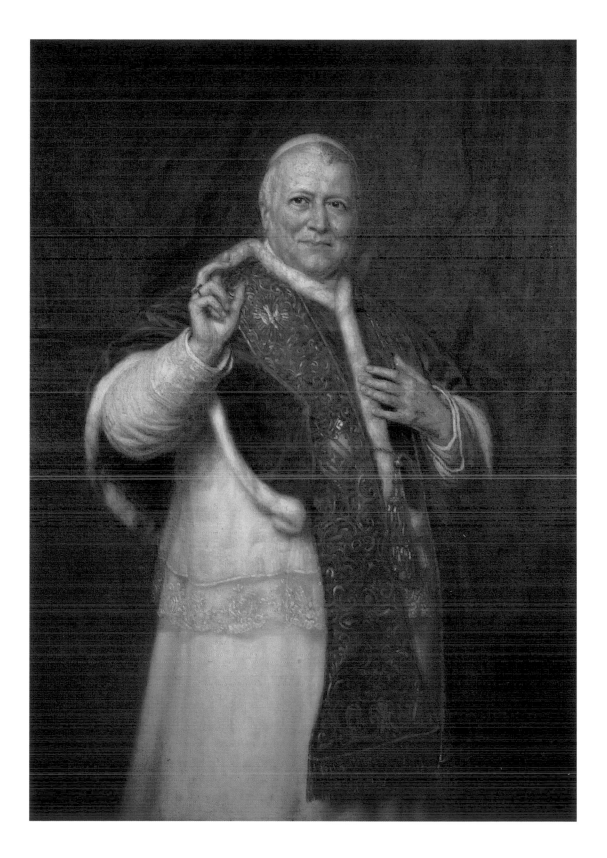

Giulio Tadolini
(Rome, 1849-1918)

Bust of Leo XIII (Gioacchino Pecci, 1878-1903)
marble, h. 82 cm.
Rome, Benucci Antiquarian Galleries

Bibliography: S. Starnotti, in *Papi in posa…*, 2004, p. 130

The unpublished work here exhibited, for which only a preparatory terracotta study was known, fills a gap in the *oeuvre* of the sculptor Giulio Tadolini. Previously this marble version was known only through a photograph in the Tadolini Archive. (1) The work is signed "TADOLINI" on the *recto*, and inscribed on the left shoulder *"Leo confidens"*; the stole bears the coat of arms of the Counts Pecci, the noble family to which the Pope belonged, and the Latinized name "LEO XIII".

Giulio Tadolini enjoyed significant success during the Umbertine period, most notably for his sculpted portraits, until his career was interrupted by the outbreak of World War I. Although he did produce busts of fantasy characters and of persons not historically renowned, much of his work immortalizes in stone the faces of the reigning monarchs of the House of Savoy: Umberto I (c. 1901) and Queen Margherita, whose image he sculpted in the form of a bust (1893) and in full figure, in the act of rising from a throne (1893). Tadolini also produced a portrait bust of Leo XIII's predecessor, Innocent XII (c. 1885) (2).

The portrait under review was executed as soon as Vincenzo Gioacchino of the Counts Pecchi was elected to the papacy on February 20, 1878. Born in 1810 at Carpineto Romano, he underwent strict Jesuit training in the College of Viterbo, then in Rome. He was ordained in 1837 upon completion of his theological, law and philosophy studies. Bishop of Perugia from 1846 to 1878, he dedicated himself with great zeal to the reorganization of places of worship, to reinvigorating pious congregations and to the foundation of new dioceses. He was created Cardinal in 1853, influencing the work of Pius IX especially with respect to editing the *Syllabus*: the sovereignty of the State of the Church, as it is known, was recognized only under Pius XI (1929) also as a result of Leo XIII's political activism. As a consequence of the uprisings of 1848 and 1859, and of the new role of Rome as the capital of Italy, Cardinal Pecci opposed the spread of democratic ideals and emerging socialist thought all aimed at the secularization of society. Reinvigorating the cult of the Sacred Heart and that of Saint Joseph, model of family virtue and patron of artisans, seemed to the Cardinal to be a way to draw society once again into the religious sphere; his sensitivity and political acumen led him to meditate seriously on the problems of the working class.

Leo XIII much appreciated Tadolini's talent for portraiture. The sculptor participated in and won the competition for the execution of the Pontiff's imposing funeral monument at St. John Lateran (1906-1907). Tadolini's success in portraiture owes much to his naturalistic style and attention to detail, enhanced by his propensity for depicting the psychological introspection of his subject. Giulio presents the Pope in an unidealized way, depicting Leo's large nose and prominent ears without apology. The good-natured and attractive smile, the slightly furrowed brow, and the proud gaze, directed into the distance, confer upon the features of the subject an unaffected attitude, suited to a Pope who was truly dedicated to the social and religious problems of his day, problems of which he was an active interpreter.

Simone Starnotti

1) See T.F. Hufschmidt, 1996, cat. G1, page 216
2) Portraits of little-known persons include the bust of Nennella, a young flower seller of the Piazza di Spagna, close to the artist's workshop on Via del Babbuino where the bust is still conserved. The bust of Umberto I, in bronze, is today at Palazzo della Provincia in Rome. The location of the bust of Queen Margherita is unknown. The 1:1 model is kept in Rome, at the Canova Tadolini Workshop Museum. The original bronze is known solely from the photographic archives. The model for the full-length figure of the Queen is still in the sculptor's former studio. The bronze bust of Innocent XII is today in the Palazzo Pignatelli in Rome

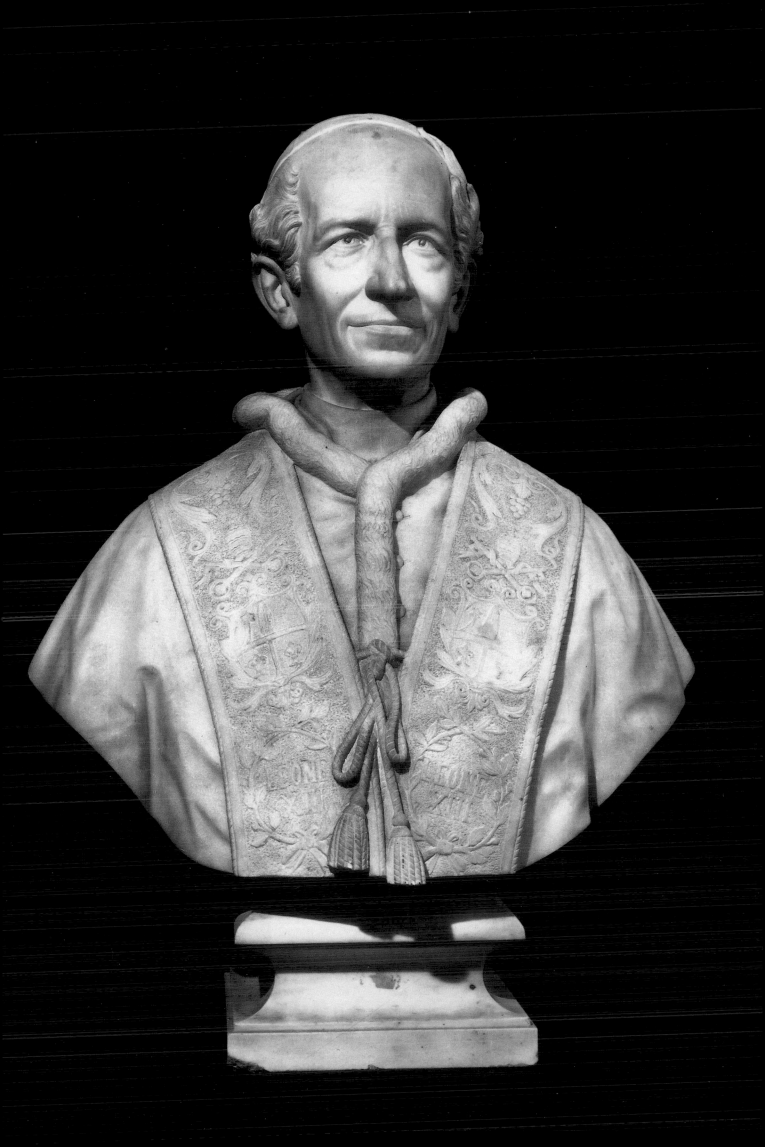

Jean Joseph Benjamin Constant
(Paris 1845-1902)

Portrait of Leo XIII (Vincenzo dei conti Pecci, 1878-1903)
oil on canvas, 112 x 87 cm.
Vatican City, Vatican Museums, inv. MV 2600

Bibliography: F. Petrucci, 2004b, p. 38, fig. 53

The portraiture of Leo XIII is characterized by its remarkable quality and by the initial international acceptance of the changes that were also occurring in Europe in the field of figurative arts. This signed canvas unquestionably represents one of Constant's most beautiful and original portraits. The painting, which originated from the *Sala dei Santi e dei Beati* [Room of the Saints and the Blessed] (Massi, 1914-1922) in the Vatican Papal Palace, is in storage in the Vatican Museums.

A constant element in portraits of Leo XIII is the Pope's smile; he has himself portrayed like an elderly cheerful grandfather, but with the bearing and the style of his noble house. The portrait is executed in an original composition, related to the pose of the portrait of Leo XIII made that same year by Philipp Alexius de László (Budapest, Hungarian National Gallery). It is painted in loose and deft brushstrokes, the face illuminated by the light falling from the window at the upper left, almost as a sign of Divine Grace as in many Baroque paintings derived from Caravaggio.

Benjamin Constant apprenticed at the School of Fine Arts of Toulouse and in 1886 at the School of Fine Arts of Paris; in 1867 entered the workshop of the historical painter Alexandre Cabanel. He made his debut at the 1869 Salon with *Hamlet and the King*, distinguishing himself as a great colorist. He then traveled in Spain, to Madrid, Toledo and Cordoba, and met Mariano Fortuny at Granada, deeply affected by the influence of his orientalist painting.

In 1872 he went to Morocco and stayed for two years, fascinated by the colors, the customs and the exotic beauty of that culture. After an initial production in the field of historical painting, he affirmed himself as one of the greatest "orientalists" of his time, obtaining awards and important recognition.

Around 1870, he abandoned this genre to dedicate himself to decorative painting and portraiture. For a time he was the preferred painter of English high society. He executed portraits of Queen Victoria, Queen Alexandra, and the Duke d'Aumale, while his portrait of his son André won a medal of honor in 1896. In 1893 he was named a member of the [French] Institute of Fine Arts, then a member of the Legion of Honor. He had a great number of students, among them Ernest Leonard Blumenschein, Frank Dumond, William Horton, William Kendall, Caroline Lord, and Granville Redmond.

Francesco Petrucci

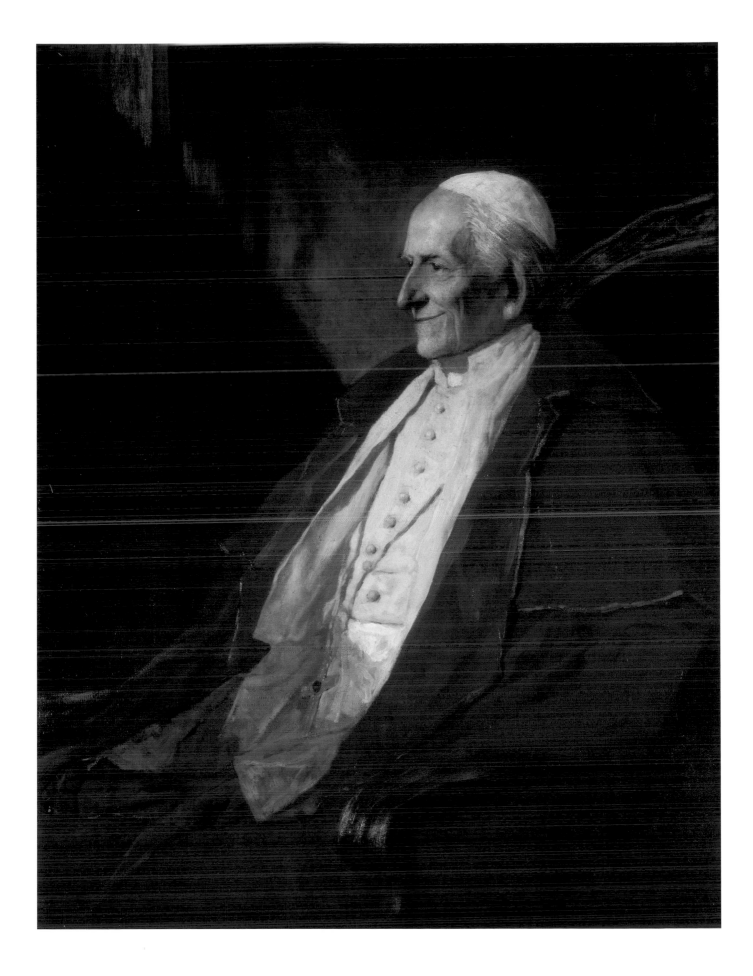

Alessandro Milesi
(Venice 1856-1945)

Portrait of Pope Saint Pius X (Giuseppe Sarto, 1903-1914)
oil on canvas, 134 x 105 cm.
Vatican City, Vatican Museums, inv. MV 42598

Bibliography: F. Petrucci, 2004b, p. 38, fig. 54

This image of Pope Saint Pius X has a more official character than the private and confidential portrait painted by Antoon van Welie, which depicts the Pontiff seated at his desk. (1) The canonical Raphaelesque pose returns here, presented from a slightly higher viewing point. The Holy Father fixes the viewer with an intense gaze; he holds a breviary in his left hand and rests his right hand on the arm of the chair. Pius's white robe and the short mantle on his shoulders recall the papal vestments described in Jean Joseph Constant's Portrait of Leo XIII.

The portrait is signed in the upper right by the Venetian painter Alessandro Milesi: "A. Milesi 1904." Milesi was one of the greatest exponents of nineteenth century Italian portraiture; happily, longevity allowed him to continue painting well into the twentieth century, although his later work sometimes repeats successful compositions established earlier in his career.

The present painting demonstrates Milesi's complete fluency in the pictorial language of Titian and the Venetians, which had been revived at that time by the synthetic tendencies of the *"macchiaiola"* [a group of impressionist artists active in Tuscany in the second half of the nineteenth century] and Impressionist schools. After attending the Academy of Venice, Milesi became a student of Napoleone Nani, whom he followed to Verona in 1874. He then moved to Venice under the protection of his patron Perpicich. He exhibited *Colazione del gondoliere* [*The Gondolier's Repast*] and *Wedding at Venice* in the National Exposition of Fine Arts held in that city in 1887, for which he received acclaim and wider recognition.

An erratic artist, Milesi achieved his greatest successes in portraiture, depicting refined "Belle Époque" ladies, the bourgeoisie, artists, intellectuals and politicians. Among his greatest achievements are the *Portrait of Giosuè Carducci* (Bologna, Carducci House) and the *Portrait of A Woman* called *Al Caffè* [*At the Coffeehouse*] for which he won the gold medal at the 1890 Boston Exposition (Genoa, Villa Grimaldi Fassio). From 1895 he participated in every Venice Biennale. His works are in numerous Italian and international museums, including the National Gallery of Modern Art of Rome.

Giuseppe Melchiorre Sarto was born in Riese near Treviso on June 2, 1835. After having been Bishop of Mantua and Patriarch of Venice, he was elected Pope on August 4, 1903. From the moment of his installation he declared that the nature of his papacy would be exclusively spiritual, alien to politics and interests of a temporal nature. He distinguished himself for his intransigent struggle against "modernism", which he strongly condemned in his encyclical *"Pascendi dominici gregis"* of September 1907. He also undertook a series of reforms to make the Church's organizational structure more efficient, issuing the *Codex Iuris Canonici*. He fought for the Church's total autonomy from politics, declaring that the right of veto for papal elections was forfeit. He placed great importance on children's education, which gave rise to the evangelization project known as the Catechism. He was canonized by Pius XII in 1954 for his papacy's very great spiritual action.

Francesco Petrucci

1) See S. Marra, in *Papi in posa...*, 2004, p. 132

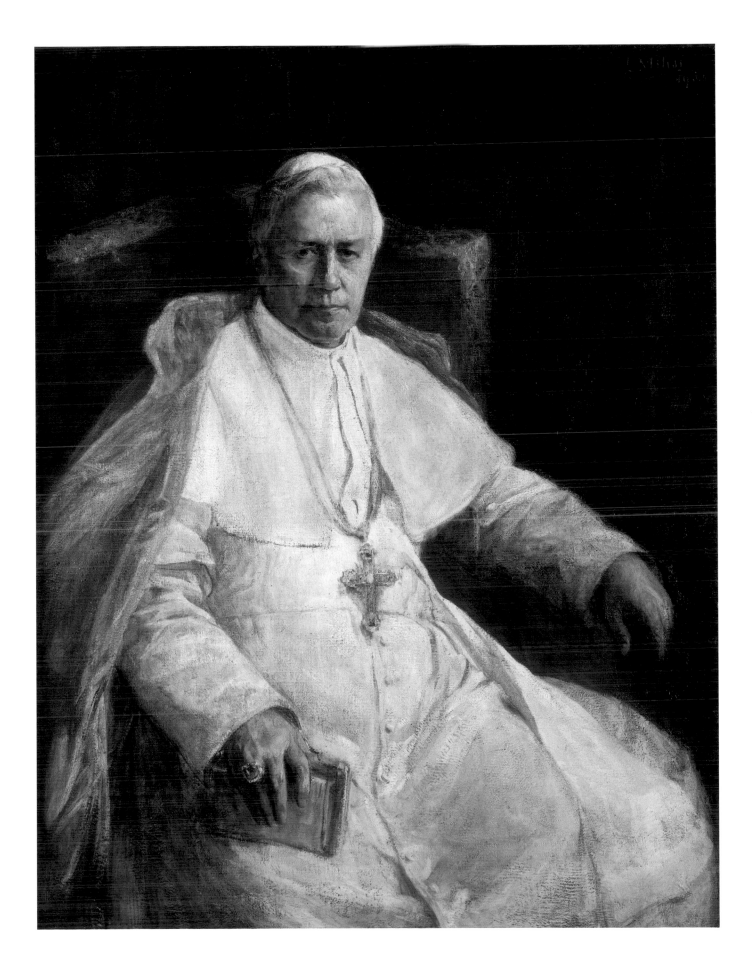

Giacomo Grosso
(Cambiano 1860 -Turin 1938)

Portrait of Benedict XV (Giacomo della Chiesa, 1914-1922)
oil on canvas, 189 x 123 cm.
Vatican City, Vatican Museums, inv. MV 2599

Bibliography: M. Bernardi, 1946; S. Marra, in *Papi in posa…*, 2004, p. 134

Giacomo Grosso's portrait of Benedict XV portrays the Pope in a new way: Benedict is captured at prayer, kneeling before the faldstool. The moment is intimate, but the humble gesture of the Holy Father encompasses the entire weight of his role as the Vicar of Christ praying on behalf of all humanity. The innovative iconography departs from the hallowed tradition of depicting a Pontiff enthroned. Monumental in stature and in zeal, Benedict is beyond our world and yet human, in the concentration of his expression and in his very natural gesture of prayer. The canvas is painted with great facility; thick brushstrokes of opaque pigment bring the figure to almost sculptural form, and the gilt furniture glistens with golden highlights applied with a flickering brush. Grosso's talent for naturalism results in a style that is readily accessible to the viewer.

Like Giovanni Boldini and Francesco Michetti, Grosso dominated the Piedmontese milieu for fifty years, flooding it with still lifes and female nudes against damasked backgrounds, but also with portraits of princes and cardinals, portraits set among gilt furniture and opulent brocades in accordance with the taste for luxurious detail that distinguishes his style. A student of Castaldi and Giraldi, Grosso attended Turin's Albertine Academy; his rich and enduring career repaid him for his humble origins as the last of eleven children in a family of modest means. He began producing signs for tobacconists and small inexpensive photo portraits; when Count Panissera invited him to the capital, Grosso earned his initial success as a portraitist among the aristocracy. At the age of twenty-four, he won fame with *"La Cella delle Pazze"* (*"The Cell of the Madwomen"*). At the end of the 1880s he was in Paris, where he saw works by Degas, Bonnat and Basten Lepage. During the first Venice Biennale, he created a furor when he won—not without controversy—the *Premio del Pubblico* or People's Choice Prize with the work *"Supremo Convegno"* (*"Last Meeting"*, 1895), surpassing Michetti who exhibited *"La Figlia di Jorio"* (*"Jorio's Daughter"*). Grosso won a bronze at the Universal Exposition of 1900, and was made a Knight of the Legion of Honor in 1904.

Grosso loved color and the form it generates and shapes through tones. The largest exhibition dedicated solely to his work took place in Turin in 1936, with forty of his works shown to unanimous admiration (1) for that figurative style that he never abandoned even in the years of universal experimentation [by other artists].

Born at Genoa in 1854 of a noble family and christened Giacomo della Chiesa, Benedict XV died at Rome in 1922. He earned a degree in law before entering the Capranica College in Rome to study theology. He was elected Pope in 1914, the successor to Pius X. The warring nations of World War I each pressured him strongly for an explicit condemnation of their opponent, but he defined war as "useless massacre" and tried in vain to end the hostilities.

At the end of the conflict, he built bridges toward the new nations that emerged in Eastern Central Europe (Hungary, Czechoslovakia and Yugoslavia). He exercised a great impulse toward missionary activities and displayed goodwill to the Separated Churches of the East (Congregation for the Oriental Churches, 1917). He promulgated the Code of Canon Law. Steadfast in his condemnation of Modernism, he voiced support for the creation of the Italian Popular Party.

Susanna Marra

1) M. Bernardi, 1946

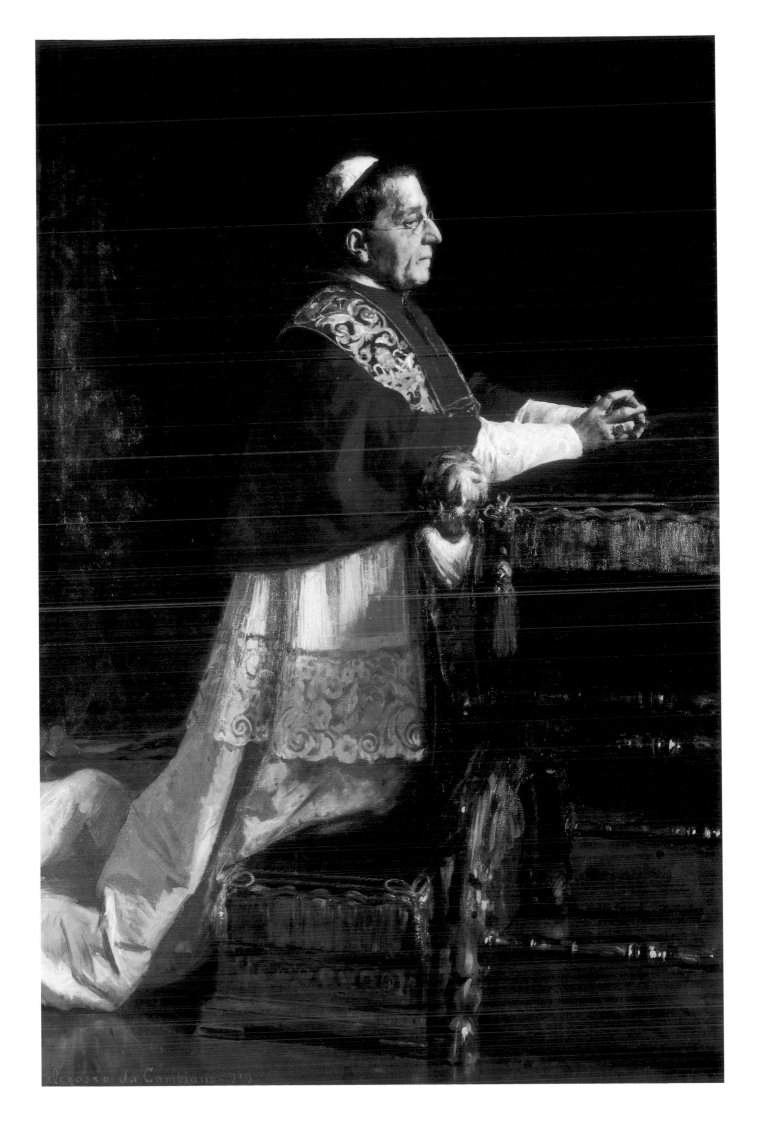

Franciscan Missionary Daughter of Mary

Portrait of Pius XI (Achille Ratti, 1922-1939)
oil on canvas, 113.5 x 84.8 cm.
Genzano (Rome), Jacobini Palace

Bibliography: S. Marra, in *Papi in posa...*, 2004, p. 136

This work, of which many faithful copies are known, can be considered the official portrait of Pius XI. An inscription on the reverse of the canvas at the lower right, *Francescana Missionaria di Maria, Rome 1928*, reveals the author to be an anonymous Franciscan nun. The nuns of this Order dedicate themselves to a conspicuous production of papal portraits that are of good quality despite the serial nature of their execution, as documented in the photographic volume at the archives of the Vatican Historical Museum at the Lateran Palace. The unknown artist of this picture created a work in the classical tradition, of great refinement and with a high degree of finish. The photographic attention to small details is achieved through a subtle application of paint with an extremely fine brush. As with art photography and in keeping with a modern sensibility, the figure poses against a formal background devoid of spatial or temporal cues, against which emerge the tactile quality of the velvety *mozzetta* and such details as the veins visible on the full, wrinkled hands. The Pope is seated in the traditional three-quarter pose, but with his hands resting on his legs rather than on the arms of a chair as tradition would dictate. The head is turned toward the viewer, to whom the Pope directs his gaze. The composition surely derives from a contemporary photograph of the Pope that portrayed him in the same position.

Identical to the portrait on exhibit is the one kept at the Congregation of Seminaries (St. Callixtus), with the Pope's coat of arms in the upper left, signed on the lower right "F.M.M. Rome 1928" (105 x 85 cm., inv. 42935) (1). Similar to the Jacobini canvas, but without the hands, is a portrait by an unknown artist conserved at Saint John Lateran in Rome (75 x 60 cm, inv. 43116). A full length portrait, missing only the feet, is found at the Lateran Greater Seminary, signed "S.M.M., 1924" (150 x 112 cm., inv. 43116). The half-length portrait at the Vatican's Pontifical Ethiopian College is anonymous (60 x 80 cm., inv. 44492), while a half-length copy by F. Zonghi Lotti is found at the Ecclesiastical Academy (30 x 40 cm., inv. 44312).

Of high quality but different in composition are two portraits again signed "F.M.M." The first, acquired in 2003 and today in the Vatican Museums' Storerooms, depicts the Pope seated, intent on writing (132 x 132 cm., inv 1985). The second, conserved in the Lateran State Museum, shows the Pontiff enthroned in a frontal pose (175 x 125 cm., inv. 56208).

Ambrogio Damiano Achille Ratti was born at Desio in 1857 and earned degrees in theology, law and philosophy. During his ecclesiastical career, his work was firmly supported by Pope Benedict XV; he succeeded the latter as Pope in 1922, taking the name Pius XI. His papacy assumes particular relevance for his strenuous defense of the Church's rights against national powers and the Nazi dictatorship. He is the Pope of the Lateran Treaties, which formally approved the reconciliation that took place between the Italian State and the Church, defining their reciprocal relations. His attention to missionary activities earned him the name "Pope of the Missions". He was the author of numerous encyclicals, among them *Mit Brennender Sorge* (With Great Anxiety): it openly denounced the impossibility of conciliation between the Church's principles and the Nazi regime's pagan and racist attitudes; specific attention was paid to the difficult position of the German Church. Pius XI was the first Pope to communicate via radio with the Christian faithful: on February 12, 1931 he inaugurated Vatican Radio and greeted the world in Latin. He died on February 10, 1939.

Susanna Marra

1) F.M.M. are the initials used as a signature by the Franciscan Missionary Daughters of Mary. These nuns are responsible for the industrious production of a series of papal portraits, among which are works of appreciable quality such as the one exhibited here

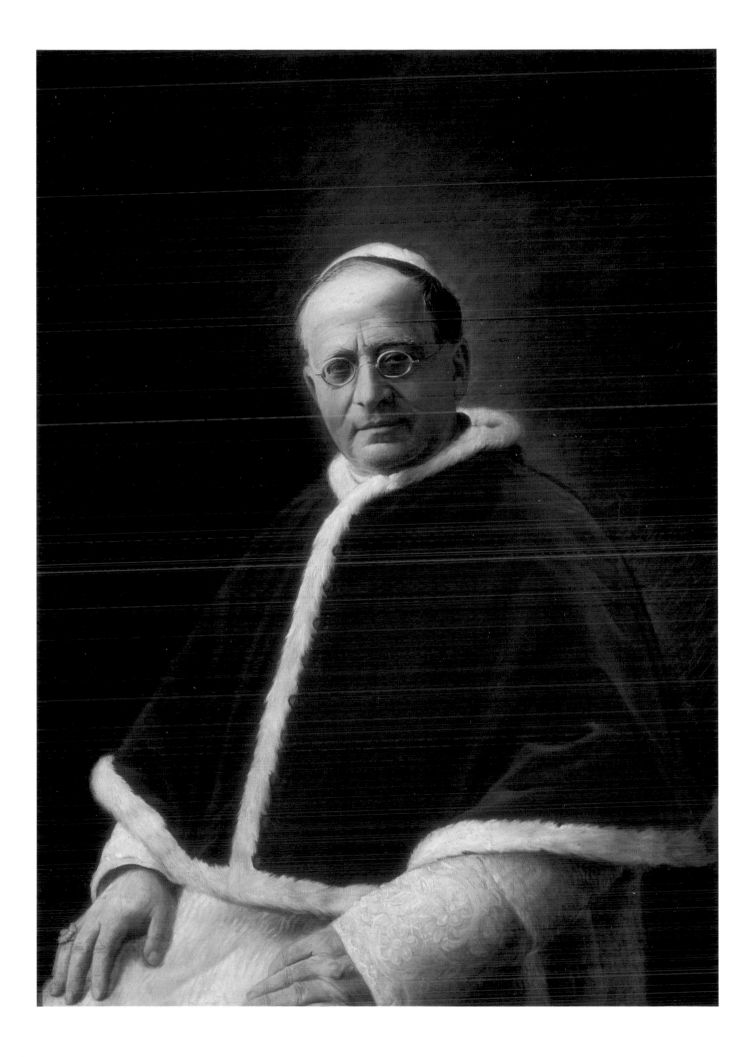

Carlo Siviero
(Naples 1882-1954)

Portrait of Pius XII (Eugenio Pacelli, 1939-1958)
pastel on cardboard, 133 x 101 cm.
Genzano (Rome), Jacobini Palace

Bibliography: S. Marra, in *Papi in posa...*, 2004, p. 138

Pius XII's iconic profile emerges from the background of this canvas like a Renaissance portrait medallion. The pontiff is enthroned in the usual three-quarter pose, but the turned head contradicts the attempt at three dimensionality, and the Pope's gaze is fixed into the distance, perhaps aimed at the future like that of a military general. These iconographic features recall the court portraiture of Bernini, who rendered the images of Francis I D'Este and Louis XIV in an abstract scheme that presents an idealized image of a sovereign.

The drawing displayed here is a preliminary study for an oil portrait, signed by Siviero and today in the Palazzo della Cancelleria's Papal Commission on Sacred Art (120 x 151 cm., inv. 43472).

Like the portrait of Pius XI also in the Jacobini collection, this portrait exists in a vast number of reproductions. An anonymous portrait, similar to the one on display, but bust length and without the hands (97 x 70 cm., inv. 43070), is kept at the Holy Congregation of the Sacraments. A copy by Francesco Torsegno (73 x 88 cm., inv. 43379) is conserved in the Vatican Museums' storerooms. A portrait signed by C. Palmieri shares the composition of the present work by Siviero, depicting the Pope enthroned but looking out at the viewer (138 x 100 cm., inv.4451). Finally, a signed copy by Polverini is found in the Lateran Historical Museum, a beautiful and expressive picture that depicts the Pontiff similarly gazing at the viewer (1).

Born in Naples in 1882, Carlo Siviero studied painting under Bernardo Celentano. His style was influenced by Morelli, Cassciano and Rossano, and he was fascinated by English and Dutch portraiture. He earned prestigious positions, always maintaining his policy of aversion to servility or utilitarianism in the production of art. He presided over the Academy of St. Luke, as director and later as professor emeritus of the Academy of Fine Arts, becoming a member of the Elected Group of Consultants of the Central Papal Commission for Sacred Art in Italy. In contrast to those who produced sacred art solely for monetary purposes and without spontaneous inspiration, Siviero always declared the nobility of art, asserting that it should not be undertaken by individuals without a natural dedication to it; and this despite the possibility of his receiving sure commissions due to his professional success. Through portraiture, a genre congenial to him, he invested the sacred with naturalness, declaring even that when he "found himself before something of the utmost holiness, such as the person of Christ's Vicar..." he always decided to do what he knew how to do: a portrait (2).

Born into a noble family, Eugenio Pacelli was elected Pope on March 2, 1939 and took the name Pius XII after his predecessor. Throughout his ecclesiastical career and papacy, he took part in events that were revolutionary in scope. In 1929, as Secretary of State, he joined Pope Pius XI, Benito Mussolini and Pietro Cardinal Gasparri in signing two documents of capital importance for Church-State relations: The Lateran Treaty, which established the Vatican as an independent state, and the Concordat, which defined the roles of and relationships between Church and secular leaders in Italy. Soon after his election to the papacy the Second World War broke out, which he tried to avert with appeals. In 1939, Pius XII broke decades of voluntary Papal isolation and officially left Vatican territory to repay a visit by the King of Italy: accompanied by groups of soldiers and a cheering crowd, he went to the Quirinal Palace to meet Victor Emmanuel III. The 1950 Jubilee Year was marked by Pius's promulgation, on November first, of the dogma of the Assumption of the Virgin Mary. Pius XII died on October 19, 1958. The most touching image of him is surely the photograph that depicts the Pontiff amidst the desperate, offering comfort to those who had suffered the torment of the bombs in Rome's San Lorenzo district: the Pope shares the people's pain, even bearing the physical evidence of it on his bloodstained robes.

Susanna Marra

1) For the information cited here, see F. Petrucci's study present in the catalog
2) C. Siviero, 1953

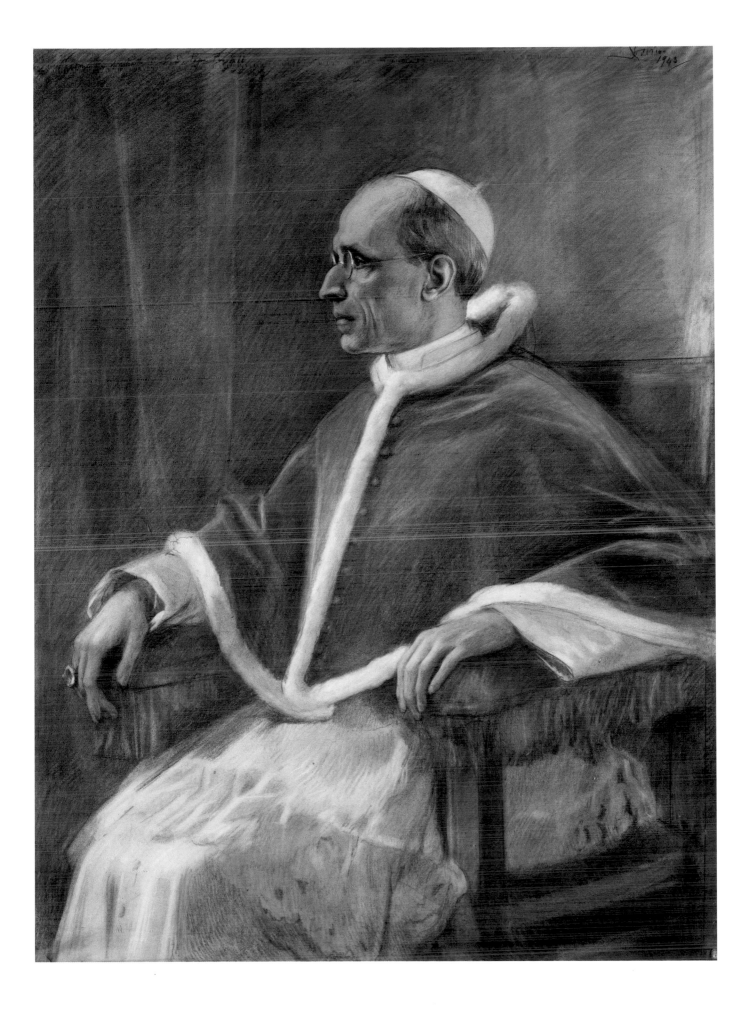

Mario Russo
(Naples 1925 – Rome 2000)

Portrait of Pius XII (Eugenio Pacelli, 1939-1958)
oil on canvas, 80 x 60 cm.
Rome, Russo family

Bibliography: M. Greco, 1981, p. 178

The portrait is a posthumous interpretation of the face of Pius XII executed in 1977 for a series of papal portraits. The Pope seems to be focused and absorbed in thought, withdrawn into a moment of solitude and deep meditation. The image appears to evoke not only the tragic times that the Pacelli Pope had to face during his papacy, but also his ascetic and highly spiritual nature.

Mario Russo was born at Naples in 1925. After graduating in 1948 from the Naples Art Institute, between 1948 and 1949 he taught architectural drawing at Anagni. In 1950 he settled in Rome, and began to participate in Italian and international exhibitions. He made numerous journeys abroad, both as educational periods of constant growth and creative stimulus and for exhibitions which concerned him: in 1953 he sojourned and studied in Paris, in 1960 he was in London for two monographic exhibitions, in 1965 he was in Spain executing a series of cartoons for the bullfight, in 1965 at Munich where an exhibition was dedicated to him; in 1978 he held a one-man show at Refrat at Cologne, and in 1983 he was invited by the Royal College of Spain at Bologna for a retrospective.

An international artist, he often traveled to America. In 1968 he was in New York for a monographic show at the Rizzoli Galleries and he exhibited paintings at the Royalton College; in 1979 by invitation of the Italian Cultural Institute, he held a one-man exhibition at Toronto and exhibited at the University of Sudbury; in 1987 he was present with his works at Washington for the exhibition dedicated to film director Federico Fellini, later repeated in 1988 at Palm Beach, Florida.

In 1992 he was honored with a great retrospective at the Braschi Palace, seat of the Museum of Rome, which included 160 works dated 1942 to 1992. In 1993 he exhibited at Palermo with the show *"Ars Nova. [New Art.] The Eternal Feminine in the works of Mario Russo"* and showed a selection of his works at the Galerie de Poche in Geneva Switzerland. The artist died in March, 2000. On the initiative of the Ministry for Fine Arts and Cultural Activities, preparations are underway for a great anthology exhibition which will be held at Rome. (1)

Francesco Petrucci

1) See M. Greco, 1981; *Mario Russo*, exhibition catalog, Galerie de Poche, Geneva, 2003

Giacomo Manzù
(Bergamo, 1908 – Ardea, 1991)

Head of John XXIII (Angelo Roncalli, 1958-1963)
gilded bronze, 29.5 x 23.5 x 23.5 cm.
Ardea, Manzù Museum collection (National Gallery of Modern Art, Rome) inv. 5792
Inscriptions: on verso at right: *Manzù/n.f.m.m*

Bibliography: L. Velani, 1994 (with prev. bibl.) p. 62; L. Velani, 2002, p.165; L.F. Capovilla, 2002, pp.51-56; F. Buranelli, 2002, pp.33-36; M. Apa, 2002, p. 10; I. Colucci, in *Papi in posa...*, 2004, p. 140

This bronze sculpture depicts John XXIII wearing the *camauro*, the traditional papal headdress. His soft, tranquil smile colors his features, giving the face a deeply human expression. Giacomo Manzù executed the work, of which other versions exist (Velani 1994), the day after the Roncalli Pope's death on June 3, 1963. The sculptor was revisiting the familiar theme of papal portraiture: between 1960 and 1963 he executed seven busts of the Pontiff, four of which he destroyed, while three surviving bronze busts are conserved in the Museo d'Arte Sacra in the Vatican, the Museum of San Marco in Venice, and in the Capovilla collection (Velani 1994). Manzù executed a number of works for John XXIII, legacy of the artist's frequent visits to the Vatican. This longstanding interest was brilliantly affirmed when Manzù won the competitions, held between 1947 and 1949, to execute the *Door of Death* (1952-64) in the atrium of St. Peter's, a commission awarded to him in 1952. Execution of the Door was protracted and troublesome, issues resolved only when the Pope allowed Manzù to make considerable changes to the design with which he had won the competition. In all these events, Monsignor Giuseppe De Luca, a leading figure and influential promoter of Roman cultural policy played an extremely important role. Through active mediation he enthusiastically supported the sculptor in matters relative to the Door, as well as with the aforementioned bronze portraits of the Pope; in fact, he had promoted the friendship that developed in Venice between Manzù and the future John XXIII, at that time Patriarch of the canalled city (Apa 2002.) A great admirer of the figurative interpretation offered by the artist, in 1961 De Luca commissioned Manzù to decorate the Chapel of Peace in the prelate's residence in Rome. De Luca later donated this work to the Vatican Museums' collection of Modern Religious Art, inaugurated in 1973 by Pope Paul VI Montini, where it constitutes one of the most significant nuclei of that collection.
The relationship between the artist and the Pope – strengthened by their common roots in the city of Bergamo – is translated into the artistic interpretation offered by Manzù, able to express a message of dedicated social and moral commitment, of the resounding ecumenical religious sentiment expressed with good-natured humanity by John XXIII. Manzù is also the interpreter, through the commemorative medals he designed, of the most significant events of John's papacy. An emblematic example is the medal issued for the opening of the Second Vatican Council (11 October 1962), which depicts the meeting between the Roncalli Pope and the Tanzanian Lauren Rugambwa, whom John created the first African Cardinal, alluding to the guiding principles of the *Mater et Magistra* encyclical published on May 15, 1961.

Isabella Colucci

Umberto Romano
(Naples 1905-1982)

Portrait of John XXIII (Angelo Roncalli, 1958-1963)
oil on canvas, 131 x 104,5 cm. (with frame)
Vatican City, Vatican Museums, inv. MV 24687

Bibliography: F. Petrucci, 2004b, p. 40, fig. 59

The portrait, executed in 1967, is signed at the lower left "Umberto Romano". It was donated to the Vatican Museums in 1983 by Clorinde Romano. It is a painting of good pictorial quality, executed with expressionist brushstrokes, almost informal, with blots and sprays of the brush (derived from "action painting"), but exhibiting nonetheless perfect control of form. Romano's *Portrait of John XXIII* depicts the Pontiff in profile and in prayer, an image of intense spirituality but also a private and intimate glimpse of the Pope, profoundly absorbed in his inner meditation and without the *zucchetto* or traditional *camauro* that he himself wanted to reinstate.

Angelo Giuseppe Roncalli was born at Brusicco, near Bergamo, on November 25, 1881. Ordained a priest in 1904, he was a lieutenant chaplain during the First World War. In 1921 he was named a prelate of the household of His Holiness, and began to travel throughout Europe. In 1925 he became bishop of Aereopoli and was sent to Bulgaria; in 1934 he was apostolic delegate to Turkey and from 1941 to Greece. In 1944 he was named apostolic nuncio to France, and in 1953 he was created Cardinal. In 1953 he became Patriarch of Venice.

Upon the death of Pius XII he was elected Pope on October 28, 1958, after a three-day conclave, taking the name John XXIII. He was the first Pope in history to give a press conference immediately afterward, in the presence of journalists from around the world. He was also the first Pope to break with the tradition of a visit to the Basilica of St. John Lateran immediately after his election, instead preferring Castel Gandolfo; he traveled outside the Vatican one hundred and fifty times, thus inaugurating a custom which until then was unprecedented. His famous visit to the Hospital of the Baby Jesus [Rome] on December 25, 1958, was broadcast on radio and television around the world, as was his visit the next day to the Queen of Heaven Prison [Rome]: it was the first example of the Church's use of the media as an instrument of mass communication. He was also the first Pope receptive to the language of contemporary figurative arts; his official portraitist was the sculptor Giacomo Manzù.

After only three months of his papacy, he announced the Vatican II Ecumenical Council, whose execution required four years and was concluded by his successor, Paul VI in 1965.

Fundamentally important was the 1963 encyclical *Pacem in Terris*, written by John XXIII entirely in his own hand, which demonstrated such a projection towards the future that it surpassed any other previous papal document. He died on June 3, acclaimed by the entire world as the "Good Pope".

Francesco Petrucci

Umberto Romano

Mario Russo
(Naples 1925 – Rome 2000)

Portrait of John XXIII (Angelo Roncalli, 1958-1963)
oil on canvas, 100 x 70 cm.
Rome, Russo family

Bibliography: unpublished

John XXIII is portrayed in an unusual and original pose, completely in profile, with a miter and a sumptuous golden mantle, seated on the papal throne and absorbed in prayer, probably during a celebration in the Vatican Basilica but completely isolated from its context.

The present picture recalls another portrait by Russo, limited to the face like a medieval icon (70 x 50 cm.), which again presents the Pope in profile in an oval with the Vatican Basilica in the background, perhaps suggesting the mosaics in the papal portrait gallery at Saint Paul's [Outside the Walls]. This second papal portrait, like Russo's picture of Pius XII, depicts the Pontiff alone and absorbed in deep thought, but turned toward the outside, in the direction of the line of pilgrims heading toward Saint Peter's Basilica. His image crosses the oval and is present in the undertone of the picture's background, as though representing the renewed desire to communicate with the world. (1)

These are two unusual portraits, outside the traditional schemes for papal portraiture. It is not a coincidence that the phrase "fantastic realism" has been applied to Russo's work, in which reality is transferred to a dreamlike and surreal sphere that I would call metaphorical. Both pictures are posthumous, executed in 1977 and in 1980 (the one in the exhibition) for a papal portrait gallery.

In his heterogeneous and vast production Russo never stopped at one result, but was sensitive to new cultural stimulations and further experimentation with subject matter and symbolism. In 1973-74 he traveled throughout Italy following theater groups from whom he drew inspiration for some of his works; in 1977 he was in Canada, where he developed new ideas on the relationship between men and machinery; in 1981 he produced a series of paintings inspired by the Riace Bronzes; and in 1982 he executed a series of works on the subject of Canadian football for an exhibition in that country. In 1984 he challenged himself with exotic subjects inspired by Japanese theatre, while in 1985 he painted canvases inspired by the world of Fellini's films and characters. He was the subject of a one-man exhibition at Antwerp in 1988, with works dedicated to Flemish masters such as Van Eyck, Rubens, and Ensor. In 1989 at Porto Cervo he exhibited a series of paintings dedicated to the sea of Sardinia, and in 1991 he executed five canvases on the Gulf War and the Kurdish crisis.

Francesco Petrucci

1) See M. Greco, 1981, p. 184

Dina Bellotti
(Alessandria 1912 – Rome 2003)

Portrait of Paul VI (Giovanni Battista Montini, 1963-1978)
mixed media on paper, 80 x 60 cm.
Rome, private collection

Bibliography: unpublished

This portrait, exhibited and published here for the first time, is a preparatory sketch for a painting in the Vatican collections, today in the Lateran Palace Historical Museum. The final version was displayed in the exhibit *Papi in Posa* held at the Braschi Palace in Rome in 2004. (1)

The late Dina Bellotti produced more portraits of Pope Paul VI than any other artist, leaving numerous paintings, drawings and sketches that portray the Pope in various situations and on different occasions. The work in Vatican, exhibited in *Papi in posa* 2004, is without a doubt among her best and constitutes the official portrait of Pope Paul VI. The painting, characterized by a vivid realism, depicts the Pope in near-profile seated behind a microphone, addressing the public in one of his many speeches. The contrast between the Pontiff's white robes and the shadows behind him make the figure appear to emerge in three dimensions from the background of the picture. The diluted pigment produces a watercolor effect, creating delicate transparent passages on the garments and on the arms of the chair, while the face is sketchy.

Dina Bellotti was honored by Paul VI as the first woman artist to be represented in the Vatican's Modern Religious Art Collection. Her numerous catalogs were edited by Carlo Bo, her greatest critic. Among her most important portraits, in addition to one of John Paul II produced also as a color lithograph, is that of then-Cardinal Joseph Ratzinger, today Pope Benedict XVI, a friend and supporter from whom she received significant recognition.

Giovanni Battista Montini was born September 26, 1897 into an aristocratic family at Concesio, near Brescia. He was educated by the Jesuits at Brescia and ordained in 1920. Fundamental to his career and advancement was his relationship with Eugenio Cardinal Pacelli, which began when the latter was Vatican Secretary of State and continued when Pacelli became Pope Pius XII. In 1954 Montini was named Bishop of Milan; in 1958 Pope John XXIII made him a cardinal. The same "Good Pope John" had indicated him as his possible successor; and in fact, following the death of John XXIII, Montini was elected Pope on June 26, 1964, the twentieth day of the conclave, and took the name Paul VI. In his first message Paul proposed to continue the policies of his predecessor, but he was never able to win over the masses. Nevertheless he demonstrated his concern for the problems of the poor, distinguishing himself by his high intellectual and spiritual stature. He died at Castel Gandolfo on August 6, 1978, undermined by health problems and saddened by the tragic assassination of the Italian political leader Aldo Moro.

A great lover of art, in 1964 he delivered a now-famous speech in the Sistine Chapel during an Artists' Mass, in which he firmly reiterated the importance and the role of artists who use their creativity and genius to give body, shape and color to the Church's ideas and thoughts. Paul VI was acutely aware that artists play a fundamental role in the dissemination of the Divine Word, translating events and thoughts into visual language. The pope denounced the repression and censorship visited at times on artists of the past, recalling the example of Caravaggio, who on several occasions had to repaint his canvases because they were deemed unsuitable. And let us not forget that Daniele da Volterra was forced to paint breeches on some of the nudes in Michelangelo's great *Last Judgment* in the Sistine Chapel. Paul VI affirmed that there must be an alliance between the Church and art, an alliance that has at times (as with Pope Julius II, Michelangelo and Raphael, or with Popes Urban VIII, Alexander VII and Bernini) borne extraordinary fruit. (2)

Daniele Petrucci

1) See D. Petrucci, in *Papi in posa...*, 2004, p. 142
2) See P. V. Begni Redona, *Paolo VI, l'arte e gli artisti: la continuità di un pensiero*, [*Paul VI, Art and Artists: the Continuity of a Thought*] in E. Brivio, M. Ferrazza, 1999, pp.15-34

Álvaro Delgado
(Madrid 1922)

Portrait of Paul VI (Giovanni Battista Montini, 1963-1978)
oil on canvas, 130 x 97 cm.
Vatican City, Vatican Museums, inv. MV 24783

Bibliography: E. Brivio, M. Terrazza, 1999, fig. p. 21, no. 336, p. 185; F. Petrucci, 2004b, p. 40, fig. 61

No other Pope can boast such a vast corpus of images as Paul VI, nor one so diversified in its stylistic expressions and in its artistic techniques. The Pope demonstrated an extraordinary openness toward the language of contemporary art, inaugurating the Modern Religious Art Collection at the Vatican Museums on June 23, 1972. Paul's great interest in art is revealed in such memorable speeches as the one he delivered on May 7, 1964 during the Artists' Mass in the Sistine Chapel, and in the report made during the inauguration of the Vatican Museums' mosaic section in 1973. It is not a coincidence that the exhibition *Paul VI, A Light for Art*, was dedicated to images of this Pope, held at the Vatican in the Braccio di Carlo Magno in 1999.

Delgado's portrait, executed in 1978, is on permanent display in the Collection of Modern Religious Art at the Vatican Museums. The Spanish artist proposes a victorious image of the Pope, seated on the papal throne with his left arm in an ample gesture of benediction and the raised right arm describing a great semicircle with the pastoral staff. The features of the face are very forcefully portrayed, almost caricatured, and evident despite the dissolution of the form through long, wide, decisive brushstrokes and running lines, with the pigment percolating in some areas. Paul VI is portrayed as a great sovereign, a champion of spirituality.

Born in Madrid in 1922, Álvaro Delgado is considered one of the greatest contemporary Spanish painters, noted especially for his portraiture. In a style characterized by scholars as "Spanish expressionism", Delgado's canvases—which suggest the influence of Francis Bacon—participate in a great tradition of portraiture that includes El Greco, Velázquez and Picasso, through a language of strong emotional and communicative impact.

Delgado began his studies at the School of Painting at Madrid directed by Vázquez Diaz, later becoming one of the founders of the School of Vallecas. He held his first exhibition at Madrid in 1945, later followed by monographic shows and retrospectives around the world, from Buenos Aires to Montevideo, from New York to Paris, London and Rome. A member since 1973 of the Royal San Fernando Academy of Fine Arts at Madrid, he is the recipient of such prestigious prizes as the Gold Medal from the Madrid City Hall and the Gold Medal of Fine Arts. His works are exhibited in the Madrid Museum of Contemporary Art, and in museums in San Francisco, Buenos Aires, Florence and in the Vatican Museums.

Francesco Petrucci

Natalia Tsarkova
(Moscow, 1967)

Portrait of John Paul I (Albino Luciani, 1978)
oil on canvas, 80 x 60 cm.
Vatican City, Vatican Museums, inv. MV57165
Inscriptions: Signed by the artist at the lower right: "Natalia Tsarkova/ 2002. Rome."
On verso in capital letters: "Natalia Tsarkova/ His Holiness John Paul I year 2002. Rome oil on canvas 80 x 60 cm."

Bibliography: F. Buranelli, in *Papi in posa…*, 2004, p. 144

This posthumous portrait, based on a photograph, was acquired from the artist on January 10, 2003 and constitutes the official image of Pope Luciani. Natalia Tsarkova's artistic inclination was apparent from her very early youth and was supported by rigorous and continual training which saw her enrolled at the prestigious Moscow Conservatory of Fine Arts at the age of ten. Those are only the first steps of a career in which Tsarkova received the most important awards from academic institutions in her native country under the guidance of her teacher, Ilia Sergeevich Glazunov and through a revisitation of the high tradition of Russian art. This tradition was central to the evolution of pictorial languages in the nineteenth and twentieth centuries, an extraordinary period of history painting and realism that prevailed until the arrival of the great avant-garde movements of the first half of the last century. This is an artistic culture that offers a wide range of challenges to those who, with courage and determination, decide to dedicate themselves to the world of art. Tsarkova studies, assimilates and interprets her culture, and finds in representational painting her preferred style, through which she manifests a great sensitivity, a refined technique and a rare power of expression.
In the path of this tradition the young artist challenges herself with the entire range of themes and subjects belonging to the iconographic experience of the painter's art: from landscapes to still life, from depictions of animals to symbolic compositions, from religious themes to portraits. And it is portraiture, a genre of painting that has crossed centuries, cultures, civilizations and styles without ever suffering a pause, that best synthesizes Tsarkova's exceptional talent and that, through this young artist, has returned to its highest levels.

Francesco Buranelli

Mario Russo
(Naples 1925 – Rome 2000)

Portrait of John Paul II (Karol Wojtyla, 1978-2005)
oil on canvas, 80 x 60 cm.

Rome, Russo family
Bibliography: M. Greco, 1981, p. 170

Pope Wojtyla's face emerges from the penumbra like an apparition, illuminated by a light that, as in Caravaggio's paintings or in Bernini's sculptures is loaded with symbolic meaning, alluding to Divine Grace and the Holy Spirit. Once again, as in other portraits by Mario Russo, reality is surpassed by a surreal and metaphysical vision that transfers the subject to an abstract sphere. Critics have referred to Russo's work as theatrical, a term justifiably applied to his portraits.

The Pope looks to his left as though in the act of addressing or replying; this is, therefore, a lively and speaking presence, open to exchanges and not absorbed in prayer like Russo's images of Pius XII and John XXIII. The interpretation of temperament against seems to emerge as a distinctive element of the Neapolitan painter's portraiture, which does not stop at appearances, at the simple "description" of reality. The artist himself stated: "I am not interested in a news story; rather, I am interested in the story of a life."

The painter's skills in portraiture are well demonstrated by the series of ten papal portraits that are still in part with his heirs; between 1977 and 1978 he executed forty portraits of illustrious twentieth-century politicians, artists and sculptors, according to a custom that was much in vogue in the sixteenth and seventeenth centuries, starting with the famous Jovian series in the Uffizi. Russo's keen interest in portraiture was at its height in the 1970s, and is revealed in one of his last exhibitions, held in 1991, when he displayed "Ideas for three portraits" at Rome.

Russo portrayed John Paul II in another portrait wearing the papal tiara and a good-natured smile, with John XXIII in the background to the right, as though to establish a link between the two papacies so open to communication and dialog among cultures. In 1983 *"L'Unitas"*, an association for Christian unity, commissioned Russo for a work that would represent the 1983-1984 Jubilee, to be given to the Pope as a gift: it met with immediate approval and the work was later distributed in countless prints.

Francesco Petrucci

Natalia Tsarkova
(Moscow 1967)

Portrait of John Paul II (Karol Wojtyla, 1978-2005)
oil on canvas, 150 x 120 cm.
Washington, Pope John Paul II Cultural Center

Bibliography: F. Buranelli, in *Papi in posa...*, 2004, p. 146

In the upper left, the painting bears the inscription: "SUMMUS PONTIFEX/ JOANNES PAULUS II/ PONTIFICATUS SUI XXIII/ AD MMI" [Pope John Paul II, in the twenty-third year of his pontificate, A.D. 2001]. In the lower right, there is the signature: "Natalia Tsarkova 2001 Rome".

The painting, which was commissioned from the Russian artist by Cardinal Adam Joseph Maida, was officially presented during the opening to the public of the Pope John Paul II Cultural Center in Washington, D.C. in March, 2001. The President of the United States, George Bush, and the Pope's personal representative, Cardinal Edmund Casimir Szoka, participated in the inauguration ceremony along with many representatives from the clergy and from American political and cultural circles.

During the inauguration of this important cultural center, Tsarkova gave several interviews to newspaper and domestic television reporters, who paid remarkable attention to this and other paintings by the artist.

This painting, like others made by Tsarkova, is charged with symbolic and metaphorical meaning, demonstrating the painter's willingness to always go beyond a simple representation of reality and a purely faithful description of the Pope's physical features.

Pope Wojtyla, once again outside the rooms of the Vatican, projects his gigantic image upon the world, the earthly sphere alluded to in the curve of the horizon. On the right is the Cupola of the Vatican Basilica; to the left there is a multitude walking toward the light that radiates from the mystical figure of the Pope, dressed in white. The night or twilight setting exalts the luminosity of the Pontiff, beacon and guide for a world thirsting for spirituality and values that are not ephemeral. The portrait almost seems to be a precognition of the huge outpouring of emotion and popular attention occasioned by the death of the Holy Father and his funeral rites, a media event without precedent in the history of mankind.

The painting is a large group portrait of praying figures preceded by a group of children in the foreground; it includes a self-portrait of the artist with her palette, intent on painting this very work. Also present are many well-known persons: Cardinal Adam J. Maida, archbishop of Detroit and president of the Washington D.C. Cultural Center; Monsignor Stanislav Dziwisz, the Pope's private secretary; Cardinal Franciszek Macharski; Cardinal Francis Eugene George O.M.I., archbishop of Chicago; Joaquin Navarro-Valls, director of the Press Office of the Holy See; Francesco Buranelli; director of the Vatican Museums; Fra' Andrew Bertie, Grand Master of the Sovereign Military Order of Malta; Fra' Ludwig Hoffman von Rumerstein, Bailiff and Commander of the Sovereign Military Order of Malta; Fra' Franz von Lobstein, Grand Prior of Rome of the same Order; Alberto Michelini, Italian parliamentary deputy and journalist-biographer of the Pope; Lt. Col. Gianfranco Linzi, head of the Public Relations Office of the General Commandant of the Army of the Carabinieri, and Giuseppe De Carli, manager of the RAI* – Vatican organization.

Francesco Petrucci

TRANSLATOR'S NOTE: RAI STANDS FOR RADIOTELEVISIONE ITALIANA, THE ITALIAN STATE BROADCASTING AGENCY

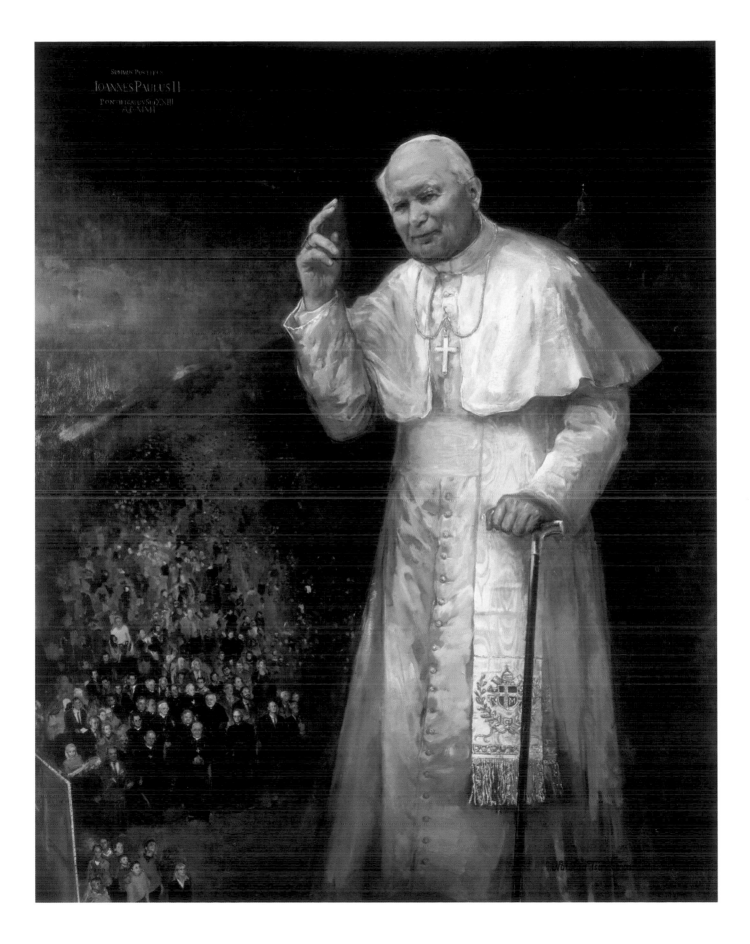

Natalia Tsarkova
(Moscow 1967)

Portrait of John Paul II (Karol Wojtyla, 1978-2005)
oil on canvas, 70 x 32 cm.
Detroit, monsignor Michael R. Dylag

Bibliography: unpublished
The portrait is signed by the author on the upper right edge of the canvas, parallel to the long side: "Natalia Tsarkova 2004. Rome".

Compared to the other two portraits executed by the painter, this canvas presents a personal but still official image of John Paul II, limited as it is to a half-figure of the Pope wearing the papal cloak and the miter. The smiling and communicative face emerges from the penumbra establishing a dialog with the viewer.

The portrait is deftly executed in loose and easy brushstrokes that suggest rather than describe, sketching in the parts with a few rapid lines. The unusual vertical format follows the axis of the composition established by the miter and the central opening of the cloak that uncovers the white robe. The Pope's face and the large brooch at the center with its image of the sacred Visitation create a double horizontal axis in the composition.

Natalia Tsarkova, born in Moscow in 1967, completed her apprenticeship first at the Lyceum of Art and then at the Academy of Fine Arts of Moscow, where she was the only female student. Since 1995 she has been living and working in Rome. A versatile artist with a heterogeneous production, she specializes in portraiture and quickly established herself as the fashionable portraitist for the Roman Curia and aristocracy.

Among her most important and successful portraits are those of Fra' Franz Vön Lobstein, Grand Prior of Rome of the Sovereign Military Order of Malta (1999), of prince Fra' Andrew Bertie, Grand Master of the Sovereign Military Order of Malta (2001), ambassador Paolo Enrico Principe Massimo Lancellotti, and the princes Paolo Boncompagni Ludovisi and Alessandro Boncompagni Ludovisi Altemps. One of her greatest achievements in this genre is certainly the extraordinary portrait of Cardinal Jorge M. Mejia, Archivist and Librarian of the Holy Roman Church (2002), which stands out as one of the most beautiful portraits in the entire Cardinal series of the Vatican Apostolic Library, begun at the end of the sixteenth century. The painting depicting the *Global Synod of Bishops*, dated 2001, contains portraits of over two hundred Cardinals and bishops (Vatican City, General Secretariat of the Synod). On April 16, 2005 Tsarkova's portrait of Her Highness the Grand Duchess Maria Theresa with her daughter princess Alexandra was presented at the Royal Palace at Luxembourg, while a series of oval portraits of the other princes of the ruling house is kept in the same palace.

Tsarkova executes "portraits in settings", highlighting not only her subject's psychological characteristics, but also their roles, their interests, the tools of their work or their function in society.

This is in the wake of the great Russian academic tradition, but I would propose that it is also included in the tradition of Roman court painting that passed from Maratta to Batoni and Mengs. The brushstrokes are soft, alternating nuanced strokes with quick broad lashes and glazing, and do not hide a graphic propensity for clear lines, which are evident in some parts.

But Tsarakova does not paint only portraits. The strong academic characteristics that were evident in her paintings of sacred and profane subjects even in the 1990s have been surpassed by her more recent work, among them the *Last Supper* (artist's collection) and the altarpiece entitled *Madonna of the Light* (presented at Washington, D.C. in the United States Capitol Building on May 19, 2005) which represent important points of reference; they reveal a maturing of expression and the adoption of a language which is completely personal and free of didactic constraints. The influence of the Roman Baroque and the culture of Caravaggio seem to have marked another turning point in the young artist's career.

Francesco Petrucci

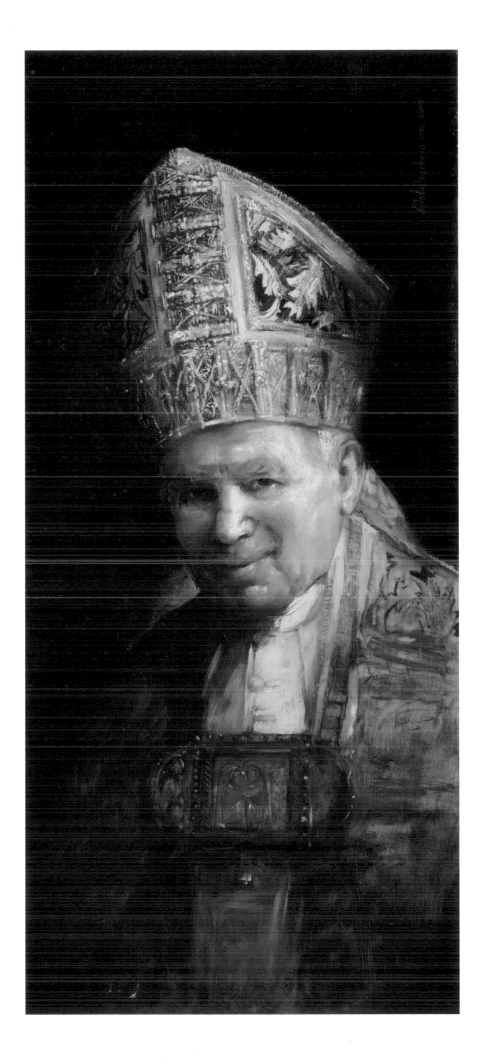

Natalia Tsarkova
(Moscow, 1967)

Four Death Portraits of John Paul II (Karol Wojtyla, 1978-2005)
pastel on paper, 40 x 30 cm.
Rome, Tsarkova Studio

Bibliography: unpublished

This is a series of four sheets, with sketches in red (nos. I-III) and brown (no. IV) pastel, portraying the body of John Paul II, which lay in state April 4-8, 2005 in the Vatican Basilica. The Pope died on Saturday, April 2 at 9:37 p.m. (*L'Osservatore Romano*, year CXLV, no. 76, Sunday April 3, 2005). On April 3-4, the body lay in state in the Clementine Room for homage and prayer by the members of the Roman Curia, the authorities and the diplomatic corps. Its transition to Saint Peter's Basilica for the homage by the faithful took place on Monday, April 4, at 5 p.m.

Natalia Tsarkova obtained special permission from the Pope's private secretary, Monsignor Stanislav Dziwsz, to depict the deceased Pontiff. She remained in the Vatican Basilica near the body on April 7, for about two hours, around 12 noon.

The first sheet, (numbered I), folded in the middle, contains a summary sketch of the entire figure in the lower left and a sketch limited to the half-figure above.

The second sheet (numbered II), folded in the middle, contains a half-figure sketch.

The third sheet (numbered III) contains a sketch of the entire body.

The fourth sheet (numbered IV) contains a drawing of the face, executed with a brown pastel pencil and characterized by a shadowy effect obtained by rubbing the pastel with the fingers. The painter does not appear to relinquish an expressive and symbolic value: the effect is of an evanescent presence, now detached from the world.

The execution of papal funeral portraits is not without precedent, even if it is rare. We recall that Giovanni Battista Gaulli, called "il Baciccio" was summoned on August 12, 1687 to execute a portrait of Innocent XI Odescalchi on his deathbed in the Pope's room at the Quirinal Palace; Baciccio drew "a pastel portrait on a sheet of royal paper, which he subsequently perfected." For this he received as a gift the Pope's white *camauro* and *zucchetto*, which he kept as holy relics because the Pope was beatified. (1)

Francesco Petrucci

1) R. Pantanella, *Regesto documentario*, in M. Fagiolo dell'Arco, D. Graf, F. Petrucci, 1999, p. 336

PAPI
IN
POSA

500 Years
of Papal Portraiture

Riproduction of the catalogue
Mostra di ritratti dei Papi
edited by Amici dei Musei di Roma, 1950

AMICI DEI MUSEI DI ROMA

MOSTRA
DI RITRATTI DEI PAPI

PALAZZETTO VENEZIA
DICEMBRE 1950
FEBBRAIO 1951

A cura dell'Ente Provinciale per il Turismo
ROMA

La mostra iconografica dei Sommi Pontefici è un degno coronamento alle sacre esposizioni tenutesi in Roma nel corso dell'Anno giubilare 1950.

Il merito di questa iniziativa spetta alla Associazione « Amici dei Musei di Roma » presieduta da S. A. E.ma il principe Lodovico Chigi Albani, che ha opportunamente realizzato una idea di notevole significato religioso e di alto valore storico. Questa esposizione dà la misura della forza della Chiesa. ed offre una felice opportunità per la conoscenza visiva dei Pontefici che, in tempo non sempre sereni, furono i supremi reggitori della Chiesa e della cosa pubblica. Sono le effigi dei Sommi Pastori che condussero con saggezza le loro greggi, che seppero opporsi ai potenti della terra, che affrontarono con serena fermezza il martirio, che promossero le arti e le scienze, che edificarono stupendi monumenti alla fede, che insegnarono all'umanità a vivere e ad operare secondo i precetti evangelici. Ad Essi, nei corsi e ricorsi storici, l'Orbe deve la salvezza dell'Urbe dalla furia dei barbari; per Essi Roma eterna rimarrà per i secoli la Sede di Pietro, nell'aureola delle vecchie gloriose mura.

Francesco Massimo Lancellotti
Presidente dell'Ente Provinciale per il Turismo di Roma

3

INTRODUZIONE

La « Mostra di ritratti dei Papi » è la prima iniziativa dell'Associazione « Amici dei Musei di Roma » che conta già due anni di vita e uno scelto gruppo di aderenti, e sta prendendo un posto di rilievo sempre maggiore accanto alle sue consorelle italiane e straniere per l'opera proficua che svolge a vantaggio delle collezioni d'arte della città e in particolare di quelle del Comune, nel cui ambito è nata ed opera.

La « Mostra di ritratti dei Papi » che l'Associazione presenta in occasione del Giubileo e la cui inaugurazione è stata dovuta ritardare a causa della indisponibilità dei locali, è essenzialmente una mostra storico-iconografica; essa si propone di documentare l'effigie dei pontefici romani attraverso immagini, per quanto possibile, contemporanee, selezionate con criteri artistici.

Per ragioni contingenti la raccolta del materiale è stata effettuata a Roma e nelle sue immediate vicinanze; essa ha inizio dalle origini con copie in pittura e riproduzioni fotografiche e continua dal sec. XVI ai giorni nostri con opere originali che forniscono la serie quasi continua dei ritratti dei pontefici. Naturalmente la scelta delle opere nell'ambito delle collezioni romane ha impedito che figurassero nella Mostra alcuni quadri e busti famosi conservati nei Musei di Firenze, Napoli, Bologna, Milano, ecc.; in compenso, molti ritratti in collezione privata, difficilmente accessibili, sono offerti al pubblico, alcuni per la prima volta.

I critici d'arte osserveranno forse qualche diseguaglianza nella qualità delle opere d'arte esposte; tali diseguaglianze non si sarebbero potute eliminare senza creare lacune nella serie iconografica. Ma accanto ai ritratti anonimi, alcuni dei quali potranno trovare una paternità, ecco una serie di nomi di insigni autori: Andrea Sacchi e Scipione Pulzone; Pietro Bracci e Gianlorenzo Bernini; Pietro da Cortona e il Baciccia; Bartolomeo Bellano e il Canova; e infine Pietro Tenerani, il Lazlo e molti altri.

L'Associazione è particolarmente grata al Sommo Pontefice Pio XII per la paterna benevolenza con cui ha voluto eccezionalmente consentire che alcune opere d'arte dei

5

Sacri Palazzi Apostolici figurassero nella Mostra; è grata altresì alla Direzione Generale Antichità e Belle Arti, al Comune di Roma, all'Accademia Nazionale di S. Luca, al Venerabile Capitolo di S. Giovanni in Laterano, ai rappresentanti delle famiglie papali e ai privati che hanno aderito al prestito delle opere d'arte in loro proprietà. Un ringraziamento va rivolto anche alle Direzioni della Biblioteca « Vittorio Emanuele » e del Gabinetto Nazionale delle Stampe per il prestito di volumi, incisioni, disegni con ritratti papali.

La Direzione Generale Antichità e Belle Arti ha consentito che venissero occupate dalla Mostra alcune Sale del Palazzetto Venezia già precedentemente utilizzate per manifestazioni affini e che torneranno, alla chiusura della Mostra, alla loro originaria destinazione di Museo. Per tale concessione un particolare ringraziamento va dato al prof. Guglielmo De Angelis d'Ossat, Direttore Generale delle Antichità e Belle Arti e al prof. Achille Bertini Calosso, Soprintendente alle Gallerie di Roma, alla cui amichevole comprensione non è stato mai ricorso invano.

Il nostro vivo ringraziamento va anche al Comune di Roma ed in particolare al Sindaco ing. Rebecchini e all'Assessore per le Belle Arti Senatore Bergamini che sono stati larghi di aiuti e facilitazioni durante la preparazione della Mostra.

L'espressione della nostra riconoscenza è altresì rivolta all'Ente Provinciale per il Turismo, presieduto da don Francesco Massimo Lancellotti, per la cortese collaborazione offerta alla Mostra con la stampa del presente catalogo e al Comitato Centrale dell'Anno Santo che ha voluto contribuire con la stampa del manifesto.

Particolare menzione merita l'opera del Comitato organizzatore della Mostra composto, oltre che dal sottoscritto, Presidente, dal prof. Achille Bertini Calosso, dal prof. A. M. Colini, dal dott. Doeclecio Redig de Campos, dal Marchese Giovanni Incisa della Rocchetta, dal prof. Emilio Lavagnino, e dal dott. Carlo Pietrangeli.

A tutti l'Associazione esprime la sua gratitudine.

Dicembre 1950.

LODOVICO CHIGI DELLA ROVERE ALBANI
Presidente dell'Associazione
« Amici dei Musei di Roma »

6

ESPOSITORI

Museo di Palazzo Venezia · Galleria Nazionale d'Arte Antica · Galleria Borghese · Museo Nazionale di Villa Giulia · Museo Nazionale di Castel S. Angelo · Sopraintendenza Foro e Palatino · Galleria Nazionale dell'Umbria (Perugia) · Musei Capitolini · Museo di Roma · Museo Napoleonico · Galleria dell'Accademia di S. Luca · Sacri Palazzi Apostolici · Sacra Congregazione de Propaganda Fide · Ven. Capitolo di S. Giovanni in Laterano · Chiesa di S. Francesca Romana · Principi Clemente e Ferdinando Aldobrandini · Principe Ludovico Altieri · Principessa Maria Barberini · Principe Francesco Boncompagni Ludovisi · Principe Lodovico Chigi della Rovere Albani · Barone Basile de Lemmerman · Marchesa Eleonora Incisa della Rocchetta Chigi · Ing. Edoardo Lombardi · Contessa Maria Moroni Pecci · Contessa Matilde della Rocca de Candal Bruschi Falgari · Marchese Gaetano Ferrajoli · Principe Innocenzo Odescalchi · Contessa Anna Laetitia Pecci Blunt · Marchesa Maria Luisa Persichetti Ugolini Ratti · Eredi Tenerani · Principe Alessandro Torlonia · Duca Andrea Torlonia · Comm. Ugo Ximenes · On. Conte Camillo Orlando Castellano · Arch. Andrea Busiri Vici

7

ICONOGRAFIA DEI PAPI

PIETRO

1 - Testa della statua in bronzo del sec. V in S. Pietro in Vaticano.

SILVESTRO

(314-335)

2 - Copia del ritratto della serie papale di S. Paolo, opera del V sec., ridipinta nel sec. IX.

Museo di Roma

DAMASO

(366-384)

3 - Copia del ritratto della serie papale di S. Paolo, opera del V sec., ridipinta nel sec. IX.

Museo di Roma

PELAGIO II

(romano, 579-590)

4 - Testa del mosaico dell'arco trionfale di S. Lorenzo fuori le mura.

GIOVANNI IV

(dalmata, 640-642)

5 - Testa del mosaico absidale della Cappella di S. Venanzio presso il Battistero Lateranense.

9

TEODORO I
(greco, 642-649)

6 - Testa del mosaico absidale della Cappella di S. Venanzio presso il Battistero Lateranense.

GIOVANNI VII
(di Rossano in Calabria, 705-707)

7 - Riproduzione a colori di M. Barosso della testa in mosaico già nella Cappella della Madonna in S. Pietro, ora nelle Grotte Vaticane.

Museo di Roma

ZACCARIA
(greco, 741-752)

8 - Riproduzione a colori di L. Paterna Baldizzi dell'affresco in S. Maria Antiqua.

Roma, Soprint. Foro e Palatino.

LEONE III
(romano, 795-816)

9 - Copia del Grimaldi dal distrutto mosaico del Triclinio Leoniano nel Patriarchio Lateranense.

PASQUALE I
(romano, 817-824)

10 - Testa in mosaico dall'abside di S. Maria in Domnica.

GREGORIO IV
(romano, 827-844)

11 - Testa in mosaico dall'abside di S. Marco.

10

LEONE IV
(romano, 847-855)

12 - Testa dell'affresco dell'Ascensione nella Chiesa sotterranea di S. Clemente.

CLEMENTE II
(Suidgero dei signori di Moreselve, sassone, 1046-1047)

12a - Figura giacente e particolari della tomba del pontefice nel duomo di Bamberga.

INNOCENZO III
(Lotario dei Conti di Segni di Anagni, 1198-1216)

13 - Testa in mosaico dell'abside del Vecchio S. Pietro.
Roma, Duca Andrea Torlonia

13a - Affresco nel Sacro Speco di Subiaco.

GREGORIO IX
(Ugolino dei Conti di Segni di Anagni, 1227-1241)

14 - Testa in mosaico della facciata del Vecchio S. Pietro.
Roma, Duca Andrea Torlonia

14a - Affresco nel Sacro Speco di Subiaco.

INNOCENZO IV
(Sinibaldo Fieschi dei Conti di Lavagna di Genova, 1243-1254)

15 - Tomba del pontefice nel duomo di Napoli.

CLEMENTE IV
(Guido Foulques Le Gros di Saint-Gilles sur le Rhône, 1265-1268)

16 - Testa della figura giacente nella tomba del papa in S. Francesco di Viterbo (Pietro Oderisi).

11

GREGORIO X
(Teobaldo Visconti di Piacenza, 1271-1276)

17 - Tomba esistente nella Cattedrale di Arezzo (Agostino di Giovanni e Angelo di Ventura da Siena?).

ADRIANO V
(Ottobono Fieschi dei Conti di Lavagna di Genova, 1276)

18 - Testa della figura giacente nella tomba del papa a S. Francesco di Viterbo (Arnolfo di Cambio).

ONORIO IV
(Jacopo Savelli, romano, 1285-1287)

19 - Calco della testa della figura giacente del papa già in S. Pietro, ora in S. Maria in Aracoeli.

Museo di Roma

NICOLO' IV
(Gerolamo Masci di Lisciano, 1288-1292)

20 - Mosaico nell'abside di S. Maria Maggiore (Jacopo Torriti).

INNOCENZO V
(Pietro di Tarantasia di Moutier - Savoia, 1273-1276)

21 - Testa di figura inginocchiata di pontefice in S. Giovanni in Laterano, da attribuirsi probabilmente al b. Innocenzo V.

CELESTINO V
(Pietro da Morrone di Isernia, 1294)

22 - Miniatura del Codice di S. Giorgio nell'archivio di S. Pietro (scuola di Simone Martini).

12

BONIFACIO VIII
(Benedetto Caetani di Anagni, 1294-1303)

23 - Calco del busto nelle Grotte Vaticane (Arnolfo di Cambio).

Museo di Roma

PONTEFICE ANONIMO
della fine del sec. XIII

24

Roma, Museo di Palazzo Venezia

BENEDETTO XI
(Nicolò Boccasini di Treviso, 1303-1304)

25 - Figura giacente della tomba del papa in S. Domenico di Perugia (seguaci di Arnolfo o di Lorenzo Maitani)

CLEMENTE V
(Bertrando de Goth di Villandran - Bordeaux, 1305-1314)

26 - Affresco in S. Maria Novella (Andrea di Bonaiuto).

BENEDETTO XII
(Giacomo Fournier di Saverdun - Tolosa, 1334-1342)

27 - Busto in marmo nelle Grotte Vaticane (Paolo da Siena).

GREGORIO XI
(Pietro Roger de Beaufort di Château Maumont - Limoges, 1370-1378)

28 - Affresco di Matteo di Giovanni nello Spedale di S. Maria della Scala a Siena rappresentante il ritorno a Roma del pontefice.

13

PIO V
(Antonio Ghislieri di Bosco Marengo - Alessandria, 1566-1572)

57 - Busto in marmo di anonimo.

Museo di Roma

GREGORIO XIII
(Ugo Boncompagni di Bologna, 1572-1585)

58 - Dipinto su tavola attribuito a Scipione Pulzone.

Roma, Principe Boncompagni-Ludovisi

SISTO V
(Felice Peretti di Grottammare, 1585-1590)

59 - Tela ad olio di ignoto (trad. attrib. al Padovanino).

Roma, Accademia Nazionale di S. Luca

URBANO VII
(G. B. Castagna, romano, 1590)

60 - Ritratto ad olio di anonimo.

Sacri Palazzi Apostolici

GREGORIO XIV
(Nicolò Sfondrati di Cremona, 1590-1591)

61 - Incisione.

INNOCENZO IX
(Giovan Antonio Facchinetti di Bologna, 1591)

62 - Incisione.

18

CLEMENTE VIII
(Ippolito Aldobrandini di Fano, 1592-1605)

63 - Busto in bronzo dorato di ignoto.

Frascati, Principe Aldobrandini

'63a - Tela ad olio dello Scalvati.

Roma, On. Conte Camillo Orlando Castellano

LEONE XI
(Alessandro de' Medici di Firenze, 1605)

64 - Tela ad olio di ignoto.

Roma, M.sa Eleonora Incisa Chigi

PAOLO V
(Camillo Borghese, romano, 1605-1621)

65 - Tela ad olio, copia da Caravaggio.

Roma, Galleria Borghese

GREGORIO XV
(Alessandro Ludovisi di Bologna, 1621-1623)

66 - Busto in bronzo di anonimo.

Roma, Palazzo di Propaganda Fide

URBANO VIII
(Maffeo Barberini, 1623-1644)

67 - Busto in marmo di G. L. Bernini.

Roma, Galleria Nazionale d'Arte Antica

68 - Tela ad olio di A. Sacchi (?).

Roma, Principessa Maria Barberini

68a - Tela ad olio di A Sacchi (?).

Roma, Galleria Nazionale d'Arte Antica

68b - Tela ad olio di Pietro da Cortona.

Roma, Pinacoteca Capitolina

19

INNOCENZO X
(G. B. Pamphili, romano, 1644-1655)

69 - Tela ad olio di anonimo.

Sacri Palazzi Apostolici

ALESSANDRO VII
(Fabio Chigi di Siena, 1655-1667)

70 - Tela ad olio di anonimo.

Ariccia, Principe Chigi Albani

CLEMENTE IX
(Giulio Rospigliosi di Pistoia, 1667-1669)

71 - Ritratto ad olio (Baciccia).

Ariccia, Principe Chigi Albani

72 - Ritratto ad olio (Baciccia).

Roma, Accademia Nazionale di S. Luca

CLEMENTE X
(G. B. Altieri, romano, 1670-1676)

73 - Tela ad olio di anonimo.

Roma, Principe Altieri

INNOCENZO XI
(Benedetto Odescalchi di Como, 1676-1689)

74 - Tela ad olio di anonimo.

Roma, Principe Odescalchi

ALESSANDRO VIII
(Pietro Ottoboni di Venezia, 1689-1691)

75 - Incisione.

20

INNOCENZO XII
(Antonio Pignatelli di Spinazzola - Bari, 1691-1700)

76 - Tela ad olio di Ludovico David in Villa Albani.

Roma, Principe Torlonia

77 - Busto in terracotta di anonimo.

Museo di Roma

CLEMENTE XI
(Giovan Francesco Albani di Urbino, 1700-1721)

78 - Tela ad olio (Baciccia?) in Villa Albani.

Roma, Principe Torlonia

78a - Tondo in marmo di anonimo

Museo di Roma

INNOCENZO XIII
(Michelangelo Conti, romano, 1721-1724)

79 - Tela ad olio di anonimo.

Poli, Duca Andrea Torlonia

BENEDETTO XIII
(Vincenzo Maria Orsini di Gravina - Bari, 1724-1730)

80 - Busto in terracotta colorata di anonimo.

Roma, Museo di Palazzo Venezia

CLEMENTE XII
(Lorenzo Corsini di Firenze, 1730-1740)

81 - Busto in marmo di Pietro Bracci.

Roma, Musei Capitolini

82 - Testa in marmo di anonimo.

Museo di Roma

82a - Busto in terracotta attribuito a Pietro Bracci.

Roma, On. Conte Camillo Orlando Castellano

21

BENEDETTO XIV
(Prospero Lambertini di Bologna, 1740-1758)

83 - Tela ad olio di P. Subleyras.
Roma, Museo di Palazzo Venezia
83a - Testa in marmo di anonimo.
Museo di Roma

CLEMENTE XIII
(Carlo Rezzonico di Venezia, 1758-1769)

84 - Tela ad olio di Pompeo Batoni.
Roma, Museo di Palazzo Venezia

CLEMENTE XIV
(Giov. Vinc. Ganganelli di S. Arcangelo di Romagna, 1769-1774)

85 - Tela ad olio di anonimo.
Sacri Palazzi Apostolici

PIO VI
(Giovan Angelo Braschi di Cesena, 1775-1799)

86 - Tela ad olio di P. Pozzi.
Roma, Museo Napoleonico
87 - Busto in marmo di anonimo.
Roma, Marchese Gaetano Ferrajoli

PIO VII
(Barnaba Chiaramonti di Cesena, 1800-1823)

88 - Busto in marmo di Antonio Canova.
Roma, Protomoteca Capitolina
89 - Bozzetto ad olio di G. B. Wicar.
Perugia, Galleria Nazionale
89a - Tondo in gesso di Adamo Tadolini.
Museo di Roma

22

LEONE XII
(Annibale Della Genga di Genga - Ancona, 1823-1829)

90 - Busto in marmo di Antonio d'Este (1825).
Roma, Protomoteca Capitolina

PIO VIII
(Francesco Saverio Castiglioni di Cingoli, 1829-1830)

91 - Tela ad olio di Ferdinando Cavalleri.
Roma, Ing. Edoardo Lombardi
92 - Busto in gesso di Pietro Tenerani.
Roma, Museo Tenerani

GREGORIO XVI
(Mauro Cappellari della Colomba di Belluno, 1831-1846)

93 - Busto in gesso di Pietro Tenerani.
Roma, Museo Tenerani

PIO IX
(Giovan Maria Mastai Ferretti di Senigallia, 1846-1878)

94 - Busto in marmo di Pietro Tenerani.
Roma, Museo Tenerani

LEONE XIII
(Gioacchino Pecci di Carpineto, 1878-1903)

95 - Tela ad olio di Lazlo.
Marlia, (Lucca), C.ssa Pecci Blunt
96 - Tela ad olio di Chartran.
Roma, Contessa Moroni Pecci

23

Bibliography
edited by Franco Di Felice

- Aa.Vv., *Il ritratto italiano dal Caravaggio al Tiepolo*, Bergamo 1927
- Aa.Vv., *Il Settecento italiano*, catalogo mostra, Venezia 1929
- Aa.Vv., *Mostra di Roma Secentesca*, catalogo mostra, Roma 1930
- Aa.Vv., *Mostra di Roma nell'Ottocento*, catalogo mostra, Roma 1932
- Aa.Vv., *Mostra di ritratti dei papi*, a cura degli Amici dei Musei di Roma, Roma 1950
- Aa.Vv., *Il Settecento a Roma*, catalogo mostra, Roma 1959
- Aa.Vv., *Angelica Kauffmann e il suo ambiente*, catalogo mostra, Vienna 1968
- Aa.Vv., *Horace Vernet (1789-1863)*, catalogo mostra, Roma-Parigi, (Roma) 1980
- Aa.Vv., *The Vatican Exhibition*, catalogo mostra, Tokio 1981
- Aa.Vv., *The Vatican Collections, The Papacy and the Art*, catalogo mostra, New York 1982
- Aa.Vv., *Roma Capitale*, catalogo mostra, Villa Medici, Roma 1983
- Aa.Vv., *Vatican Splendour, Masterpieces of the Baroque Art*, catalogo mostra, Ottawa 1986
- Aa.Vv., *Velázquez el papa Inocencio X*, catalogo mostra, Madrid 1996
- Aa. Vv., *Il Seicento e Settecento Romano nella Collezione Lemme*, catalogo mostra, Milano-Roma 1998
- Aa.Vv., *Pittura Barocca Romana. La Collezione Fagiolo dal Cavalier d'Arpino a Andrea Pozzo*, catalogo mostra, Ariccia (Roma) 1999
- Aa.Vv., *I papi marchigiani*, Ancona 2000
- Aa.Vv., *Maestà di Roma da Napoleone all'Unità d'Italia*, catalogo mostra, Roma (Milano) 2003
- Aa.Vv., *Philip Alexius de László (1869-1937)/ a brush with grandeur*, catalogo mostra, London 2004
- Acidini Luchinat C., *Taddeo e Federico Zuccari fratelli pittori del Cinquecento*, 2 voll., Roma-Milano 1999 d'Afflitto C., Romei D. (a cura di), *I Teatri del Paradiso. La personalità, l'opera, il mecenatismo di Giulio Rospigliosi (papa Clemente IX)*, catalogo mostra, Pistoia (Siena) 2000
- Albéri F., *Lettera sul Ritratto di Clemente XIII, dipinto da Raffaele Mengs*, Bologna 1827
- Aleandri V. E., *Un semibusto di Urbano VIII del Bernini in camerino*, in "Arte e Storia", XXI, 1902, pp. 44-45
- Androsov S., Guderzo M., Pavanello G. (a cura di), *Canova*, catalogo mostra, Bassano del Grappa-Possagno (Milano) 2003
- Apa M., *Camminare con un prete romano: Manzù e Don Giuseppe De Luca*, in "Art e Dossier", 184, 2002
- Bacchi A., *Scultura del '600 a Roma*, Milano 1996
- Baglione G., *Le vite de' pittori scultori et architetti. Dal Pontificato di Gregorio XIII. del 1572. In fino a' tempi di Papa Urbano Ottavo nel 1642*, Roma 1642
- Barberini M. G., Gasparri C. (a cura di), *Bartolomeo Cavaceppi scultore romano (1717-1799)*, catalogo mostra, Roma 1994
- Barbier de Montault X., *Les Musées et galeries de Rome*, Roma 1870
- -Bardeschi Ciulich L., Ragionieri P. (a cura di), *Vita di Michelangelo*, catalogo mostra, Firenze 2001
- Barocchi P., *Vasari Pittore*, Firenze 1964
- Barroero L., *La pittura a Roma nel Settecnto*, in *La Pittura in Italia. Il Settecento*, Milano 1990, pp. 383-463
- Barroero L., *La basilica dal Cinquecento ai nostri giorni*, in *San Giovanni in Laterano*, a cura di C. Pietrangeli, Firenze 1990(a)
- Barroero L., *I primi anni della Scuola del Nudo in Campidoglio*, Roma 1998
- Bartsch A., *Le peintre-graveur*, XVIII, Vienna, 1818
- Bazin G., Lavagnino E. (a cura di), *L'Italia vista dai pittori francesi del 18. e 19. secolo*, catalogo mostra, Roma 1961
- Belli Barsali I., *Pompeo Girolamo Batoni*, in "Dizionario Biografico degli Italiani", VII, 1965, pp. 196-202
- Bellori G. P., *Le vite de' pittori, scultori e architetti moderni (Roma 1672)*, edizione a cura di E. Borea, Torino 1976
- Belotti B., *Gli eccellenti bergamaschi*, vol. II, Bergamo 1978
- Benocci (a cura di), *Le virtù e i piaceri in Villa. Per il nuovo museo comunale della Villa Doria Pamphilj*, catalogo mostra, Roma (Milano) 1998
- Benocci C., *L'inventario del 1808 del palazzo Poli a Fontana di Trevi ed un ritratto di Pompeo Batoni*, in "Strenna dei Romanisti", Roma 2002, pp. 31-45
- Bernardi M., *800 piemontese*, Torino 1946

- Bernardini M. G., Fagiolo dell'Arco M. (a cura di), *Gian Lorenzo Bernini Regista del Barocco*, catalogo mostra, Roma (Milano) 1999
- Bianconi G. L., *Scritti tedeschi*, a cura di G. Perini, Bologna 1998
- Bodart D., *Les peintres des Pays-Bas méridionaux et de la principauté de Liège à Rome au XVIIIe siècle*, 2 voll., Bruxelles-Rome 1970
Bologna:
Nell'età di Correggio e dei Carracci, catalogo mostra, Bologna 1986
- Bonasegale G., *Inventario di un ritrovamento: opere di Bertel Thorvaldsen, Pietro Tenerani, Francesco Ferraresi, Amleto Cataldi in Palazzo Braschi*, in "Bollettino dei Musei Comunali di Roma", n.s., VII, 1993, pp. 86-125
- Bonfait O., Marin B. (a cura di), *Les portraits du pouvoir*, atti del colloquio, Roma, Villa Medici, 24-26 aprile 2001, Roma-Parigi 2003
Bonn:
Kaiser Karl V (1550-1558)/ Macht und Ohnmacht Europas, catalogo mostra, Boon e Vienna 2000
- Borea E. (a cura di), *L'idea del Bello*, catalogo mostra, 2 voll., Roma 2000
- Boucher B., *Italian Baroque Sculpture*, London 1998
- Boucher B., *Busto di Papa Benedetto XIII*, in *Earth and Fire. Italian Terracotta Sculture from Donatello to Canova*, catalogo mostra, New Haven e Londra, 2001, p. 238
- Bowron E. P., Rishel J. J. (a cura di), *Art in Rome in the Eighteenth Century*, catalogo mostra, Philadelphia 2000
- Brejon de Lavergnée A., Volle N. (a cura di), *Musée de France. Répertoire des peintures italiennes du XVIIe siècle*, Paris 1988
- Briganti G., *Pietro da Cortona*, Firenze 1962, 1982
- Brivio E., Ferrazza M. (a cura di), *Paolo VI una luce per l'arte*, catalogo mostra, Milano-Roma 1999
- Brown B. L. (a cura di), *Il Genio di Roma 1592-1623*, catalogo mostra, Roma (Milano) 2001
- Brugnoli M. V., *Contributi a Giovan Battista Gaulli*, in "Bollettino d'Arte", serie IV, 34, 1949, pp. 225-239
- Brugnoli M.V., *Il 'Baciccio' di Enggass*, in "Paragone", n.s., 17, 195, 1966, pp. 71-74
- Bruno R., *Girolamo Siciolante. Revisioni e verifiche ricostruttive*, in "La critica d'arte", 133, 1974, p. 74
- Bruno R., *Roma. Pinacoteca Capitolina*, Bologna 1978
- Buranelli F., *Giacomo Manzù e la Collezione d'Arte Religiosa Moderna dei Musei Vaticani*, in C. Strinati (a cura di) e altri, *Manzù. L'uomo e l'artista. Grande Mostra Manzù*, catalogo mostra, Roma 2002, pp. 33-36
- Busiri Vici A., *Due sconosciuti ritratti marmorei romani del primo quarto del Settecento*, in "Strenna dei Romanisti", Roma 1990
- Busiri Vici A., *Pietro Nelli ritrattista del primo Settecento Romano*, in "L'Urbe", 3-4, 1982
- Busiri Vici A., *Scritti d'Arte*, edizione a cura di B. Jatta, Roma 1990
- Cajani L., Foa A., *Clemente XIII*, in "Enciclopedia dei Papi", III, Roma 2000, pp. 461-465
- Calabrese O., Strinati C. (a cura di), *Persone. Ritratti di gruppo da Van Dyck a De Chirico*, catalogo mostra, Roma 2003
- Campori G., *Lettere artistiche inedite*, Modena 1866
- Canestro Chiovenda B., *Innocenzo XI nell'isola di San Giulio*, in "Oscellana. Rivista illustrata della Val d'Ossola", anno XXVI, 2, 1996, pp. 70-75
- Cannata P., *Busto di Benedetto XIII*, in *Roma 1300-1875. L'arte negli anni santi*, catalogo mostra, Roma 1984
- Capitelli G., *Note su tre generazioni di ritratti di casa Pamphilj. Dal papa Innocenzo X benedicente alle "belle" di famiglia*, in C. Benocci (a cura di), *Le virtù e i piaceri in Villa. Per il nuovo museo comunale della Villa Doria Pamphilj*, catalogo mostra, Roma (Milano) 1998, pp. 96-99
- Capon L., *Il Museo Napoleonico*, Roma 1986
- Capovilla L. F., *Giacomo Manzù. La sua arte, la sua fede, la Porta della Morte*, in C. Strinati e altri (a cura di), 2002, pp. 51-56
- Carmassi L., *Un busto di papa Giulio III nel Museo di Villa Giulia*, in "Bollettino d'Arte", 1932- '33
- Caroli F., *L'Anima e il Volto*, catalogo mostra, Milano 1998
- Casale V., *Diaspore e ricomposizioni: Gherardi, Cerruti, Grecolini, Garzi e Masucci ai SS. Venanzio e Ansuino a Roma*, in *Scritti di storia dell'arte in onore di Federico Zeri*, Milano 1984, pp. 736-754
- Castellani G., *Un Pontefice numismatico. Pio VIII*, in "Studia Picena", V, Fano 1929, pp. 175-185
- *Catalogo dei quadri che si conservano nella Pinacoteca della Pontificia Accademia delle Belle Arti in Bologna*, Bologna 1827
- *Catalogo dei quadri che si conservano nella Pinacoteca della Pontificia Accademia delle Belle Arti in Bologna*, Bologna 1835
- Cecchi A., *Le due capitali. Tra Firenze e Roma dalla caduta della repubblica fiorentina alla morte del Vasari*, in *Storia delle arti in Toscana. Il Cinquecento*, Firenze 2000, pp. 117-136

• Charles J, (cura di), *Trésors du Vatican. La Papauté à Paris*, catalogo mostra, Parigi 1990

• Checa Cremades F. (a cura di), *Velázquez, Bernini, Luca Giordano/ Le Corti del Barocco*, catalogo mostra, Roma (Milano) 2004

• Cheney I. H., *Notes on Jacopino del Conte*, in "The Art Bulletin", LII, 1970, pp. 32-40

• Cheney I., *Conte, Jacopino del*, in *The Dictionary of Art*, 7, London 1996,pp. 776-777

• Chiarini M., *Sustermans. Sessant'anni alla corte dei Medici*, catalogo mostra, Firenze 1983 von Chtedowski C., *Rom. Die Menschen der Renaissance*, München 1912

• Clark A. M., *Pierleone Ghezzi's portraits*, in "Paragone", 165, 1963, pp. 11-21

• Clark A. M., *Neoclassicism and the Roman Eighteenth-Century Portrait*, in "Apollo", LXXVIII, 1963, pp. 325-359

• Clark A. M., *Agostino Masucci. A conclusion and reformation of the Roman Baroque*, in *Essays in the history of the art presented to Rudolf Wittkower*, London 1967

• Clark A. M., *Painting in the Eighteenth century: Rococò to Romanticism*,Chicago 1970

• Clark A. M., *Studies in Roman Eighteenth century paintings*, Washington 1976

• Clark A. M., *Studies in Roman Eighteenth Century Painting*, a cura di E. P. Bowron, Washington 1981

• Clark A. M., *Pompeo Batoni. A complete catalogue of his work with an introduction text*, a cura di E. P. Bowron, Oxford 1985

• Colalucci G., in "Bollettino Monumenti Musei e Gallerie Pontificie", IV, 1983, pp. 165-172

• Coliva A., Schütze S. (a cura di), *Bernini scultore. La nascita del Barocco in Casa Borghese*, catalogo mostra, Roma 1998

• Contardi B., Curcio G. e altri (a cura di), *Le immagini del Santissimo Salvatore*, catalogo mostra, Roma 1988

• Corradini S., *La collezione del cardinale Angelo Giori*, in "Antologia di Belle Arti", I, 1977

• Cremona C., *Giancarlo Dughetti appunti per un ritratto*, Verona 1980

• Cucco G. (a cura di), *papa Albani e le arti a Urbino e a Roma 1700-1721*, catalogo mostra, Urbino (Venezia) 2001

• Cugnoni G., *Agostino Chigi il Magnifico*, Roma 1881

• Curzi V., Lo Bianco A. (a cura di), *Domenico Corvi*, catalogo mostra, Viterbo (Roma) 1998

• De Antonio T., *El ritratto del papa Inocencio X pintado por Velázquez*, catalogo mostra, Madrid 1996

• De Benedetti E. (a cura di), *Sculture romane del Settecento, I/ La professione dello scultore*, collana "Studi sul Settecento Romano", diretta da Elisa De Benedetti, Roma 2001

• De Vita C., *Il Museo Storico Vaticano*, in *Il Palazzo Apostolico Lateranense*, a cura di C. Pietrangeli, Firenze 1991, pp. 305-318

• Della Pergola P., *Galleria Borghese. I dipinti*, vol. II, Roma 1959

• Della Pergola P., *Gli Inventari Aldobrandini*, in "Arte Antica e Moderna", III, 1960, pp. 425-444

• Della Pergola P., *Gli Inventari Aldobrandini: l'Inventario del 1682. II*, in "Arte Antica e Moderna", VI, 1963, pp. 61-87, e III, pp. 175-191

• De Vita C., *Il Museo Storico Vaticano*, in C. Pietrangeli (cura di), *Il Palazzo Apostolico Lateranense*, Firenze 1991

• Di Gioia E. B., *Museo di Roma. Le collezioni di scultura del '600 e del '700*, Roma 1990

• Di Gioia E. B., *Domenico Guidi: un modello in terracotta per un ritratto di Papa Innocenzo XII Pignatelli al Museo di Roma*, in "Bollettino dei Musei Comunali di Roma", n s , V, 1991, pp. 39-54

• Di Gioia E. B., *Le collezioni di scultura del Museo di Roma. Il Seicento*, Roma 2002

• Di Lorenzo A. (a cura di), *Due collezionisti alla scoperta dell'Italia. Dipinti e sculture dal Museo Jacquemart-André di Parigi*, catalogo mostra, Milano 2002

• Dondi D., *La questione Pietro Martire Neri*, in "Bollettino storico cremonese", n. 1, 1994, pp. 224-241

• D'onofrio C., *La Villa Aldobrandini di Frascati*, Roma 1963

• D'onofrio C., *Inventario dei dipinti del cardinal Pietro Aldobrandini compilato da G.B. Agucchi nel 1603*, in "Palatino", 8, 1964, 1/3, pp. 15-20; 7/8, pp. 158-162; 9/12, pp. 202-211

• D'Onofrio C., *Roma vista da Roma*, Roma 1967

• D'Onofrio C., *Roma nel Seicento*, Firenze 1969

• Dorez L., *La cour du pape Paul III*, Paris 1932

• Emmerling E., *Pompeo Batoni, sein Leben und Werk*, Darmstadt 1932

• *Enciclopedia dei Papi*, III, Roma 2000

• Enggass R., *The painting of Baciccio*, University Park 1964 van Esbroeck E.,

• *catalogue du Musée de Peinture, Sculpture et Archéologie au Palais Accoramboni*, Rome 1897

• Fabbrini N., *Pietro da Cortona pittore e architetto*, Cortona 1896

• Fagiolo M. (a cura di), *Gian Lorenzo Bernini e le arti visive*, Roma 1987

• Fagiolo M., Madonna M. L. (a cura di), *Roma 1300-1875. L'arte degli anni santi*, catalogo mostra, Roma (Milano) 1984

• Fagiolo M., Madonna M. L. (a cura di), *Roma di Sisto V. Arte, architettura e città fra Rinascimento e Barocco*, catalogo mostra, Roma 1993

• Fagiolo dell'Arco M. e M., *Bernini. Una introduzione al gran teatro del barocco*, Roma 1967

• Fagiolo dell'Arco M., *La festa barocca*, Roma 1997

• Fagiolo dell'Arco M., *Pietro da Cortona e i "cortoneschi"/ bilancio di un centenario e qualche novità*, Roma 1998

• Fagiolo dell'Arco M., *Pietro da Cortona e i 'cortoneschi'/ Gimignani, Romanelli, Baldi, il Borgognone, Ferri*, Milano 2001

• Fagiolo dell'Arco M., Carandini S., *L'Effimero barocco. Strutture della festa nella Roma del '600*, voll. 2, Roma 1977-1978

• Fagiolo dell'Arco M., Cipriani A., *Bernini*, Roma 1981

• Fagiolo dell'Arco M., Graf D., Petrucci F. (a cura di), *Giovan Battista Gaulli Il Baciccio*, catalogo mostra, Ariccia (Milano) 1999

• Fagiolo dell'Arco M., Pantanella R., *Museo Baciccio, In margine a quattro inventari inediti*, Roma 1996

• Fagiolo dell'Arco M., Petrucci F. (a cura di), *L'Ariccia del Bernini*, catalogo mostra, Ariccia (Roma) 1998

• Fagiolo dell'Arco M., Petrucci F. (a cura di), *Il Baciccio un anno dopo. La collezione Chigi restauri e nuove scoperte*, catalogo mostra, Ariccia (Milano) 2001

• Faldi I., *Nuove note sul Bernini*, in "Bollettino d'Arte", XXXVIII, 1953, pp. 310-316

• Faldi I., *Mostra di antichi dipinti restaurati nelle raccolte accademiche*, Roma 1968

• Faldi I., *L'Accademia Nazionale di San Luca*, Roma 1974

• Favorini E., *Il ritratto di Paolo III e di Francesco Colonna del Sermoneta*, in "L'Arte", XXXII, 1929, pp. 165-168

• Ferino-Pagden S. (a cura di), *Vittoria Colonna/ dichterin und muse Michelangelos*, catalogo mostra, Vienna (Milano) 1997

• Ferrari O., Papaldo S., *Le sculture del Seicento a Roma*, Roma 1999

• Flamini G., Mariotti A., *Senigallia/ Museo Pio IX e Museo Diocesano*, Senigallia 1991

• Francescane Missionarie di Maria, *La Grace du travail*, ediz. FMM, Vanves 1937

• Franciolli M , Kahn-Rossi M. (a cura di), *Il giovane Borromini, Dagli esordi a San Carlo alle Quattro Fontane*, catalogo mostra, Lugano (Milano) 1999

• Fraschetti S., *Bernini*, Milano 1900

• Fredericksen B. B., Jaffé D., Allen D., Carr D., Stein P., *Masterpieces of Paintings in the J. Paul Getty Museum*, Malibu 1995, n. 9

• *Fürsterzbischof Wolf Dietrich von Raitenau Gründer des barocken Salzburg*, catalogo mostra, Salzburg 1987

• Gasparri C., Ghiandoni O., *Lo studio Cavaceppi e le Collezioni Torlonia*, in "Rivista dell'Istituto di Archeologia e Storia dell'Arte", XVI, 1993, numero speciale, Roma 1994

• Ghirardi A., *Indagini per Bartolomeo Passerotti: i ritratti di papa Gregorio XIII*, in "Il Carrobbio", XV, 1989, pp. 125-130

• Ghirardi A., *Bartolomeo Passerotti*, Rimini 1990

• Goethe J. W., *Italienische Reise*, in J. W. Goethe, *Werke. Hamburger Ausgabe*, XI, München 1974

• Golzio V., *Documenti artistici sul Seicento nell'archivio Chigi*, Roma 1939

• Greco M., *Mario Russo/ L'uomo e le sue immagini*, Firenze 1981

• Guarino S., *La collezione Sacchetti*, in *Palazzo Sacchetti*, a cura di Sebastian Schütze, Roma 2003, pp. 161-185

• Guerrieri Borsoi M B., *Villa Sora a Frascati*, Roma 2000

• Haidecher A., *Geschichte der Päpste in Bildern*, Heidelberg 1965

• Haile M., *Life of Reginald Pole*, London 1911

• Hartmann J. B., *A proposito del busto di Gregorio XVI nel Museo di Roma*, "Bollettino dei Musei Comunali di Roma", II, 3-4, 1955, pp. 52-60

• Haskell F., *Mecenati e pittori*, III ed. ital., Torino 2000

• Hermanin F., *Inventario di stima per l'acquisto della Galleria Spada da parte dello Stato Italiano*, manoscritto, 12 settembre 1925

• Hermanin F., *Due busti di Pietro Bracci*, in "Dedalo", 1929-30, pp. 254-262

• Hermanin F., *Il Palazzo Venezia*, Roma 1948

• Herrmann Fiore K. (a cura di), *Da Sendai a Roma un'ambasceria giapponese a Paolo V*, catalogo mostra, Roma 1990

• Hiesinger U., *The Paintings of Vincenzo Camuccini,1771-1884*, in "Art Bulletin", 1978

• *Hochrenaissance im Vatikan-Kunst und Kultur im Rom der Päpste I,1503-1534*, catalogo mostra, Bonn 1998

- Hofmeister (Cheney) I., *A Portrait by Jacopino del Conte in the Borghese Gallery*, in "Marsyas", VI, 1950/53, pp. 35-41
- Honour H., *Pietro Bracci*, in "Dizionario Biografico degli Italiani", 13, Roma, 1971, pp. 620-623
- Hufschmidt T. F., *Tadolini –Adamo, Scipione, Giulio, Enrico. Quattro generazioni di scultori a Roma nei secoli XIX e XX*, Roma 1996
- Hunter J., *Girolamo Siciolante pittore da Sermoneta (1521-1575)*, Roma 1996
- Incisa della Rocchetta G., *La mostra dei ritratti dei papi*, in "Capitolium", anno XXVI, 1951, pp. 129-136
- Incisa della Rocchetta G., *Ritratti di papi*, in "Ecclesia", X, 1951 (a), pp. 63-68
- Incisa della Rocchetta G., *La mostra di ritratti dei papi*, in "Capitolium", 1951, XXV, pp. 130-131
- Incisa della Rocchetta G., *La collezione dei ritratti dell'Accademia di San Luca*, Roma 1979
- Jansen G., Sutton P. C., *Michael Sweerts (1618-1664)*, catalogo mostra, Amsterdam-San Francisco-Hartford 2002
- Johns C. M. S., *The Entrepot of Europe: Rome in the Eighteenth* Century, in *Art in Rome in the Eighteenth Century*, catalogo mostra, a cura di E. P. Bowron e J. J. Rishel, Philadelphia 2000, pp. 17-45
- Johnston C., Vanier Shepard G., Worsdale M. (a cura di), *Vatican Splendour. Masterpieces of Baroque Art*, Ottawa 1986
- Kirsh A., Levenson R. S., *Seeing Trough Paintings: Physical Examination in Art Historical Studies*, New Haven, Yale University 2000
- Klaczko J., *Rome et la Renaissance. Jules II*, Paris 1902
- Kruft H-W., *Ottavio Leoni als Porträtmaler*, in "Storia dell'arte",72, 1991, pp. 183-190
- Lavagnino E., *La Galleria Spada in Roma*, Roma 1933
- Lefevre R., *Palazzo Chigi*, Roma 1973
- Leone R., Pirani F., Tittoni M. E., Tozzi S. (a cura di), *Il Museo di Roma racconta la città*, Roma 2002
- Litta P., *Famiglie celebri italiane*, Milano 1836
- Lo Bianco A., *La vita di Clemente XI Albani: venti incisioni dai disegni di Pier Leone Ghezzi*, in *Committenze della famiglia Albani*, "Studi sul Settecento Romano", collana a cura di E. Debenedetti, 1985-86, 1/2, pp. 13-42
- Lo Bianco A., *Pier Leone Ghezzi pittore*, Palermo 1985
- Lo Bianco A., *Pier Leone Ghezzi Ritratto di Clemente XI Albani*, in *L'Arte degli Anni Santi 1300-1875*, catalogo mostra, a cura di M. Fagiolo e M. L. Madonna, Roma (Milano) 1985
- Lo Bianco A. (a cura di), *Pietro da Cortona 1597-1669*, catalogo mostra, Roma (Milano) 1997
- Lo Bianco A., *Pier Leone Ghezzi. Settecento alla moda*, catalogo mostra, Ascoli Piceno-Roma, (Venezia) 1999
- Lo Bianco A., *Papa Albani e i Ghezzi*, in *Papa Albani e le Arti a Urbino e a Roma 1700-1721*, a cura di G. Cucco, Venezia 2001, pp. 144-150
- Londra, *Armada 1588-1988*, catalogo mostra, Londra e Belfast (London) 1988
- Lucco M., *L'opera completa di Sebastiano del Piombo*, Milano 1980
- Lugano P., *Santa Maria Nuova*, Roma 1923
- Macioce S., Zuccari A. (a cura di), *Innocenzo X Pamphilj/ Arte e Potere a Roma nell'Età Barocca*, Roma 1990
- Mahon D., *Studies in Seicento Art and Theory*, London 1947
- Mahon D., *Guercino as a Portraitist and His Pope Gregory XV*, in "Apollo", n. 113, 1981, pp. 230-235
- Malvasia C. G., *Felsina pittrice* (1678), Bologna 1841
- Mancinelli F., *Musei Vaticani, Pinacoteca*, Firenze 1981
- Manilli J., *Villa Borghese fuori di Porta Pinciana*, Roma 1650
- Marcenaro G., Boragina P. (a cura di), *Viaggio in Italia – un corteo magico dal Cinquecento al Novecento*, catalogo mostra, Genova (Milano) 2001
- Mariano F., Papetti S. (a cura di), *I papi marchigiani*, catalogo mostra, Ancona 2000
- Marini M., *Innocentius X pont. Max. Olimpia Pont. Max. Innocenzo X, Donna Olimpia Maidalchini Pamphilj e Velázquez*, in A. Zuccari, S. Macioce, 1990, pp. 109-125
- Marini M., *Un contributo a Gianlorenzo Bernini "al dipingere…molto inclinato"*, in "Arte Viva. Fima Antiquari", n. 0, 1992, pp. 40-50
- Marini M., *Caravaggio "pictor praestantissimus"*, Roma 2001
- *Mario Russo*, catalogo mostra, Galerie de Poche, Génève 2003
- Marti L., *Santa Francesca Romana (Santa Maria Nuova)*, in "Roma Sacra", 3, Roma 1995, pp. 40-47
- Martinelli V., *I disegni del Bernini*, in "Commentari", n., 1950, pp. 172-186
- Martinelli V., *Le pitture del Bernini*, in "Commentari", 2, 1950, pp. 95-104
- Martinelli V., *I busti berniniani di Paolo V, Gregorio XV e Clemente X*, in "Studi Romani", III, 1955, pp. 647-666
- Martinelli V., *I ritratti di pontefici di Gian Lorenzo Bernini*, Roma 1956
- Martinelli V., *Nuovi ritratti di Guidubaldo Abbatini e Pier Francesco Mola*, in "Commentari", IX, 2, 1958, pp. 99-109
- Martinelli V., *Un modello di Angelo de' Rossi per la statua di Alessandro VIII Ottoboni in San Pietro*, in "Studi Romani", VII, 1959, pp. 429-437
- Martinelli V., *Alessandro VII e Pierfrancesco Mola*, in *Studi offerti a Giovanni Incisa della Rocchetta*, Roma 1973, pp. 283-292
- Martinelli V., *Nuove precisazioni su due ritratti di Urbano VIII Barberini, dipinti da Gian Lorenzo Bernini*, in M. Fagiolo (a cura di), *Gian Lorenzo Bernini e le arti visive*, Roma 1987, pp. 251-258
- Martinelli V. (a cura di), *L'ultimo Bernini 1665-1680*, Roma 1996
- Masini P. (a cura di), *Pietro da Cortona, il meccanismo della forma-Ricerche sulla tecnica pittorica*, catalogo mostra, Milano 1997
- *Masperpieces of the J. Paul Getty Museum: Paintings*, Los Angeles 1997
- Matitti F., *Il cardinale Pietro Ottoboni mecenate delle arti. Cronache e documenti (1689-1740)*, in "Storia dell'Arte", 84, 1995, pp. 156-243
- Matitti F., *Le antichità di casa Ottoboni*, in "Storia dell'Arte", 90, 1997, pp. 201-249
- Mauclair C., *Antoon Van Welie: Un Peintre Hollandais Contemporain*,Paris 1924
- Mazzocca F., Colle E., Morandotti A., Susinno S. (a cura di), *Il Neoclassicismo in Italia. Da Tiepolo a Canova*, catalogo mostra, Milano 2002
- Melasecchi O., *Pietro Martire Neri, ritrattista cremonese nella Roma di Innocenzo X*, in S. Macioce, A. Zuccari (a cura di), *Innocenzo X Pamphilj/ Arte e Potere a Roma nell'Età Barocca*, Roma 1990, pp. 177-191
- Melchiorri G., *Guida metodica di Roma e suoi contorni*, Roma 1840
- Meloncelli R., Osbat L., *Clemente IX*, in "Enciclopedia dei Papi", III, Roma 2000, pp. 348-360
- Meloni Trkulja S., *Gli Uffizi. Catalogo Generale*, Firenze 1979
- Mencucci C., *Il Palazzo Mastai/ Senigallia*, Senigallia 1978
- Merz J. M., *Pietro da Cortona*, Tübingen 1991
- Mezzetti, *Contributi a Carlo Maratti*, in "Rivista dell'Istituto Nazionale di Archeologia e Storia dell'Arte", n.s., XV, 1955, pp. 253-354
- Michel O., Rosenberg P., *Subleyras 1699-1749*, catalogo mostra, Parigi-Roma (Roma) 1987
- Montagu J., *I monumenti papali nei refettori della Ss. Trinità de' Pellegrini*, in *Sculture romane del Settecnto, I/ La professione dello scultore*, "Studi sul Settecento Romano", collana diretta da Elisa De Benedetti, Roma 2001, pp. 37-60
- Morello G. (a cura di), *Vatican Treasures*, catalogo mostra, Denver (Colorado), Milano 1993
- Morello G., De Angelis M. A. (a cura di), *La fe y el arte*, catalogo mostra, Montevideo 1998
- Morello G., De Angelis M. A. (a cura di), *Fe y arte*, catalogo mostra, Santiago de Chile 1998 (a)
- Moroni G., *Dizionario di erudizione storico-ecclesiastico*, Venezia 1840-1879
- Morselli R., Vodret R. (a cura di), *Ritratto di una collezione. Pannini e la galleria del Cardinale Silvio Valenti Gonzaga*, catalogo mostra, Mantova (Milano) 2004
- Moücke F., *Museo Fiorentino che contiene i ritratti de' Pittori consacrato alla Sacra Cesarea Maestà dell'Augustissimo Francesco I*, vol. IV, Firenze 1762
- Mould P., *Sleepers: in Search of Lost Old Masters*, London 1995
- Muñoz A., *La Collezione Stroganoff*, in "Rassegna d'Arte Contemporanea", fasc. X, 1910, pp. 85-92
- Muñoz A., *Pièces de Choix de la Collection du Comte Grégoire Stroganoff. Seconde Partie […]*, Roma 1911, p. 128, tav. XCIX
- Muñoz A., *Studi sul Bernini*, in "L'Arte", XIX, 1916, pp. 99-114
- Muñoz A., *La scultura barocca a Roma. Le statue onorarie*, in "Rassegna d'Arte antica e moderna", luglio-agosto 1917, pp. 1-17
- Natoli M., Petrucci F. (a cura di), *Donne di Roma dall'Impero Romane al 1860/ Ritrattistica romana al femminile*, catalogo mostra, Ariccia (Roma) 2003
- Negri Arnoldi F., *Il ritratto di Clemente XI di Pierleone Ghezzi e una medaglia dell'Amerani*, in "Paragone", 239, 1970, pp. 67-73
- Negro E., *La Collezione Rospigliosi*, Roma 1999
- Negro E., *La scuola dei Carracci*, Modena, 1989
- Nibby A., *Roma nell'anno MDCCCXXXVIII*, III, Roma 1839
- Nogara B., *Monumenti, Musei e Gallerie Pontificie, Relazione*, in "Rendiconti della Pontificia Accademia di Archeologia", X, 1930-34, pp. 66-67
- *Novità dei Musei Comunali. Acquisti, doni, restauri, 1959-1964*, a cura di C. Pericoli Ridolfini, C. Pietrangeli, Roma 1965
- Oberhuber O. K., *Raffaello l'opera pittorica*, Milano 1999
- Oliva M., *Giulia Gonzaga Colonna tra Rinascimento e Controriforma*, Milano 1985
- Olson R. J. M. (a cura di), in *Ottocento. Romanticism and Revolution in 19th*

century Italian painting, catalogo mostra, Baltimora-Worcester-Pittsburg 1992-1993, New York 1992

• Orbaan J.A.F., *Documenti sul barocco in Roma*, voll. 3 in 2 tomi, Roma 1920

• Orbaan J. A. F., *Rome under Clemens VIII (Aldobrandini) (1592-1605)*, 's Gravenhage 1920

• Orsini L., *La Sacrestia Papale. Suppellettili e paramenti liturgici*, Milano 2000

• Pampalone A., *Le Omelie di Clemente XI versificate da Alessandro Guidi*, in *Committenze della famiglia Albani*, "Studi sul Settecento Romano", collana a cura di E. Debenedetti, 1985, 1/2, pp. 43-76

• Pampalone A., *Presenza di Pier Leone Ghezzi tra i marchigiani in Roma*, in *Giuseppe e Pier Leone Ghezzi*, a cura di V. Martinelli, Roma 1990, pp. 65-89

• Pampalone A., *Lo sterro della Colonna di Antonino Pio... (II parte)*,in corso di pubblicazione su "Rivista dell'Istituto di Archeologiae Storia dell'Arte", 2005

• Pansecchi F., *Giuseppe Ghezzi: Tre quadri fuori sede*, in *Scritti di storia dell'arte in onore di Federico Zeri*, Milano 1984, vol. II, pp. 724-729

• Panvinio O., *XXVII Pontificum Maximorum Elogia et Imagines accuratissimae ad vivum aeneis typeis delineatae*, Roma 1568

• Paolucci A. (a cura di), *Tiziano*, catalogo mostra, Venezia 1990

• *Papi in posa dal Rinascimento a Giovanni Paolo II*, catalogo mostra, a cura di M. E. Fittoni, F. Buranelli, F. Petrucci, Roma, Palazzo Braschi, Roma 2004

• Papini M. L., *L'ornamento della pittura. Cornici, arredo e disposizionedella Collezione Corsini di Roma nel XVIII secolo*, Roma 1998

• Pascoli L., *Vite de' pittori, scultori ed architetti moderni*, Roma 1730-1734; edizione moderna dedicata a V. Martinelli, Perugia 1992

• Passeri G. B., *Vite de pittori scultori et architetti dall'anno 1641 sino all'anno 1673*, edizione a cura di J. Hess, Leipzig und Wien 1934

• von Pastor L., *Storia dei Papi dalla fine del medio evo*, 16 voll.,Roma 1929-1934

• Pavanello G., *I Rezzonico: committenza e collezionismo fra Venezia e Roma*,in "Arte Veneta", 52, 1998, pp. 87-111

• Pelissier L. G., *Un inventaire inédit des collections Ludovisi à Rome*,in « Mèmoires de la Société Nationale des Antiquaires de France », LIII,Paris 1894

• Pepper S., *Guido Reni*, Oxford 1984

• Perez Sànchez A. E. (a cura di), *Museo del Prado. Inventario General de Pinturas, I. La colección real*, Madrid 1990

• Pericoli Ridolfini C., *Museo di Roma, Itinerario*, Roma, 1963

• Petrucci F., *Nuovi contributi sulla committenza Chigi nel XVII secolo alcuni dipinti inediti nel palazzo di Ariccia*, in "Bollettino d'Arte", 73, 1992,pp. 107-126

• Petrucci F., *Notizie d'archivio su alcuni busti marmorci chigiani*, in "Bollettino d'Arte", n. 78, 1993, pp. 91-98

• Petrucci F., *I dipinti chigiani del Gaulli: una ricognizione*, in "Bollettino d'Arte", n. 84-85, 1994, pp. 87-98

• Petrucci F., *Monsù Ferdinando ritrattista. Note su Jacob Ferdinand Voet (1639-1700?)*, in "Storia dell'Arte", 84, 1995, pp. 283-306

• Petrucci F., *Gian Lorenzo Bernini per casa Chigi. precisazioni e nuove attribuzioni*, in "Storia dell'Arte", 90, 1997, pp. 176-200

• Petrucci F., *Baciccio ritrattista/ proposta per un catalogo*, in "Arte Viva/ Fima Antiquari", 10-11, 1997 (a), pp. 37-57

• Petrucci F., *Sull'attività ritrattistica di Giovanni M. Morandi*, in "Labyrinthos", 33/34, 1998, pp. 131-174

• Petrucci F., *La Ritrattistica*, in *Giovan Battista Gaulli "Il Baciccio"*,catalogo mostra, Ariccia (Milano) 1999, pp. 89-102

• Petrucci F., *Palazzo Chigi com'era. Gli interni in alcune fotografie d'archivio anteriori al 1918*, in C. Strinati, R. Vodret (a cura di), *Palazzo Chigi*,Milano 2001, pp. 103-127

• Petrucci F., *Contributi su Carlo Marchionni scultore*, in *Sculture romane del Settecento, I/ La professione dello scultore*, "Studi sul Settecento Romano", collana diretta da E. De Benedetti, Roma 2001 (a), pp. 37 60

• Petrucci F., *L'opera pittorica di Bernini*, in M. G. Bernardini (a cura di), *Bernini a Montecitorio/ Ciclo di conferenze nel quarto centenario della nascita di Gian Lorenzo Bernini*, Salerno 2001(b), pp. 61-91

• Petrucci F. (a cura di), *Castelli e Castellani. Viaggio attraverso le dimore storiche della Provincia di Roma*, catalogo mostra, Ariccia (Roma) 2002

• Petrucci F., *I dipinti del Bernini*, in D. Gallavotti Cavallero (a cura di), *Bernini e la pittura*, Roma 2003, pp. 143-144

• Petrucci F. (a cura di), *Le Stanze del cardinale*, catalogo mostra, Ariccia (Roma) 2003 (a)

• Petrucci F. (a cura di), *I Volti del Potere. Ritratti di uomini illustri a Roma dall'Impero Romano al Neoclassicismo*, catalogo mostra, Ariccia (Roma) 2004

• Petrucci F., *I ritratti del potere a Roma tra '500 e '700*, in *I Volti del Potere. Ritratti di uomini illustri a Roma dall'Impero Romano al Neoclassicismo*, catalogo mostra, Ariccia (Roma) 2004a, pp. 13-24

• Petrucci F., *Ritrattistica papale in pittura dal '500*, in M. E. Tittoni, F.

Buranelli, F. Petrucci (a cura di), *Papi in posa dal Rinascimento a Giovanni Paolo II*, catalogo mostra, Roma 2004b, pp. 21-45

• Petrucci F. (a cura di), *Mecenati e Dimore Storiche nella Provincia di Roma*, catalogo mostra, Tivoli (Roma) 2005

• Piantoni G. (a cura di), *Vincenzo Camuccini (1771-1844). Bozzetti dallo studio dell'artista*, catalogo mostra Roma, Galleria Nazionale d'Arte Moderna, Roma 1978

• Pierguidi S., *Il cardinale Lanfredini collezionista e committente: la decorazione della SS.ma Trinità della Missione, un'impresa a ridosso del 1750*, in E. Debenedetti (a cura di), *L'arte per i giubilei e tra i giubilei del Settecento*, vol. II, collana "Studi sul Settecento Romano", Roma 2000, pp. 51-71

• Pietrangeli C., (a cura di), *Palazzo Braschi e il suo ambiente*, Roma 1967

• Pietrangeli C., *Il Museo di Roma. Documenti e iconografia*, Bologna 1971

• Pietrangeli C., *La provenienza delle sculture dei Musei Vaticani*,in "Bollettino dei Monumenti Musei e Gallerie Pontificie", VIII, 1988,pp. 140-210

• Pietrangeli C. (a cura di), *San Giovanni in Laterano*, Firenze 1990

• Pietrangeli C., *I Musei Vaticani*, Roma 1993

• Pinelli A. (a cura di), *La Basilica di San Pietro in Vaticano*, 4 voll.,Modena 2000

• Pio N., *Le vite de' pittori scultori et architetti (1724)*, a cura di C. e R. Enggass, Città del Vaticano 1977

• Podesti F., *Memorie biografiche, 1870 ca.*, edizione a cura di M. T. Bardo, con premessa di G. L. Mellini, in "Labyrinthos", I, 1982, 1/2, pp. 203-253

• Polverari M. (a cura di), *Francesco Podesti*, catalogo mostra,Ancona (Milano) 1996

• Porcella A., *Le Pitture della Galleria Spada*, Roma 1931

• Prange M. C. F., *Des Ritters Anton Raphael Mengs ersten Mahlers Karl III. König in Spanien hinterlaßne Werke*, 3 voll., 1786

• Van Puyvelde L., *Een Vlaamsch schilder te Rome in de XVIIde eeuw, Lodewijk Primo*, in "Verslagen en Mededelingen van het Koninklijke Vlaamse Academie voor taal- en letterkunde", XI-XII, 1958, pp. 629-637

• Quieto P.P., *Giovanni V di Portogallo e le sue committenze nella Roma del XVIII secolo*, Bentivoglio 1988

• Quieto P.P., *Mestres Italianos que trabalharam para Portugal: Odazzi, Zoboli, Masucci, Alfani e Batoni*, in *Joanni V Magnifico*, catalogo mostra, Lisboa 1994, pp. 323-406

• Quieto P.P., *Relaçoes artistico-culturais entre Lisboa e Roma*, in *Johanni V Magnifico*, catalogo mostra, Lisbona 1994, pp. 63-79

• Quieto P. P., *Gaulli nel Settecento*, in Fagiolo dell'Arco M., Graf D., Petrucci F. (a cura di), *Giovan Battista Gaulli Il Baciccio*, catalogo mostra, Ariccia (Milano) 1999, pp. 73-85

• Radcliffe A. F., Baker M., Maek-Gerard M., *The Thyssen-Bornemisza Collection: Renaissance and Later Sculpture*, London 1992

• Ratti C.G., *Delle Vite de' pittori, scultori, ed architetti genovesi*, Genova 1769

• Redig de Campos D., *Ritratti inediti di Leone XI*, in "L'Urbe", anno II, 5, 1937, pp. 11-18

• Redig de Campos D., *Un ritratto inedito di Urbano VII*, in "Atti della Pontificia Accademia Romana d'Archeologia. Rendiconti", XVIII, 1941-'42, pp. 175-182

• Ricci E., *Pier Leone Ghezzi. Il ritratto di Clemente XI*, in *Scrittura e popolo nella Roma Barocca 1585-1721*, catalogo mostra, Roma 1982

• Riccoboni A., *Roma nell'arte. La scultura nell'evo moderno dal Quattrocento ad oggi*, Roma 1942, pp. 291-299

• Rizzo M. T., *Ottavio Leoni pittore (1578-1630). Precisazioni sulla produzione pittorica e contributi documentari*, in "Studi Romani", 52, n. 1-2, 1999, pp. 25-42

• Rizzo M. T., *Dal ritratto "cortese" al ritratto "parlante": interpretazioni del ritratto tra manierismo e Barocco, Ottavio Leoni e Gianlorenzo Bernini*, in "Studi romani", 50,1 3, 2002, pp. 100 113

• Roettgen S., *Anton Raphael Mengs, 1728-1779: Das malerische und zeichnerische Werk*, Monaco 1999

• Roettgen S., *Mengs. La scoperta del Neoclassicismo*, catalogo mostra, Padova 2001

• Roettgen S., *Anton Raphael Mengs 1728-1779*, 2 voll., München 2003

• Romei D., D'Afflitto C. (a cura di), *I Teatri del Paradiso. La personalità, l'opera, il mecenatismo di Giulio Rospigliosi (papa Clemente IX)*, catalogo mostra, Pistoia (Montespertoli) 2000

• Roettgen S., *Anton Raphael Mengs, 1728-1779: Das malerische und zeichnerische Werk*, Monaco 1999

• Romei F., Tosini P., *Collezioni veneziane nelle foto di Umberto Rossi*, Napoli 1995

• Rosa M., *Benedetto XIV*, in "Enciclopedia dei Papi", III, Roma 2000, pp. 446-461

• Rosa M., *Clemente XIV*, in "Enciclopedia dei Papi", III, Roma 2000, pp. 475-492

- Rota G., *Un artista bergamasco dell'Ottocento: Giovanni Maria Benzoni nella storia della scultura e nell'epistolario famigliare*, Bergamo 1938
- Rudolph S., *La pittura del '700 a Roma*, Milano 1983
- Rudolph S., *Niccolò Maria Pallavicini. L'ascesa al tempio della virtù attraverso il mecenatismo*, Roma 1995
- Rudolph S., *Carlo Maratti*, in *L'idea del bello. Viaggio per Roma nel Seicento con Giovan Pietro Bellori*, catalogo mostra, Roma 2000, pp. 456-479
- Safarik E. A., *Catalogo sommario della Galleria Colonna in Roma*, Roma 1981
- Safarik E. A., *Palazzo Colonna*, Roma 1999
- Salerno L., *I dipinti del Guercino*, Roma 1988
- Sani B., *Precisazioni sul giovane Ottavio Leoni*, in "Prospettiva", 57-60, 1989-1990, pp. 187-194
- Sani B., *Carte d'inventario: Ottavio Leoni e Domenico Manetti*, in "La Diana"', 2, 1997, pp. 55-84
- Santangelo A., *Museo di Palazzo Venezia. Catalogo delle sculture*, Roma 1954
- Satolli A., *La pittura dell'Eccellenza*, in "Bollettino dell'Istituto Storico Artistico Orvietano", XXXVI, 1987, pp. 17-275
- Scavizzi G., *Catalogo Generale del Gabinetto Fotografico Nazionale. I. Le chiese di Roma*, Roma 1961
- Schütze S., *Urbano VIII*, in A. Coliva, S. Schütze (a cura di), *Bernini. La nascita del Barocco in casa Borghese*, catalogo mostra, Roma 1998
- Scoppola F., *Palazzo Altemps*, Roma 1987
- Schütze S., *Maffeo Barberini tra Roma, Parigi e Bologna: un poeta alla scoperta della "Felsina pittrice"*, in *I Cardinali di Santa Romana Chiesa. Collezionisti e Mecenati*, vol. I, a cura di Marco Gallo, Roma 2002, pp. 41-55
- Schütze S. (a cura di), *Palazzo Sacchetti*, Roma 2003
- Shearman J., *Raphael in Early Modern Sources 1483-1602*, New Haven 2003
- Siviero C., *Un artista che non volle fare arte sacra*, in "C.S. Fede e Arte", I, fasc. XII, 1953, pp. 380
- Sestieri G., *Repertorio della pittura romana della fine del Seicento e del Settecento*, 3 voll., Torino 1994
- Solinas F. (a cura di), *I segreti di un collezionista. Le straordinarie raccolte di Cassiano dal Pozzo 1588-1657*, catalogo mostra, Roma 2000
- Solinas F. (a cura di), *I segreti di un collezionista. Le straordinarie raccolte di Cassiano dal Pozzo 1588-1657*, catalogo mostra, Biella (Roma) 2001
- Solinas F., *La "Signora degli Scorpioni". Un inedito di Ottavio Leoni (1578-1630) e qualche ritratto romano del tempo di Caravaggio*, in *Caravaggio nel IV centenario della cappella Contarelli*, atti del convegno internazionale di studi (Roma, Accademia Nazionale dei Lincei, 24-26 maggio 2001), a cura di C. Volpi, Roma 2002, pp. 243-265
- Spear R. E., *Domenichino*, New Haven-London 1982
- Spike J. (a cura di), *Baroque Portraiture in Italy*, catalogo mostra, Sarasota 1984
- Spiriti A., *Luigi Alessandro Omodei e la riqualificazione di San Carlo al Corso*, in "Storia dell'Arte", 84, pp. 269-282
- Spiriti A., Capelli S. (a cura di), *I David: due pittori tra Sei e Settecento*, catalogo mostra, Rancate (Milano) 2004
- Strinati C., Vodret R. (a cura di), *Palazzo Chigi*, Milano 2001
- Strinati C. e altri (a cura di), *Manzù. L'uomo e l'artista. Grande Mostra Manzù*, catalogo mostra, Roma 2002
- Strinati T., *Pasquale Cati a Santa Maria in Trastevere e un probabile ritratto di Michelangelo*, in "Studi di Storia dell'Arte", 9, 1998, pp. 115-154
- Sutherland Harris A., *Andrea Sacchi. Complete edition of the paintings*, Oxford 1977
- Testa L., *"...In ogni modo domatina uscimo": Caravaggio e gli Aldobrandini*, in *Caravaggio nel IV centenario della cappella Contarelli*, atti del convegno internazionale di studi (Roma, Accademia Nazionale dei Lincei, 24-26 naggio 2001), a cura di C. Volpi, Roma 2002, pp. 129-154
- Titi F., *Studio di pittura, scoltura, et architettura nelle chiese di Roma*, edizione comparata a cura di B. Contardi e S. Romano, Firenze 1987
- Trento, *I Madruzzo e l'Europa*, catalogo mostra, Trento 1993
- Trumble A., *The marble bust*, Yale Center For British Art, s.l. 2004
- Urbani G., *Schede di restauro*, in "Bollettino dell'Istituto Centrale del Restauro", 1950, pp. 103-104
- Urrea Fernandez J., *La Pintura italiana del siglo XVIII en España*, Valladolid 1977
- Vannugli A., *La "Pietà" di Jacopino del Conte per S. Maria del Popolo: dall'identificazione del quadro al riesame dell'autore*, in "Storia dell'arte", 71, 1991, pp. 59-93
- Vannugli A., *Conte, Jacopino (Jacopo) del*, in *Saur Allgemeines Künstlerlexikon*, 20, München-Leipzig 1998, pp. 600-602
- Vannugli A., *Il primo ritratto del cardinale Benedetto Giustiniani "in tela d'imperatore". Con una proposta per Antonio Scalvati e tre per Pietro Fachetti*, in *Caravaggio nel IV centenario della cappella Contarelli*, atti del convegno a cura di C. Volpi, 24-26 maggio 2001, Roma 2002, pp. 267-290
- Valenti M. (a cura di), *Invito a Camaldoli*, catalogo mostra, Monte Porzio Catone 2003
- Vasari G., *Le vite de' più eccellenti pittori scultori ed architettori* (Firenze 1568), a cura di G. Milanesi, Firenze 1906
- Waterhouse E., *Baroque Painting in Rome*, Oxford 1937
- Velani L. (a cura di), *La Raccolta Manzù, Ardea. Catalogo delle sculture*, Latina 1994
- Velani L., *Anni '60*, in C. Strinati e altri (a cura di), *Manzù. L'uomo e l'artista. Grande Mostra Manzù*, catalogo mostra, Roma 2002

Venezia:
Il Settecento italiano, catalogo mostra, Venezia, 1929

Venezia:
Tiziano, catalogo mostra, Venezia 1990
- Venturi A., *Storia dell'arte italiana*, voll. XI, Milano 1908-1939
- Vicini M. L., *Guida alla Galleria Spada*, Roma 1998
- Villa E., *Un episodio sconosciuto della ritrattistica del '600: Clemente X, Bernini e Gaulli e altre novità sulla committenza Rospigliosi, Altieri e Odescalchi*, in V. Martinelli (a cura di), *L'ultimo Bernini 1665-1680*, Roma 1996, pp. 142-152
- Voss H., *Die Malerei der Spätrenaissance in Rom und Florenz*, Berlin 1920 (ed. it., *La pittura del tardo Rinascimento e Roma e a Firenze*, Roma 1994)
- Voss H., *La pittura del barocco a Roma*, a cura di A. De Marchi, Vicenza 1999
- Wethey J. (a cura di), *The Painting of Titian, II. The Portraits*, London 1971
- Whinney M., *English Sculpture 1720-1830, Victoria and Albert Museum*, Londra 1971
- Winckelmann J., *Pier Leone Ghezzi: un ritratto inedito a Bologna*, in "Musei Ferraresi Bollettino Annuale", V-VI, 1975-'76, pp. 57-71
- Wittkower R., *Gian Lorenzo Bernini the sculptor of the roman baroque*, London 1955, 1966
- Wittkower R., *A new bust of Pope Urban VIII by Bernini*, in "The Burlington Magazine", CXI, 1969, pp. 60-64
- Wittkower R., *Bernini. Lo scultore del Barocco romano*, Milano 1990
- Vitzthum W., *I Disegni dei Maestri. Il Barocco a Roma*, Milano 1970, ediz. 1983
- Worsdale M., *Eloquent Silence and Silent Eloquence in the work for Bernini and his contemporaries*, in *Vatican Splendor. Masterpieces of Baroque Art*, catalogo mostra, Ottawa 1986
- Zamboni S., *Pietro Bracci: il modello per il monumento di Benedetto XIV*, in "Arte Antica e moderna", 26, 1964, pp. 211-218
- Zapperi R., *Tiziano, Paolo III e i suoi nipoti*, Torino 1990
- Zeri F., *Salviati e Jacopino del Conte*, in "Proporzioni", II, 1948, pp. 180-183
- Zeri F., *La Galleria Spada in Roma*, Firenze 1954
- Zeri F., *I dipinti del Museo di Palazzo Venezia in Roma*, Roma 1955
- Zeri F., *Quattro tele del baciccia*, in "Paragone", n. 67, 1955, p. 55
- Zeri F., *Pittura e Controriforma*, Torino 1957, edizione Vicenza 1998
- Zeri F., *La Galleria Pallavicini in Roma*, Firenze 1959
- Zeri F., *Italian Paintings in the Walters Art Gallery*, 2 voll., Baltimore 1976

Ended to print in september 2005
Gangemi Editore S.p.A. – Rome